P9-AQR-393

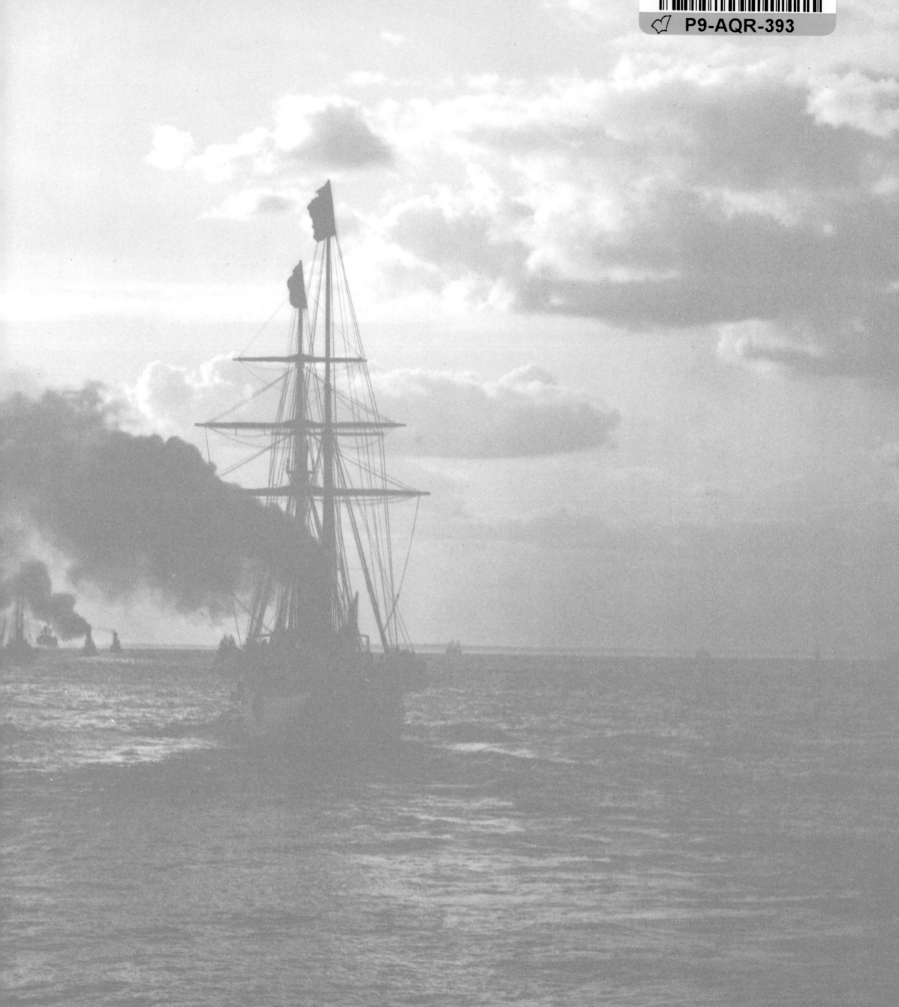

MILLIONAIRES, MANSIONS AND MOTOR YACHTS

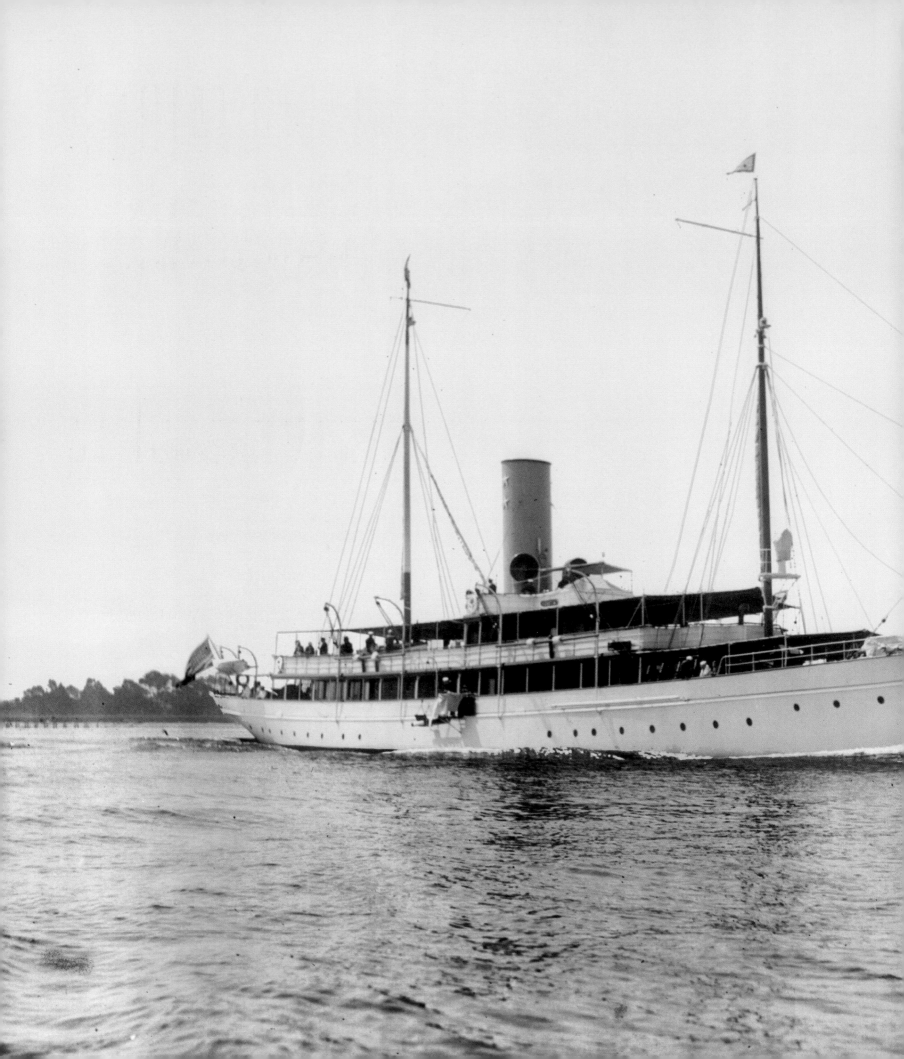

MILLIONAIRES, MANSIONS, AND MOTOR YACHTS

—

AN ERA OF OPULENCE

—

ROSS MacTAGGART

W. W. NORTON & COMPANY

NEW YORK · LONDON

Copyright 2004 by Ross MacTaggart

All rights reserved
Printed in Italy
First Edition

The text of this book is composed in Miller (designed by Matthew Carter)
and Interstate Condensed (designed by Tobias Frere-Jones) with the
display type set in Univers Thin Ultra Condensed (designed by Adrian Frutiger)
and Engraver's Gothic (designed by Morris Fuller Benton).

Manufacturing by Mondadori Publishing, Verona

Book design by Robert Wiser, Silver Spring, Maryland

Library of Congress Cataloging-in-Publication Data
MacTaggart, Ross.
Millionaires, mansions, and motor yachts : an era of opulence / Ross MacTaggart.
 p. cm.
ISBN 0-393-05762-3
1. Yachts—United States—History. 2. Millionaires—United States—Biography.
3. Mansions—United States—History. I. Title.
VM331.M1724 2004
920.073—dc21 2-3044171

W. W. Norton & Company, Inc., 500 Fifth Avenue, New York, N.Y. 10110
www.wwnorton.com
W.W. Norton & Company Ltd., Castle House, 75/76 Wells Street, London, WIT 3QT

1 2 3 4 5 6 7 8 9 0

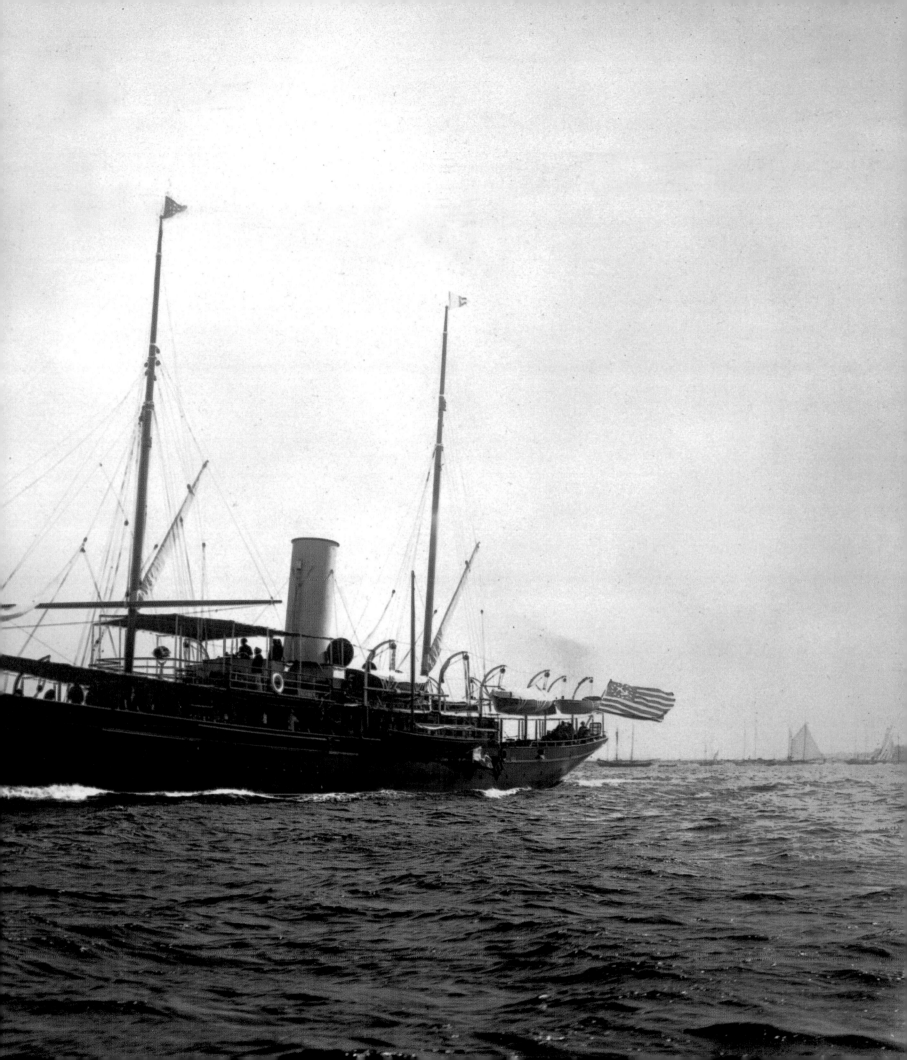

CONTENTS

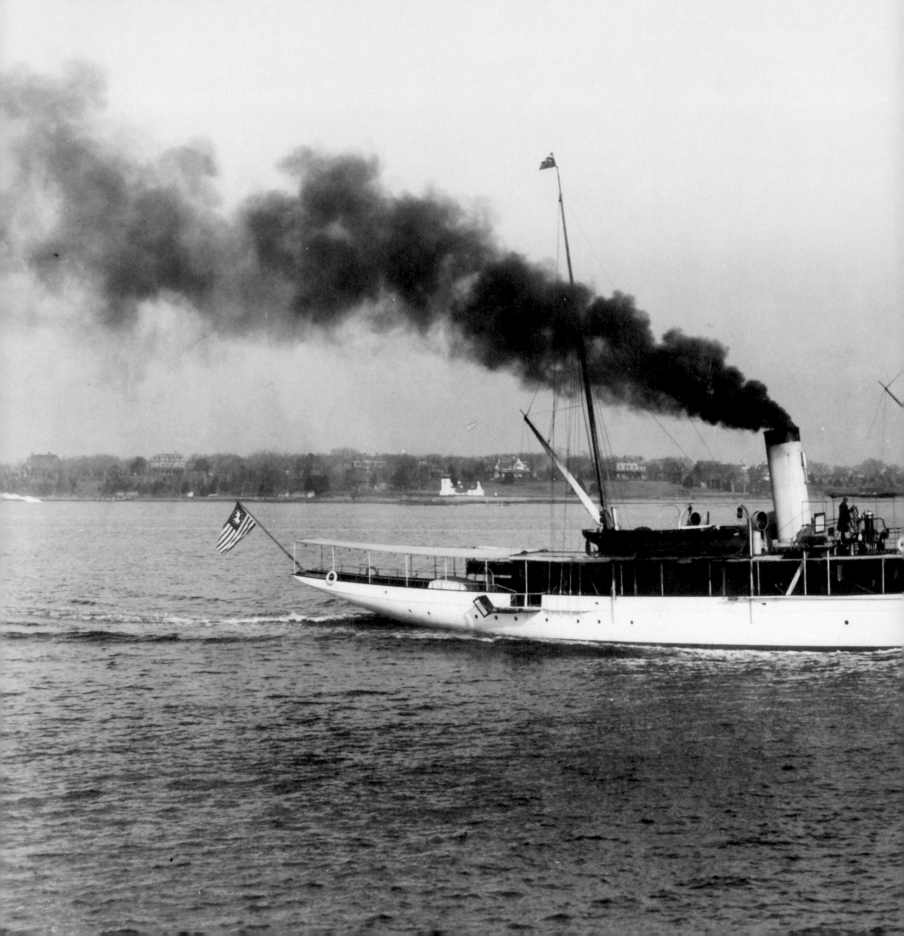

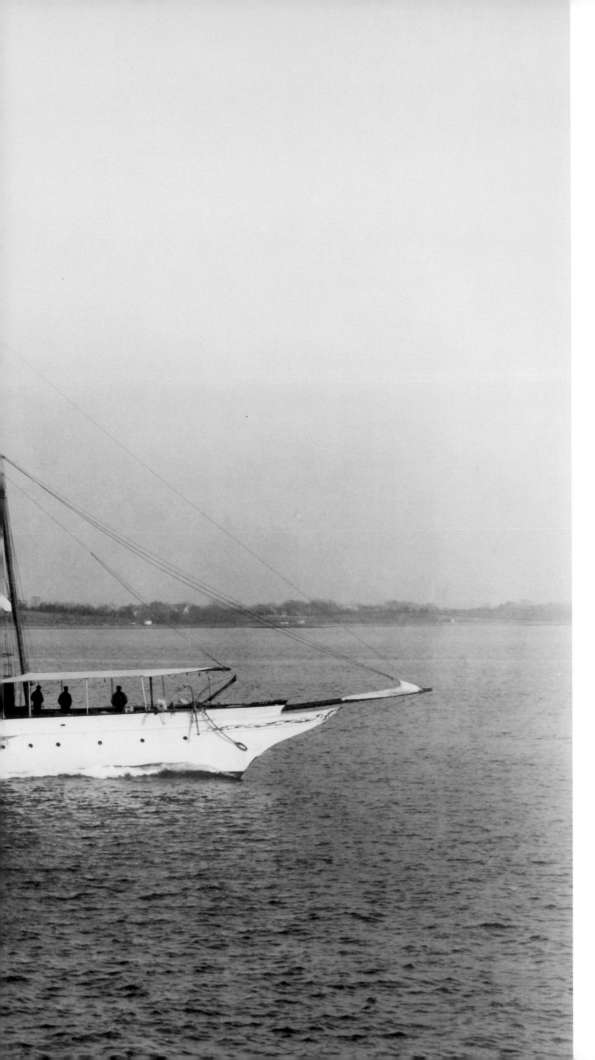

ACKNOWLEDGMENTS

The publishing of many books is greatly assisted by personal wealth, grants, spouses, or corporate underwriting. *Millionaires, Mansions, and Motor Yachts* and my previous book, *The Golden Century*, had no such buttressing, and contrary to their elegant appearance and expensive finish, they were produced by the author under financial anguish. Passion, to date, has overruled common sense.

It is therefore all the more significant to acknowledge the help received. Most important, a dear friend, John Dalessio, provided help during the winter it took to complete this volume. It is a not-to-be-repeated experience trying to type with fingers akin to ice, so the maintenance of the heating was a great boon. As with *The Golden Century*, the small town I live in (pop. 600) offered support. I thank Kay Lauer, Glenda and Jim Fink, Jane and Ron Scott, and Vikki and Marvin Adcock, particularly.

I have also been blessed with a wonderful, supportive, eccentric, fascinating, endearing, and funny editor: Jim Mairs. A book could be made of our e-mail correspondence and it would likely become a bestseller.

Many of the people who made *The Golden Century* so, well, magnificent in its appearance, have returned to midwife this volume. I thank Robert Wiser for a sophisticated layout, and Sue Carlson and Brook Wilensky-Lanford of W. W. Norton for all manner of small niceties. Kathleen Brandes copyedited my words toward the appearance of intelligence. These individuals make me look smarter; I wish to have *teams* of such people around for every aspect of my life.

The interior images of the 407-foot *Savarona* have never been published. Until now. I thank Anton Fritz for revealing their existence, and for allowing their use.

Richard Wheeler graciously supplied a rather impressive image of *Venetia* (pages 20–21).

Both *The Steam Yachts* by Eric Hofman and Fred M. Walker's *Song of the Clyde: A History of Clyde Shipbuilding* have continued to be of enormous assistance.

Many of the biographies in this volume have been enriched by Internet wonders like www.abebooks.com. In an instant, almost any out-of-print book can be found. Truly, it is a wonder.

The many words in this volume are produced, usually, with great joy. For me, it is fascinating to slowly recreate the life of an individual and a yacht's history. When the many disparate bits come together to form a coherent story, my delight is great indeed. I am pleased that so many readers of *The Golden Century* contacted me and offered compliments on the many words and stories. Nonetheless, I am not fooled. It is the *images* that sell these books. Almost all have never been published, most are breathtaking, and all are, I am hopeful, of interest. This is all to the good, because finding so many unpublished images and arranging for their publication is an enormous amount of work, far harder than writing the text. That such images exist and are made available is thanks to countless dedicated people who ensure their preservation. I have now had the pleasure of working with many of those listed adjacent for a decade or more and look forward to many additional years together.

Barge House Museum
Pat Bausell
Peter Tasi

Boston Public Library
Aaron Schmidt

California State
University

Copley Library

Hagley Museum
and Library
Barbara Hall

Historical Collections
of the Great Lakes
Bowling Green State
University
Robert Graham

Hotel del Coronado

Hoover Library

Houghton Library,
Harvard University
Annette Fern

Library of Congress

Maine Maritime
Museum
Nathan R. Lipfert
Susan Russell

Mariners' Museum
Heather Friedle
Claudia Jew
Charlotte Valentine

Maritime Museum
Association
of San Diego
Craig Arnold
Chuck Bencik

Mystic Seaport
Philip L. Budlong
Mary Anne Stets
Peggy Tate Smith
Louisa Alger Watrous

The Rosenfeld
Collection:
Deborah M. DiGregorio
Jack (The Intrepid)
MacFadyen
Elizabeth Rafferty
Victoria R. Sharps

Ships' Plans:
Ellen C. Stone
Pat Wilbur

Photography:
Judy Beisler
Claire White-Peterson

Naval Historical
Foundation

Nemours Mansion
and Gardens
Paddy Dietz
Shirley S. Jelinek

New York Yacht Club
Joseph Jackson
Bill Watson

Peabody Essex
Museum
Carolle Morini
Kathy Flynn

Scituate Historical
Society
John Galluzzo

Society for the
Preservation of New
England Antiquities
Rebecca Aaronson
Lorna Condon
Sally Hinkle
Jessica Parr

Washington and
Lee University
Lisa McCown
Vaughan Stanley

PREFACE

My friends tease me; they say I am having a love affair with the dead. Well, it *is* a fascinating, absorbing process: creating life. Like Dr. Frankenstein, I assemble people out of many disparate, lifeless pieces. These pieces are not the type used by the mythological doctor but rather pieces of information. When I encounter images of, for example, a fine-looking craft such as *Idalia* from old yachting magazines, I know nothing about the person who commissioned her other than a name: Eugene Tompkins. Unlike, say, a John Pierpont Morgan, a Eugene Tompkins does not resonate in my mind with dozens of half-remembered stories; I know utterly nothing about him, and there are no vague memories of relevant resources (such as for Morgan—the Morgan Library) or readily available biographies. While a miracle called the Internet is just that—offering dozens or even hundreds of tantalizing tidbits in mere seconds—the Internet offered nary a clue as to the mysterious Mr. Tompkins.

His yacht, *Idalia*, fared better; there were numerous contemporary magazine articles on her, and a fine set of glass-plate negatives of her Louis Tiffany–designed interiors (pages 37–43). But what about her owner? Other than knowing that he lived in Boston—nothing. All research proved fruitless. Finally, a tidbit: He made his "fortune in the theater business." A short while later, another bit: he had something to do with a Globe Theater in Boston. I knew, of course, about a like-named theater in London, but Boston? Immediately, I dispatched an inquiry to a favored archivist at the Boston Public Library.

On the other hand, there was a wealth of material on Thomas W. Lawson (pages 52–79), but two things caused irritation. First, his lovely yacht, *Dreamer*. I had century-old magazine images of her elegant interior, but I could not trace the whereabouts of the glass-plate negatives or even copy prints. Second, the favored Boston Public Library archivist had unexpectedly sent me dozens of superb images of Lawson's sprawling estate, Dreamwold. But what happened to it? Contemporary accounts state that Dreamwold was in Egypt, Massachusetts. I quickly ascertained that Egypt—at least the one on this side of the Atlantic—no longer existed; hence, my inquiries about the estate could not be forwarded to an Egypt Historical Society. Years passed before an obvious thought struck me: Egypt had to have been subsumed by some neighboring community. A few days later, and after a couple of wrong turns, I had my long-anticipated answer: Scituate. I laughed. Years earlier, I had extensively toured this charming coastal town. Not knowing it to be the location of the elusive Dreamwold, I never looked or asked. When I called the Scituate Historical Society (found instantly on the Internet), a talkative (a researcher's dream) gentleman answered. When I asked about Dreamwold—did it still exist?— the reply was, "Well, yes, I am looking at the main house right now, through my window." When I told him about the dozens of fine images I had, he one-upped me—delightfully so—by replying that he had *hundreds*. Graciously, he forwarded them to me.

Lawson owned a yacht called *My Gypsy* and had previously leased *Reva*. When images of these vessels arrived in the mail, I was fascinated by these never-published, long-forgotten vessels. Would anyone else on the planet have been able to identify them as being associated with Lawson? Such are the odd moments of wonder for an obsessive.

Lawson was unusual; the vast majority of yacht owners were more like Eugene Tompkins and George Fabyan. In their time, they might have been people that the average person—at least those paying attention to Society—had some sense of, no matter how vague. A century later, however, they have been essentially erased by time. Even someone extremely well known (at least in yachting circles) can almost disappear from the records, such as Thomas Fleming Day. This intriguing individual wrote many books and for decades was the editor of the influential and popular *The Rudder* magazine. But biographical information about him proved maddeningly scarce. I knew when he died, but when was he born? Was he married? Were there children?

While I had information about Lawson's yacht *Dreamer*, I could not locate the glass negatives of the images featured in old yachting magazines. Nor was *Dreamer* famous in her day, unlike

the various Morgan *Corsair*s (there were four; see *The Golden Century*, page 146). You would think, then, that a famous vessel would make life easier for a researcher. This is not necessarily the case. *Sequoia II* became the U.S. presidential yacht and served nine presidents; obviously, she was photographed countless times, but few of the images offer a clear look at the vessel—the famous people typically are the focus. Nor was she professionally photographed after her launching, as were so many yachts. *Savarona* (pages 192–99) is another example; she was the third so-named vessel and the largest private yacht ever built, at an incredible 407 feet (a record only eclipsed in 1999). By comparison, the fourth *Corsair* was 343 feet. *Savarona*'s size was distinctive and this, combined with the fact that she exists today (remarkable in itself), would lead one to believe that plenty of information was available about her and the woman who commissioned her, Emily Cadwalader. This is not the case, either. To save on import duties, *Savarona*, launched at the same time as another behemoth—the Great Depression—was never brought into American waters, even though Cadwalader was a Philadelphia resident. As such, the photographers who prowled U.S. waters never captured the boat's image; in turn, *The Rudder* and *Yachting* gave her scant coverage. Through a slim Internet thread, I found one Anton Fritz. He has long been fascinated by the name Savarona, and for decades he has obsessively researched anything associated with the word. I contacted him via e-mail (one obsessive to another) and was quite pleased—no, thrilled—to learn that he had never-published builder's images of *Savarona;* he graciously sent them, and for the first time I could admire the interior of this almost-mythical vessel. And Emily Cadwalader? She remains elusive, annoyingly so.

While the largest private yacht in the world did not generate much archival material, her earlier namesake revealed a wealth of documentation. The second *Savarona,* launched two years previously—a mere 294 feet—was given ample press and was, thankfully, extensively photographed. There existed an unintentionally humorous account of her maiden voyage as well as a complete set of construction images showing the yacht from keel-laying to the dramatic launching and final fitting-out (pages 181–85).

While Cadwalader remains rather a mystery, a later owner of *Sequoia II* is well chronicled, for, among other milestones, he introduced the television remote control. Couch potatoes the world over bless Eugene Francis McDonald.

Alfred du Pont, who dominates this volume with almost a hundred images, is unique: He made my life easy. His illustrious family left a wealth of archival material; his yachts were frozen in time through available negatives and pristine prints; several biographies existed (even for his third wife, Jessie); his papers were accessible; and his two mansions are extant (one is even open to the public). Going through thousands of du Pont papers is as close to time travel as a researcher can hope for. These documents detail Alfred's intense involvement in the design and construction of two yachts, both named *Nenemoosha*; indeed, so abundant were du Pont's ideas that it can be claimed he was a co-designer, an attribution supported by the singularly unique appearance of the two vessels. The papers also offer a fascinating glimpse into long-ago companies, and archaic hardware, machinery, fittings, electrical devices, and plumbing—allowing an era to be re-created. Anyone hoping to restore a 1920s yacht would do well to peruse the du Pont papers. The documents reveal more than a lost age; they unveil personalities. Alfred is unfailingly gracious during what must have been a tedious battle with naval architect Edward Carroll, who designed the first *Nenemoosha*. When du Pont decided to commission a new vessel and did not retain Carroll, the architect sent dozens of letters and telegrams filled with anger, threats, and self-righteousness. He claimed that du Pont had stolen his design for the yacht. After the second *Nenemoosha* was completed—and clearly was not a Carroll design—the architect sent a brief telegram and humbly apologized. Also brought to life were Alfred's running problems with his chief engineer, O. W. Kummerlowe. Carroll and Kummerlowe were constantly squabbling, each clearly having no respect

for the other's profession, while du Pont himself seemed to have little faith in his engineer. Was du Pont justified? It is likely that no engineer could have pleased him (as no naval architect did); he micromanaged every aspect of his yacht.

The du Pont papers offer a rare, all-too-quick glimpse into the question about which I am most curious, but one that the record-keepers have almost universally refused to answer: What were these people *really* like? Did they marry for love or for societal and financial reasons? Were they liked by those who knew them or were they sons-of-bitches? Did they treat their children well, largely ignore them, or, worse, brutalize them? Were they true to their spouses, loving and devoted, or were they cruel and involved in tawdry affairs? It is rare to unearth answers to any of these questions. The biographies contained within cyclopedias are sanitized, the subjects treated with Christ-like reverence.

This is unfortunate, for several reasons. First, it renders history false. Second, it makes such individuals less interesting, textured, and human. And certainly less entertaining. In reading about such "perfect" people, one cannot help but wonder: *Why am I not as such?* Edward Carroll's letters to Alfred du Pont, although somewhat painful to read, nonetheless give Carroll a singular distinction: He comes alive. One can *feel* his emotions. While du Pont's responses are courteous to the extreme, his emotional responses to this delusional vendetta were not recorded; thus, it is hard to *know* the man.

As with *The Golden Century*, this book is dedicated to the extraordinary individuals described within its pages. As a record-keeper, I hope I have rendered them as they might have liked, and with accuracy. They have blessed me with an absorbing passion, one that I do not much understand but question little.

INTRODUCTION

It is difficult to imagine life in the early nineteenth century. The Industrial Revolution was in its infancy, and life for the average person was little different than it had been for hundreds of years. Ninety-five percent of the people in the Western world worked on a farm or in a related activity (today, fewer than five percent do). The plethora of conveniences we now take for granted—computers, wireless phones, television, and automobiles—were neither invented nor imagined. Florida was an unexplored swampland. The moon was something to look *at*, not walk *on*. Madonna was a religious icon, not a musical one. A skyscraper was four stories high. A glass of water usually came from a well; milk was obtained by molesting a cow. A soda was just that, not a diet Coke. Electricity was exotic, not something coursing through the walls of your home. Traveling, sometimes even short distances, was difficult and time-consuming. Paved roads were almost non-existent. A hotel chain—with clean bathrooms—was an unimaginable concept. Indeed, a bathroom was largely a concept. If one wanted to travel by boat, the schedule was wholly dependent not on human timetables or elements but on God's—the wind.

Imagine, then, just how extraordinary it was when the *Menai* was launched in 1830 (see *The Golden Century*, page 14). This otherwise-quite-ordinary craft had within her hull a stupendous creation never before used aboard a private yacht: a steam engine. For the first time, an individual could control his or her vessel's schedule. It would prove, in part, the beginning of an era of opulence. By the 1880s, the Industrial Revolution was in full swing; life for many people was now more fundamentally different than it had been since humans first walked the earth. By 1930, life was even more thoroughly transformed. Automobiles clogged paved roads; planes, albeit primitive, existed; friends and family could be just a phone call away; and electricity was so widespread as to no longer be a luxury, but rather an expected necessity. And this golden century spawned another heretofore-unknown creation: the self-made millionaire.

While a moneyed elite had existed for several millennia, they were either royalty or titled gentry. By the mid-nineteenth century, there were people like Cornelius Vanderbilt—born dirt-poor to unremarkable peasants—who rose to become the richest non-royal person in the world. A new social order was born—a new class of person, a new life form. Today, millionaires are commonplace. They can travel wherever they might wish, even into space. They also can communicate effortlessly with the farthest reaches of the planet, transmit and receive information in a split second, and rule vast business empires from a computer keyboard.

In 1830, trying to learn what happened a few hundred miles away—to say nothing of around the globe—could take weeks or months. An elegant private carriage had to travel the same rutted, misbegotten roads with the poorest farm wagon. Going from London to New York entailed weeks aboard a vessel—with no heat, no en-suite bathrooms, no refrigeration for food, and certainly no first-class dining rooms—tossed like a cork by the mighty Atlantic waves. Things improved by the late nineteenth century, when trains, particularly private rail cars, offered plush accommodations, but a millionaire still had to accept the fact that trains went where they *could*, not where you *wanted*. Late-nineteenth-century oceangoing liners also had predetermined landing and departure points, although they were much improved, luxury wise, over their sister ships from a few decades earlier.

What was the point of being a millionaire if one could not do whatever one wanted, whenever and wherever? And comfortably?

The development of the private steam yacht in the mid-nineteenth century was, therefore, an extraordinary blessing, a fantastic creation enabling freedom—and the all-important comfort—unprecedented in the history of travel. "The most striking personal possession ever produced," noted Erik Hofman in *The Steam Yachts*. Until private spacecraft are available, this dynamic will continue to ring true. (While some might argue that private jet aircraft are analogous, I disagree. No plane, no matter how extravagantly outfitted, can compare to, say, a 300-foot yacht. Moreover, planes are largely unseen by the public. A 300-foot yacht is a possession about which one cannot easily be discreet.)

In England, as a result, an entirely new social schedule evolved: the yachting season. Men and women whose wealth

had been created over centuries (usually from enormous tracts of land) took to yachting with gusto, albeit a laid-back enthusiasm that typified the "restful composition" of the English.

In America, that other recent phenomenon—the industrial tycoon—also took to yachting, although, unlike the landed gentry abroad who favored long cruises lasting months and even years, these newly minted tycoons liked yachting for one essential purpose: speed. Their yachts were rarely used for leisurely cruises, but rather for swiftly dispatching the moneyed few between their estates and their downtown offices.

Edwin S. Jaffray, a renowned nautical writer, learned the value of speed as he steamed up the Hudson River toward his home in Irvington after a hard day at his Manhattan office. Along the way, he passed James Stillman aboard his sailing vessel, *Wanderer*. The next morning, bound for work, Jaffray re-boarded his steam yacht … and soon passed *Wanderer*. She had squeaked along seven miles in the intervening twelve hours.

The new breed of tycoons also discovered a unique advantage yachts offered. Rivals would be invited aboard for a cruise, only to discover that returning to shore was impossible until they gave in to the desires of their host: selling their company, agreeing to a merger, or any number of other shenanigans. One American president understood such power when he observed that any person could do his job—as long as he or she owned a yacht.

Wealthy widows—who formerly might have been imprisoned in their grand mansions, curtains drawn—could order a splendid yacht, throw off their mourning clothes, and spend years, even decades, traveling the globe well out of eyesight of those who might have considered such behavior improper.

As steam yachts grew in popularity, exotic ports and mystical lands suddenly became accessible. With the dawn of this new era, yachts were provisioned, crews drilled, coal bunkers filled, and nannies, maids, valets, and secretaries shuffled on board. As engines slowly built up steam, lines were cast ashore and a mode of travel previously unknown was greatly assisted by one thing—a ton of money. Yachts, then as today, require this lubricant.

Not every millionaire could justify such an expense. When a young David Rockefeller was asked why his family did not own a large yacht, he replied, "Who do you think we are—Vanderbilts?"

Indeed, the Vanderbilts were *the* preeminent yacht-building family. The first American steam yacht appears to have been *North Star*, commissioned by Cornelius "Commodore" Vanderbilt in 1853 and costing a reported $500,000 (about $15 million in today's dollars). Vanderbilt left a fortune of $40 million when he died (about $1.2 billion in today's dollars), so it may be presumed that the cost of yachting was not a principal concern. This unprecedented fortune enabled his descendants to indulge in steam and sailing yachts with an extravagant passion, culminating with Harold Vanderbilt, who became the only triple winner of the America's Cup, and his brother William, who took extended voyages exploring the globe (*The Golden Century*, pages 83 and 95, respectively).

While inherited wealth, no doubt, greatly assisted yachting, the majority of those depicted in these pages came from impoverished backgrounds. Their yachts, perhaps, became imposing symbols of their success—as conspicuous a status symbol as ever existed. And because the depreciation value on a yacht was considerable, quite grand vessels were available inexpensively, relatively speaking. Alfred I. du Pont hoped for $75,000 when he sold the twenty-year-old *Alicia*; he received $24,000 for the 155-foot vessel.

Even though the first private steam yacht was built in 1830, it took decades for millionaires to realize its significance. By 1863, there were still only thirty steam yachts listed in England; this number shot up to 140 a few decades later; a decade after that, the total was an astonishing 466. The New York Yacht Club experienced a similar surge, going from four steam yachts in 1870 to seventy-one within two decades. This popularity was greatly assisted by the fact that, while a private rail car could only be eighty-two feet long by ten feet wide (and ran on a fixed rail), a private yacht could be as spacious, luxurious, and accommodating as one wanted and could afford. Plus, it had an extra pleasing feature: the unprecedented ability to travel the world, free of departure schedules, predetermined routes, poor roads,

and even other people. Still, even millionaires had to be careful. Those who dealt with Alfred du Pont considered him, well, cheap. Was he? Or was his constant penny-pinching a calculated tactic to instill in those working for him the concept that, while a millionaire, he was not stupid?

In time, the very rich began to discern a few negatives about yachting. John P. Morgan discovered one such problem with cruising: How many people had the time, inclination, wealth—and pleasant personality—and could also take several months off? He once advised a prospective yacht owner: "Have you got one or two men whom you are fond of, that you can depend on always to go off yachting with you? Because if you haven't, don't buy a yacht, as it will be the loneliest place in the world for you."

Another problem was that a competition of sorts developed, a costly one. "In New York Society, a bigger and faster yacht was a better yacht, but the best yacht of all was the most expensive," as Lord Feversham observed in *Great Yachts*. As noted, Emily Roebling Cadwalader entered this race in the late 1920s with a passion, ordering five vessels in only five years. She effectively won the imagined Grand Prize, after having commissioned the largest, most expensive private yacht then built: the $4 million *Savarona* ($120 million in today's dollars). By comparison, the luxurious *Sea Cloud* reportedly cost a mere $900,000 ($27 million in today's dollars).

All the money in the world would not have allowed a millionaire to steam across the globe without another essential lubricant: a crew. In America, they were culled from Maine (particularly Deer Isle) and other coastal ports, and they could spend their lives with one yacht owner. Aboard English vessels, the chief engineers were usually Scots who had apprenticed in yards building ocean liners, naval vessels, and yachts. They, like the rest of the crew, were paid low wages and even had to purchase their own food (a cook was graciously provided by the owner), while American crews were paid slightly better and meals were included. (It took a few decades for English crews to have food included as part of their wages.)

Moreover, as Erik Hofman detailed, "Stewards had the un-enviable task before them to provide food of the type and variety the owners and guests were accustomed to ashore. There was little refrigeration until the latter part of the [steam yacht] era, so the steward and cook would have to purchase supplies in ports as they went along, dealing with the problem of strange languages, strange foods, and in the Mediterranean, heat and food spoilage."

The importance of having a highly trained and knowledgeable crew was highlighted when Vanderbilt's *North Star* was readied for her epic maiden voyage. Just before departure, her crew went on strike for higher wages, but *North Star*'s owner was not the type to brook such action—he fired the lot. Scrambling for replacements, the captain signed on green hands and perhaps was not entirely surprised when one such youth, after being ordered to strike two bells, returned a short while later and reported that he could find only one bell. Or so the story goes.

In time, a ready supply of crew members was exhausted, and millionaires looked to the Baltic, Scandinavia, and, on occasion, Holland and Germany, for recruits. There were even reported instances of entire Norwegian villages working on American yachts. While many crew members took great pride in "their" yacht—keeping teak decks scuff-free, topsides gleaming, galleys spotless, and engine rooms cleaner than hospital operating rooms—they would also be separated from their families for months at a time, and they had to endure the whims, foibles, and eccentricities of their owners. And, no question, the rich *are* different.

What was life like for a crew member? An officer was retained on an annual basis and many served one owner for decades. The captain of *Venetia* (pages 92–97) worked twenty-two years for John D. Spreckels; chief engineer William Neil Darroch served sixteen years. The employment of both men was only terminated upon Spreckels's death. Officers aboard Alfred du Pont's yachts never served such long tours—revealing a different story.

A crew member was often retained on a seasonal basis. From spring till fall, they would be part of a complement ranging from a half-dozen to dozens of men crammed into the least desirable spaces aboard a yacht. What must life have been like for these

men (and all *were* men), and their annual unemployment each winter so that an owner could save a few dollars? Nor did serving aboard a yacht seem much to brag about. Jay Ottinger, in *The Steam Yacht Delphine and Other Stories,* writes that men who worked on cargo vessels felt superior to those aboard passenger liners; each felt above yacht crews, or "ice cream sailors," as they called them. Ottinger said that when *Delphine* (*The Golden Century,* page 105) dropped anchors, the rush of heavy chain thundering through the hawsepipes—and directly adjacent the crew quarters—sounded like "the world was coming to an end."

In America, the golden century of steam and motor yachting came to an abrupt close when the Great Depression cast its shadow across the economy and industry. (In the United Kingdom, it took World War II to bring a close to the golden century of yachting.) The 407-foot *Savarona* was offered for sale but had no takers—not surprising, considering her $20,000 monthly operating expenses. When owner Emily Cadwalader tried to charter the yacht, the $80,000 monthly fee proved an impediment. Seven years after her launching, the Turkish government purchased *Savarona* for a reported $1,000,000—a quarter of her construction cost.

The Depression—coupled with the advent of the automobile and good roads, mixed with U.S. income taxes (a 1914 creation), and further distressed by early airplanes—brought an end to a century of grand mansions and yachts. Once the crippling effects of the depression lifted, and after the world was scarred by a horrific war, Western civilization was fundamentally different.

Over time, this golden era was eclipsed. Very few yachts remain from that era, *Sea Cloud* being the most famous survivor. The many Vanderbilt yachts are gone, unlike their kindred creations on shore that continue to astonish people decades after their construction—Biltmore, the Breakers, Shelburne Farms, and Marble House. The four Morgan *Corsair*s? Gone. Gone, too, are *Idalia, Dreamer,* both *Nenemoosha*s, and every yacht contained within these pages save two commissioned by Emily Cadwalader: *Sequoia II* and the third, immense *Savarona.*

The yachting stories of these rich men and lone woman, and the crews that enabled their pursuits, were consigned to a few books, tattered scrapbooks, and old tales. The glass-plate negatives of marine photographer Nathaniel Stebbins—17,500 of them—were sold and reportedly used as greenhouse glass, their only perceived value. Stebbins's remaining photographic images of these great steam and motor yachts, as well as those by Rosenfeld, Levick, and others, were largely forgotten and relegated to dusty storerooms, dark archival vaults, and hot attics—unlike the images of their more popular relations: sailing vessels, ocean liners, and even tugboats. These latter vessels generated thousands of books and magazine articles. A century of steam and motor yachts? Less than a handful of books were written, with an occasional chapter in books about sailing yachts. The envy these steam and motor yachts once engendered, the tabloid headlines they commanded, the pride of their crews, and the admiration of many non-millionaires—all eventually became obscured by time.

An opulent era. It must have been grand.

CURMUDGEON COMMENTS:

I concluded this section with the statement: "An opulent era. It must have been grand." As a record-keeper, I feel strongly about accuracy as the desired goal. And so, I must add some clarity to this statement. The era depicted within these pages was also a golden century of architecture and urban planning. Almost every building constructed during this era was better built, and from superior materials, than its post–World War II counterparts. They were also, well, friendlier; given a choice, the vast majority of people today would prefer a block filled with robust Victorian buildings than modern steel-and-glass buildings set aloof behind a parking lot.

While I lament the loss of these aspects of an opulent era, I do not mourn the loss of its more distasteful aspects, such as rigid social orders, rampant racism and anti-Semitism, imperial aggrandizement (although the United States has a bad case of this illness), the second-class citizenship of women and minorities, slavery, the virtual slavery of industrial workers, the domination of churches over people's lives, and prehistoric medical knowledge. This list could be longer, but you get the idea. In short, I mourn the *aesthetic* loss of this opulent era; I do not mourn the death of its *societal* pressures, judgments, and treatment of people.

Moreover, the elegant yachts within these pages could only be owned by a rarefied few: those with a lot of money. Such vessels consumed vast quantities of coal, gasoline, or diesel fuel; steam and motor yachts were, by no measure, environmentally friendly. Precious old-growth trees were felled to create teak deckhouses and elaborate interior joinerwork, while metals were laboriously gouged from the earth by overworked, underpaid workers. How many men anguished or died digging coal so that a millionaire could relax on an afterdeck? Yachts also required vast crews; were they treated well by their yacht masters? Some, no doubt, were not. While I acknowledge the faults inherent with grand yachts, I still love 'em.

ELUCIDATION

This book is presented in roughly chronological order by way of yacht-launching dates. Each section begins with a biography of a yacht owner, followed by related material (mansions, businesses, etc.), and then by their yacht(s) in order of launching or ownership date.

The vessels depicted were chosen because one, or all, of the following existed: (a) splendid yacht images, (b) accommodation plans, (c) biographical information on the owner, (d) images of the buildings that made up their lives. If all four categories were fulfilled, then all the better.

Another consideration was the desire to offer a range of lengths—from the 407-foot *Savarona* down to the eighty-three-foot *Rosewill*.

Accommodation plans are always a desired addition to these pages; they are not always available. They are, in fact, the most difficult images to reproduce. Original plans, when available, can be eight feet long. Or longer. They also, more often than not, have been rolled in a tube for a century; once unrolled, they can be quite fragile. Understandably, museums are reluctant to allow this unrolling—no matter how much I beg. One museum had dozens of plans I particularly coveted (just for one yacht), but they were so compacted into a tight tube that the archivist was afraid to release them. I never did get 'em. Assuming that a plan *can* be obtained, once it is reduced photographically to a manageable size, the lines run together. Reproducing plans from old yachting magazines is a preferred option—when they exist. Even this is fraught with difficulty. A museum holding the desired issue must be "persuaded" to scan or photograph them, and museums are overworked, understaffed, and underfunded. So, in a perfect world, each vessel depicted within these pages would have dazzling, crystal-clear plans. Instead, I have included what I could lay my hands on. Savor them.

I also wish that any plans included could be on foldout pages—large enough to drool over them. My editor says this is not financially realistic. You see what I am up against.

It grieves me that this volume and the one that preceded it are so, well, American. There were *far* more steam yachts in England; this volume and *The Golden Century* do not convey this,

for, ironically, there are simply more yachting images in U.S. archives than in U.K. ones. Old magazines tantalizingly reveal wonderful images by U.K. photographers—such as the long-vanished Rothesay & Collotype, Edinburgh, and others—but they cannot be traced. William Kirk was a preeminent English photographer and many of his images are at the Cowes Maritime Museum on the Isle of Wight. Unfortunately, the museum does not hold the copyright for the Kirk images and thus cannot authorize their publication. Another valuable U.K. resource is priced almost three times higher than any other archive; I simply cannot afford them. Glasgow University has proven an excellent resource, although they rarely have interior images of vessels. The National Archives of Scotland is strongly disinclined to respond to research requests; they ask that I come in person to look at their holdings.

Accessing images is an art form. Museums, as mentioned, are usually understaffed, with underpaid and overworked employees; the genealogy boom has created an unprecedented volume of extra work. Every museum also has its own set of eccentricities, rules, and guidelines. Since I was working with dozens of museums, it was a matter of psychology as much as research that enabled the publication of the images contained within these pages.

Many museums are predisposed to researchers arriving in person to access images. While an extremely enticing invitation, this is not feasible. The dozens of museums with which I work are scattered across several continents. Both finances and a lack of time preclude such adventures. I can write. I can travel. But I lack the brilliance to do both. And I would *rather* travel—if it paid royalties (although, at this point, royalties remain a theory).

Because museums do not give away images, finances play a vital role in what appears within these pages. My costs to use the images in this volume, and the one that preceded it, exceeded my advances. Reducing the number of images by half would help matters. (Each volume has twice what most comparable books offer.) But, through impressive fiscal acrobatics, this drastic option has, so far, not been exercised.

To continue this book series, I may need to inherit a fortune, marry quite well, or force my publisher to quadruple my royal-

ties. Of course, if these volumes would sell like Stephen King novels, all these problems would be solved. Hum ... what if I write a mystery novel that takes place aboard a variety of classic steam and motor yachts, and with a lot of images included?

Thomas Perkins, who owns several magnificent yachts, including the Herreshoff-designed *Mariette* and the diesel-powered *Atlantide*, requested that when I use the term Length Over All (LOA) it include the spar length of a yacht—meaning that the bowsprit, if any, would be included in such a measurement. This has been done to the best of my knowledge.

Dr. William Collier, who is in charge of the *Nahlin* restoration (*The Golden Century*, page 80) and responsible for saving numerous Fife-designed yachts, graciously invited me to visit *Nahlin* in the spring of 2001. He gently kidded me about my yachting lexicon, such as the names I used to describe various stern designs in *The Golden Century* (page 90). I reminded him that every authority uses different terms and, thus, I will hold to the same lexicon for consistency's sake.

And, finally, my broad use of the term motor yacht in *The Golden Century* upset a die-hard purist or two. I knew this would get me into trouble, for a steam yacht is not usually referred to as such, while diesel- and gas-engined yachts are. For the sake of editorial simplicity—and a catchier title—I continue referring to any yacht driven principally by an engine as a motor yacht.

ADDENDUM

It is generally agreed that paintings, classic cars and planes, antiques, and other myriad objects are worthy of preservation.

Majestic houses are also now revered, after decades of being casually discarded—"They're too big, and too expensive to maintain!" This shift ensued because an enlightened sensibility arose during the last thirty years; today, for example, it would be unthinkable (and illegal) to destroy a first-rate stately home in the United Kingdom, although thousands were destroyed prior to the 1970s.

Likewise, the last twenty years have ushered in the restoration of classic sailing yachts.

A similar era of enlightenment awaits classic steam and motor yachts. During the past twenty years, I have been a sad witness to the destruction of too many motor yachts. As well, only a handful of steam yachts exist today, brutally culled from thousands. "They're too big, and too expensive to maintain!" That these few remaining vessels are not national treasures is something that will never make sense to me. Still, I am enormously pleased that several endangered vessels *have* been given miraculous new leases on life; the brave souls who undertake such extraordinary feats have my highest praise and respect.

My web site, www.TheGoldenCentury.com, details these lucky vessels. Readers can also contact the author from the site.

Tragically, some classic yachts are so altered while being "saved" that their original grace and beauty are lost, the Cox & Stevens-designed *Talitha G* (ex. *Reveler*) being a notable example, as well as the recent rebuild of a famed commuter depicted in *The Golden Century*. This is preservation at a high cost. I shudder at the thought of the G. L. Watson-designed *Nahlin* being so "improved."

The front endpaper of this volume depicts the elegant *Freedom*, detailed on pages 192–94 in *The Golden Century*. Her single image in this volume exists to draw attention to her last minute rescue from the scrap heap (too late to be fully included in this volume), a salvation initiated by me, and hugely enabled by Earl McMillen. Please gaze upon her image; she is one of two surviving Mathis-Trumpy's with a spectacular counter stern—a high mark of naval architecture. Never have so many complex curves come together with such sublime grace; a ballet of lines, if you will. Yet, while saved from eminent destruction, her restoration awaits sponsors; please visit my web site for details.

GEORGE FRANCIS FABYAN

Settled in America since the mid-seventeenth century, the Fabyan family originated in Berkshire, England. George Fabyan had a distinguished line of forebears, including a grandfather who was a judge, a soldier in the Revolutionary War, and a co-founder of Maine's Bowdoin College. His father was a successful Boston physician. Fabyan started work at seventeen, accepting employment with a Boston dry-goods emporium. He later developed important connections in the cotton textile industry, such as with the famous New York department store A.T. Stewart & Company, which led to his working with John S. and Eben Wright & Company. Fabyan rose through the company ranks, which became Bliss, Fabyan & Company; Fabyan was in charge of five New England mills. The firm became known worldwide as one of the largest dry-goods commission houses. Fabyan involved himself in numerous other businesses and amassed a "considerable fortune." Through a $250,000 gift, he endowed the George Fabyan Chair of Comparative Pathology at Harvard in memory of his father, and he donated a carillon to Harvard Church. Possessing "the qualities of mind and character that command attention and respect, he was a recognized leader in the business, intellectual, and cultural life of New England." Was this true? Or good press?

Married in 1864 to the former Isabella Frances Littlefield, the couple had five children: Gertrude Stewart (Thomas), George (who became a leading scientist in the field of acoustics and other areas), Francis Wright, Isabel (Lombard), and Marshall. In the mid-1880s, the family was living at 36 Beacon Street, Boston.

In addition to his interest in yachting, Fabyan enjoyed driving and growing flowers. A member of the Eastern Yacht Club of Marblehead, he commissioned *Formosa* in his fifty-seventh year.

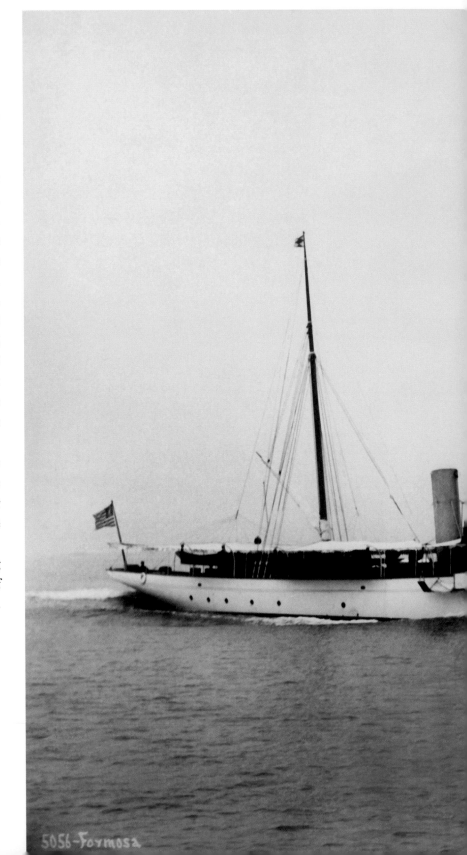

Designed and built by Atlantic Works, East Boston
Vertical, triple-expansion Atlantic Works steam engine
13 1/2" + 21" + 34" × 22" stroke cylinders
Twin Almy water tube boilers

FORMOSA

1894

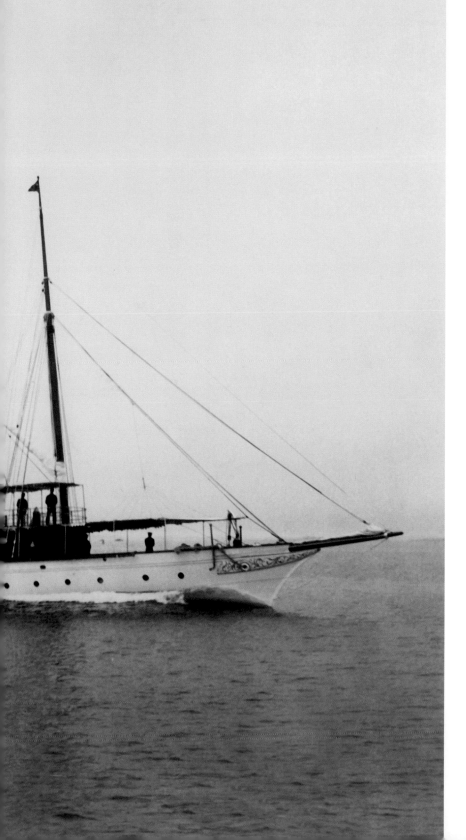

In this image, the 157-foot *Formosa* has a decidedly jaunty appearance, with her bow finely cutting the water, numerous people on board, a pair of steadying sails, many lines, raked masts, and a long canvas overhead dancing in the wind. *Formosa* had a steel hull, two mahogany deckhouses, an ice room (aft of the galley) that carried four tons of ice, and a steam steering-engine by Williamson (akin to power steering); her electric dynamo powered the searchlight and seventy-five, sixteen-candlepower lights (much dimmer, obviously, than their modern counterparts).

Atlantic Works, the company that built *Formosa*, was founded by mechanic Abishai Miller (1809–1883) and five other mechanics in 1853. They proved successful, and in 1869 moved to an expansive site in East Boston. Atlantic built a variety of vessels, such as Union "monitors," tugboats, lighters, ferries, and, obviously, the occasional yacht; their engines were also built in-house. In the early 1920s, Atlantic was the largest such facility privately owned in the port of Boston. The company was purchased by the Bethlehem Shipbuilding Corporation in 1928.

Today, most very grand yachts are custom-made, but much of what goes into them—engines, hardware, furnishings—is ordered from other companies. Not so a century ago. A yard built the hull as well as the engines, other machinery, and hardware that completed the vessel. A machine shop was the heart of a well-established yard, such as the Atlantic Works main machine facility. Indeed, as W. H. Bunting stated in *Portrait of a Port: Boston 1852–1914*, an "engine-building shop ... was the essence of the spirit and the changes of the second half of the nineteenth century in America."

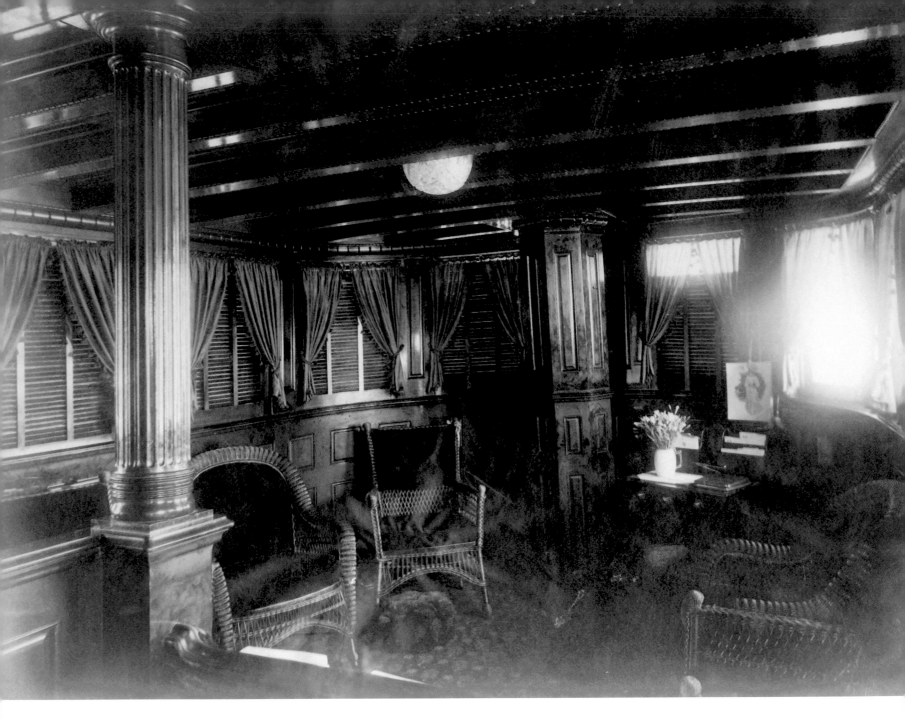

These images of *Formosa* are from the archives of the Society for the Preservation of New England Antiquities (SPNEA), founded in 1910 by William Sumner Appleton, one of those rare, great characters who bless civilization with their presence. In an age when the preservation movement was, to be generous, in its infancy, Appleton roamed New England, saving dozens of houses, their contents, and a "staggering quantity" of miscellaneous items that he deemed of value—items that, at the time, few people thought of as such. It would take decades to verify Appleton's astute eye. A case in point are these fine images of *Formosa* by Nathaniel Stebbins (pages 216–17), as well as the images in this volume of *Idalia, Elreba,* and *Dreamer.* When Appleton realized that the 2,500 remaining Stebbins glass-plate negatives were going to be sold for window glass (as 17,500 others reportedly were), he frantically scurried around to buy the lot. After much negotiating, he was successful—a $182 purchase. And everyone thought him mad. SPNEA was chronically underfunded, Appleton was overworked (as all driven people are), and their many properties were overdue for repairs. Today, SPNEA manages thirty-five properties open to the public (ten by appointment only). Several SPNEA homes are complete with the fixtures and furnishings of their last private owners; SPNEA considers the survival of this original context its most important asset. While the collection began with nineteen objects, today this number exceeds 100,000—the "largest assemblage of New England art and artifacts" in America. The majority of these items are not the types of "masterpieces" de rigueur for most museums but rather the average, even trivial items that help shape our lives—items that we may give little thought to until they are gone. In addition to its buildings, SPNEA maintains a library and archive of more than a million items, including more than 300,000 images. SPNEA is headquartered in Boston.

Formosa's intimate and delightful deck saloon (opposite) was pierced by the forward mast—always an appealing feature. The wicker furnishings were simple, yet inviting. Note the beaded detail on the highly varnished overhead. The fluted column was a peculiar, non-nautical touch, although attractive nonetheless.

Another inviting saloon aboard *Formosa,* with ladderback chairs that were an unusual addition (top right). Observe how the four arms of the lively chandelier were wisely attached to the overhead. Hidden in the sideboard was a dumbwaiter connecting to the galley below. In the sideboard mirror can be observed the partial, disembodied figure of a woman; perhaps Mrs. Fabyan captured unaware?

This bright setting (bottom right) was, presumably, *Formosa*'s main saloon; the simple, painted joinerwork offered an appealing contrast to the woodwork a deck above.

(It must be remembered that, during such an age, if one wanted to hear music, one had to *play* an instrument. Think for a moment about the subtle, but perhaps significant, distinction offered by the dynamic of *action* for *outcome*, a distinction wholly lacking when one simply pops a CD into a player. A century ago, this type of distinction was similar to the fact that, if one wanted a drink of water, one likely had to pump it; if one wanted a glass of milk, a cow likely had to be milked. Today, we are increasingly disconnected from the source of things. Is this good?)

Formosa was a lovely creation, obviously built with care and attention to detail, and probably loved by George and Isabella Fabyan and their five children (notice the fresh flowers, crocheted doilies, and selected paintings and prints). The yacht, it is presumed, was a source of pride for her designer and builder; yet, except for these few beautiful Stebbins images, nothing remains of *Formosa* and all that went into her.

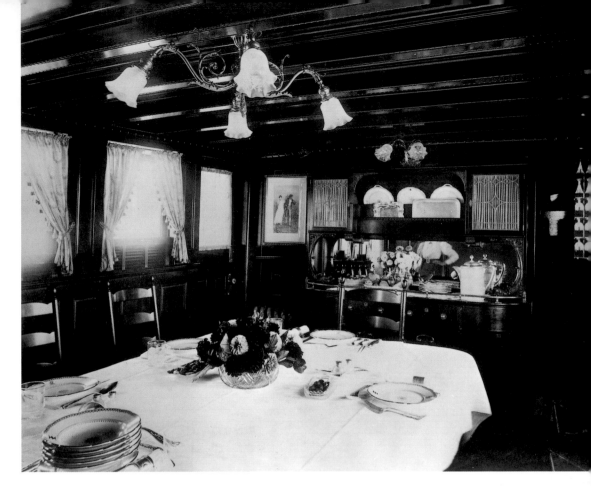

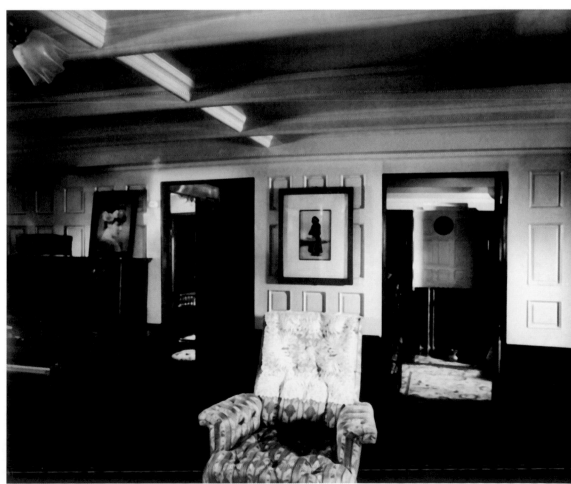

EUGENE TOMPKINS

Of all the individuals chronicled in this volume, Eugene Tompkins (1850–1909) proved the second most elusive (first prize goes to Emily Cadwalader, page 170). Years of research uncovered only two small items of information: He garnered a fortune in the theater business, and he had something to do with a Globe Theater in Boston, Massachusetts. Finally, a seemingly minor lead developed into a cache of information. Trying to find interior images of the Globe Theater, I was directed to the Houghton Library at Harvard, and its Harvard Theater Collection. When I contacted Annette Fern, the research and reference librarian, she replied that the library had a wealth of material on Tompkins, "the Napoleon of theater managers." Interestingly, it appears that Tompkins had nothing to do with the Globe Theater, but he *was* synonymous with the Boston Theater, which had opened in 1854.

In his day, Tompkins was renowned as a brilliant manager; he garnered a fortune through his handling of the Boston Theater and other properties. His career began at the age of seventeen, when he accepted a clerk's position with a wool merchant, Harding, Gray & Dewey. He later became involved in the mercantile business. His father, Orlando Tompkins, a part owner and manager of the Boston Theater (having been with the theater since 1864), had not wished his son to follow in his footsteps (an older son, Artemus, was doing quite well in the iron trade). In 1877, Eugene embarked on a year-long tour of Europe. While in Paris, he happened upon a new play by Victorien Sardou, *Les Exiles*, which was a huge hit. Tompkins "at once divined its possibilities on the American stage," and cabled his father about bringing the production to the Boston Theater. Receiving no reply, Eugene continued cabling and writing letters, begging the elder Tompkins to produce the play. Finally, Orlando agreed and

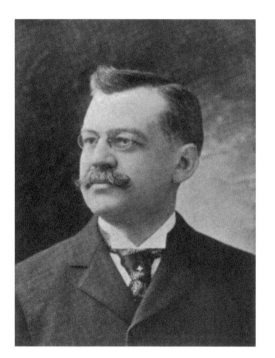

Eugene Tompkins

Eugene paid $10,000 for the American rights before leaving for Russia to develop ideas for staging and costumes. Upon returning to Boston, Eugene spent an additional $30,000 to mount the production, an "unheard-of amount" for that era. The play made enough money, Eugene later said, to have run the Boston Theater for an additional two years with no further income stream. The elder Tompkins, obviously, acceded to his son's theatrical career. (This is a wonderful story, but is it accurate? Other reports have Orlando sending his son to Paris to secure the rights to the smash hit, while yet another stated that Eugene realized the play's potential after reading a review in America, and he took the next boat to France to secure rights.)

Tompkins went on to produce a string of successes and was honored by the Boston public in an 1882 testimonial that included speakers such as the governor of Massachusetts and the mayor of Boston, their predecessors, and other important people. Tompkins assumed control of the Boston in 1886 and later became involved with two theaters in New York City, purchasing the Academy of Music in 1887 and leasing the Fifth Avenue building the following year. The Park Theater in Boston became another Tompkins house in 1896. That same year, Tompkins was found guilty of producing a Sunday concert that "was not sacred and was not for a charitable object." He was fined $50. This was not Tompkins's first brush with the church. Many years earlier, the theater had been denounced to supportive business leaders by the Rev. Dr. Kirk as "the worst debaser of the morals of their clerks and the greatest hindrance to Christianity," and just a mere step above gambling.

Other Boston Theater distinctions included the farewell performance of one Charlotte Cushman in 1858—that lasted eighteen years—and the night in 1877 when a young, well-dressed

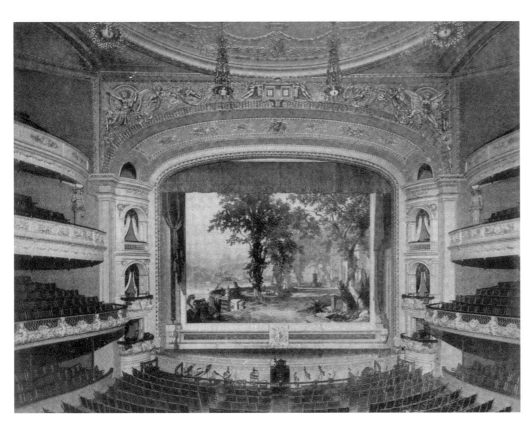

An 1896 view of the Boston Theater (above). Over the decades, a wide variety of actors, musicians, and performers appeared at the Boston Theater, including Sandow the Strong Man (right) in 1895.

man attended a performance of the somber tragedy *Medea* and applauded "vociferously" during intense, quiet scenes until finally being ejected. It developed that the man—a Harvard freshman—had hoped to become a member of a secret society; his conduct during *Medea* was an initiation requirement. It was not reported whether or not the freshman was accepted, but many years later he was elected to a highly visible position with the U.S. government: President Theodore Roosevelt.

Many years earlier, when word had reached Boston of Abraham Lincoln's assassination by the actor John Wilkes Booth in 1865, Tompkins (then age fifteen) was with Edwin Booth, the assassin's brother, who was starring in *The Iron Chest* at the Boston Theater and staying with the Tompkins family (he was a close friend of Orlando Tompkins). For many years thereafter, Tompkins vividly recalled "the horror and shame that overcame the great player when he realized what his brother had done."

Tompkins retired in 1901, purchased a Boston home at 325 Commonwealth Avenue, and concentrated on producing a lavish, limited-edition tome of 160 copies, *The History of the Boston Theater*, which he co-authored with Quincy Kilby (the treasurer of the theater for three decades) and published in 1908. The book claims that during the thirty-seven-year reign of the Boston by Orlando and Eugene Tompkins, each season was profitable, and "most seasons extremely so." This assertion is given credence by Tompkins's estate, which was valued at more than a million dollars upon his death in 1909, at the age of fifty-nine. (Almost the entire estate was directed toward a wide variety of charitable causes. The Perkins Institute for the Blind, in South Boston, was the largest beneficiary, receiving $750,000. Mrs. Tompkins and her son by a previous marriage each received $50,000, and co-author Kilby received $25,000.)

A yachting enthusiast, Tompkins was a member of the New York, Eastern, Larchmont, Seawanhaka, and Boston Yacht Clubs, as well as "every other yacht club of any note in this country." Tompkins was married twice: to the former Gertrude Griswold in 1884 (she died in 1897), and to Maude Huguley Pevear in 1906. Neither marriage was blessed with children.

Tompkins was known as the Napoleon of theater managers for his energy, daring, precision, and breadth, but a competitor disagreed: "Tompkins never had a Waterloo."

NYDIA

1890

Designed by Henry J. Gielow
Built by H. C. Wintringham, Bay Ridge
Direct-acting, inverted compound steam engine
11" + 22" × 15" stroke cylinders
Single Roberts boiler

Eugene Tompkins purchased *Nydia* in 1895; the yacht was built for R. V. Pierce of Buffalo, New York. A later owner was Isaac E. Emerson, who lived in a "palatial residence" at 2500 Eutaw Place in Baltimore, Maryland. During his ownership, "no yacht parties [were] jollier than those enjoyed on board the *Nydia* every summer during the cruise of the New York Yacht Club," of which Emerson was a member (as well as the American and Larchmont Yacht Clubs). The "clean-cut" yacht was launched at a length of 99 feet; this was extended to 125 feet in 1898. Her planking was yellow pine in "long lengths," secured with composition spikes and copper bolts; her keel, stem, and sternpost were of white oak. Under her boiler and engine, the space between the frames was filled solid; the ceiling was an inch thick. The clear-white-pine deck was "free from all imperfections, knots, shakes, splits, and thought to be very handsome." The diminutive deckhouse (later extended), as well as all other deck structures, was mahogany. The main saloon was almost thirteen feet long, paneled in polished mahogany. The schooner-rigged yacht carried three boats: an eighteen-foot naphtha-powered launch, an eighteen-foot gig, and a thirteen-foot dinghy.

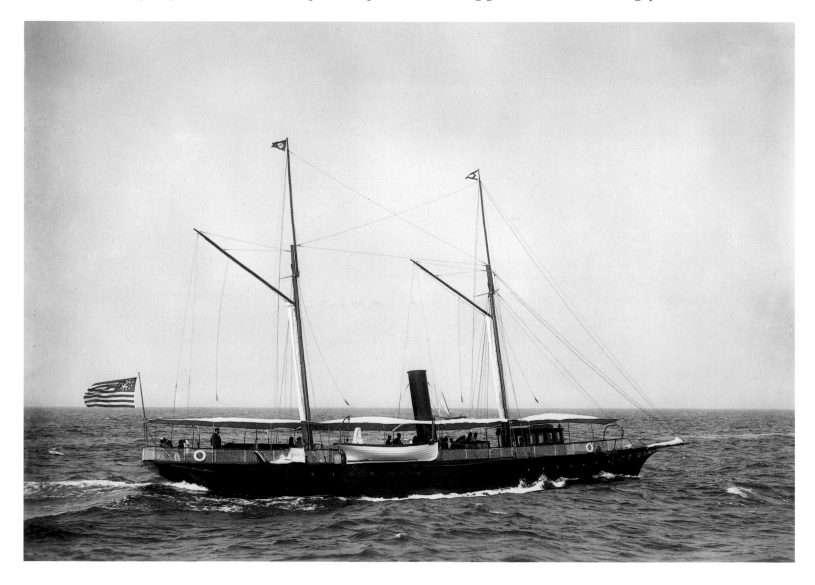

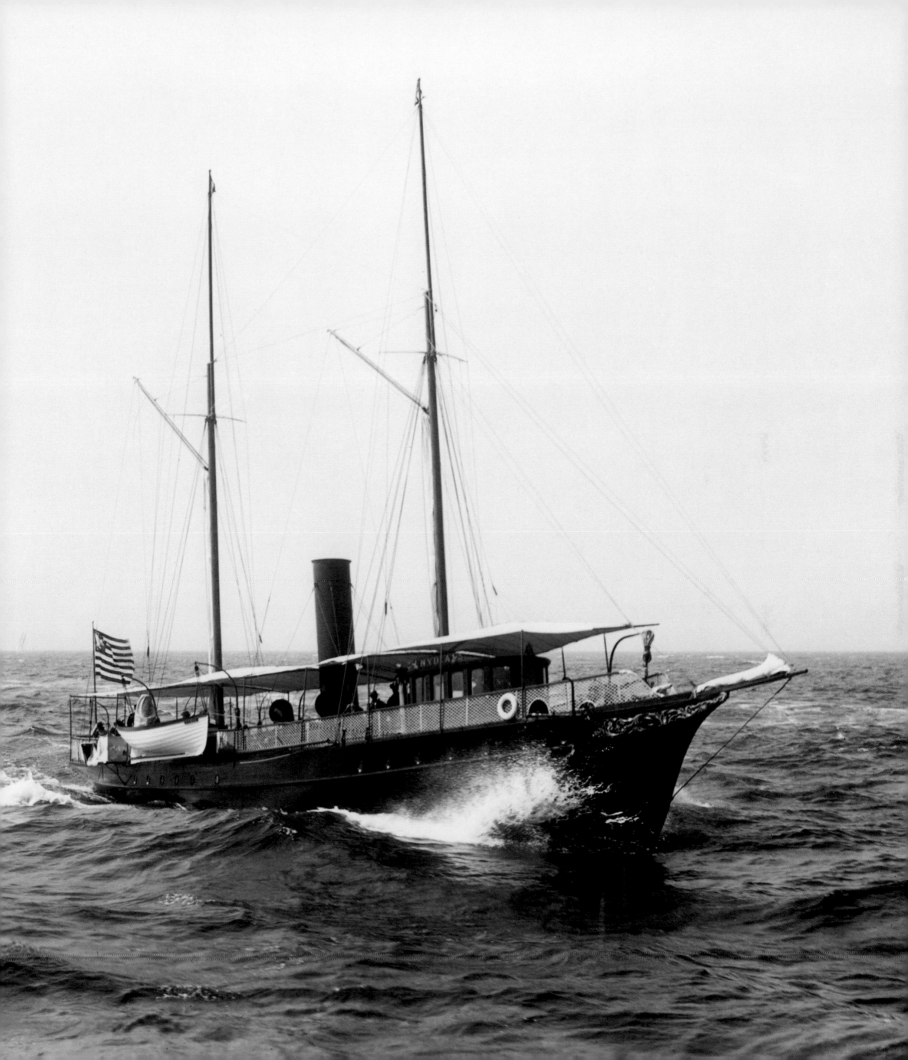

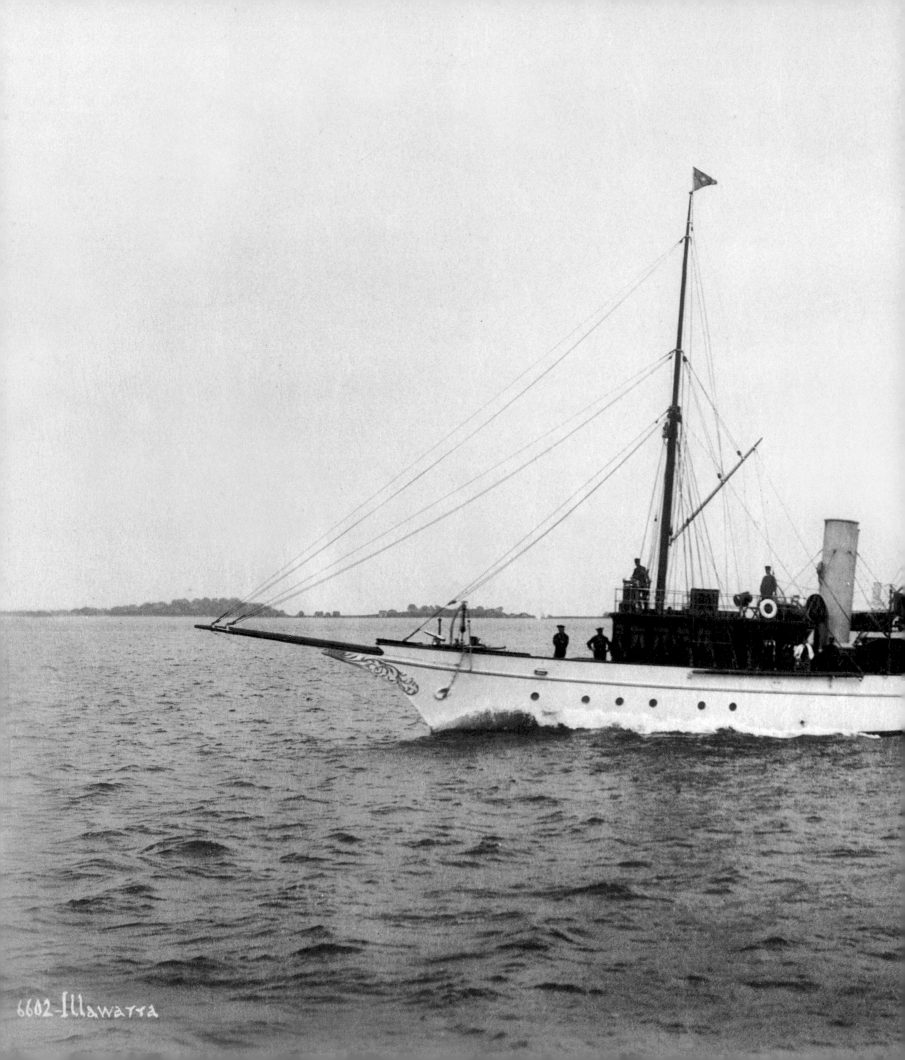

6602-Illawarra

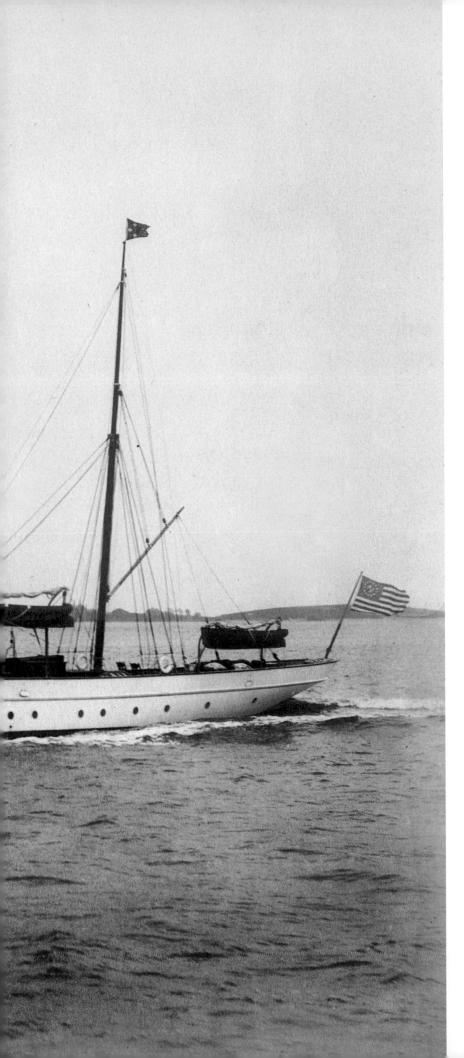

ILLAWARRA

1896

Eugene Tompkins's ownership of the 110-foot *Illawarra* would prove ill-fated and brief. His wife, Gertrude, died suddenly aboard the yacht in August 1897. The following April, the U.S. Navy purchased *Illawarra* for use in the Spanish-American War. Renamed USS *Oneida*, she was fitted as an armed gunboat. After the war, she remained inactive until 1912, when she was sold to the District of Columbia Naval Militia. Two years later, she was transferred and converted to Navy Disciplinary Barracks in Port Royal, South Carolina. In 1915, the yacht was used as a pilot boat in Charleston, South Carolina, and renamed *Henry P. Williams*. Reacquired by the U.S. Navy in 1917, she was used for patrol and minesweeping training (renamed *SP-509*), until disappearing from the record in 1918.

Designed by Charles Ridgely Hanscom
Built by Bath Iron Works, Bath, Maine
Triple-expansion, 3-cylinder Bath Iron Works steam engine
11" + 19" + 30" × 18" stroke cylinders
Two Almy water tube boilers

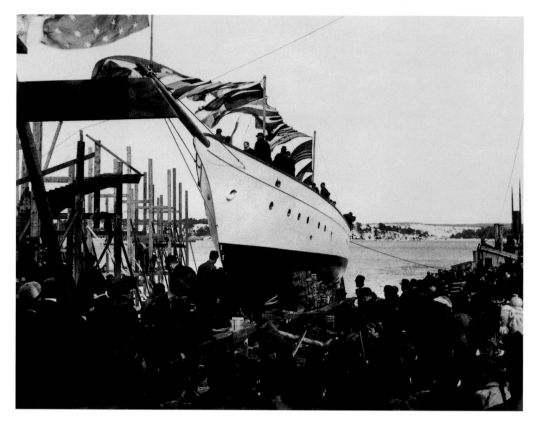

Left, the launching of *Illawarra* at Bath Iron Works (hull #14).

Opposite, one of my favorite images, highlights the extraordinarily narrow beam typical of turn-of-the-twentieth-century yachts, both sail and power. It is interesting that *Illawarra* has no protective canvas awning; one was probably added at a later date. Note the three launches hanging from davits.

This image possibly was taken at the builder's yard, as the furniture did not seem placed for conversation.

Illawarra is shown below after her conversion by the U.S. Navy into the USS *Oneida* in 1898.

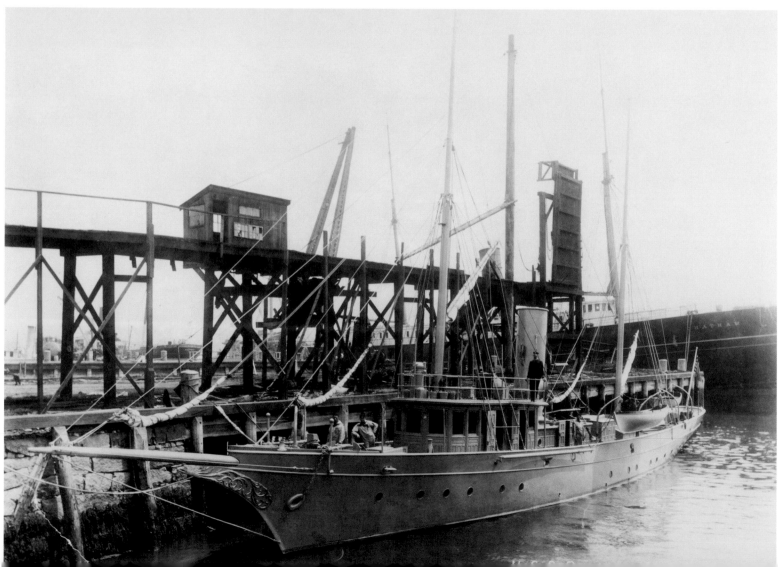

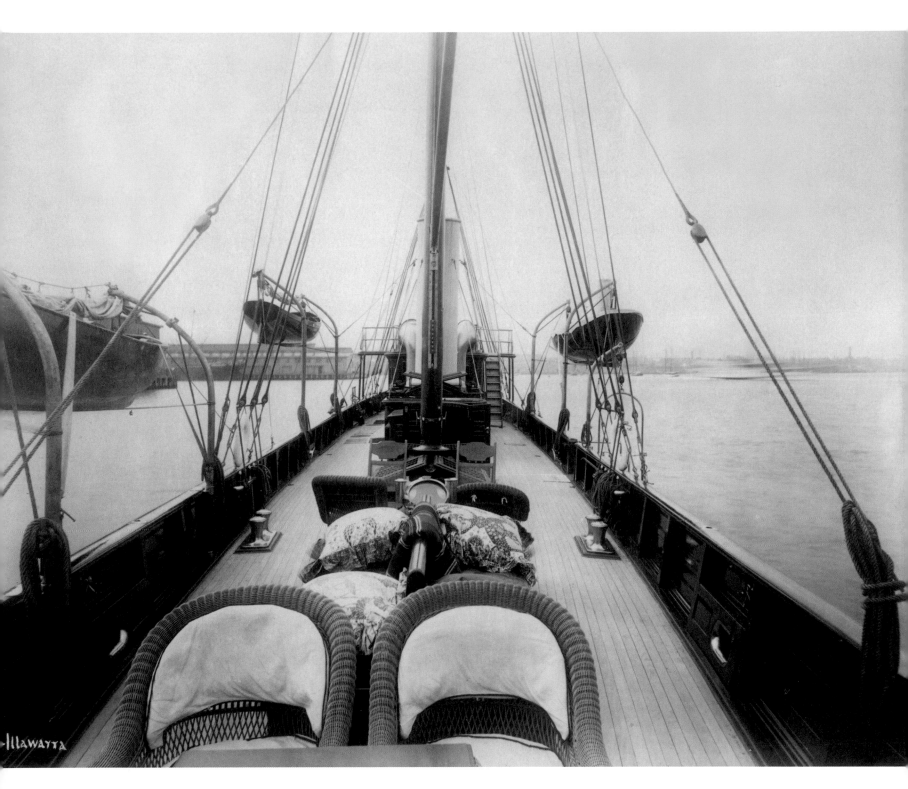

Illawarra was designed by Charles Ridgely Hanscom (1850–1918), Superintendent of Hulls at Bath Iron Works, after a background at U.S. Navy yards, Clyde shipyards, and the University of Glasgow. Hanscom was educated by private tutors; in his twenty-third year, he began an eight-year position as a draftsman for U.S. Navy yards in New York, Philadelphia, Boston,

and Washington. From 1880 to 1896, he was a draftsman, naval expert, and superintendent at the Navy Department, before assuming his position at Bath in 1896. Besides *Illawarra,* Hanscom designed steam yachts such as the 158-foot *Peregrine*, the 243-foot *Eleanor*, and the 302-foot *Aphrodite*. He left Bath in 1900 to assume the presidency of the Eastern Ship-

building Company, New London, Connecticut, a post he held until his 1906 retirement. Other designs include the steamships *Minnesota* and *Dakota*. Hanscom married Eva L. Pettigrew in 1874; she died four months later. He took a second wife, Adah L. Fernald, in 1879; the couple had a son, Ridgely Fernald. Adah died in 1908, Charles a decade later.

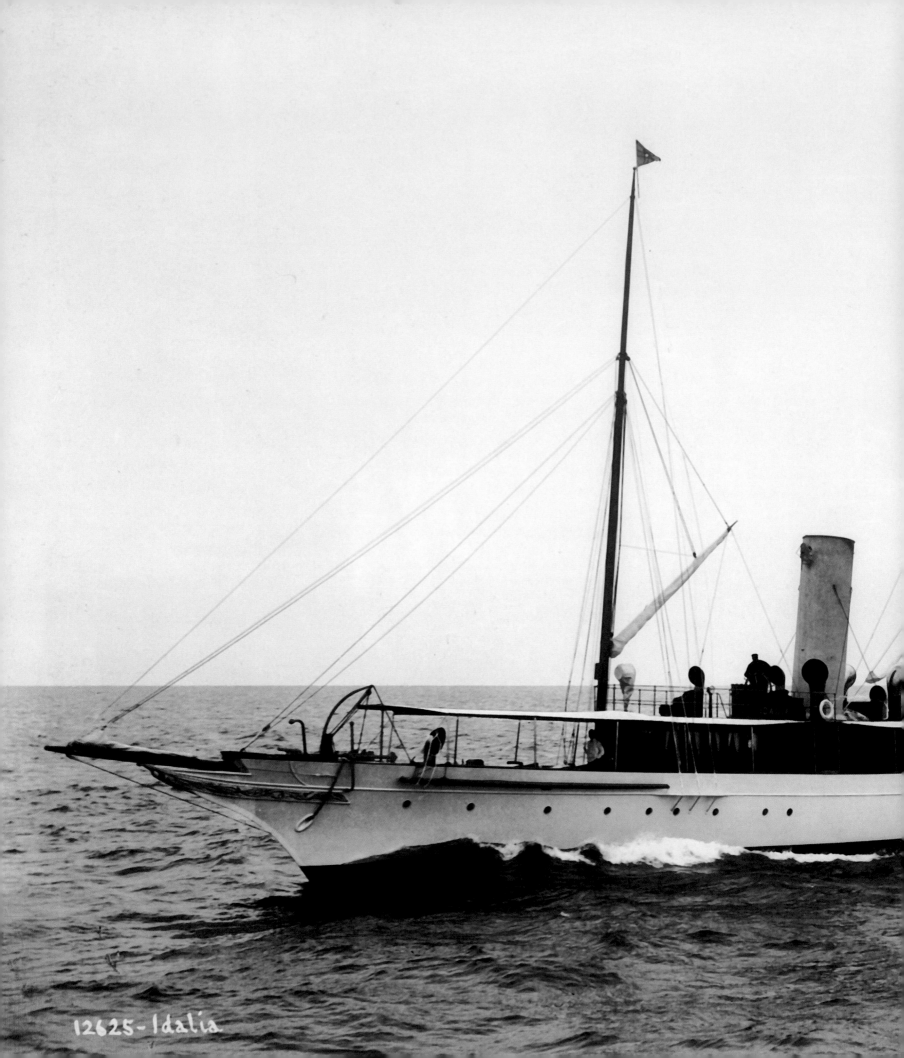

12625- Idalia

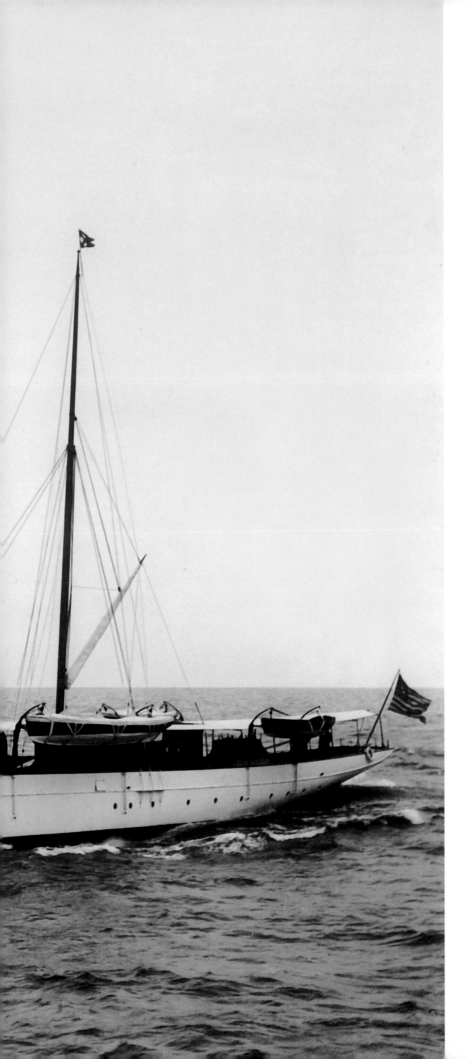

IDALIA

1899

After *Illawarra* was requisitioned by the U.S. Navy, Eugene Tompkins commissioned a larger vessel, the 176-foot *Idalia*. Designed by the firm of Gardner & Cox, Tompkins's new $75,000 yacht was one of the most palatial and elegant of her day, with the studio of the famed Louis C. Tiffany having been retained to design the interiors.

Idalia was a well-balanced design and extremely attractive. Her outboard profile was typical of turn-of-the-twentieth-century yachts and featured a clipper-type hull with long overhangs, several deckhouses (likely teak), an open pilot station, and an array of cowl vents (looking somewhat like penguins). The tall funnel (likely buff-colored) and masts with vestigial sails were also standard. (Early yachts such as *Idalia*, with an extremely narrow beam, rolled easily. Sails were often used for steadying purposes and to increase maneuvering capabilities in an age of single screws, and before bow thrusters.)

Designed by Gardner & Cox
Built by John Roach & Sons, Chester, Pennsylvania
Triple-expansion 4-cylinder steam engine
12½" + 20" + 22½" + 22½" x 18" stroke cylinders
Four Babcock & Wilcox boilers

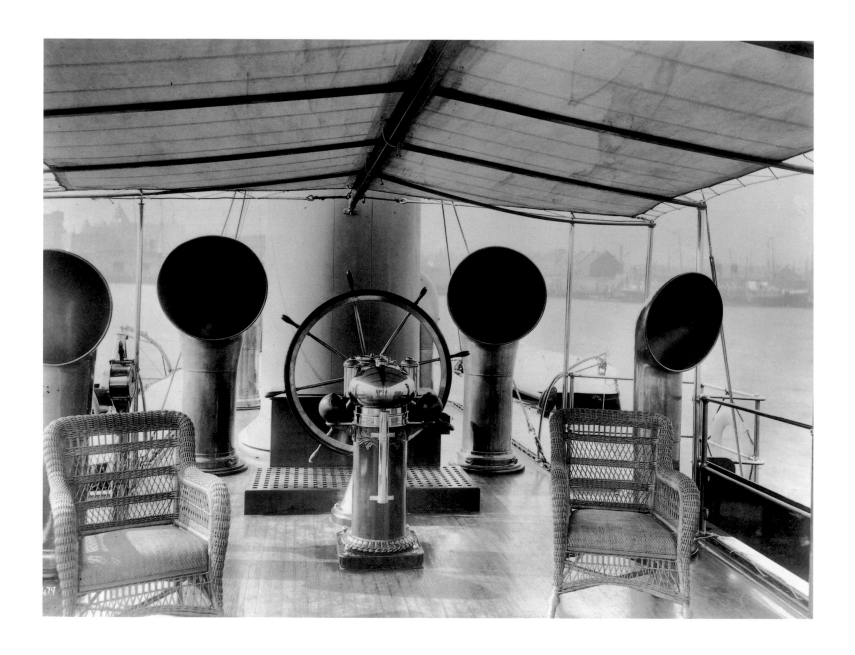

In this extraordinary scene above, *Idalia*'s open bridge is protected by a canvas awning (not in place in the previous image). The four imposing cowl vents appear like sentinels guarding the highly polished and varnished steering column forward of a raised teak platform.

Idalia's forward deck cabin (opposite) housed the dining saloon, the pantry, and a head. While this black-and-white image is beautiful, it, like all such images, obscures the play of color and light that enlivened such settings. We are fortunate to have a contemporary description of this charming saloon and through such words can close our eyes and imagine the "quartered antique oak" joinerwork highlighted by the glint of polished brass caps and bases on the pilasters; the "Pompeian red" of the overhead bisected by golden oak beams; matching red silk curtains with tassel fringe offering a delightful tactile contrast to the paneling; and the unique chandelier, its upper portion composed of green glass beads selected to match "kelp and transparent seaweeds." The aft bulkhead featured a "secret" door to the pantry; another such panel allowed the steward access to the oak serving table on the port side.

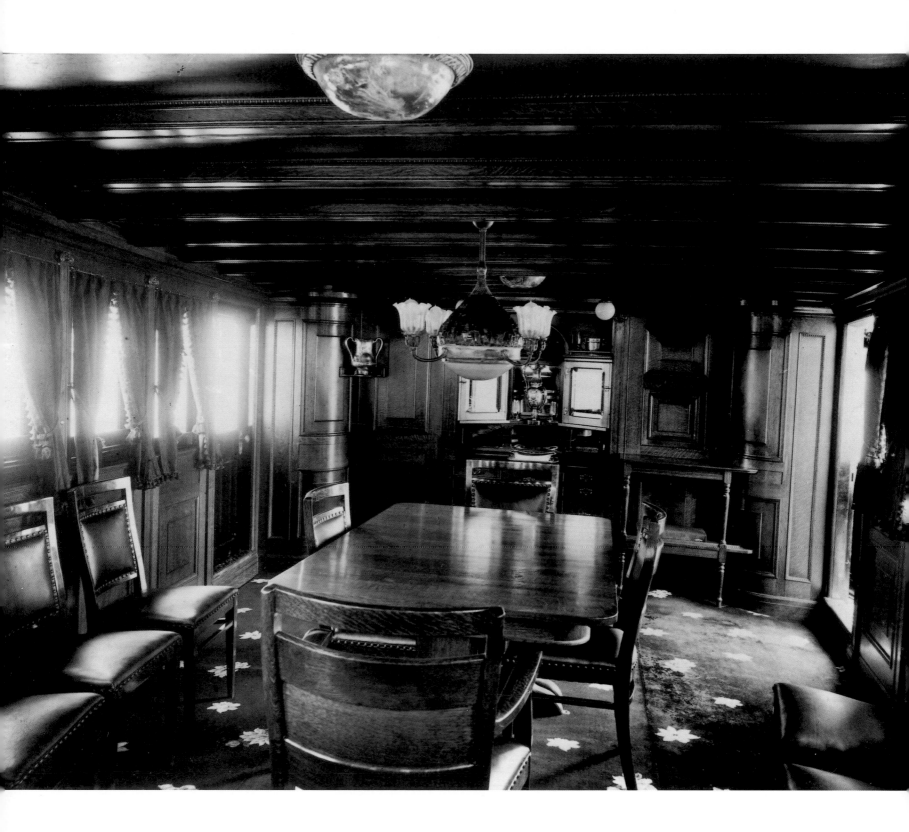

William Gardner (1859–1934), who designed *Idalia* (in association with Irving Cox), is best known for his 185-foot auxiliary schooner *Atlantic*, built in 1903, which brought him "general prominence both at home and abroad." *Atlantic* catapulted to fame when, captained by the indomitable Charlie Barr, she won the Kaiser's Cup Transatlantic Race in 1905, besting the second yacht to finish, the *Hamburg*, by almost a day. *Atlantic* led a long life, serving in both world wars before suffering the ignominy of being converted to a New Jersey teashop. In 1969, she was rescued, and restoration plans were developed. During a winter storm, however, the boatshed where she was stored collapsed and *Atlantic* was crushed.

Gardner, an orphan, chose naval architecture as a career during an era when the profession was at "a very low ebb." After graduating from Cornell University, Gardner worked at the Delaware River Iron Shipbuilding & Engine Company (known as Roach's Yard), in Chester, Pennsylvania. Hoping to expand his career opportunities, Gardner attended the Royal Naval College and spent his free time visiting shipyards. Returning to the States, Gardner opened an office in New York City and received his first commissions in 1888—the thirty-foot *Kathleen* and the forty-foot *Liris*. The former yacht led an uneventful racing career, while the latter had a difficult start. In her first season, she was dismasted twice and parted with every spar, yet she still managed to end the season with $1,250 in winnings (a not-inconsiderable sum for the era). Gardner designed numerous steam yachts, including the presidential yacht *Sylph*.

The aft deckhouse gracing *Idalia* was divided into a smoking room (with a buffet), a stair to the staterooms, and an "Empire Saloon," which featured red oak joinerwork accented by polished brass ornaments, an overhead painted in a "rich olive tone" and "relieved by gold beading," and green curtains—a plush and enveloping comfort unmatched by modern yachts. Note the electric lights, "held in bronze husks," protruding from the frieze.

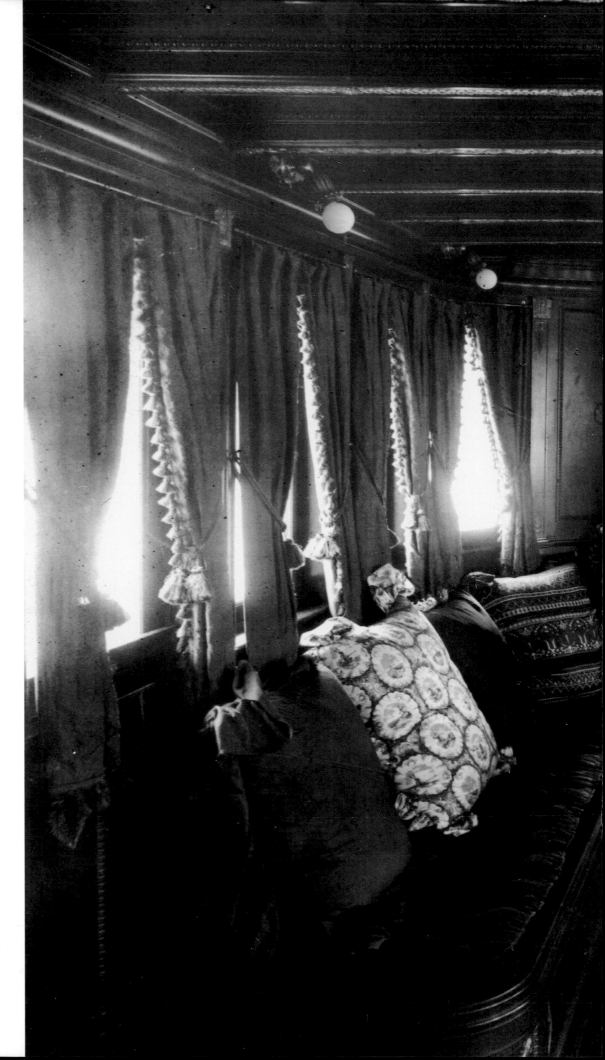

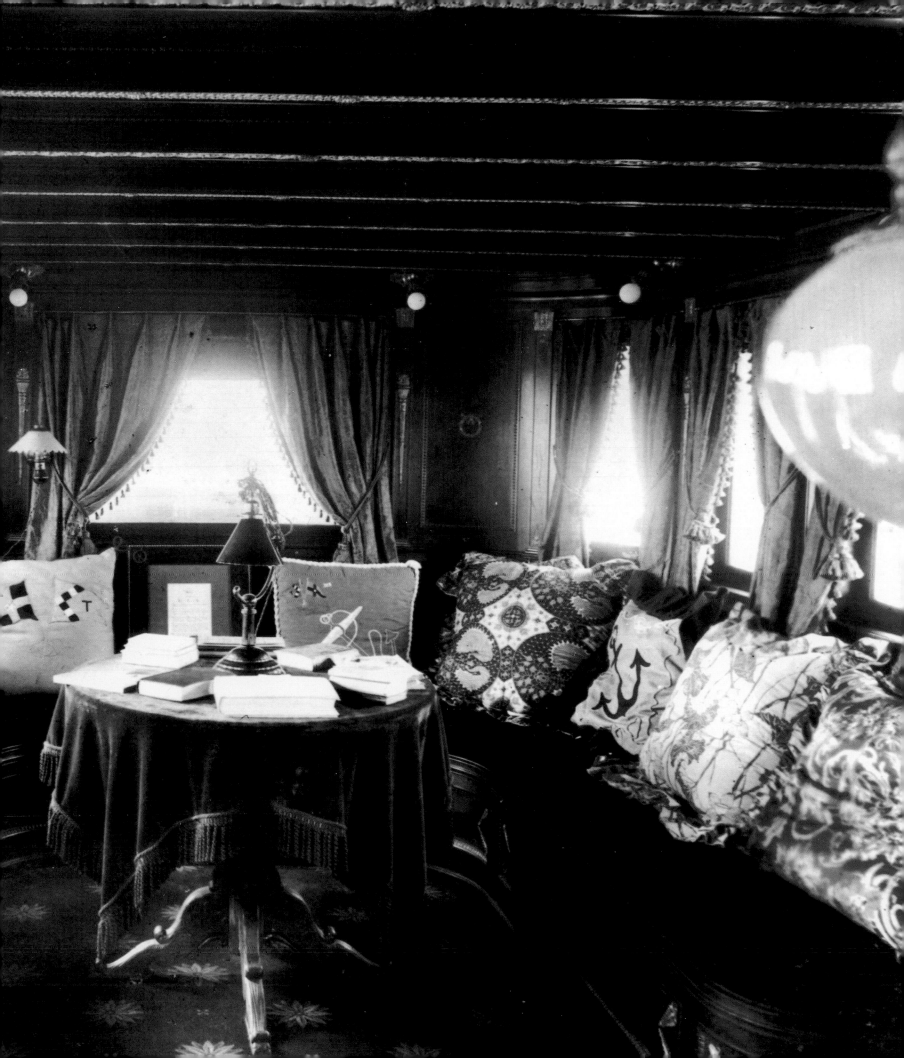

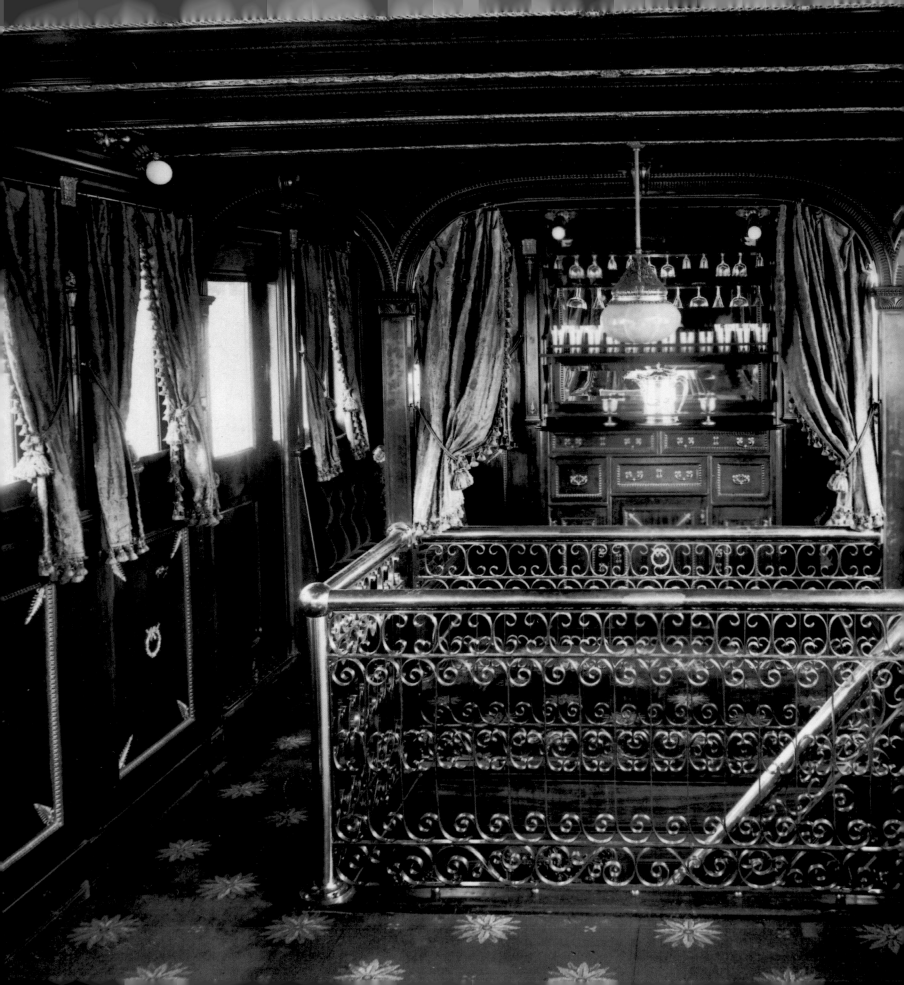

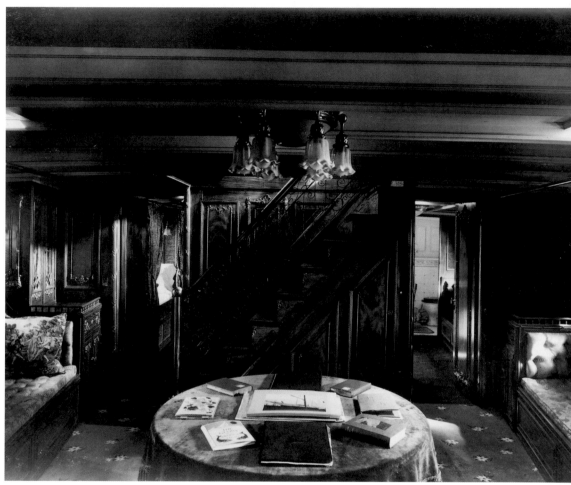

Looking forward in the "Empire Saloon" (left), a setting enlivened by an impressive and intricate stair balustrade (typical of the work by Tiffany Studios) and an arched colonnade. The stair chandelier featured an opalescent glass globe (Tiffany, of course, being famed for its opalescent and iridescent glass).

Idalia's main saloon (above) on the lower deck was detailed with Louis XV joinerwork in white mahogany and satinwood, accented with gold carving in relief, and topped by a white painted overhead of finely detailed beams. In each corner were leaded-glass cabinets. The pair of built-in settees had tufted cushions covered in "old rose" satin damask, while the ports (unseen in this image) were draped with fabric of "old rose" and green. The chandelier with six opalescent glass shades would be worth a tidy sum today (particularly if created by Tiffany).

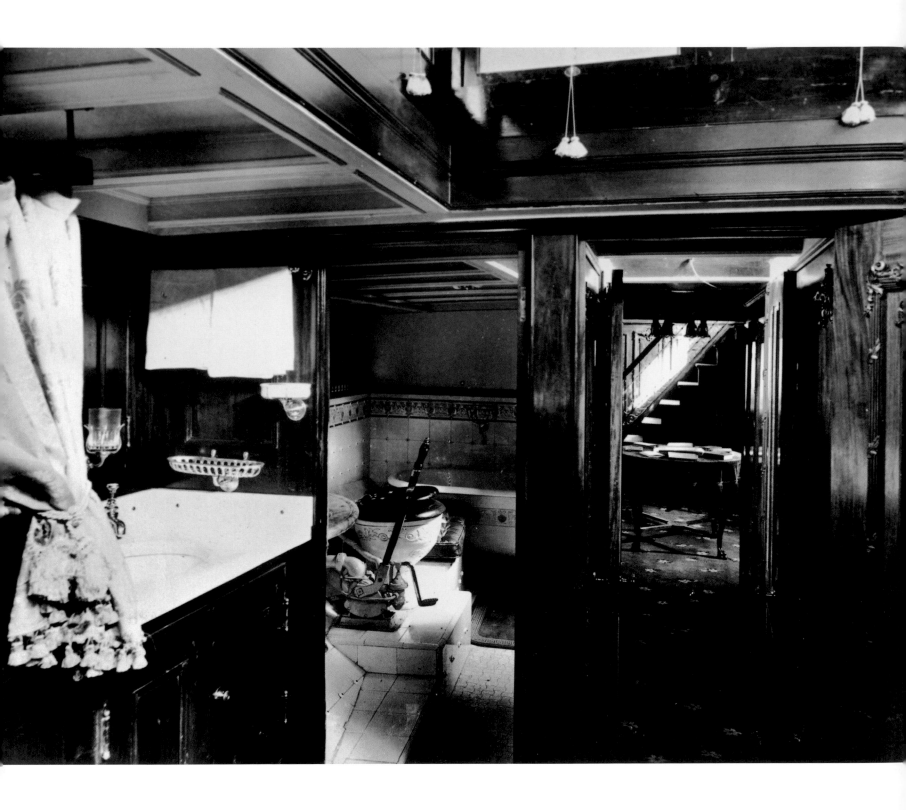

On the forward bulkhead of the "Ladies' Double State-room" were doors leading to a companionway and to a large, well-equipped head to port. Note the edge of a marble counter, the glass-like tile, full-size tub with dec-orative border (matched on the toilet bowl), and im-pressive hand pump. It's extremely rare for images of this era to feature heads. On the starboard side of the com-panionway was another stateroom, probably a single.

The impressive "Ladies' Double Stateroom" aboard *Idalia* featured red mahogany joinerwork, tufted velvet cushions, silk curtains with elaborate tiebacks, and overstuffed down pillows (top right). Overhead, an ample skylight provided additional light. Note the camera in the beveled mirror. Surely, one could spend eternity sleeping in such a setting?

Idalia's owner's stateroom (bottom right) was forward of the main saloon, and enveloped with satinwood paneling; the overhead light—made of bronze, opalescent glass, and glass beads—offered a kind of diffused glow akin to "a light showing through submarine depths." Through the open door we catch a rare glimpse of a Victorian head; note the tiles with seashell frieze, marble counter, and impressive pumping mechanism for the head.

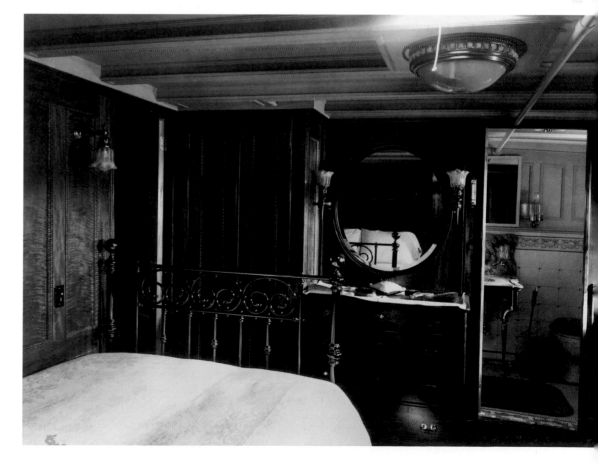

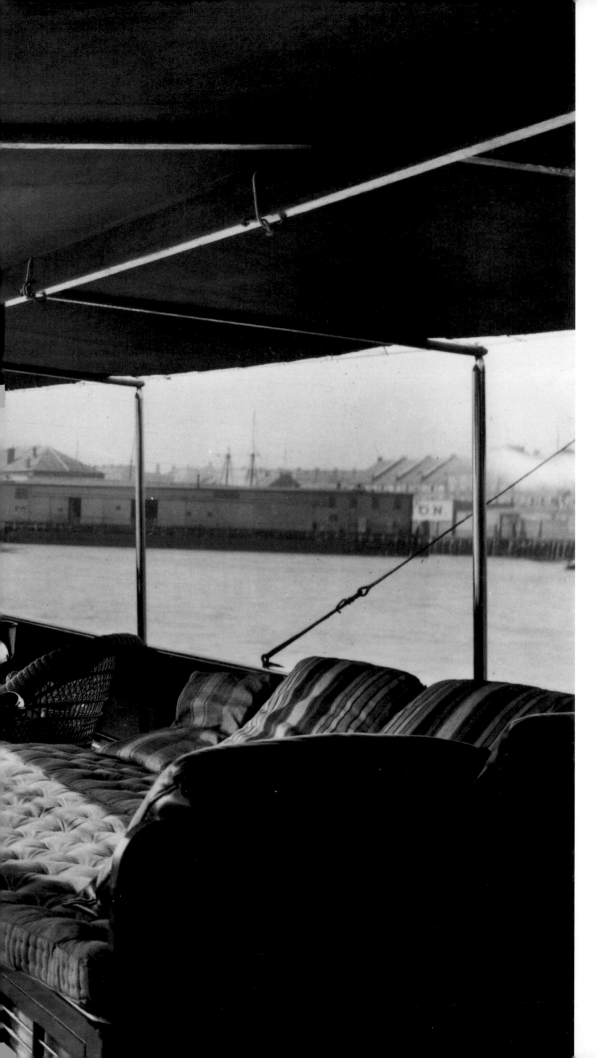

From 1917 to 1923, *Idalia* was owned by William Dixie Hoxie (1866–1925), a marine engineer and inventor, and son of a clipper-ship captain. Born in Brooklyn, New York, Hoxie graduated from the Stevens Institute of Technology in New Jersey with a mechanical engineering degree. His first job was with Babcock & Wilcox, which made boilers; he remained with the company for his entire career, being named president in 1919. Hoxie adapted the company's boiler for use in marine applications; the first installations were aboard Great Lakes steamers and, in 1896, aboard the U.S. Navy gunboats *Annapolis* and *Marietta*. Eventually, Hoxie-designed boilers were used in every U.S. battleship and "a great many foreign ones." During World War I, Babcock & Wilcox was building boilers so efficiently (the firm had orders for 1,500 units) that the output exceeded demand; at war's end, there were more boilers than completed ships. A yachting enthusiast, Hoxie used *Idalia* as a testing ground for his many experiments with super-heating and oil-burning. "A man of attractive personality, and with a wide circle of friends," Hoxie married Lavinia Brown of Westerly, Rhode Island; the couple had a daughter. In a seemingly appropriate gesture, Hoxie died at sea.

Delicious is the word that likely pops into one's head when looking at this image. Most significant, the narrow beam creates an inviting intimacy, while the tufted cushions atop the skylight (lighting the "Ladies' Double Stateroom") surely would have seduced anyone into an afternoon nap. Or any number of activities. Note the Oriental rugs scattered about. The canvas overhead, a typical feature on yachts of the era, has qualities unmatched by later static wooden overheads.

Of the thousands of steam yachts launched between 1830 and 1930, the loss of *Idalia*—and her Tiffany-designed interiors—is one of the most regrettable. Her preservation would have offered an invaluable window to a now extinct level of opulence and craftsmanship.

HARRY DARLINGTON

Like many people of his era, Harry Darlington (1838–1914) amassed a fortune without the aid of higher education. As a youth, he worked for the Philadelphia, Wilmington & Baltimore Railroad until the outbreak of the Civil War, when he enlisted in the Union Army and served for three years. Returning to civilian life, Darlington relocated to Pittsburgh, Pennsylvania, and opened a brewery. After selling the company in 1886, he channeled the proceeds into a new venture, the Cambria Natural Gas Company. Over the ensuing decades, he diversified his investments into a wide variety of companies, including railroads, steel, banks, glass, and real estate. Darlington "showed himself to be a man of broad gauge, inexhaustible energy, dauntless courage and unflinching fidelity to principle—a veritable captain of industry," no less.

Married in 1858 to Margaret McCanles De Wald, the couple had two children, Frank and Margaret Hardy (Bennett). After Margaret died in 1872, Darlington married Mary Elizabeth McCullough in 1877; the couple had five children, two of whom lived to adulthood, Rebecca (Stoddard) and Harry, Jr. The family home, at 721 Irwin Avenue, was on one of Pittsburgh's premier residential streets, and a summer residence, Summer Oaks, was located in Mamaroneck, New York. An additional summer home, The Bungalow, was in Watch Hill, Rhode Island. (As an indicator that we are, indeed, living in more complicated times, note the telephone numbers for the Darlington residences: The Irwin Avenue home was 366 Cedar; Summer Oaks was 143; and The Bungalow was 5.)

The Darlingtons reportedly were the largest contributors to the Allegheny General Hospital building fund, and they also donated the funds to build a children's ward. Every Christmas, the ward children would be surprised by gifts from the Darlingtons (after having learned what each child wanted). Additional support was directed toward the Allegheny Preparatory School and scholarships.

Darlington was a member of numerous clubs, including the Larchmont, American, and Corinthian Yacht Clubs, all of New York. *Elreba* was a combination of his wife's and daughter's names, Mary Elizabeth and Rebecca. After Harry died in 1914, Mary continued to maintain *Elreba* until the mid-1920s. She was presumably replaced when Harry, Jr., purchased *Ardea*, an eighty-one-foot Consolidated motor yacht built in 1926. The family maintained offices at 52 Fidelity Building, Pittsburgh.

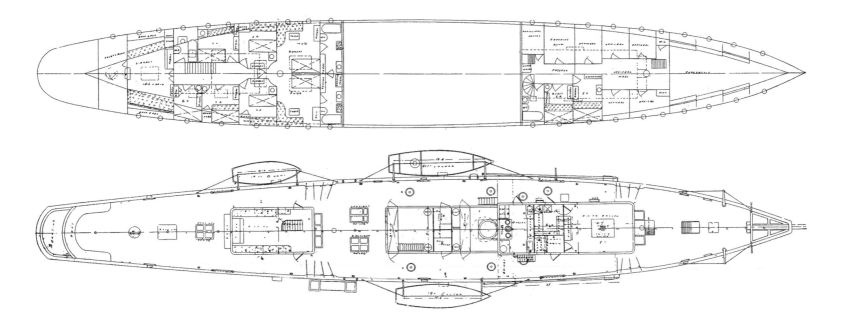

ELREBA

1898

Designed by Tams & Lemoine
Built by Crescent Shipyard, Elizabeth, New Jersey
A Sullivan triple-expansion steam engine
12" + 18" + 20" + 20" × 15" cylinders
Two Almy water tube boilers

The 150-foot *Elreba* was not so large that she could "poke about into any or all of the many harbors along our Atlantic sea coast, [but she was] staunch enough to keep the sea should bad weather overtake her." *Elreba* could exceed fourteen knots using forced draft, fixed grate bars, and burning anthracite coal. By substituting rolling bars burning soft coal, her speed could be measurably increased. The outboard profile of *Elreba* "resembles somewhat that of a Watson-designed craft with just enough Americanizing to it to proclaim her nationality." She was similar to *Formosa* (pages 23–25), with her twin mahogany deckhouses, springy sheer, raked masts carrying steadying sails, and an open pilot station typical of the era. In a word, she was a work of art, one manifestly superior in design to her modern counterpart.

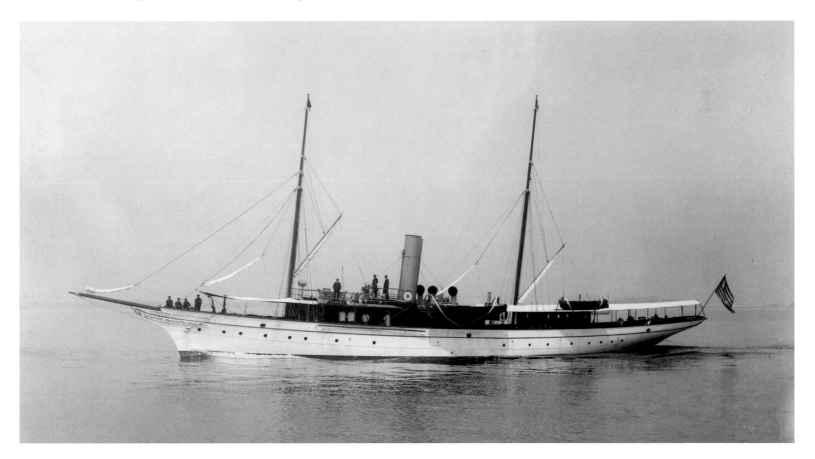

The deck and accommodation plans of *Elreba* (opposite) provide insight into late-nineteenth-century naval architecture. Note the twin deckhouses, the matching owners' cabins with en-suite heads, and expansive deck areas.

The Rudder commented in 1898: "It is within the last ten years that owners have gone into the extravagance of fitting out palaces to sail the sea in. Twenty years ago if a man had one bathtub aft he was content, but now there must be a separate wash pond for every berth. He is no longer content to turn into a bunk to sleep, but must have a four-post draped bedstead. A library is no longer a novelty, neither is an organ or a huge marble fireplace. Every art, from high sculpture down to mattress making, is brought under requisition to supply splendor and comfort, and there are yachts afloat whose bill for furnishings is equal to the whole cost of engines and hull."

Yet, *The Rudder* approved of *Elreba*, finding her "able-looking" and being pleased that a decorator and "furnisher" had not been allowed to "run riot." The three tubs and eight sinks in the owners' section obviously escaped *Rudder*'s critical eye.

The plan further indicates three boats: a twenty-one-foot launch (with engine), a nineteen-footer (with sail), and a fifteen-foot dinghy.

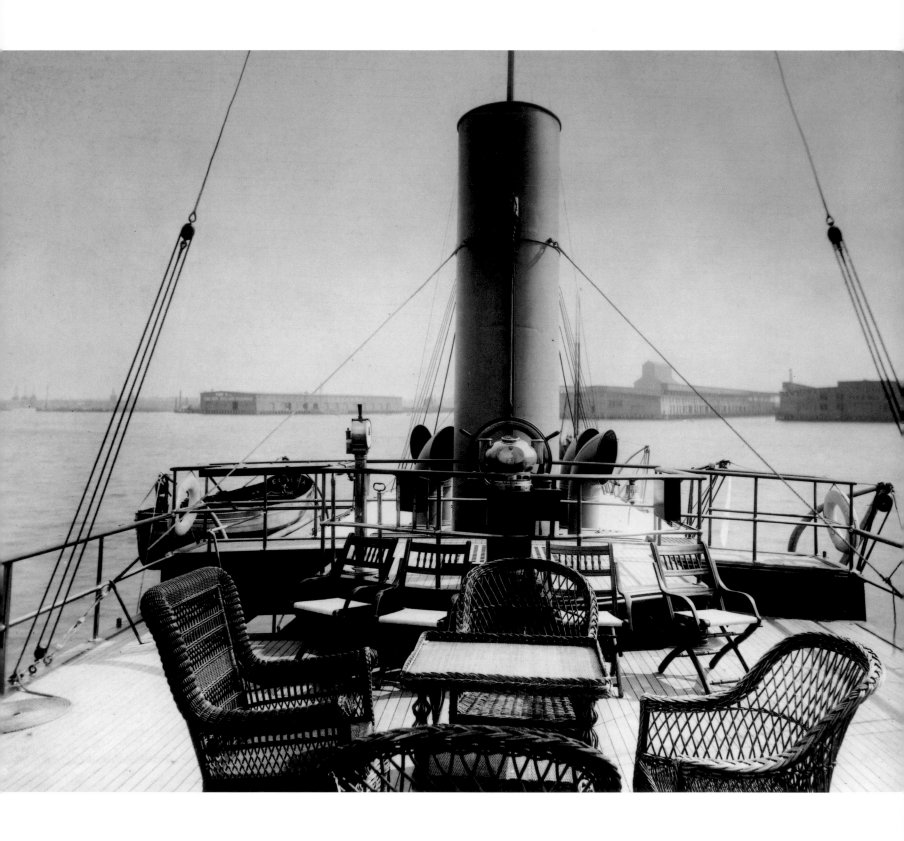

The disparate items that collectively created this composition represented a brief moment in time. Except for the wicker furnishings, the remaining players in this scene are now extinct: the tall, imposing funnel and the cowl vents huddling around it, the lines reaching toward the pole mast and the heavens, the shining telegraph and binnacle, and the design aesthetic that created this tableau.

Why should such an aesthetic be extinct?

Note the raised platform of the bridge; this kept the helmsman a head above the owners' party mingling on the forward deck (positioned above the deckhouse). To starboard is a nineteen-foot cutter, the name *Elreba* gracing the inner transom.

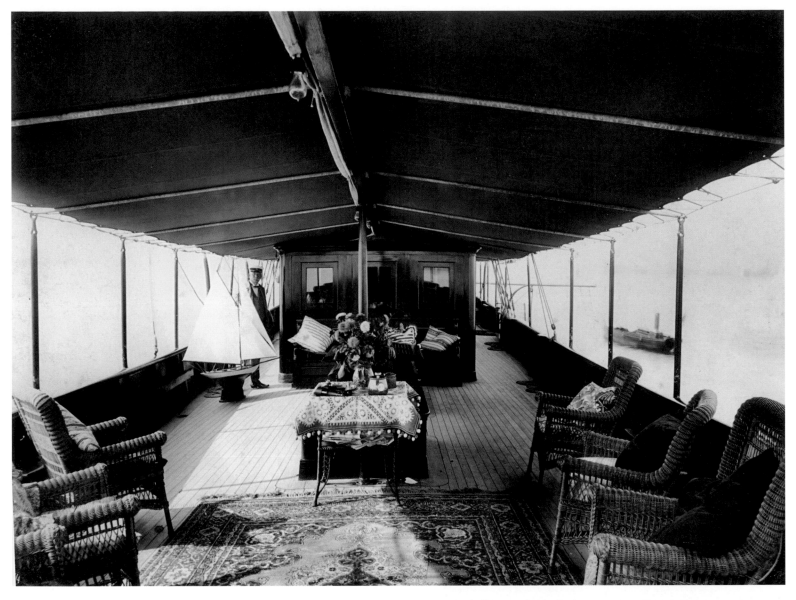

No matter how beautiful black-and-white images can be—such as these superb Stebbins photographs—they cannot do justice to the scene. The long overhead gracing *Elreba* was underlined with a bright blue canvas "to deaden the sun's rays." The Oriental-style rug, no doubt, added a panoply of additional color, along with the flowers atop the small wicker table and the many pillows. The man holding the sailboat is unidentified and unexplained; they are, nonetheless, an appealing addition to this composition. Above, an elusive moment captured.

The same deck, looking aft (right). Note how the furnishings have been rearranged from that in the adjacent image. One wonders as to the purpose of the carved box atop the skylight? A humidor?

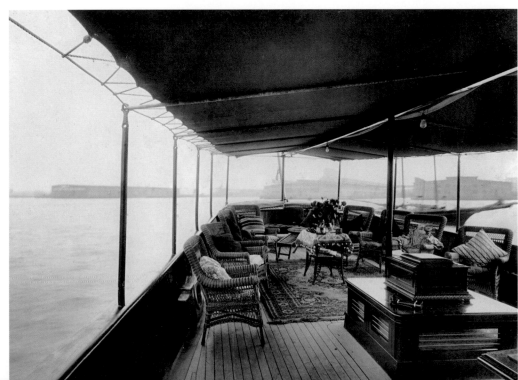

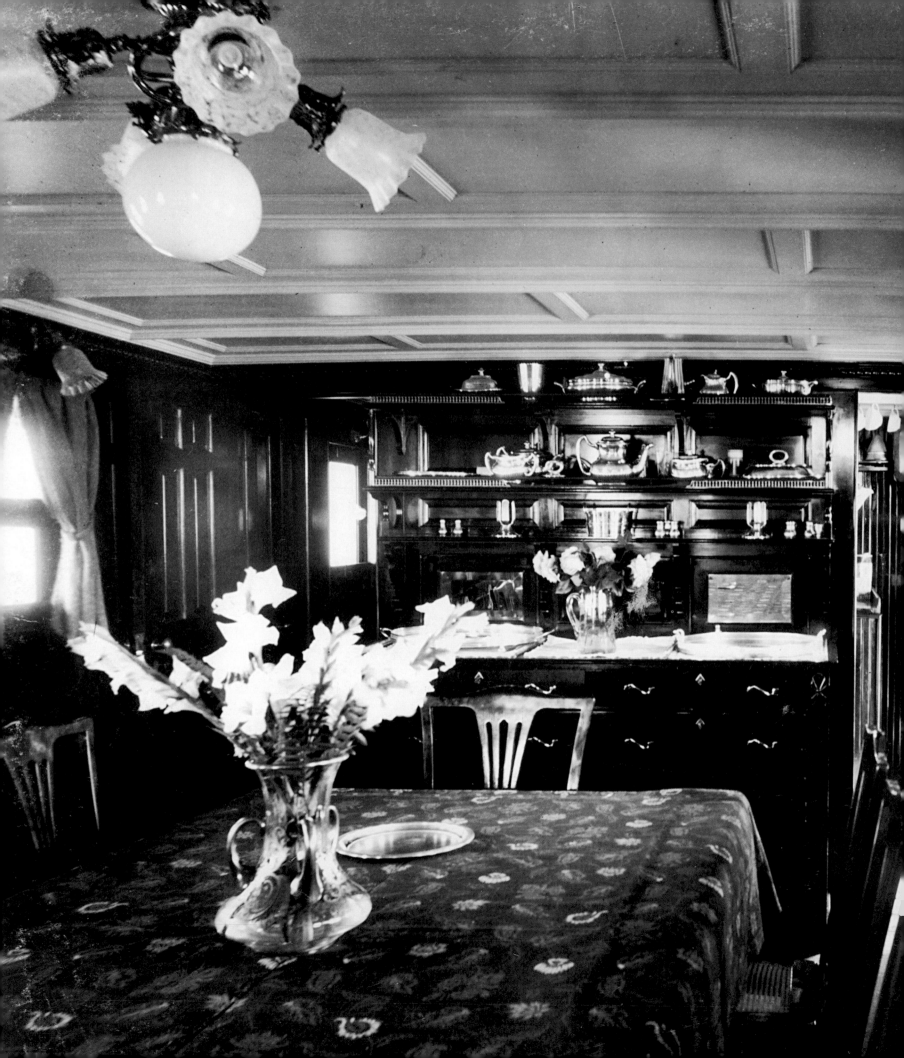

It is unfortunate that the only extant image of *Elreba*'s interior is that of her dining saloon. We have nothing to document the appearance of her other cabins, presumably more attractive. The appealing and inviting setting pictured (located in the forward mahogany deckhouse) confirms the tragedy of this loss.

We live in an age where infant mortality is relatively low (at least in Western cultures), but this is a relatively recent occurrence in human history. Harry and Mary Darlington experienced the not-uncommon deaths of three of their five children. A surviving child, Rebecca, married Louis E. Stoddard and had three children before she died in her mid-twenties. It is difficult to imagine the grief the family must have collectively experienced, since we today are almost immune from such a level of tragedy. Were people of an earlier age, somehow, better able to emotionally survive such loss? One wonders about the societal structures presumably then in place to help manage such grief. Was the Darlingtons' generosity in underwriting the construction of a children's hospital, and buying Christmas presents for hundreds of children, a type of coping mechanism? The historical record offers no answer.

THOMAS W. LAWSON

One of the most enigmatic and interesting personalities of his era, Thomas W. Lawson (1857–1925) was the son of a carpenter and received little schooling, but early on he exhibited an innate grasp of finance. When he was eight, his father died; Thomas, apparently worried about being a burden, ran away at the age of twelve. After a four-mile walk to Boston, the tired boy saw a sign saying, "Office Boy Wanted." He later wrote about this fateful moment: "My tired legs forgot their kinks, and in a jiffy I was standing, all of a tremble, before [a] mahogany and etched-glass counter [while] only six feet away . . . was a long bin heaped high with the shining Eagled- and Liberty-headed gold of my dreams." A banker appeared and asked the young boy if he could shovel (literally) gold. Lawson wrote—forty-three years later—that he had shoveled gold ever since.

The records are unclear as to how Lawson went from shoveling gold coins to stock market speculations, but at seventeen he reportedly made an enormous overnight profit on railroad stocks—a windfall that was wiped out just days later. Lawson seemingly learned the value of this experience and, by his thirtieth year, he had amassed a fortune (varying between $1 million and $10 million; reports differ). He reportedly earned another $40 million within the next decade. His Boston firm, Lawson, Arnold and Company, at 333 State Street, became a leading brokerage house.

In 1897, Lawson acted as the market manager for the establishment of the Amalgamated Copper Company (created by Standard Oil interests to reorganize the Anaconda mine and allied companies), a deal that garnered vast profits for the insiders involved, Lawson included. Then the new stock dropped in value, and infuriated subscribers were left with heavy losses. Beginning in 1904, Lawson wrote about his experience with the Amalgamated deal over a twenty-month period in *Everybody's*

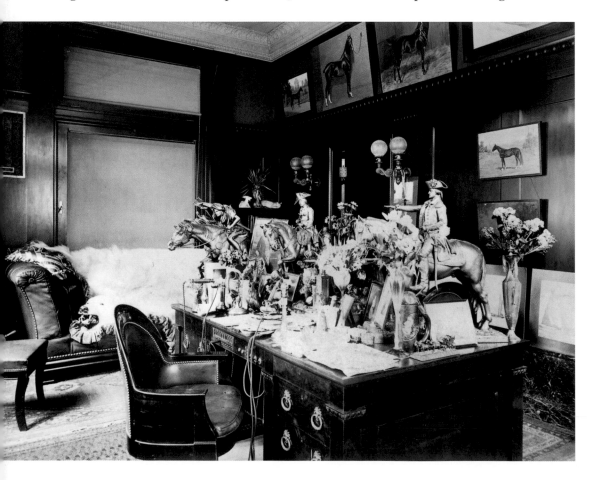

Lawson's State Street office was a remarkably personal environment, with flowers from his personal estate, bronze sculptures, oil paintings (of his beloved trotters?), books, an oversize divan (with a bear taking an eternal nap), and a desk featuring a unique built-in switchboard. The effect, too cluttered for modern sensibilities, is nonetheless inviting. Cordless phones, though, might have made things easier.

One wonders about the psychology of a man like Thomas Lawson, who came from humble beginnings, amassed a fortune, and yet, in the closely knit circle of people who defined the era's financial community, turned against the very people he needed to prosper by "outing" those involved in the Amalgamated deal. What was the effect of this on Jeannie and their children? Did he ever feel defeated by his crusade, or did a deeply held sense of "moral duty" nourish him until his death? The historical records are silent on such intriguing questions. (When daughter Dorothy wrote *The Copper King's Daughter,* she never touched upon these issues.)

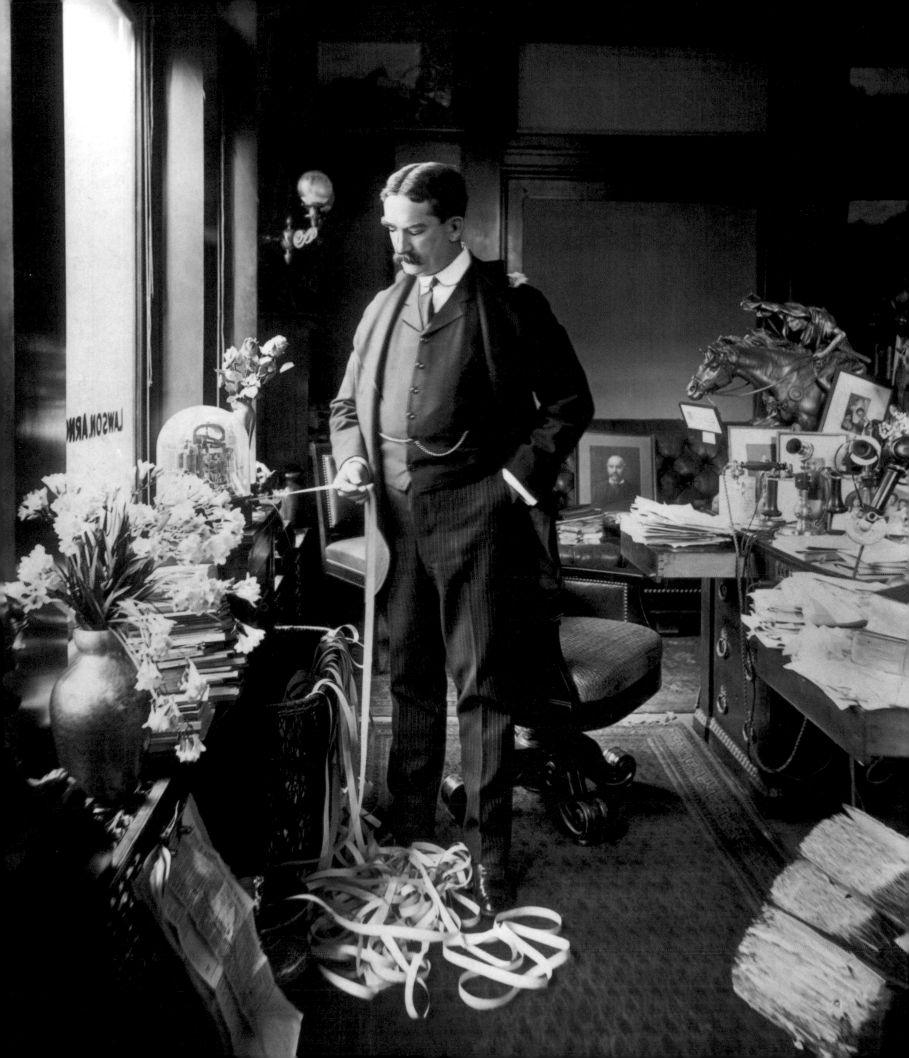

Thomas Lawson, presumably in his thirties (left), and three years before his death in 1925 (right)—still the dapper gentleman. Lawson married his childhood sweetheart, the former Jeannie Augusta Goodwillie (opposite), in 1878; the couple had six children. Jeannie died in 1906 (and was buried at the couple's estate, Dreamwold), and

speculators into a pool. When the promised profits turned into a $3.6 million loss by year's end (1905), his once-formidable reputation was tarnished, and his attacks on financial circles through his *Everybody's* series had alienated the very people with whom he did business (some of these individuals reportedly conspired to ruin Lawson).

Magazine. The articles doubled the magazine's circulation and detonated a bomb in financial circles. (Among those Lawson implicated was Henry H. Rogers, the owner of *Kanawha*; see *The Golden Century*, page 48.) It was Lawson's intention that President Theodore Roosevelt, inspired by the revelations contained in these articles, would "shake the largest trusts and corporations until their teeth chattered and their backbones rattled like hung dried corn in the fireplace when the wind gets at it." To this end, Lawson spent a reported $250,000 to publicize his exposé. Yet, people were suspicious of Lawson's reasons for "outing" those involved in Amalgamated and remained unsure whether he was driven by public interest or personal motive.

While this furor was going on, Lawson organized a group of

As his financial reputation plummeted, Lawson turned to writing and authored ten books on a variety of subjects, including a book version of his *Everybody's* articles of the same title, *Frenzied Finance* (1905); a novel entitled *Friday, the Thirteenth* (1907), which was another attack on financial circles (as opposed to the slasher movies of the same title); *The Remedy* (1912); *The High Cost of Living* (1913); and *The Leak* (1919).

Yet, to yachting enthusiasts, Lawson is best remembered for *The Lawson History of the America's Cup* (1902), which he wrote in conjunction with Winfield M. Thompson. The expensively produced, 402-page limited-edition volume was the outcome of Lawson's grievance with the august New York Yacht Club (NYYC), which had barred Lawson's yacht, *Independence*, from

Boston-born millionaire Charles Jackson Paine (1833–1916) was a significant yachting character of the late nineteenth and early twentieth centuries. Besides the courtesy he extended Thomas Lawson in the controversial *Independence* matter, Paine was instrumental in "saving the Cup" by underwriting three successive America's Cup defenders: *Puritan*, *Mayflower*, and *Volunteer*—each Boston-designed and -built. Paine, a slender, balding, "hawk-eyed" man with a robust handlebar mustache, was credited with recognizing the talent of Edward "Ned" Burgess (1848–1891), who designed all three winners; *Puritan* catapulted the virtually unknown designer to instant fame. Burgess acknowledged Paine's intimate involvement and

many suggestions during the design process, such as ordering a quarter of an inch planed off a deck in order to save weight.

An 1853 graduate of Harvard, Paine later passed the bar but never practiced law. Besides an inherited fortune (from railroads), Paine's wife "brought him plenty more." (An early biography on Paine, reflecting the times, did not think it necessary to mention Mrs. Paine's name—Julia—other than to note that she was the daughter of "an eminent" merchant, John Bryant.) During the Civil War, and after having survived severe injuries from early engagements, Paine rose to the rank of brigadier general. He played a major role in the capture of Port Hudson, commanded a volunteer African-

American division (which received fourteen Medals of Honor for its role in the 1864 Richmond campaign), and distinguished himself during the capture of Fort Fisher. After the war, Paine focused his attention on yachting and became known for his tattered clothing and red suspenders; America's Cup challengers "grew weary of seeing the angle of those suspenders in the back."

Paine's son, Frank C. Paine, became a noted naval architect and was the president of George Lawley & Son for many years. After Frank's death in 1952, almost two dozen half models and thousands of plans were donated to the Hart Nautical Collections at the Massachusetts Institute of Technology, of which Charles Paine had been an early benefactor.

Lawson never seemed the same afterward. His enthusiasm for finance declined, and he spent considerable time in Oregon at the estate of daughter Dorothy and her husband Hal McCall. (Their son, Tom Lawson McCall, became governor of Oregon.) Even repeated entreaties from his Boston office could not dislodge Lawson from Oregon.

While *earning* money seemed to have lost its interest for Lawson, *spending* it did not. The upkeep on Dreamwold must have been considerable (reportedly $200,000 annually), and Lawson was also quite generous to his children, giving Dorothy and Hal the land on which their home, Westernwold, was built, as well as the funds to

fully landscape and develop the property and purchase livestock. Dorothy wrote that her father believed money should be kept circulating and "never stashed away." The cumulative effect of this dynamic—spending instead of earning—as well as a public increasingly confused about his character and motivation, would exact its toll.

entering the 1901 America's Cup race because he was not a member. As one reporter commented, the NYYC was "composed of admirable and conceited gentlemen, who, as a rule, don't work for a living." Many Americans, no doubt, thought the same, giving Lawson's challenge an appealing underdog quality. The story would rivet the yachting press—and the general public in America and the United Kingdom—for months on end.

It began when a group of "practical racing men" decided on a Boston-built and -designed vessel to represent their city in the 1901 America's Cup race. It soon developed that the challenging yacht would not be financed through a general public subscription, as was initially intended, but rather by one man, Lawson, who believed that all such a venture required was "wealth and will." Lawson, to no one's doubt, had both. The first order of business was to consult the NYYC: Would such a yacht be allowed to compete? An emissary discussed the issue with NYYC member and noted yachtsman General Charles J. Paine, who replied that the club would not bar the Lawson yacht, and that the very idea was "small, nonsensical and ridiculous." Thus assured, Lawson placed an order "at once" (December 17, 1900) with George Lawley & Son to build the Bowdoin B. (B. B.) Crowninshield-designed, 140-foot *Independence*. The new yacht would be a scow-type, with a shallow, flat hull, fin keel, and bronze hull plating. (Due to time constraints, the yacht was built at the Atlantic Works, in association with Lawley.)

The press continued to report that Lawson intended to sell the completed yacht to an NYYC member; no amount of public protests from Lawson could dispel such stories. During the month of April 1901, a series of excruciatingly polite, private letters passed back and forth between Lawson and the NYYC, whereby Lawson willingly agreed that, should the *Independence* be chosen as the defender, she would be "made the *representative* of the challenged club." His point was that, while he understood that the NYYC had the right to manage *Independence*, he—a non-NYYC member—would still own her. On May 18, and without alerting Lawson, the NYYC released the private correspondence to the press, with "sensational headlines"

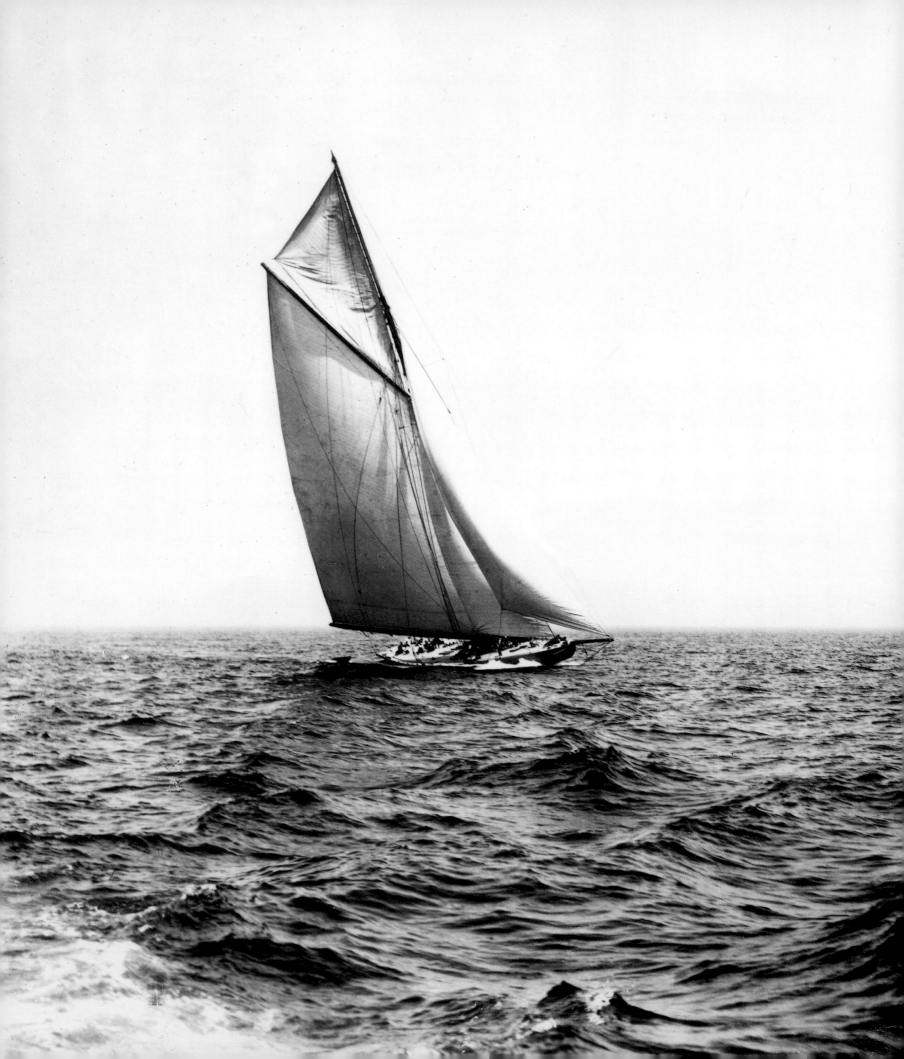

resulting, after giving notice that they had decided to bar *Independence*, after all, unless a member owned her. By way of contrast, the newly formed Newport Yacht Racing Association (of which many members were also NYYC members) invited *Independence*, through a series of informal, friendly letters, to race against the *Columbia* and the *Constitution*.

Lawson acknowledged that building an advanced racing yacht was a game of chance. He wrote: "Pared away here and there to the last degree consistent with even a moiety of safety ... built of material no thicker than a dinner plate ... equipped with towering spars ... weighted far below the hull with eighty tons or so of lead—what wonder that these vessels are almost an unknown quantity ... when they leave the hands of their builders?" Well after the fact, Lawson continued: "Her interior bracing was too light to properly support her overhangs, with the result that the vessel strained and leaked, and at the end of a season was good only for the scrap heap." The yacht was—under model conditions—extraordinarily fast. But such conditions rarely exist. While being towed from Boston to Newport to compete, *Independence* sustained considerable damage in heavy seas; her seams opened, interior steel rods "snapped like pipestems," and her crew prepared to abandon ship on three occasions. Through some miracle, the yacht remained afloat and even raced the next day, although her crew pumped 3,000 gallons of water every hour. Drastic repairs were implemented at once but proved little use; she was simply "too lightly built and too heavily canvased." During her Newport races, the water filling her hull ruined her racing form, and more repairs were required. During trials with *Columbia*, she won one race—no small feat, considering her condition—before being eliminated.

Lawson had hoped to continue improving and racing *Independence*, but no other yacht agreed to compete. Thus, Lawson ordered the brand-new vessel to be broken up. He wrote, "At last nothing remained of the yacht but the body-frames, like the bones of a giant fish on the beach."

Independence cost Lawson $205,034.80 for the three months she was in commission. She is shown in the adjacent image with Lawson's steam yacht *Dreamer*.

Lawson began developing his sprawling estate, Dream-wold, in 1901. Daughter Dorothy Lawson McCall wrote about the first time she saw the land: "Driving through the soft haze of a wet summer afternoon, they came to a huge roll of landscape whose border was marked by a winding country road. Part rugged pasture land, part sheer rocky waste, and part scrub woods, the track rolled over the country to a view of the ocean below the eastern slope." This barren waste "of stony, un-cultivated land [was] changed into a thousand acres of woodland, fields, rolling meadows and upland as pleas-ing to the eye and as soft as the rich landscape sur-rounding an estate centuries old." In 1903, upon its completion, the family moved to Dreamwold, located in Egypt (now Scituate), Massachusetts, south of Boston. The image at right shows the main facade of the Colonial Revival main house, Dreamwold Hall.

Above, the entrance gates of Dreamwold and an array of estate buildings, including the trotting barn in the distance.

To house the estate's water tower (below), Lawson built an extraordinary shingled structure that had a carillon (with ten bells) and an observation platform. It was, not surprisingly, a navigational landmark.

Right, the elegant rear terrace of Dreamwold Hall.

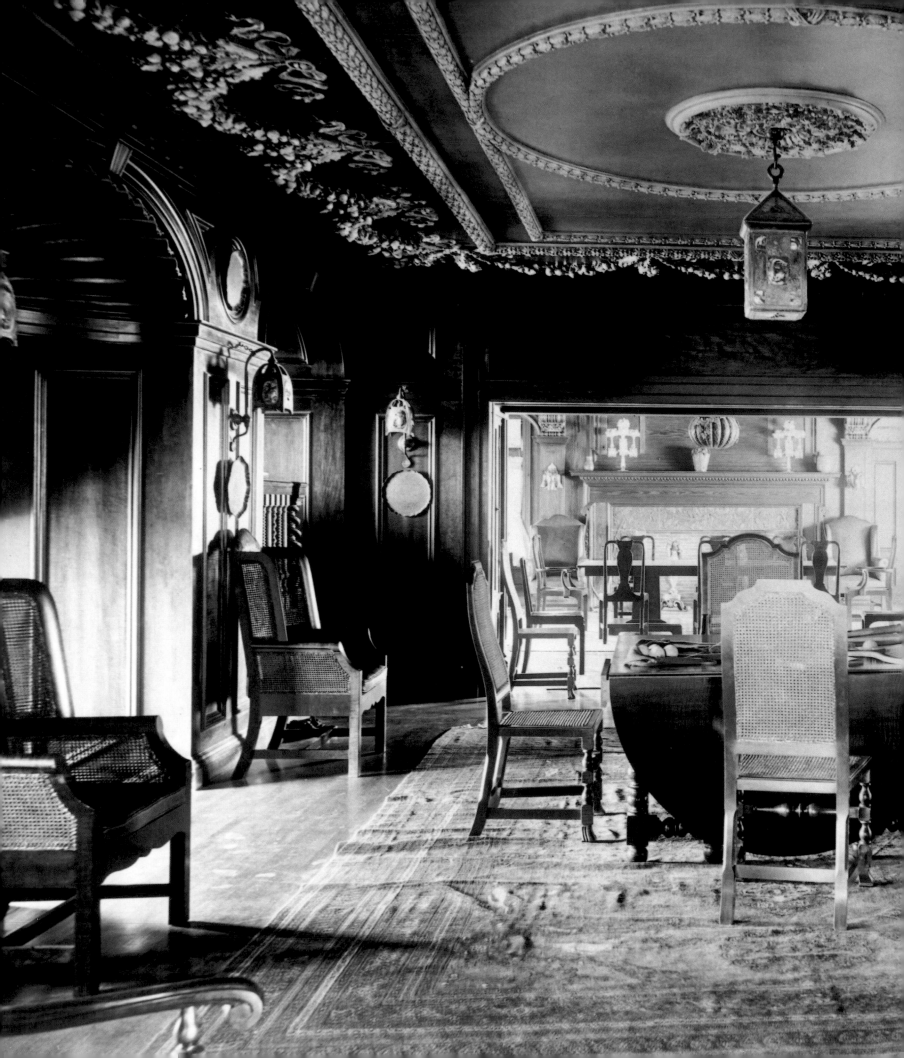

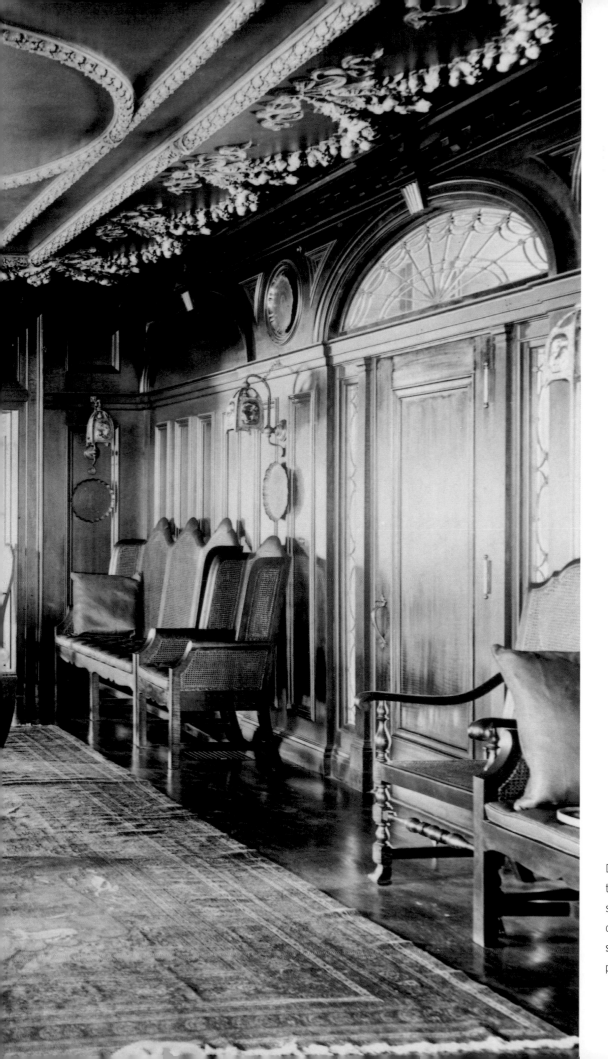

Dreamwold Hall's reception room was, like the rest of the main rooms, enveloped in dark woodwork. The oversize plasterwork on the ceiling (painted in "soft cerulean tints") overwhelmed an otherwise attractive setting. The curly maple joinerwork and staircase (not pictured) were stained a "peculiar shade of dark green."

63

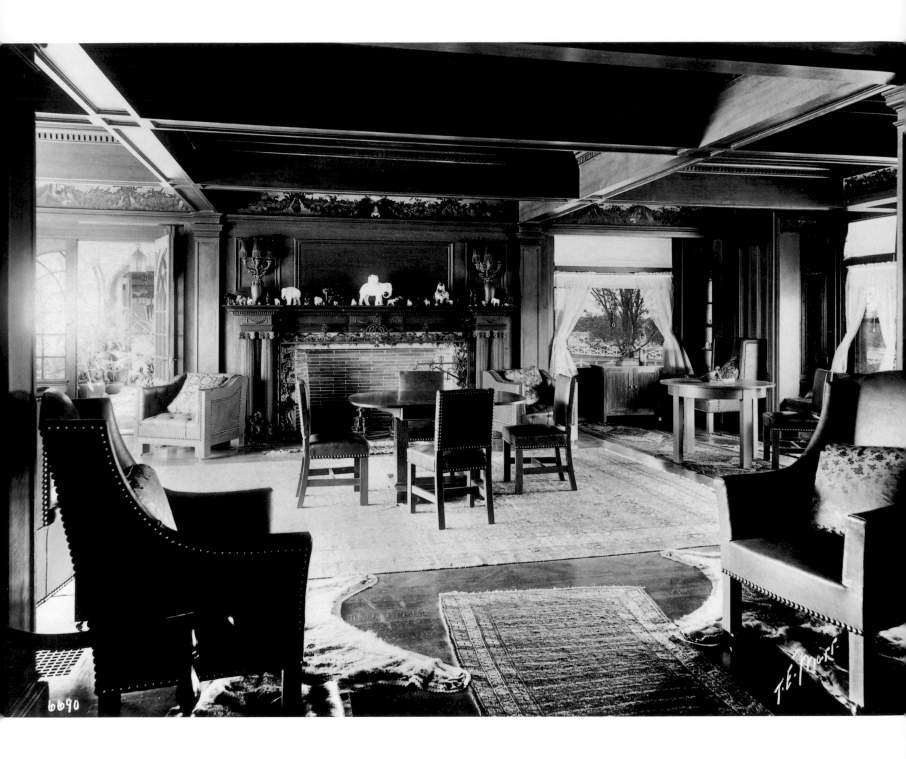

The living room at Dreamwold Hall featured a peculiar set of plain, stiff-looking furnishings at odds with the elegant, articulated decor. The pair of sconces over the fireplace were by Louis Tiffany. Overhead, the oak beams were tinted gray, while the overall coloring was "pale fawn." The collection of elephants (Lawson re-portedly had thousands) on the mantel formed "an odd and unique procession" and prompted *The House Beautiful* to observe that Lawson's taste was opposed to "conventional ideas of decoration." They also won-dered whether India and Africa could supply live spec-imens for the estate.

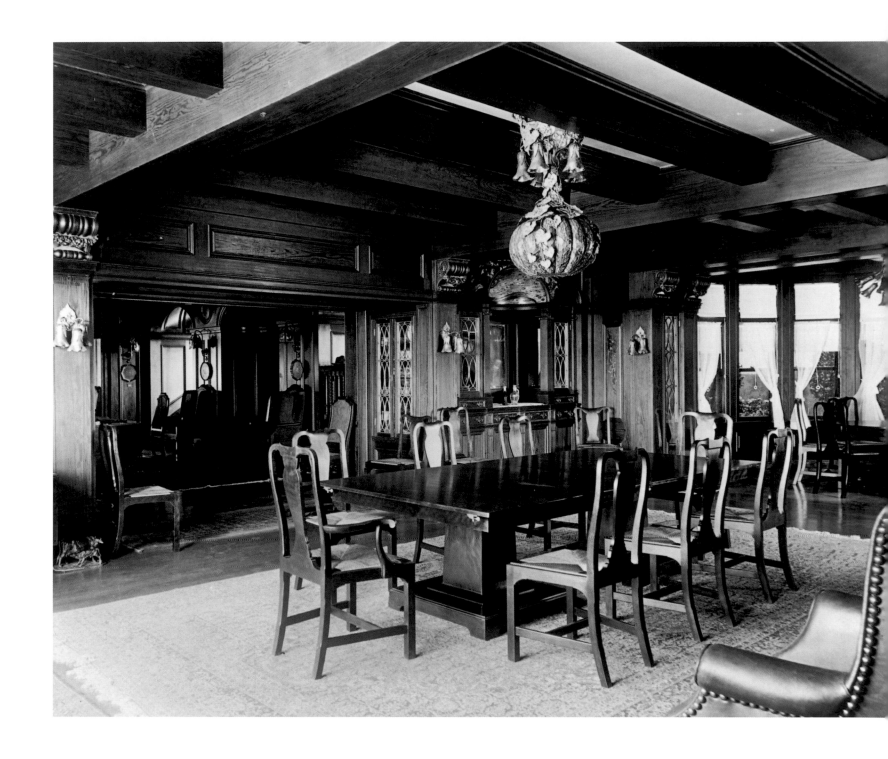

Dreamwold Hall's dining room featured an extraordinary Tiffany chandelier in the shape and coloring of a pumpkin, with "festoons of delicate vines spreading out upon the ceiling in clusters of pumpkin-flowers in their natural colors." The companion wall sconces (in the shape of pumpkin blossoms) provided a "soft orange glow." North Carolina pine covered the walls and ceiling, and the wood was stained green-gray, a "most decoratively soft and restful shade," while the ceiling between the beams was painted a "soft green-blue, in clouded effects."

Was this Jeannie and Thomas Lawson's bedroom? This setting (above) appeared more intimate than the grand main-floor rooms—and a great deal more charming. Note the portrait of Lawson, inexplicably on the floor.

Dreamwold Hall featured a pair of wings connecting to side buildings; inside one such wing was this inviting conservatory (opposite), which led to the "bachelors' quarters" and billiard room.

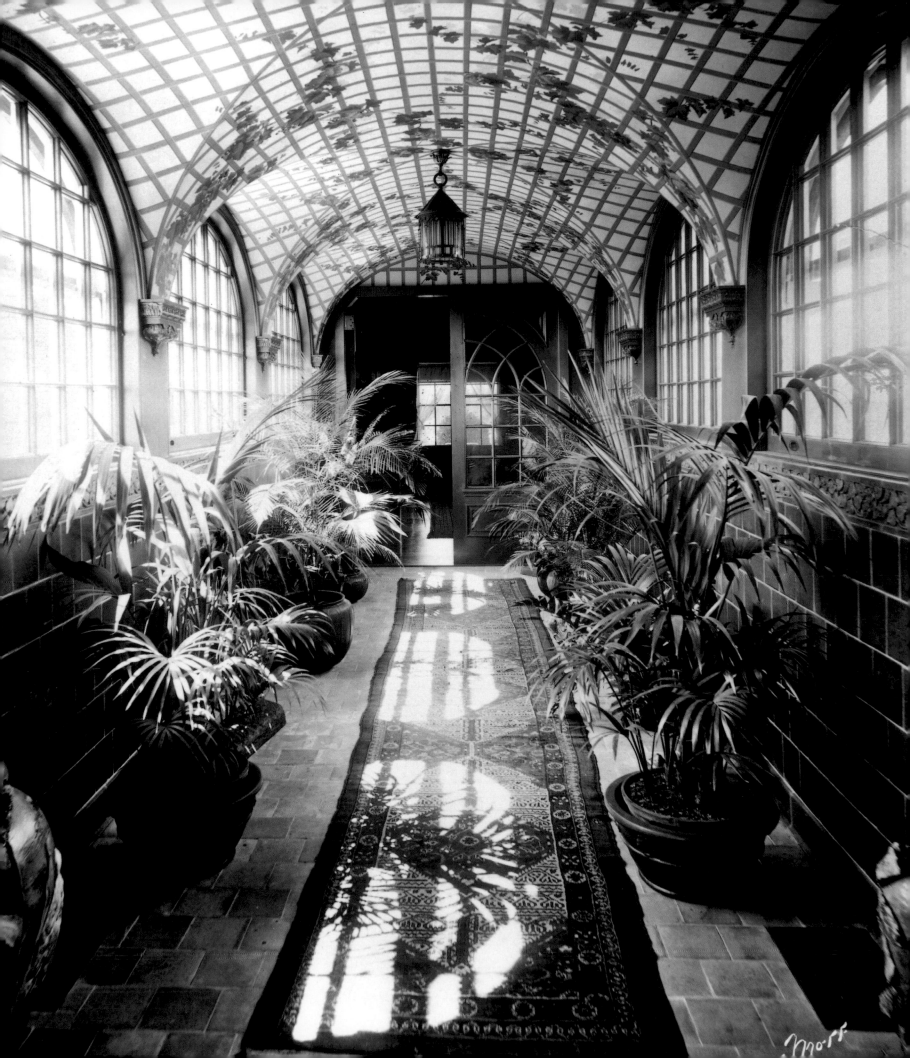

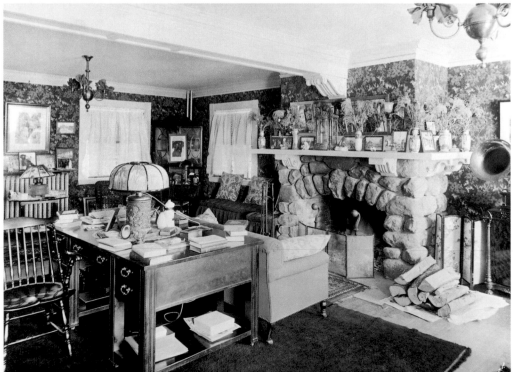

Above, Dreamwold Hall's kitchen—a serene, understated, utilitarian oasis amid extravagance.

This unidentified image (left) was, presumably, Lawson's Dreamwold office, occupying one of the many outbuildings. Its rustic charm, low ceiling, simple curtains, and cluttered furnishings must have offered a cozy retreat.

Even though he emerged from humble beginnings, Lawson developed a hunger for the finer—and more expensive—luxuries wealth could offer. At Dreamwold, he ordered the construction of stalls for his trotting horses (above), 800 feet in length and adjoining the estate's private racetrack and its shingle-style observation stand; the estate eventually housed 300 horses. Other features included a dovecote, homes for estate employees, a massive riding hall, sewage plant, windmill, post office, and firehouse—even a bank for the "accommodation and the encouragement of thrift among his employees."

CURMUDGEON COMMENTS:

For all its grandeur, size, and expense, Dreamwold lacked the grace and sophistication that typified the work of architects such as McKim, Mead & White, who excelled in designing shingle-style structures and vast compounds. The many outbuildings of the estate lacked a unifying scheme; they seemed unconnected to each other and dispelled the idea of Dreamwold being a *compound*. The furnishings of Dreamwold Hall were at odds with the architectural detailing, which itself was proportioned awkwardly. Only Lawson's estate office had particular appeal, its rustic simplicity not requiring perfection of scale and detailing.

As an architectural designer, it fascinates me when people such as Lawson set out to create something extraordinary and then retain less-than-extraordinary talents to bring their ideas to fruition. There is today a well-known American developer quite desirous of fame; yet he consistently retains less-than-stellar firms to design his many buildings in prominent locations. These resolutely banal structures insult the urban landscape—and every person who has to look at them for the next century. Why do people opt for the mundane when they have an opportunity for greatness?

Top left, the estate's post office (extant, now a private home) was a decidedly charming structure covered with the ubiquitous shingles unifying Dreamwold's diverse buildings.

Bottom left, an enchantingly animated sign, the likes of which are rarely seen today.

In 1922, Lawson lost Dreamwold after it accumulated $225,000 in debts. The estate was sold at public auction, garnering huge headlines in local newspapers. Lawson did not witness this occasion; he had transferred the estate to trustees and departed.

Dreamwold has survived the years surprisingly well. Many of its outbuildings are extant, the famous water tower is a landmark, and Dreamwold Hall was converted into expensive condominiums.

Opposite, the only seven-masted schooner ever built (with 43,000 square feet of canvas) was named after Lawson, although research has yet to uncover why. Like Lawson's life, the final fate of the 369-foot *Thomas W. Lawson*, launched in 1902, was grim. During a 1907 storm off the Scilly Isles (southwest England), loaded with oil, the vessel dropped her bow anchors with the intention of waiting out the storm. Lifeboats were sent out from St. Mary's and St. Agnes to request that the *Lawson*'s captain abandon ship; he refused, stating that he had ridden out fiercer weather. Instead, he asked for a pilot; one boarded from the St. Agnes lifeboat. When the second lifeboat arrived, it smashed its mast on the *Lawson*'s stern and left for repairs and to summon a tugboat for the *Lawson*. The first lifeboat, after a crew member fell ill, also returned; the captain of the *Lawson*, once again, refused to abandon ship. At 2:50 A.M., the *Lawson*'s lights disappeared from the sky and the smell of oil soon permeated the air. By morning, the upturned keel of the ill-fated vessel was all that remained visible, aground on the Outer Ranneys. Later that afternoon, two survivors were found from the eighteen-man crew—the captain and the engineer (reports differ as to how many survived or died). The pilot who had boarded the *Lawson* was also lost; it was his son who found the survivors.

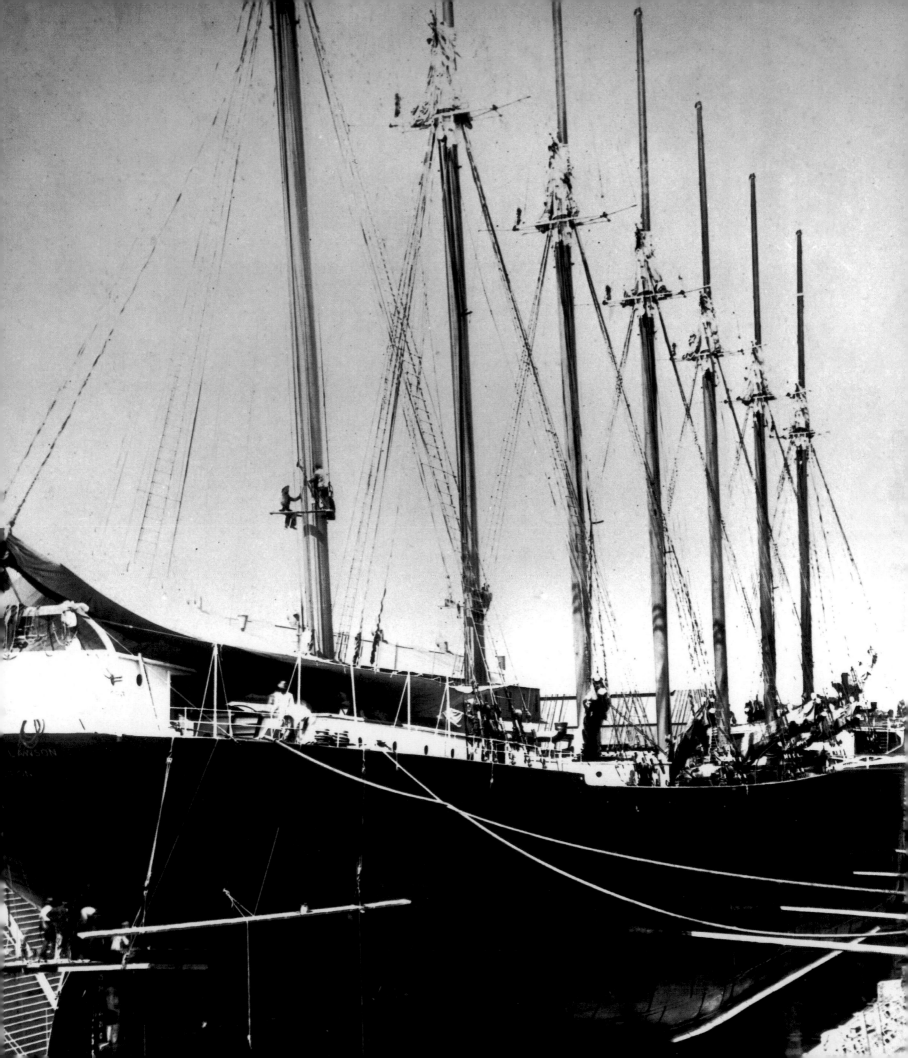

REVA

1886

Designed by Gustav Hillmann
Built by Samuel Pine, Greenpoint, New York
J. W. Sullivan steam engine
18″ + 14″ × 12″ cylinders
Boilers unknown

Reva, built for Pierre Lorillard, New York, had thirty-seven feet added to her 111-foot length in 1889. Her stack was also raised and her stubby clipper bow was changed to a plumb stem. Her restyled lines made for an unusual profile.

Thomas Lawson leased his first steam yacht, *Reva* (111 feet at launching), which he used for both family outings and business meetings. One evening, with a group of Boston businessmen on board, fog enshrouded the yacht. A "terrific crash" was heard, and the yacht shuddered. As the men clambered onto the deck, they were horrified to see an excursion steamer pulling away from a gaping hole in *Reva*'s hull. Lawson, in an instant, leapt from the deck to the steamer and ordered its captain back into *Reva*'s holed hull—sealing it. No one was hurt, although had Lawson's children been aboard, the outcome, most likely, would have been tragic. The staterooms for son Doug and daughter Dorothy were demolished.

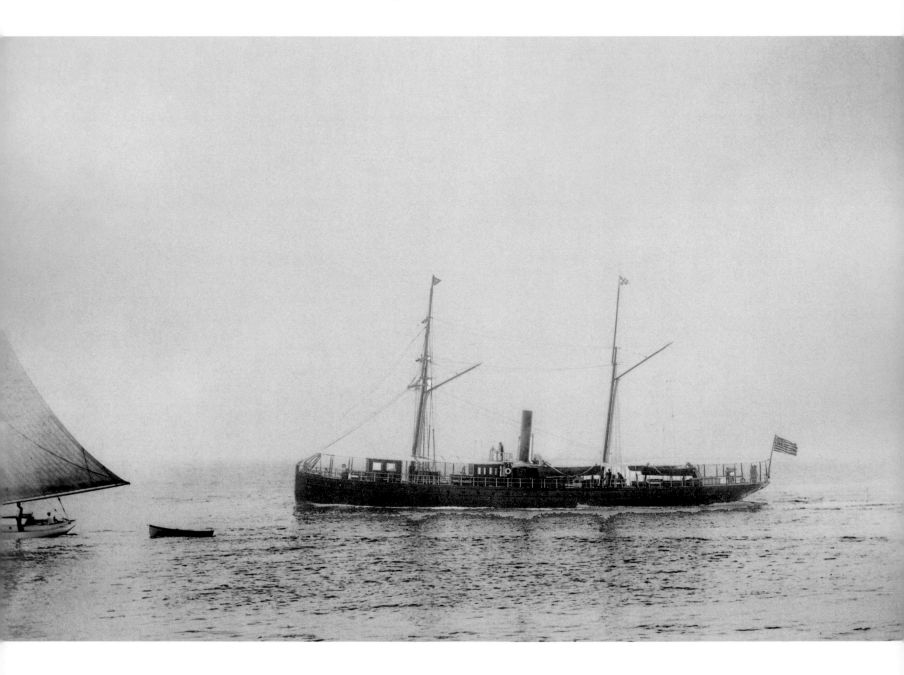

MY GYPSY

1893 · LAUNCHED AS RANDOM

Designed and built by George Lawley & Son,
Scituate, Massachusetts
Fore River steam engine
8" + 16" × 12" cylinders
Almy water tube boiler

After enjoying the leased *Reva*, Lawson purchased a seventy-six-foot steam yacht, launched as *Random* in 1893 for Frank B. McQuesten, Boston (who later commissioned *Valda*, *The Golden Century*, page 67). Lawson renamed the vessel *My Gypsy*, after a nickname given to Jeannie Lawson, who, as related by her daughter, Dorothy, had always loved gypsies. The yacht had a crew of five, as well as two "bunk bedrooms" and a "dining nook," as Dorothy remembered years later in *The Copper King's Daughter*.

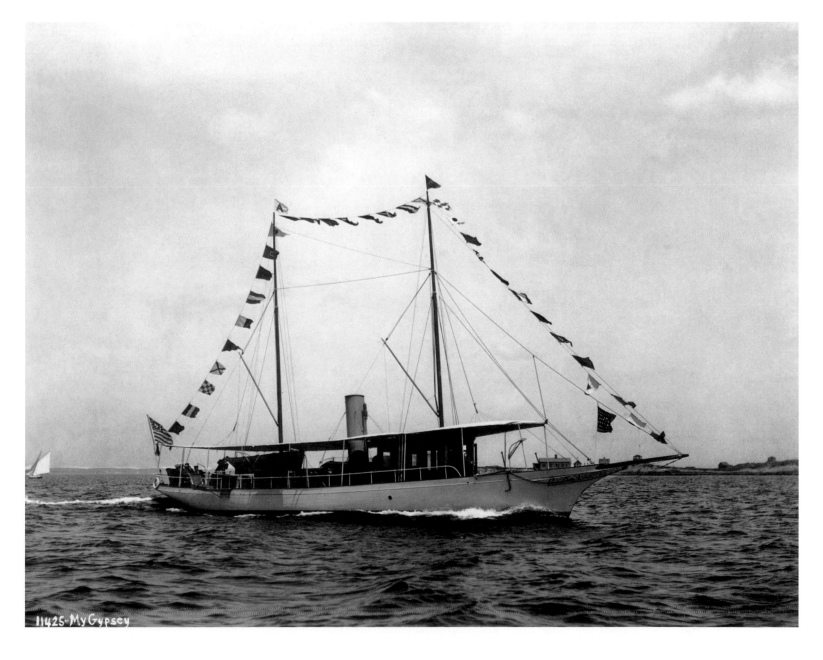

11425-My Gypsey

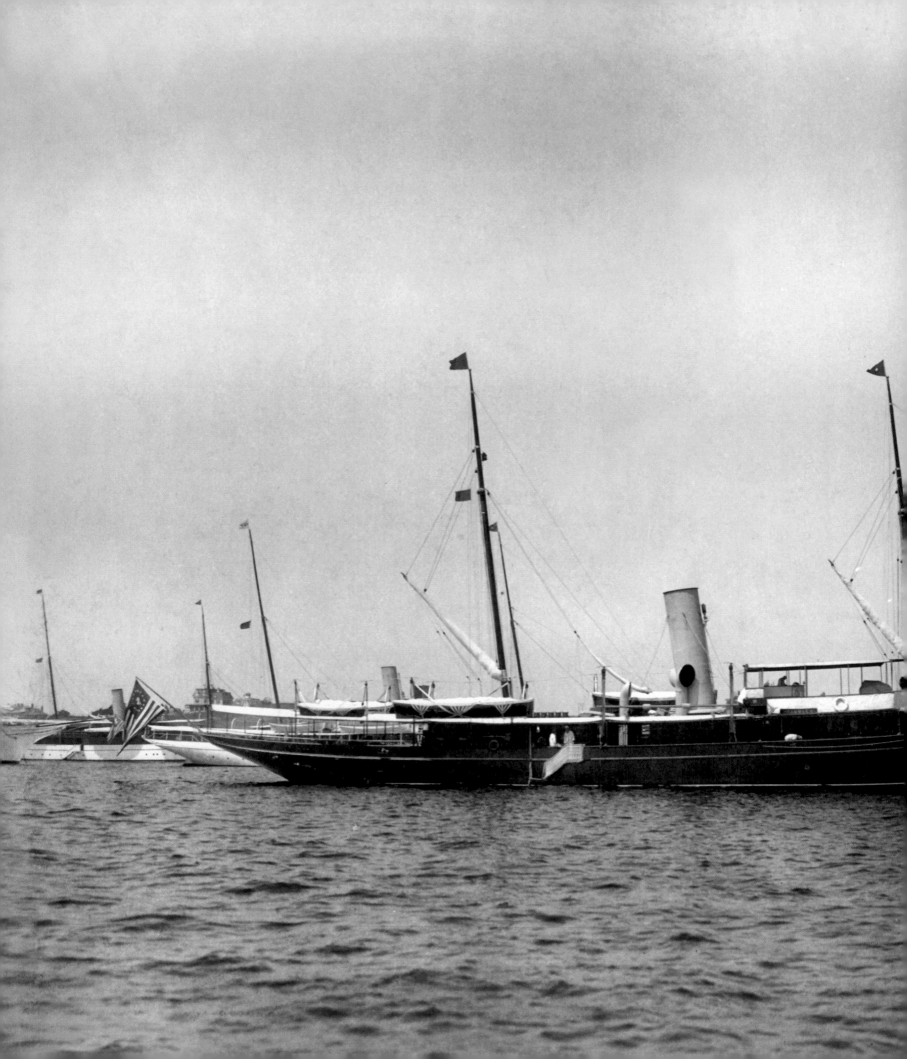

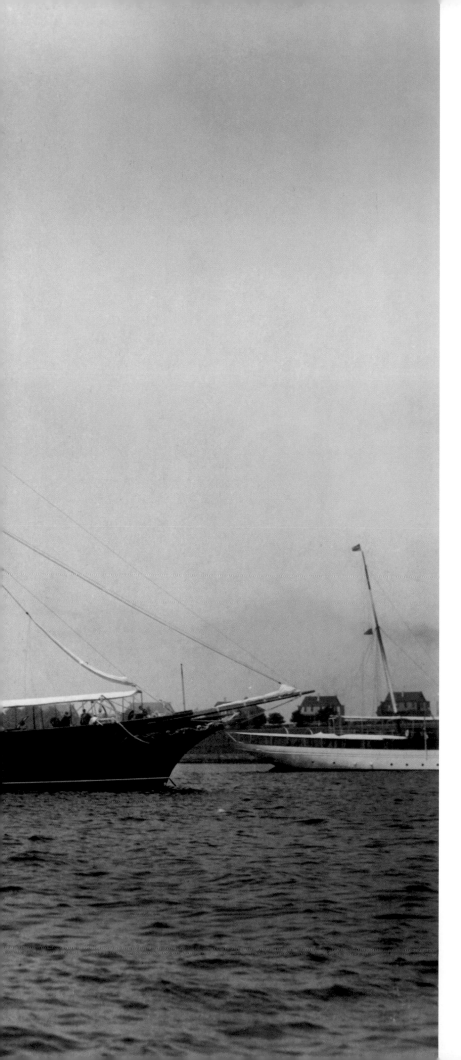

DREAMER

1899

In September 1899, the Lawson family took possession of the 167-foot *Dreamer*, which was commissioned by Lawson in his forty-second year—the height of his success. Her outboard profile represented the state of the art, the sheer was a jaunty sweep, the continuous deckhouse was a significant advance (a contrast to the previous practice of multiple houses), and the large, cream-painted funnel, twin raked masts (seventy feet in length), and black-painted hull added to her assured design.

The crew had quarters forward, in "the eyes of the ship," and fitted with pipe berths in the navy style, which "admits of thorough cleanliness," as *The Rudder* commented. The adjacent head had marble sinks, while the fact of running water was innovative enough to be mentioned in contemporary literature. The officers were located aft, an unusual arrangement, and their cabins were trimmed in sycamore with a natural finish.

A triple-expansion engine powered *Dreamer*'s single screw; the twin water tube boilers also supplied steam for the "ice machine, dynamos, steering gear, sanitary engines, blower, distiller and evaporator." Under natural draft, *Dreamer* could do fourteen knots; forced draft added three knots.

On the foredeck were models of the America's Cup entries *Shamrock* and *Columbia*, displayed in glass cases standing nine feet high. One wonders how they fared in a heavy sea.

Lawson's requirements pushed the price of *Dreamer* $80,000 above its estimated cost, for a final tally of $240,000. This must be compared with the $75,000 cost of Eugene Tompkins's resplendent *Idalia*, launched the same year, and ten feet longer (pages 34–45). Was *Dreamer*'s cost accurate, or inflated by Lawson as a boast?

Designed by Tams, Lemoine & Crane
Built by Crescent Shipyard, Elizabeth, New Jersey
Triple-expansion J. W. Sullivan steam engine
14" + 21" + 32" × 20" stroke cylinders
Two Almy water tube boilers

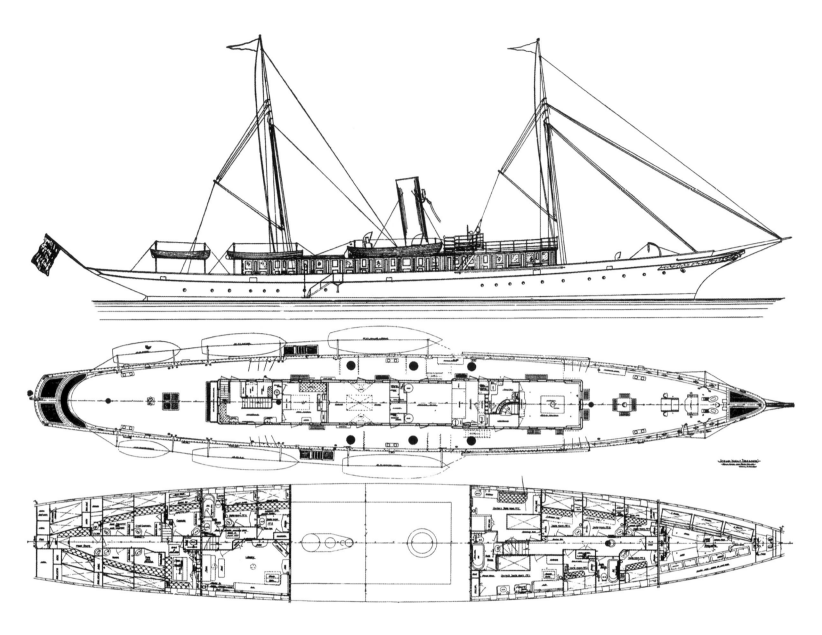

The accommodation plans for *Dreamer* (above) were somewhat unusual in that the owner's staterooms and guest quarters were forward and a library was an important feature. Moreover, as noted, officers were aft and quite separate from the crew forward. One wonders if this latter arrangement was a help or a hindrance to employee relations.

Right, the bridge of *Dreamer* (the canvas awning evident in the previous image was not in place) lacked the plethora of cowl vents evident on *Idalia* (page 36). However, forward of the pilot station was an additional deck atop the deckhouse (similar to *Idalia*), which must have offered a splendid view and bracing winds in an age when exposure to the elements was thought important for one's constitution.

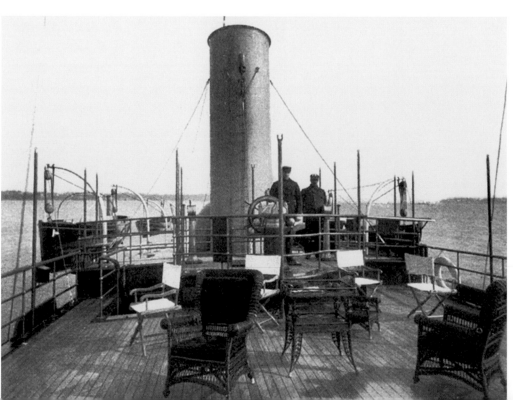

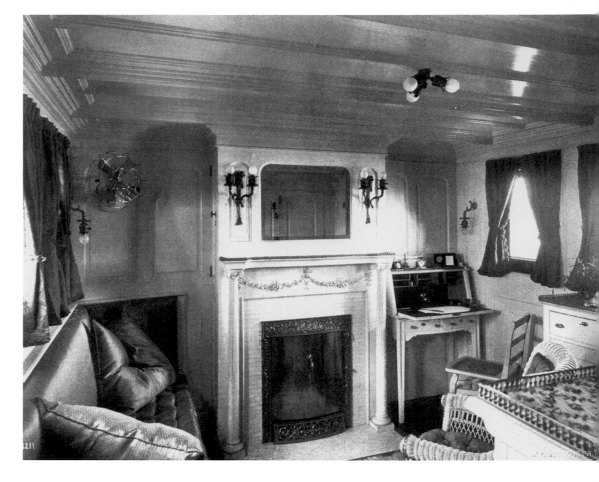

Dreamer's deck saloon (top right)—almost dollhouse-like in its proportions—was a cool oasis in the Colonial Revival style. This charmingly intimate setting must have been quite cozy by the light of a fire (likely electric) burning on a dark, wind-tossed night, with cocktails in hand and the chatter of conversation long into the evening.

Early steam yachts such as *Dreamer* (with their narrow hulls and lack of bilge keels) were easily tossed about even in moderate waves or wind. As such, precautions had to be devised to keep elegant furnishings and fittings from being wrecked when underway. Small objects were stored in specially fitted boxes and crates before a voyage was undertaken, and larger objects were bolted in place. Or, where such a procedure would have been impractical (such as the chairs in *Dreamer*'s dining saloon), unique tiebacks held such items secure to the joinerwork.

This cabin (bottom right) was graced with mahogany joinerwork (oiled, not varnished), and the large glass windows could be fitted with storm shutters of steel with an eight-inch port (for use in heavy seas). The carved mahogany buffet contained "all the appurtenances necessary for a comfortable and elegant living apartment."

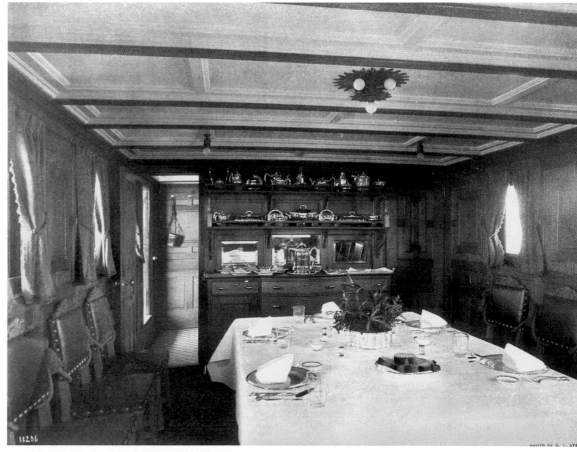

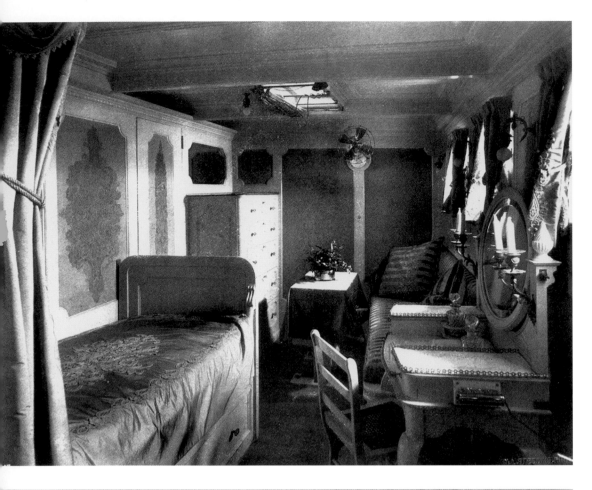

Top left, "owner's stateroom number one," seventeen feet by ten feet, would appear to have been Mrs. Lawson's, as the makeup table and inset floral patterns on the joinerwork suggest a feminine ambiance.

Bottom left, "owner's stateroom number two" would appear to have been Mr. Lawson's, with its more robust, masculine decor. Note an additional writing desk. Without leaving his berth, Lawson, through speaking tubes, could talk with the "bridge, the officers' quarters, engine room and servants' quarters"—a state-of-the-art communication system.

Opposite top, *Dreamer*'s library was below deck, and the joinerwork was golden oak. Because Lawson was a writer, this saloon looks functional and used. The "French tile" surrounding the fireplace was of an "olive tone." Note the extraordinary radiator (left).

Opposite bottom, two views of *Dreamer*'s expansive, yet still intimate, aft deck. Note the Oriental-style rugs and full canvas awning. This type of setting is far removed from the sleek, expansive look prevalent on modern yachts.

Dreamer, her name later changed to *Rambler,* was not listed in *Lloyd's* after World War I.

The *Dreamer* photographs were taken by Nathaniel Stebbins (pages 216–17), and reproduced from *The Rudder* magazine after an exhaustive search failed to trace the original negatives (or even copy prints).

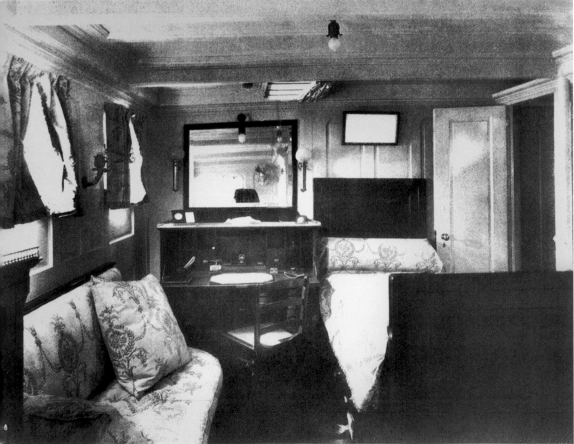

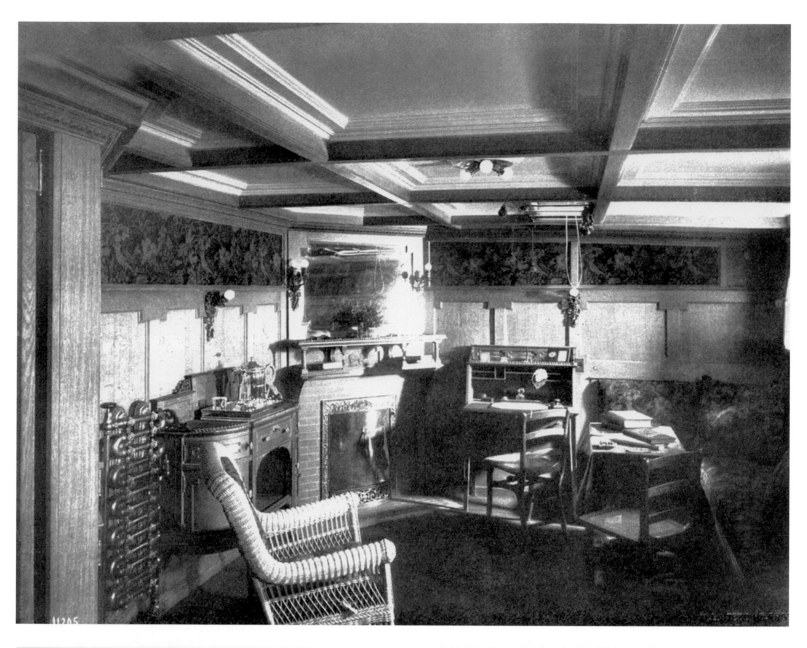

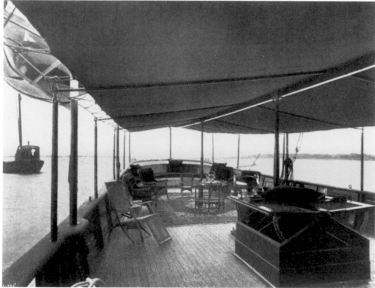

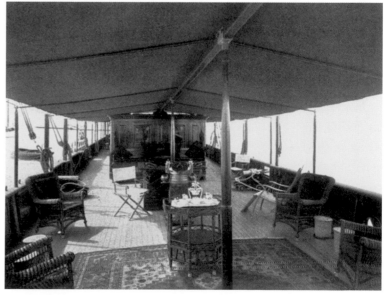

JOHN DIEDRICH SPRECKELS

Few people have left a visible mark on successive generations quite like John Diedrich Spreckels, who helped transform two sleepy communities in California—San Diego and Coronado—by constructing dozens of buildings, ensuring an adequate water supply, installing extensive trolley systems, and donating a city hall, library, park, and even an open-air organ.

The son of the Hawaiian "Sugar King," Claus Spreckels, John Spreckels (1853–1926) was the first of eleven siblings (although only four other siblings reached maturity: Adolph, Claus, Rudolph, and Emma). Claus Spreckels had been a poor immigrant and John was not initially raised in wealth and comfort. Although Claus eventually garnered a fortune (estimated at $50 million at the time of his death in 1908, or $15.1 billion in today's dollars), John's childhood was not one of indolent pleasure, but rather one of learning. "Work, not talk," was the family refrain. At the age of three, he experienced his first ship voyage when the family moved to San Francisco. At fourteen, he crossed the Atlantic to attend the Polytechnic College in Hanover, Germany (studying mechanical engineering and chemistry). These voyages engendered a passion for the sea.

At eighteen, Spreckels returned to California to begin an apprenticeship in his father's sugar refineries, learning the technical and business aspects in all departments; his salary was $50 a month. At twenty-two, he was named a superintendent, and his salary was raised to $250. In 1874, Spreckels first went to Hawaii, where Claus had substantial sugar-related interests. He later went to New York to learn more about the sugar refinery business, and he worked in a laboratory on lower Wall Street. During this period, he met Lillie Siebein; they were wed in 1877, in Hoboken, New Jersey. The newlyweds moved to Hawaii to manage Claus's sugar interests. John established his first independent venture when he commissioned a cargo vessel, the *Claus Spreckels*. After quoting rates lower than those of competitors, Spreckels won the contract to deliver his father's sugar to the mainland. This proved financially successful, and John eventually had eighteen cargo vessels and tugboats, all reportedly built without the financial aid of Claus. In 1880, Spreckels (age twenty-seven) created an importing firm, J. D. Spreckels & Com-

The Hotel del Coronado is today a recognized landmark. It was built in 1887 on an undistinguished, undeveloped peninsula across a bay from San Diego. The narrow point of land had two features: good weather and the Pacific Ocean. In the early 1880s, Elisha S. Babcock, Jr., and Hampton L. Story used to row across the bay to hunt for rabbits there. With San Diego experiencing a building boom, the men realized that their hunting grounds had other possibilities—as the story goes. They purchased the peninsula (and the small, adjacent North Island) and incorporated the Coronado Beach Company to subdivide and develop the land. Its centerpiece would be a massive wooden hotel "too gorgeous to be true," designed by Reid & Reid (a firm consisting of three brothers: James, the hotel's principal architect, Merritt, and Watson).

The rambling, four-story, shingle-style edifice (with just seventy-three bathrooms for 400 rooms) opened in 1888—just as the land boom collapsed. During its first three months of operation, the hotel lost a reported $60,000 and employees were laid off. In July 1889, John Spreckels, who previously had made substantial loans to the Coronado Beach Company, purchased a one-third interest in the corporation for $511,050 and was named vice president. He pumped new funds into the hotel and ordered lavish new furnishings.

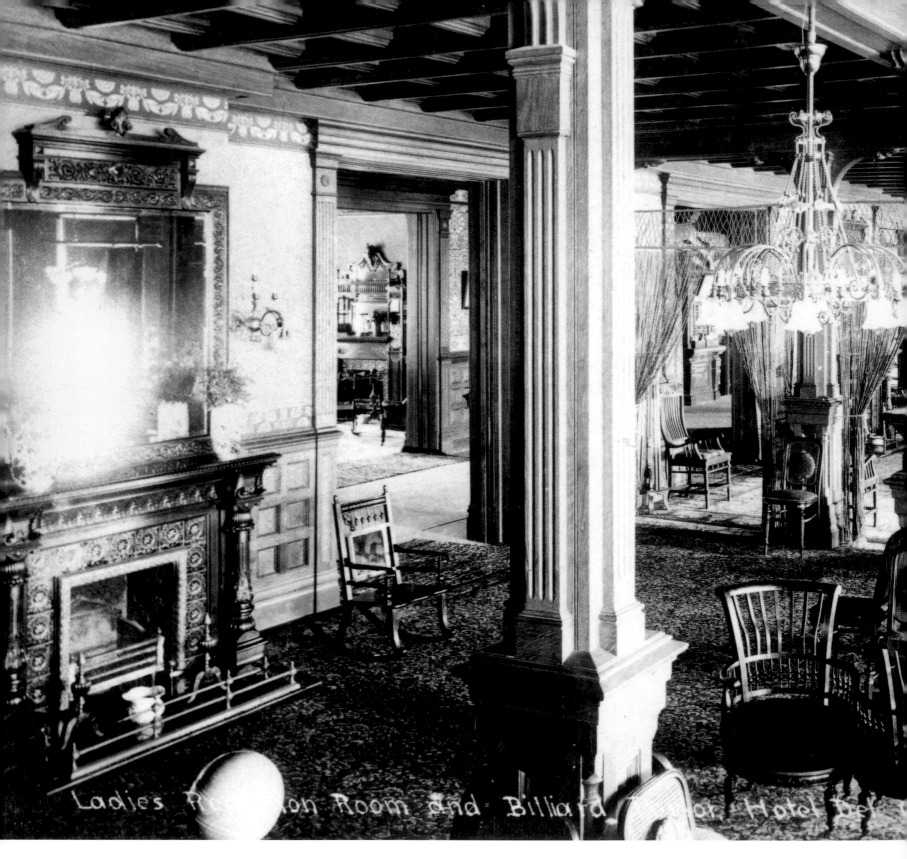

Ladies Reception Room and Billiard ... at Hotel Del ...

pany, and began what would prove a life-long partnership with his brother Adolph.

The John Spreckels family moved to San Francisco, where four children were born: Grace (Hamilton), Lillie (Wegeforth), Claus, and John D., Jr. Spreckels later bought into his father's company. Expanding his cargo and import business, he char-

tered his first steam vessel, the *Suez*, and later commissioned the steam vessels *Mariposa* and *Alameda*.

The Spreckels name is linked inextricably to the San Diego area, where the John Spreckels family lived and which John transformed. He had first encountered the sleepy town of San Diego in the summer of 1887, while on a cruise aboard his

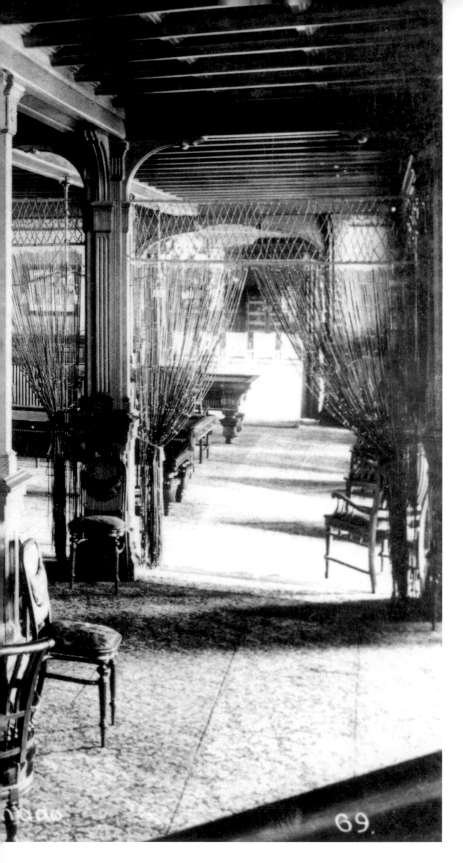

The hotel's expansive ladies' reception room;
the billiard parlor is in the background.

nado Beach Company, the Hotel del Coronado (opened in 1888 and later made famous by the Marilyn Monroe film *Some Like It Hot*), the newspapers *San Diego Union* and *Tribune*, the city's streetcar system (replacing the horse-drawn cars with electricity), and Coronado Tent City. Additional investments included the San Diego–Coronado Ferry System and Belmont Park. Spreckels built numerous structures in downtown San Diego, such as the 1908 Union Building, Golden West Hotel, San Diego Hotel, and the Spreckels Theater Building. At one point, he owned all of North Island (adjacent to Coronado). In Coronado, he built the city hall, numerous commercial and residential structures (including the Spreckels Building on Orange Avenue), and the public library; he donated the latter, and the park surrounding it, to the city.

Spreckels believed that if his adopted city were to grow, it needed to invest in its infrastructure. He spearheaded an extensive enlargement of the trolley system; constructed a dam sixty miles from the city which held fourteen million gallons of water piped to San Diego (in 1912, he sold the water company and its holdings at cost to the city); and a massive undertaking: the San Diego and Arizona Railway—the "Impossible Railroad." While many of his developments, no doubt, made a profit, many buildings and companies he created did not (at least for many years). Spreckels reportedly accepted this, believing that the city benefited from such developments. He believed that one of the purposes of money was to keep it circulating. By 1902, Spreckels employed approximately 3,000 people in the San Diego area.

Claus Spreckels failed to understand his son's intense involvement with San Diego and Coronado, which he considered a distraction to John's substantial investments in San Francisco. In a 1923 address, John offered an explanation: "I was not a capitalist seeking investments; I was a young man seeking opportunities for doing things on a big scale."

Adolph Spreckels died on June 28, 1924. John was notified while on a long cruise aboard his 227-foot steam yacht, *Venetia*; he disembarked in Miami and took a train back to California, where, twenty-five months later, he died.

schooner *Lurline*. The vessel stopped in San Diego Bay to re-provision, and Spreckels was immediately impressed with the small community (its booming real estate was at a fever pitch that summer). He soon purchased a franchise for a coal-handling wharf (which he had to build); the new business proved profitable from the start. Later investments included the Coro-

Father and son: Claus and John Spreckels (age ten).

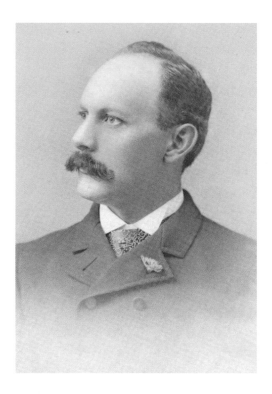

John Spreckels at thirty-four.

Right, this typically Victorian decor was reported as the San Francisco residence of the John Spreckels family.

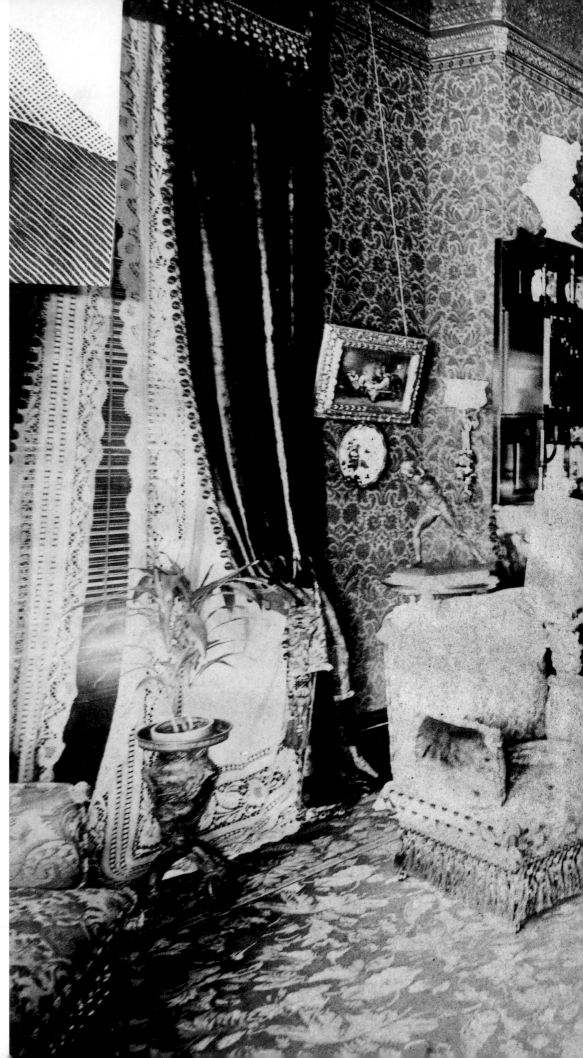

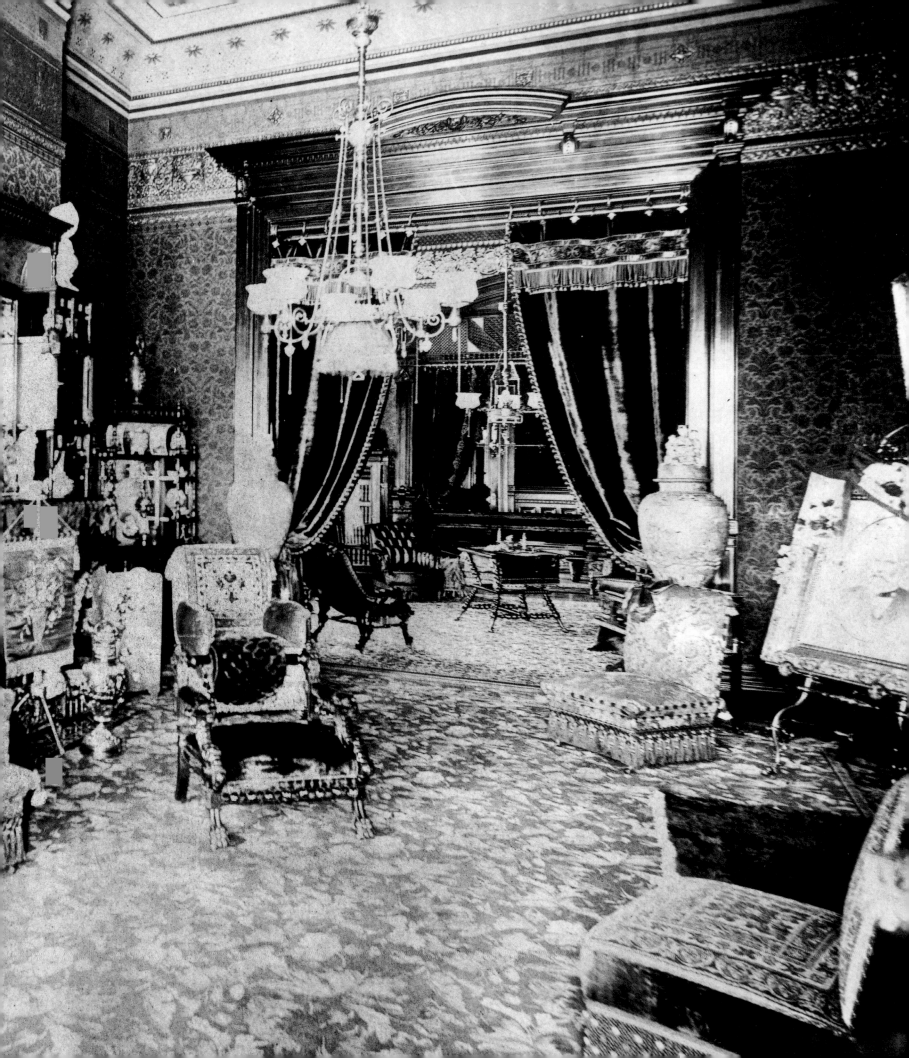

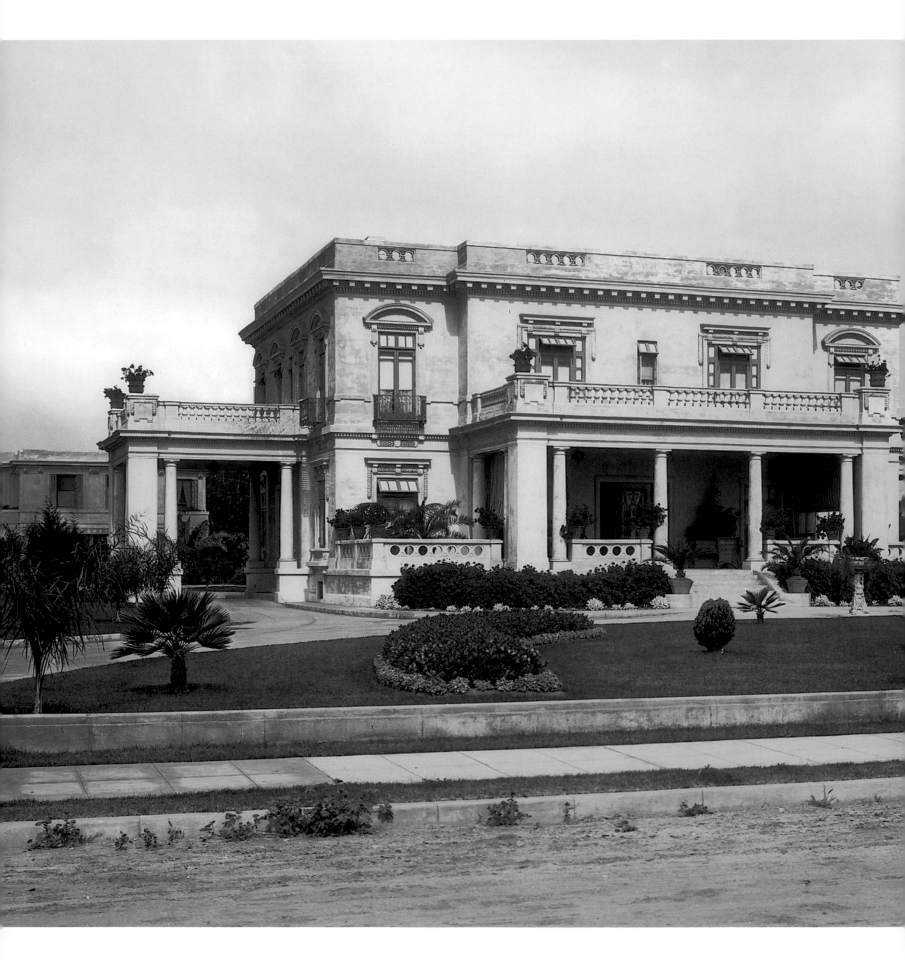

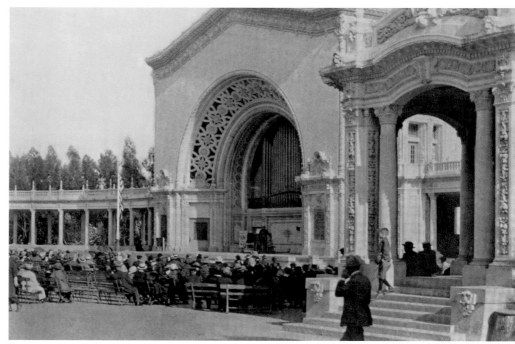

John and Adolph Spreckels underwrote the cost of a $100,000 open-air organ in San Diego's Balboa Park (above); it was first played on December 31, 1914, a few hours before the midnight opening of the Panama-California Exposition (which the brothers had generously supported). John Spreckels then paid the salary of Dr. Humphrey J. Stewart to play the organ daily, even long after the exposition closed.

In 1906, the John Spreckels family lived at the Hotel del Coronado while their mansion was being built on five acres of land overlooking Glorietta Bay. Architect Harrison Albright (who designed the Spreckels Theater) created an Italian Renaissance–style structure in concrete and reinforced steel—the result of Spreckels's experience with the San Francisco earthquake earlier that year. The six-bedroom, three-bath home cost a reported $35,000. After a 1905 storm severely damaged Coronado, including the Japanese Tea Garden at the north end of Ocean Boulevard, Spreckels built on his estate a new tea garden—"right out of an old picture book"—which proved popular for three decades. A dedicated music enthusiast, Spreckels added a music room to the mansion in 1913, and installed a forty-one-rank Aeolian organ,

which he played almost daily. He also added a third-floor solarium that enjoyed views of Glorietta Bay and the Hotel del Coronado.

After Spreckels's death, the mansion and grounds were sold in 1928 to newspaper magnate Ira C. Copley (see *The Golden Century*, page 87), who renamed the estate Dias Alegres, which means "Happy Days" (the same name as his yacht). Although Copley demolished the tea garden, he made few other changes.

In 1949, the mansion and its outbuildings were converted to a bed and breakfast, and additional guest rooms later were built on the grounds. In the 1970s, new owners modernized and restored the property. The once-magnificent organ room had been used for storage; it was restored and a baby grand piano was brought in. (The Spreckels organ had been removed; it was later restored, although its current location is unknown.)

The Adolph Spreckels mansion in San Francisco is now the residence of romance novelist Danielle Steele. John Spreckels's Coronado home is now the Glorietta Bay Inn. The image at left shows the mansion in its original form.

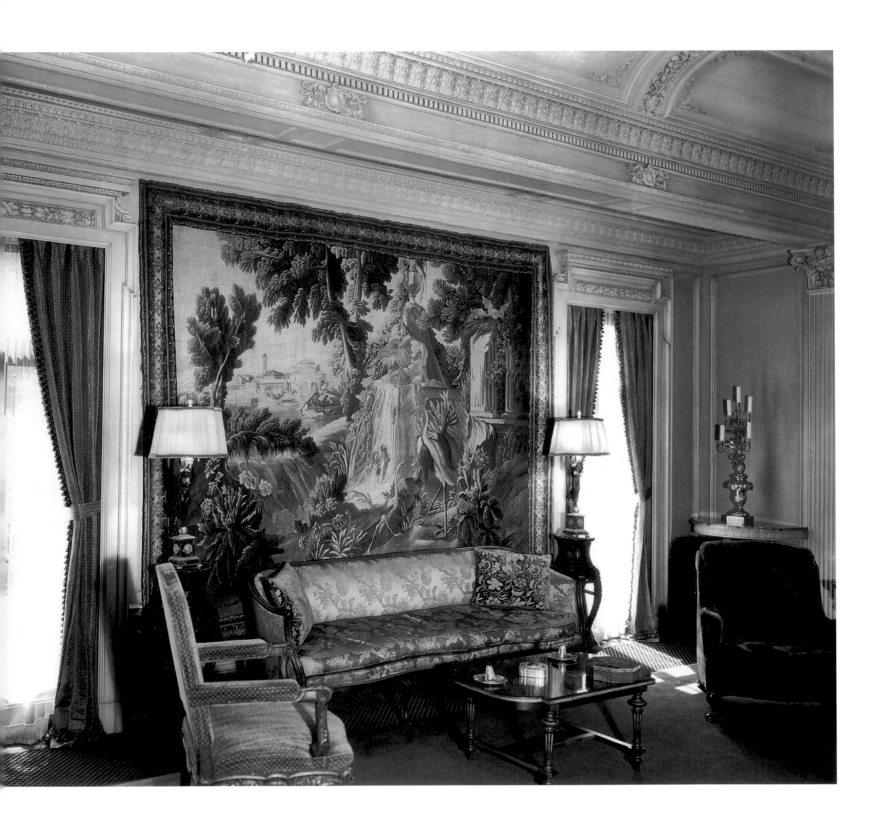

The images on these two pages and the one following,
taken in 1930, show the interior of the Spreckels Mansion
as it was during the ownership of the Copley family.

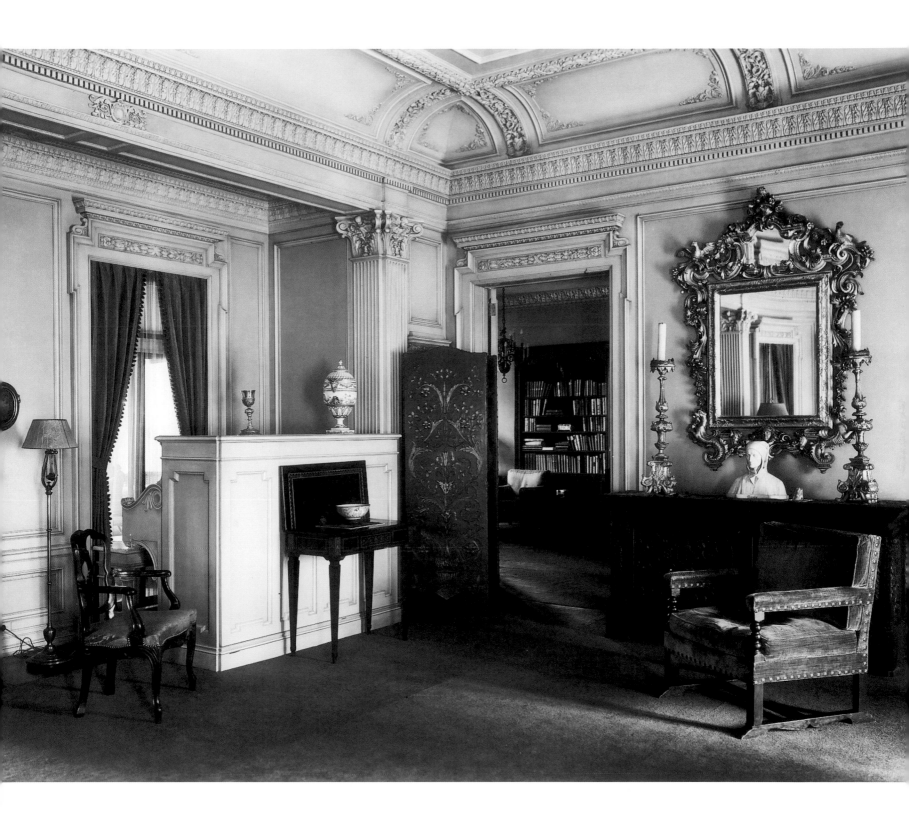

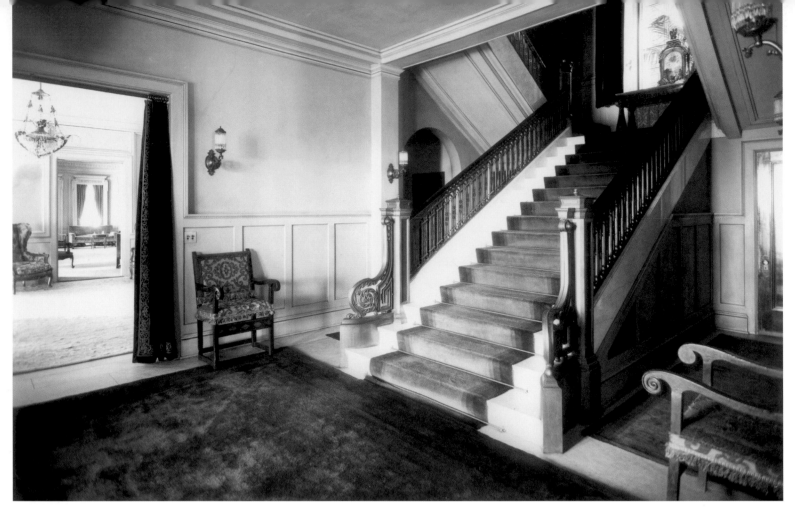

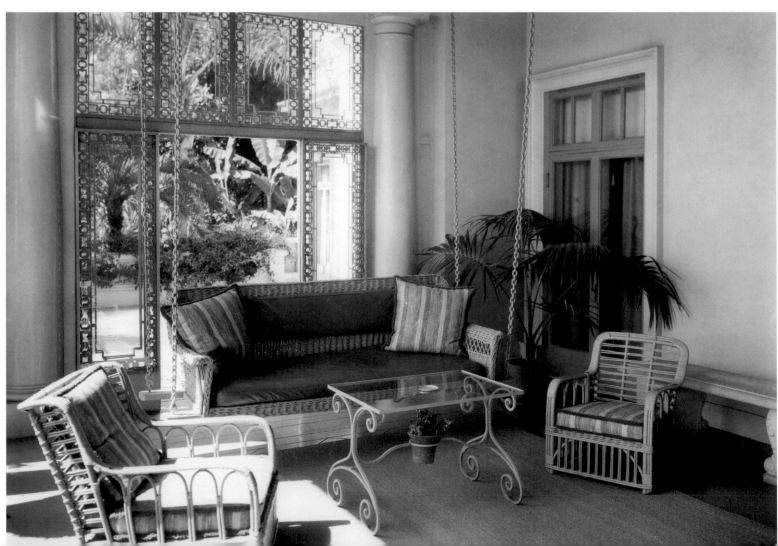

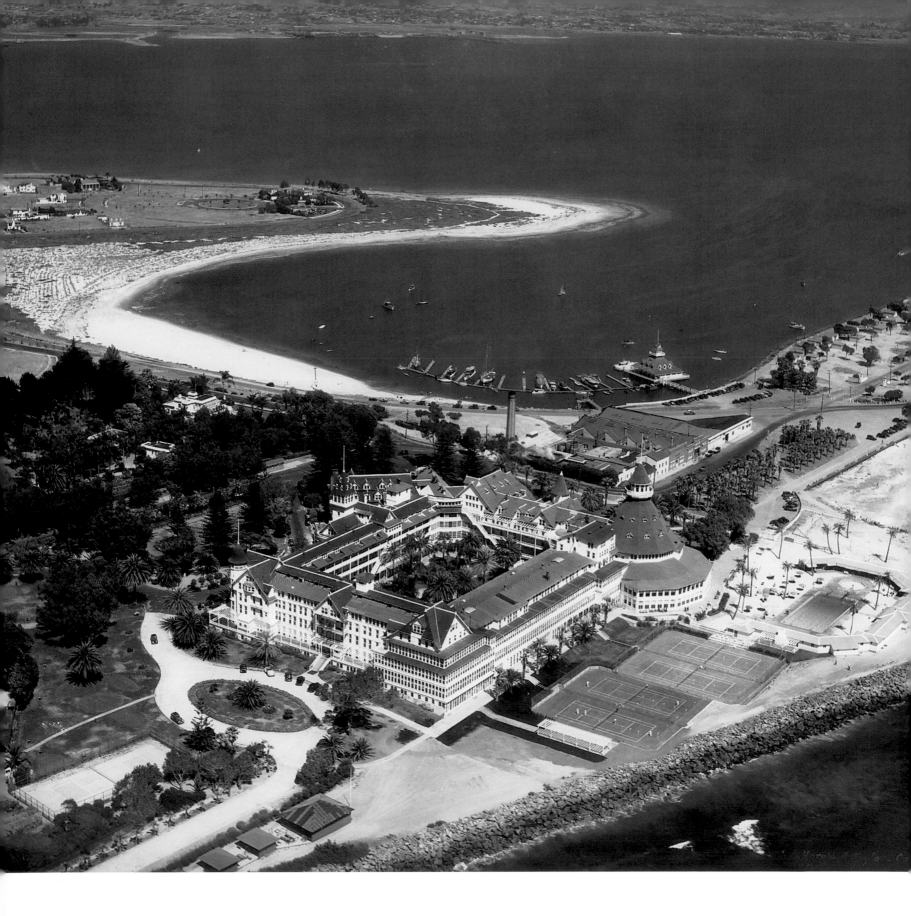

This 1926 image of Coronado clearly shows the Hotel del Coronado. Just above it, and to the left, is the Spreckels Mansion, surrounded by its expansive gardens.

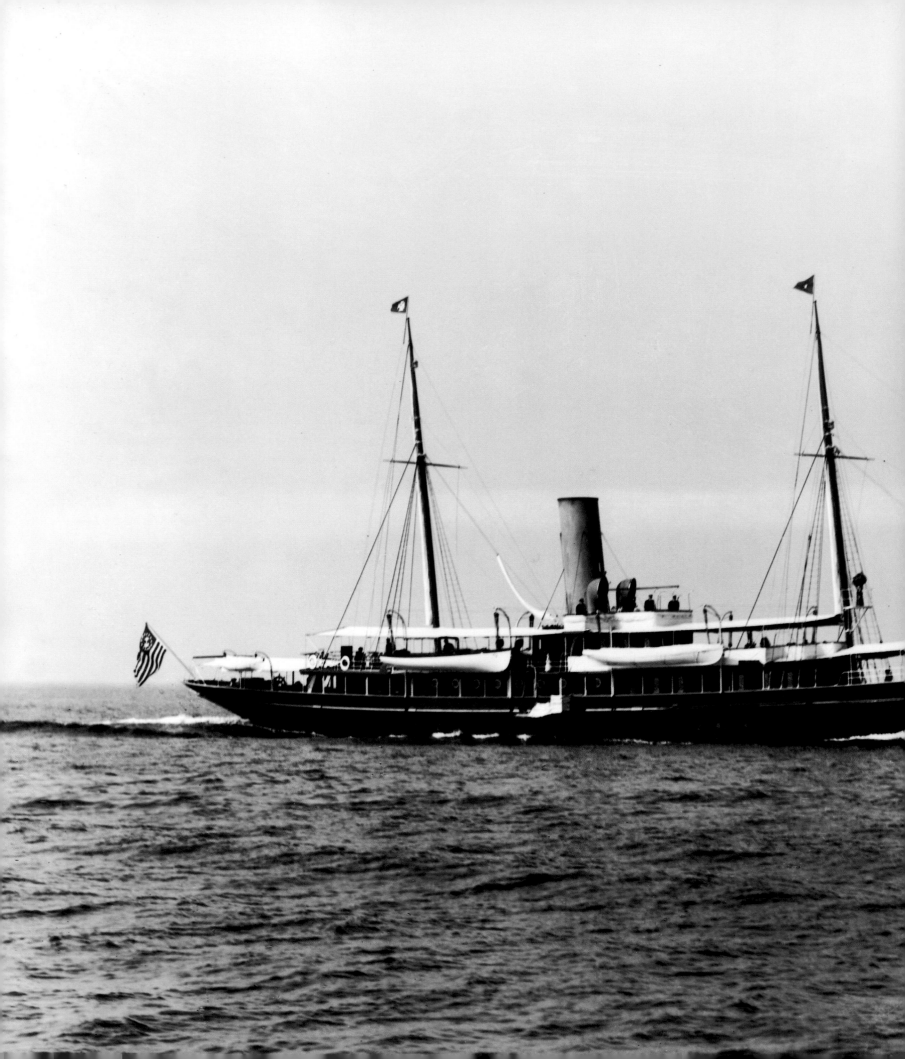

VENETIA

1903

For many years, John Spreckels enjoyed *Lurline*, an eighty-four-foot schooner he commissioned in 1883. She proved fast, reportedly won every race she entered, and was the flagship of the San Francisco Yacht Club during Spreckels's tenure as commodore. He later sold the yacht; she became a cargo vessel and sank after being over-loaded.

Spreckels purchased the 227-foot *Venetia* in 1911; he was fifty-eight. *Venetia* had been commissioned by F. W. Sykes and was previously owned by Morton F. Plant and Jesse Livermore (*The Golden Century*, pages 72 and 164, respectively), but she was most well known during her tenure under Spreckels from 1911 to 1927. He used her heavily, most often for trips between San Diego and San Francisco every few weeks, a voyage he found restorative. As biographer Austin Adams (who knew Spreckels for fifteen years and wrote an uncomfortably fawning book) wrote, "However weary or worried [Spreckels] might be on going aboard, he was another man when, two days later, he came ashore. The sea had washed his mind clean, refreshed his heart, restored to him the thrill and joyousness of life. And nowhere else as afloat could [he] indulge his craving for fun."

Venetia's captain was David V. Nicolini, who would work for Spreckels a total of twenty-two years. Of Italian descent, Nicolini was born in San Francisco and would have been twenty-eight when he accepted employment from Spreckels (presumably in 1904).

The U.S. Navy acquired the yacht in 1917 for use as a patrol craft, *SC-431*. She left California and traveled via the Panama Canal to Philadelphia, where she was refitted. On December 21, she steamed to Europe towing the *SC-67* and in tandem with another converted yacht, the former *Lyndonia* (towing the French *SC-173*). *Venetia* traveled to Bermuda, the Azores, Portugal, Gibraltar, and Tunisia (part of a twenty-eight-ship convoy, including *Agawa*, shown on the cover of *The Golden Century*).

Designed by Cox & King
Built by Hawthorne & Company, Ltd., Leith, Scotland
Triple-expansion Hawthorne steam engine
16" + 26" + 42" × 27" stroke cylinders
Two Scotch boilers, converted to oil in 1912

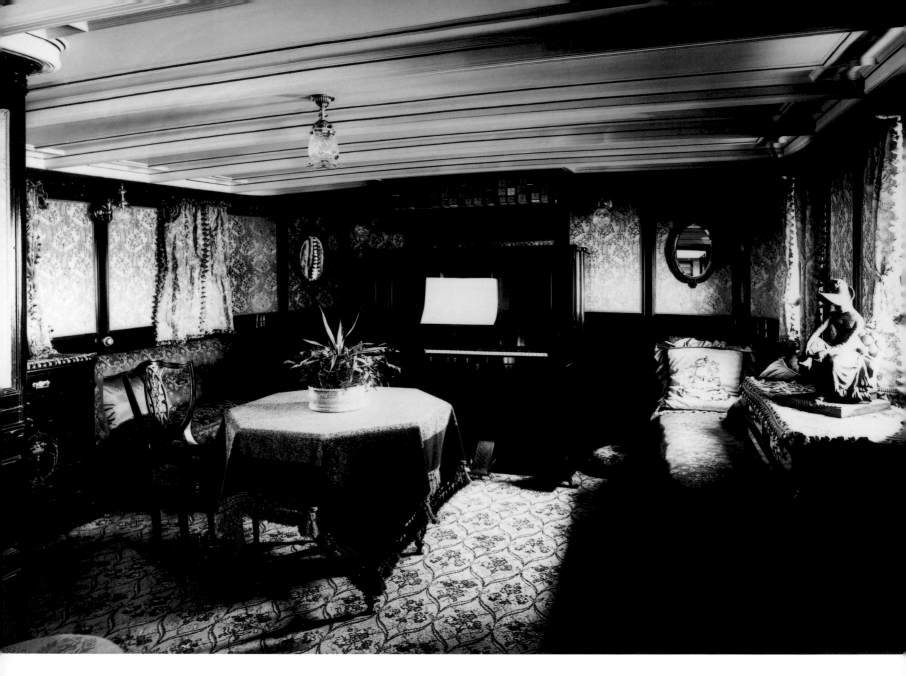

On May 11, 1918, a torpedo fired by the *U-52* streaked past the bow of *Venetia* and slammed into a French ship, the SS *Susette Fraisinette*, a mere hundred yards away; the vessel sank (thirty-four survivors were picked up by another French vessel). *Venetia* circled for hours on a lookout for the U-boat. Upon sighting her, she proceeded at full speed; the enemy vessel submerged. *Venetia* let loose a barrage of depth charges; subsequently she rejoined the convoy. The *U-52* was later destroyed by the HMS *H-4;* survivors reported that the *Venetia* had, in fact, driven the U-boat away from the convoy. Commander Porterfield of the *Venetia* received commendations for his actions.

On May 17, *Venetia* encountered the *U-39*, which had torpedoed three convoy vessels. *Venetia*'s depth charges missed their intended mark. On July 20, under a night sky, an unknown submarine torpedoed another convoy vessel, the British SS *Messi-dor*. After dropping depth charges, *Venetia* neared the stricken vessel and tried to arrange for her towing. This effort proved academic when the freighter sank in the morning.

Venetia later participated in three uneventful round-trip convoys. (There is a story of long standing—repeated by biographer Adams in his 1924 book, *The Man John D. Spreckels*, and *Venetia*'s crew—that she sank the *U-20*, which had torpedoed the Atlantic luxury liner *Lusitania*. This is a myth.) After the armistice, *Venetia* was brought back to California, refitted at the Mare Island Navy Yard, and returned to her owner—along with a refit bill for $242,000. *Venetia*'s chief engineer, William Neil Darroch (who was working on *Venetia* when she was purchased by Spreckels and stayed another sixteen years), complained that her hull, which had been as "smooth as glass" before the war, had been scaled by the U.S. Navy.

The interior images of *Venetia* (photographed by Charles Edwin Bolles) predate Spreckels's ownership; some were included in a 1907 *Yachting* article entitled, "Croesus and His Steam Yacht." Opposite we see the yacht's deckhouse, which was steel sheathed in teak. It contained a "social hall or music room" at its forward end. Note the rolls of music stored above the player piano.

Aft of the music saloon was *Venetia*'s dining saloon (below), an impressive compartment graced with a large painted-glass skylight; it could seat twenty-five.

In 1921, *Venetia* again went to the rescue when she towed the ferryboat *Ramona* to safety after the Coronado ferry landing caught fire at four in the morning.

In early 1926, Darroch was worried about his employer's "mental condition," which did not permit visitors. In a series of letters to naval architect Theodore Wells (now at the South Street Seaport library), Darroch conveyed his anxiety about *Venetia* and her future. Spreckels (who would die that July) was clearly unwell, and Darroch expressed appreciation for his employer. Spreckels "has trusted me completely" and paid "me well for my service." Darroch admired Spreckels's abilities as a machinist and his intimate knowledge of engines—high praise from an engineer. "I have never been able to slip [anything] over on the Boss."

After Spreckels's death, the 227-foot *Venetia* was purchased by James Playfair (for a reported $60,000—the cost of a new sixty-foot yacht), with a homeport in Canadian waters. Playfair, a lumber baron, sold *Venetia* in 1939 to Robert Scott Misener, who owned the yacht until she was scrapped in 1963. She was listed in *Lloyd's* until 1968, and her partial remains were extant until the early 1990s. Paul Gockel, who has extensively researched *Venetia*, reports that much of her hull was intact below the waterline, with rusty ribs above. Her remaining plates "showed no signs of deterioration." Unusually, the name of the yacht was never changed during her long life.

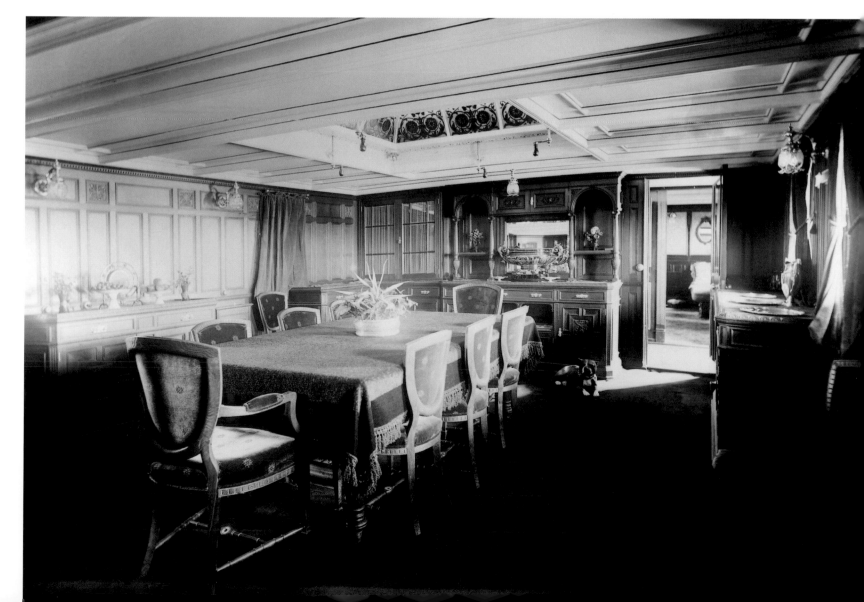

These images of *Venetia* were taken by Charles Edwin Bolles (1847–1914), who was born in Philadelphia. From an early age, he showed a "great liking" for artistic photography, and in his mid-twenties he moved to Brooklyn and opened a studio at the corner of Fulton and Clark Streets. While becoming known for his excellence as a portraitist (Mark Twain felt that his Bolles portrait was the best taken of him), Bolles was fascinated by nautical subjects, and eventually he devoted himself to marine photography. He was "remarkable for getting the picturesque effects of battered old vessels as well as the most costly and well-appointed yachts." This passion spurred the closure of the Brooklyn studio; he pursued yachts instead, and he would be found at local and international races, annual New York Yacht Club regattas, and aboard grand yachts (finding "ready sales" of his photos to their wealthy owners). Around 1907, a stomach ailment forced Bolles to abandon his marine interests (and its often-inclement weather in heavy seas) and focus on real estate. He moved to Flatbush, New York, and developed significant areas of the community and of the King's Highway section; at the time of his death, he was a major property owner. A music lover, Bolles and his wife, Mary (the couple had a daughter, Marion Preston Bolles), regularly attended concerts and opera performances. Additional interests included collecting antiques, silver, paintings, and books. Bolles's stomach problems caused his death in 1914, at the age of sixty-seven. Many of his negatives (1,174) were acquired by Morris Rosenfeld, another leading marine photographer, who had once done darkroom work for Bolles. These negatives are now part of the Rosenfeld Collection at Mystic Seaport.

This saloon—also featuring an ample painted-glass skylight—was located in *Venetia*'s deckhouse, although its precise location is unknown.

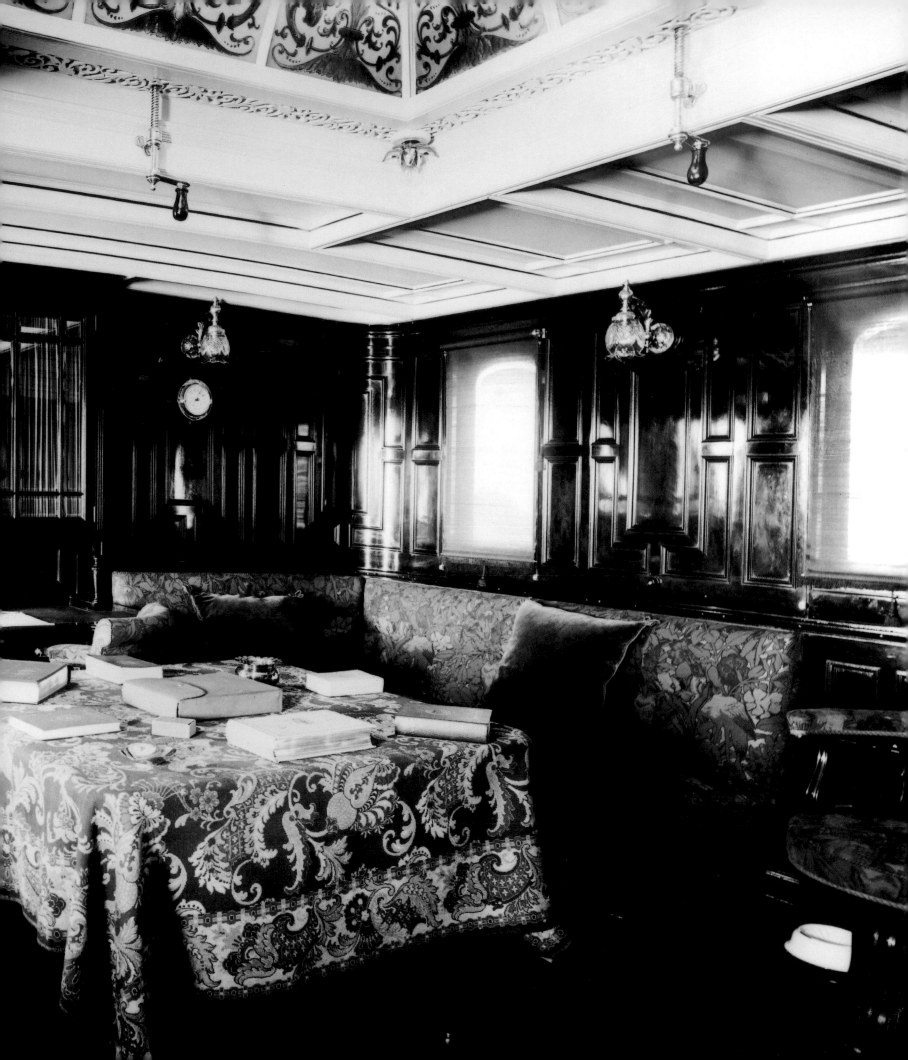

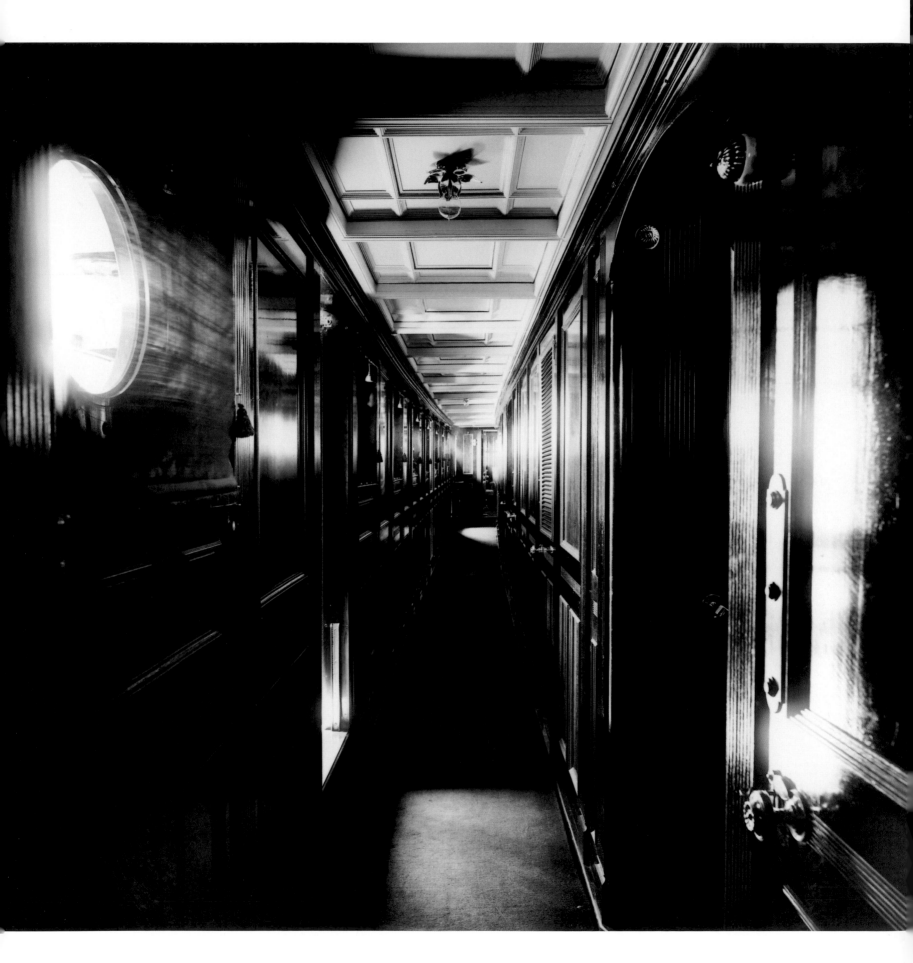

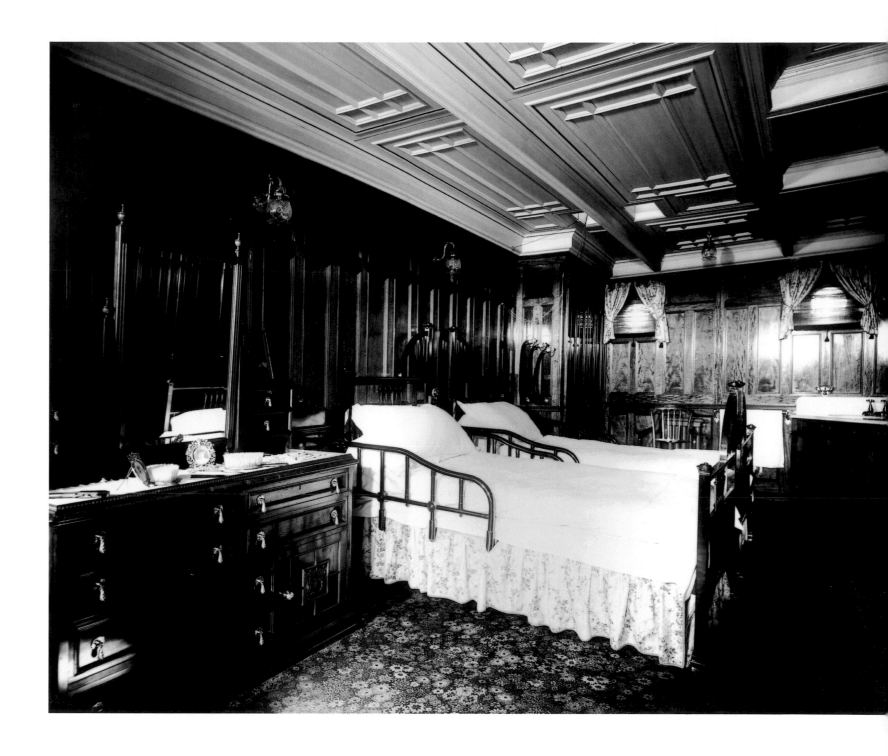

Venetia's main companionway (opposite), located in the deckhouse, must have offered a thrilling spatial experience, the rich joinerwork and extreme dimensions creating an intimate, unique composition.

Above, *Venetia* had ten staterooms finished in sycamore, bird's-eye maple, and butternut, each adjoined a head (with salt- and fresh-water taps). Also located below deck was the main saloon, a cabin occupying the yacht's full width (twenty-seven feet). *The Rudder* proclaimed it "the show apartment" and a "marvel of the joiner's and upholsterer's art." Unfortunately, it was not photographed.

ALFRED I. DU PONT

Born into a famed family dynasty, Alfred I. du Pont (1864–1935) accumulated a fortune in industry, finance, publishing, and banking; he then worked with his third wife, Jessie, to donate an impressive portion of this fortune for "the benefit of society."

Du Pont was part of a multi-generational saga of heroic and epic proportions. His great-great-grandfather, Pierre Samuel du Pont (1739–1817), was the son of a Parisian watchmaker who rose to fame and extraordinary political influence, narrowly avoiding the guillotine during the French Revolution and later advising President Thomas Jefferson. (It was Pierre who suggested that Jefferson obtain the Louisiana territories through purchase, not war.)

His neck thus saved, Pierre realized that due to continued instability in France, a move across the Atlantic would be prudent. He convinced his extended family that creating a utopian community based on agriculture, and with joint ownership of land and buildings, had great merit. After a harrowing voyage on a decrepit vessel, the transplants arrived in the newly born United States and set to work trying to realize numerous grand financial schemes. As the *process* of trying to implement each scheme proved harder than the *vision*, the underfunded utopian ideals were soon put aside when financial disaster loomed.

It was the overlooked second son of Pierre who would become the family's savior. Eleuthère Irénée (1771–1834) had an idea quite different from the grand, far-reaching visions of his father and older brother, and in his quiet, diffident way, he brought his small dream to reality—the making of gunpowder. The firm he established grew into an industrial giant known across the world. This enabled many of Pierre's dormant utopian ideals to become reality, although in modified form; the extended family prospered around the du Pont factories at the edge of Wilmington, Delaware, and lived with land and buildings under collective ownership.

Eleuthère's first-born son, Alfred Victor, later had a first son, Eleuthère Irénée du Pont II. Eleuthère II was quiet and unassuming, like his grandfather, and surprised the family when he announced his marriage to Charlotte Shepard Henderson, a well-traveled, sophisticated beauty. The couple had five children, Alfred I. being the first son. Yet the marriage would not prove happy. The historical record remains unclear, but the vivacious Charlotte may have felt smothered by the intense small-town atmosphere of the du Pont compound and its inevitable rivalries, long-held grudges, and lack of privacy. She had also suffered a traumatic postpartum depression after the birth of her first child, and she was sent away for an extended period of recuperation. During the Civil War, the ardently pro-Union du Ponts grew suspicious of the Southern-born Charlotte, while Charlotte must have suffered greatly at the thought of du Pont gunpowder killing her Southern relatives and acquaintances (the du Ponts refused to sell to the "rebels"). At one point, Charlotte was even committed to an asylum. As the years passed, she traveled extensively, spending less and less time with her husband and children. Finally, in 1877, after a dramatic hysterical episode, Charlotte was again committed; she died a week later at the age of forty-one. Her husband, already mortally ill from tuberculosis, died four weeks later at the age of forty-nine. Alfred was thirteen.

The five orphaned siblings, fearful of being separated and evicted from their home, Swamp Hall (owned collectively), marshaled a resistance. The extended family, astonished by this protest, amended the plans and allowed the children (the oldest was seventeen) to remain in Swamp Hall, although Alfred was sent to Shinn Academy in New Jersey, which emphasized Bible studies, not the science in which Alfred had already shown a keen interest. Two years later, Alfred transferred to Phillips Academy at Andover (Massachusetts) and later to the Massachusetts Institute of Technology (MIT), where he roomed with a cousin, T. Coleman du Pont. Coleman convinced Alfred of the futility of getting a degree (since guaranteed jobs awaited them), and Alfred chose only the subjects that he felt would have a direct bearing on his foremost desire: to succeed his illustrious forebears in the making of black powder.

After leaving MIT in 1887, Alfred spent almost two years learning every aspect of the family business, including working in hazardous areas where even the smallest of sparks could ignite a disastrous conflagration. Upon completing this training—unscathed—Alfred was given a $1,500 annual salary and a $100,000 share of his father's estate (his siblings received equal

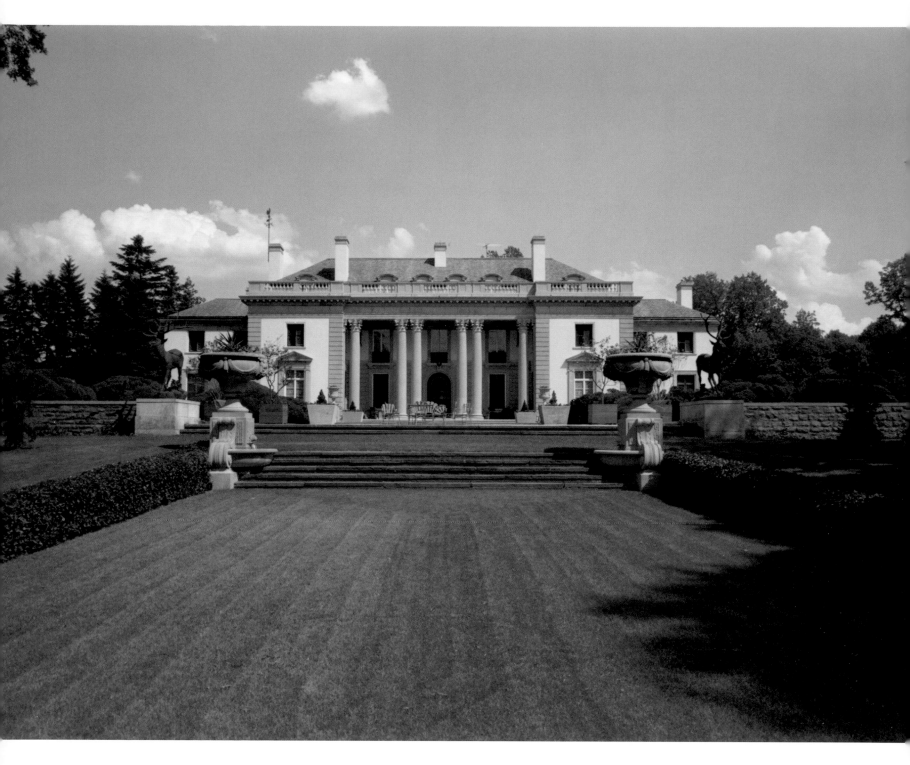

After Alfred du Pont married his second wife, Alicia Bradford Maddox, the couple embarked on a massive undertaking: a sprawling, 300-acre estate, Nemours, in Wilmington, Delaware. The name of the estate came from the French town that Alfred's great-great-grandfather had represented as an Estates-General member in 1789. The modified Louis XVI–style mansion was designed by the noted architectural firm of Carrère and Hastings (the New York Public Library is perhaps their best-known building) and built in 1909–10 with granite walls quarried on the estate. The scale of the mansion and its severely formal French design was in marked contrast to Alfred du Pont's modest former home, Swamp Hall. The extended du Pont family had lived for several generations in the immediate area in equally modest homes; Nemours, with its 47,000 square feet and 102 rooms, must have seemed overwhelming—and intimidating. Alfred and Alicia moved into their new palace and studiously avoided the neighboring du Ponts, rarely extending invitations. This dynamic would change after Alfred's third marriage, to Jessie Ball. The doors and grounds of Nemours were opened and many du Pont relatives, for the first time, were able to enjoy the elaborate, meticulous gardens and imposing rooms of the mansion.

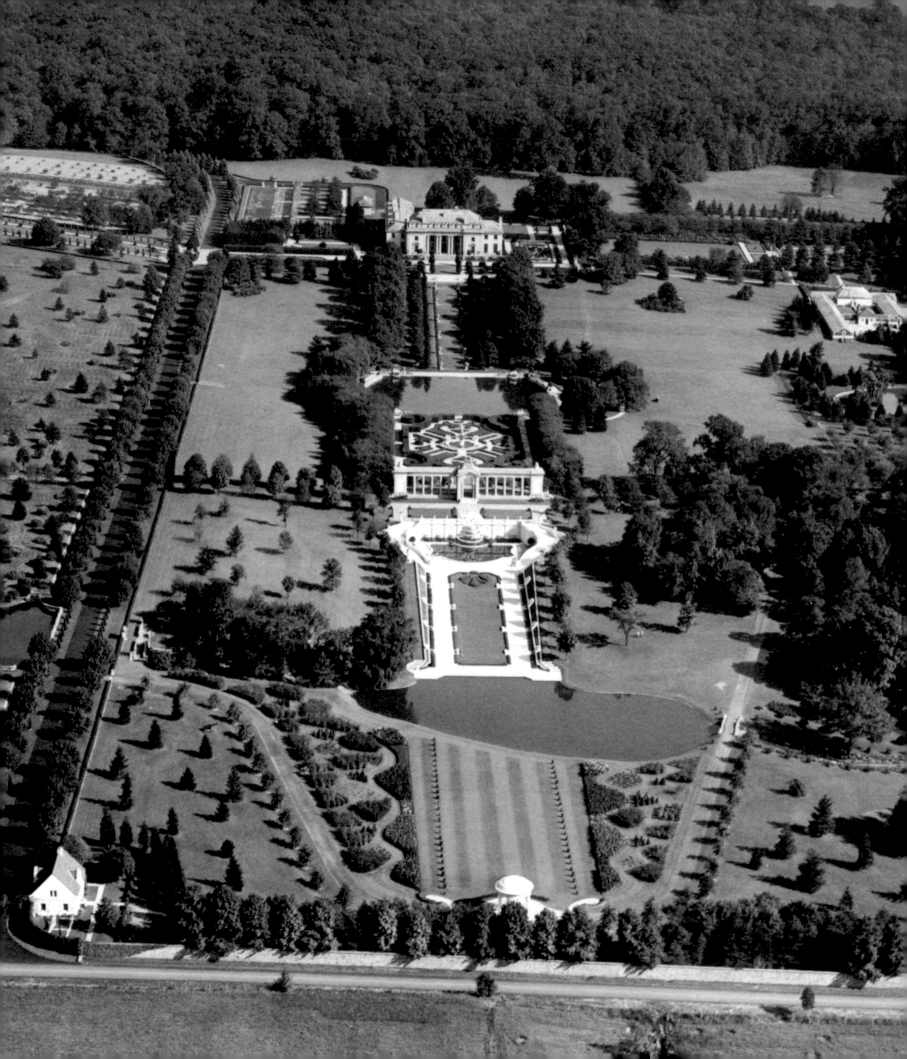

The lavish gardens of Nemour.

amounts). When his great-uncle, General Henry du Pont, died in 1889, Alfred assumed that one of the general's sons would succeed as head of the company, but conflict between the brothers resulted in the compromise choice of the general's nephew, Eugene du Pont. Alfred, his anticipated percentage of the company's shares not forthcoming, found himself pushed aside. He protested—loudly—and was granted a limited partnership role. The family was upset by such demands and proceeded to ignore the young man. Thus, for thirteen years, Alfred muffled his ideas and watched, helplessly, as the du Pont business declined and lost market share to competitors. During a later reorganization, Alfred was pointedly not given a seat on the company board.

Eugene died in 1902, and the family elders decided to sell the business for $12 million. Alfred thought this amount too low and, moreover, he felt that the company should remain firmly under du Pont control. He presented his plan to the astounded family, who, after much deliberation, agreed. A condition of their consent was that two cousins would be brought in, T. Coleman du Pont and Pierre S. du Pont, the former to be president. Alfred, friends with the two relatives (Coleman, as mentioned, had been his college roommate), readily agreed. Coleman proposed a plan whereby the three cousins would take control of the reorganized company for an inconsequential cash layout (either $2,100 in legal fees or $700—reports differ), and the elders would receive 28 percent of the new company's shares, with an additional $12 million in thirty-year bonds.

Alfred's long-dormant energies were now freed; he moved ahead with plans to reinvigorate the stagnant business. He instituted assembly-line procedures, reorganized mills, replaced aging and outmoded equipment, renovated the workers' housing (which had remained unchanged for a century), and installed his own inventions to increase efficiency and reduce accidents, the most significant being a device that diminished the chance of accidental explosions. Alfred, extremely well liked by the employees, was now the only high-ranking company official who worked directly in the factories and intimately knew the workers.

The company entered into an era of extraordinary growth, too much so. The U.S. government later filed suit, claiming that the du Ponts had created a near-monopoly. When the government won the suit in 1912, the cousins were ordered to spin off several plants. These events strained the relationship among the three du Ponts, a situation that had been exacerbated by Alfred's difficult personal life.

In 1887, Alfred had married a cousin, the former Bessie Cazenove Gardner, and the couple had four children; the marriage was marked by the couple's different temperaments. Bessie loved entertaining while Alfred disliked being social (a by-product of his increasing deafness, the result of a childhood accident). Bessie treated Alfred with cold disdain for long periods, and then, for reasons never explained, would warmly re-embrace her confused husband; such latter moments produced a son, Alfred Victor, eleven years after his sister was born. After the elder Alfred was injured in a hunting accident (he eventually lost an eye), he filed for divorce in 1906—causing a scandal among the extended du Pont family. He compounded his family troubles significantly with two additional developments.

First, he married a divorced woman, the former Alicia Bradford Maddox, in 1907. The second was his inexplicable treatment of his former wife and children. Like a man possessed, Alfred began a bizarre vendetta. He gave Bessie $24,000 annually to support their home (Swamp Hall) and children, a not-inconsiderable sum for the era, although he himself was worth millions (he stated that Bessie's support was more than they had spent while married, a statement that reflected their humble lifestyle and modest home). Then, for reasons never explained, he ceased all direct contact with his three youngest children; only his oldest daughter, Madeleine (who had turned against her mother), was welcomed into Alfred's new home. He tried to change the name of his son, Alfred, without his knowledge and consent (offering the surreal reason that he feared his son would "bring disgrace" to the family name—a notable example of what psychiatrists call projection). And, after giving his former family a week's notice, he razed Swamp Hall, the house where he had been born. (Biographers have offered little in the way of explanation for this destructive behavior so at odds with the way Alfred led his life. One wonders about the effects of the hunting accident that cost

103

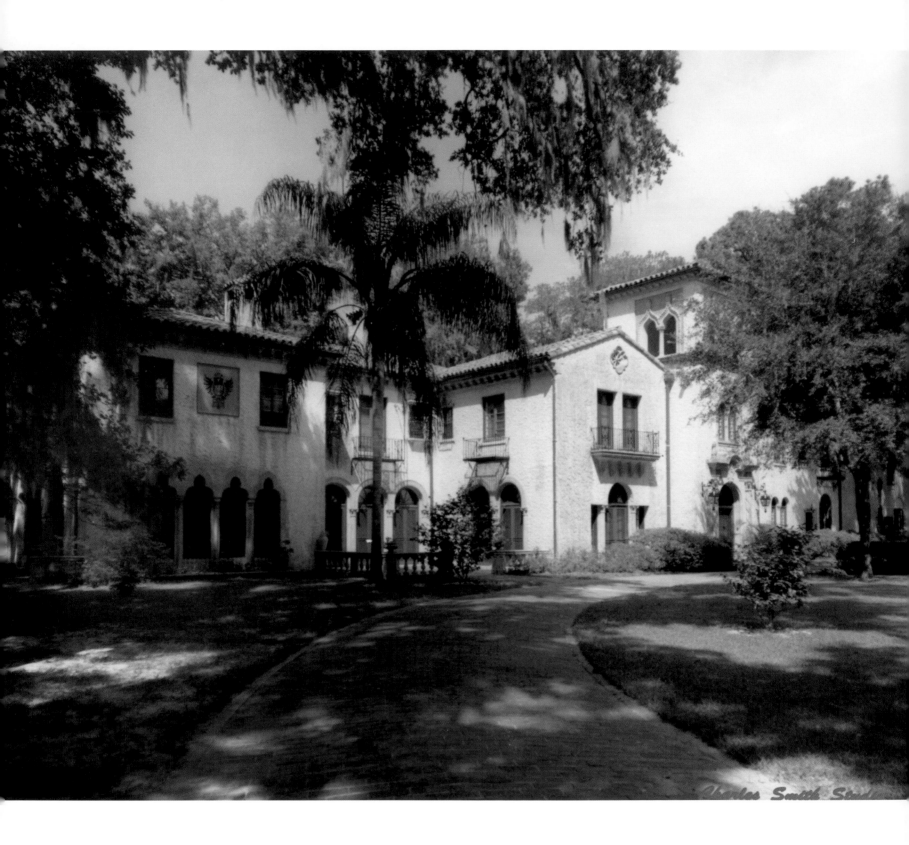

After Jessie Ball and Alfred du Pont married, they built a winter residence, Epping Forest (named after ancestral Ball homes), on the Saint Johns River, in Jacksonville, Florida. Designed in the Spanish-Mediterranean style by Harold Saxelby of Marsh Saxelby, the house and its extended grounds were developed in 1926–27. A distinctive feature of the estate was its abundance of massive live oaks and hickory trees, all evocatively draped with Spanish moss. This image details the main facade of Epping Forest.

him an eye. Could the gunshot wound have affected his brain, his reasoning?)

While this sad drama was being played out, Alfred and Alicia became increasingly aware of just how brutal their ostracized status was; this was compounded by Alfred's horrific vendetta (the extended du Pont family took sympathy on Bessie; Pierre du Pont even built her a fine home). In another strange turn of events, the newlyweds built a stunning contrast to Swamp Hall: a palatial, 300-acre estate with elaborate French-style gardens, which they named Nemours; the 102-room main house was patterned after the Petit Trianon at the Palace of Versailles. Surrounding the estate were high walls topped, reportedly, with shards of broken glass; few du Ponts were ever invited. Yet, the magnificent new home belied the nature of its occupants. Alfred and Alicia had entered their marriage for vastly different emotional reasons. Alfred loved Alicia, but Alicia had made it clear from the beginning that she did not return his love. So, while there were moments of happiness, the couple was largely estranged (Alfred even built Alicia her own home on Long Island, New York—White Eagle, a $1,102,000 "retreat"). It could not have helped matters when two children died shortly after birth.

Alfred's troubles increased in 1914 when Coleman du Pont decided to leave the company. After a series of events, Alfred filed suit against Pierre du Pont, who had secretly purchased many of Coleman's shares—making him the largest stockholder and unquestioned head of the company—and formed a syndicate to purchase the remaining shares. When Pierre learned that Alfred had filed suit, he tested his new power by having Alfred dismissed from the board. The trial—"one of the most acrimonious court cases in American industrial history"—was a Pyrrhic victory for Alfred. The court ruled, quite emphatically, that Pierre had acted in bad faith, but Coleman's stocks (ordered sold by the court) were purchased by a majority controlled by Pierre. Alfred was "evicted" from the company his family had founded. He was now fifty, having spent his adult life being largely ignored by his tightly knit family.

In what can only be described as a retaliatory move, Alfred shifted his attentions to becoming a newspaper publisher (eventually controlling ten newspapers in Delaware). He used this platform to pull the rug out from Coleman du Pont's presidential bid and to cause the defeat of his father's cousin, Colonel Henry Algernon du Pont, in a race for a third Senate term. Less self-serving accomplishments included promoting changes that affected Delaware residents, such as a graduated income and inheritance tax and significantly reduced property taxes. Alfred himself declined to run for office, although his publishing position had made him the state's most powerful political figure.

In 1920, Alicia died, and Alfred suddenly withdrew from public life, finding himself teetering at the edge of bankruptcy after a business deal gone impressively sour. Against all advice, Alfred refused to avail himself of this legal remedy. He sold off assets (including a large portion of du Pont stock) and reduced his expenses. In 1921, while immersed in this period of retrenchment and consolidation, Alfred married Jessie Dew Ball (1884–1970), a woman with whom he had corresponded for two decades; he was fifty-seven and she was thirty-eight. Ball had been born into a genteel Virginia family financially devastated by the Civil War. She attended Longwood College and assisted her father in his law practice before joining the family when they moved to San Diego, California, in 1908; she was twenty-four. Becoming the assistant principal at an elementary school, she helped support her parents. In 1920, she renewed an old acquaintance with Alfred, whom she had met on a hunting trip during her teenage years.

Jessie helped Alfred reestablish contact with three of his children (whom he had not seen in fifteen years). She also suggested that the couple start a new life in Florida. After the state's devastating 1926 hurricane, they settled in Jacksonville and built Epping Forest, a Spanish Revival mansion (although nowhere near the scale of Nemours). Alfred also purchased 1.5 million acres of pineland and acquired control of the Florida National Bank in Jacksonville. During a run on the bank in 1929, he averted a crisis by depositing $15 million of his own funds; he later opened six more branches throughout the state.

In the late 1920s, Alfred became increasingly concerned about

the welfare of children and the elderly—people, he felt, who could often be disastrously impacted by circumstances beyond their control. To this end, he worked with Laura Walls (a teacher who had written Alfred a first-hand account detailing the plight of the elderly) in targeting those in need of assistance. When the Delaware government dragged its heels in implementing a state pension plan, he funded his own program; Laura Walls became its director. This generous act was something Alfred could well afford. After narrowly averting bankruptcy just a decade earlier, his shares of du Pont stock had risen to a value of $150 million (although this would drop by two-thirds after the 1929 stock-market crash).

In addition to his fortune being re-secured, the turmoil Alfred had known for so many decades slowly eased as Jessie helped guide him into a life focused on the future instead of his painful past. While Alfred still felt at home at Nemours, Jessie preferred her own creation, Epping Forest. Nonetheless, she filled both mansions with a never-ending parade of guests; Nemours, so forbidding under the tenure of Alicia du Pont, was transformed into a glittering and gay home.

As he turned seventy, Alfred was busier than ever. He was stimulated by his desire to help his adopted state of Florida rebuild its economy after the 1926 hurricane and the Great Depression; his desire to open banks and develop the commer-

cial aspects of his pine forests were means to this end. He also enjoyed leisurely cruises aboard his yacht, *Nenemoosha*, down the Chesapeake and on the inland waters of Florida.

It is a tribute to Alfred that, at an age when most people would quietly retire, he and Jessie developed a new life positively impacting many thousands of people. Thus energized, and in apparently robust health, Alfred sparked profound shock when he died suddenly in 1935, at seventy-one. "It is my firm conviction throughout life that it is the duty of everyone [in] the world to do what is within [their] power to alleviate human suffering," as Alfred wrote in his will, thus establishing the Nemours Foundation. Jessie was entrusted with the income from the foundation during her lifetime, and she donated $70 million before her death in 1970. Today, dozens of charitable institutions exist as a result of Alfred and Jessie du Pont, including the Nemours Foundation (which includes the Alfred I. du Pont Hospital for Children, Wilmington, Delaware, with three additional facilities in Wilmington); the Nemours Children's Clinic (with four locations in Florida); and the Jessie Ball du Pont Religious, Charitable and Educational Fund in Jacksonville. (Jessie's brother, Edward Ball, was an original trustee of the Nemours Foundation and devoted his remaining life to building its assets. Upon his death in 1981, the bulk of his $75 million estate was left to the foundation.)

It is difficult for a researcher, when detailing the lives of people, to learn about their emotional health and psychological status. Alfred du Pont reported that his childhood was a happy one, with a (then) close-knit family living along a beautiful river and enjoying plenty of friends. This may not be a wholly accurate memory. One cannot help but wonder about the hidden scars of his childhood—the events, spread out over many years, that preceded the institutionalization of his mother, and the early death of both parents—which must have affected his adult self and may be assumed to have contributed to the painful conflicts with his extended family later in life. Yet it appears that du Pont found some healing with his third wife, Jessie (they were reportedly happy), and their new life in Florida was far removed from the kind of family dynamics so very much in place in Delaware.

Opposite top, Alfred du Pont and his daughter Victorine (from his first marriage) relaxing on a terrace at Epping Forest.

Opposite bottom, a long pier and boathouse extended from the grounds of Epping Forest and into the Saint Johns River.

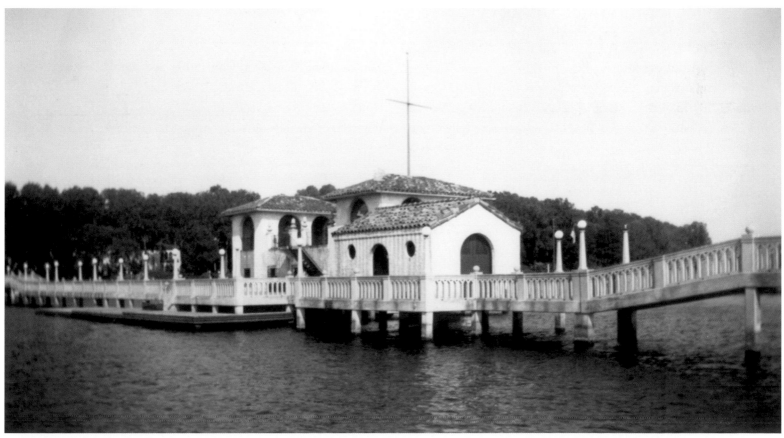

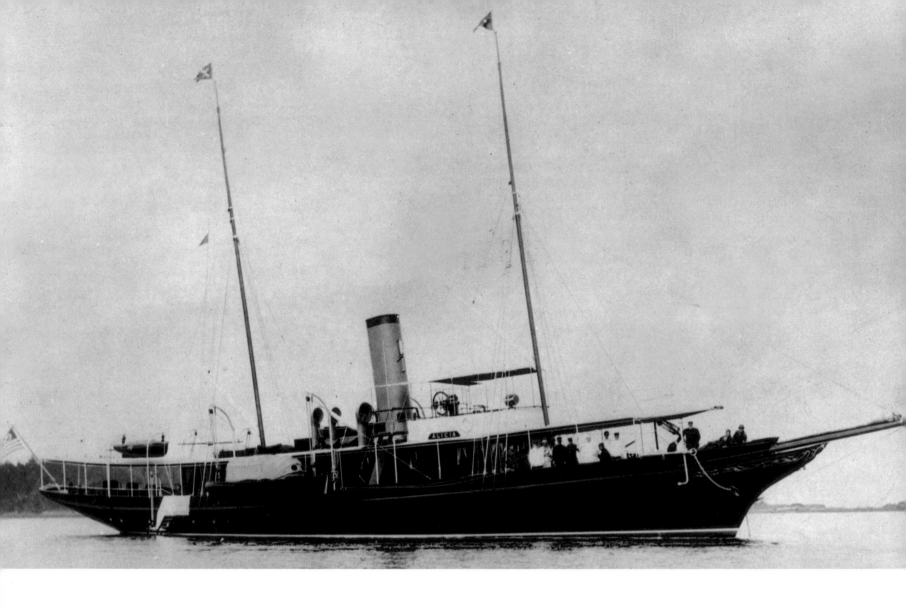

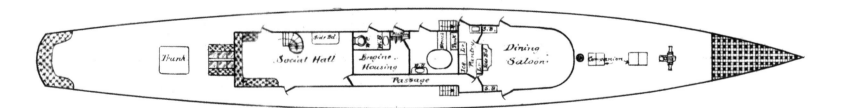

File No. 493.

Henry J. Gielow,
Engineer and Naval Architect.
30 Broadway, New York, N.Y.

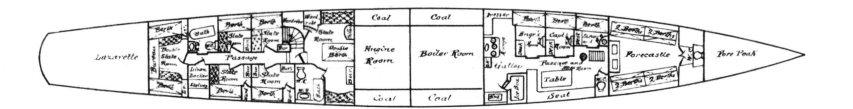

ALICIA

In 1910, while married to his second wife, Alfred du Pont purchased his first yacht, a Gardner & Cox–designed steam vessel, which had been launched as *Coranto* in 1902; he renamed the vessel *Alicia*, after his wife. *Coranto* was commissioned by Arthur E. Austin of Providence, Rhode Island, and built by Consolidated (*The Golden Century*, page 88). The 155-foot vessel was typical for the era, featuring a single teak deckhouse sixty-eight feet in length. With graceful overhangs and a single sweep of sheer, her "appearance in no way suffers."

A 1911 letter from Schenck & Schenck, insurance agents and brokers for *Alicia*, closes with the following sentence—a reminder that, today, we communicate with less deference: "We respectfully solicit your patronage and assuring you every effort will be put forth on our part to credit its continuance."

In 1916, the U.S. Navy requested that *Alicia* be presented for inspection at Philadelphia for consideration as a harbor entrance patrol vessel (it is not known if this was at the suggestion of du Pont or the demand of the navy). If accepted, she would have three guns mounted on her deck; Alfred complained that such guns would interfere with her use as a pleasure craft, as she was apparently to be used until being called for duty.

Before beginning the 1920 season, Captain Peder Songdahl prepared an estimated monthly expense report. *Alicia's* fourteen-man crew would cost $2,295 in wages; ninety tons of coal came to $900; crew provisions (at about $2 a day per man!) were $1,1021; and miscellaneous items such as fuel, water, and ice were another $125—a monthly total of $4,340. The expense associated with fitting-out the yacht was another $13,150.

Supporting an old adage—"penny-wise and pound-foolish"— Alfred wondered whether the mattresses could simply be re-covered instead of being replaced (as the captain apparently suggested), as they were of "the very best obtainable" materials. When Songdahl only received one bid (for $1,150) to replace the awnings, du Pont questioned this but added, "It may be that you are absolutely satisfied that this cannot be bettered." Was this a gracious assurance, or a subtle order? (This bid was significantly less than it had been in 1917, when du Pont received an estimate for *Alicia's* awnings to be replaced—an impressive twenty-six separate pieces totaling $1,640.) Instead of ordering a new fan for his cabin, Alfred suggested relocating one from another cabin, as it was "practically never used." A year later, in an apparent desire to order teak (for the rail, waterways, and quarterdeck), Alfred wondered whether, because teak prices had dropped in a fifteen-month period from 65 cents to 45 cents, they could obtain a better price. When Alfred sold *Alicia*, he sent her glassware and porcelain (including thirty finger bowls) to Tiffany & Company to have the name *Alicia* removed and replaced with the name of his new yacht, *Nenemoosha*.

Designed by Gardner & Cox
Built by Gas Engine & Power Company and
Charles L. Seabury & Company, Consolidated
Seabury triple-expansion steam engine
11" + 16½" + 26" × 15" stroke cylinders
Seabury water tube boiler

Above, the namesake of *Alicia,* Alicia Bradford Maddox du Pont

Opposite bottom, the plans for *Alicia* (ex. *Coranto*).

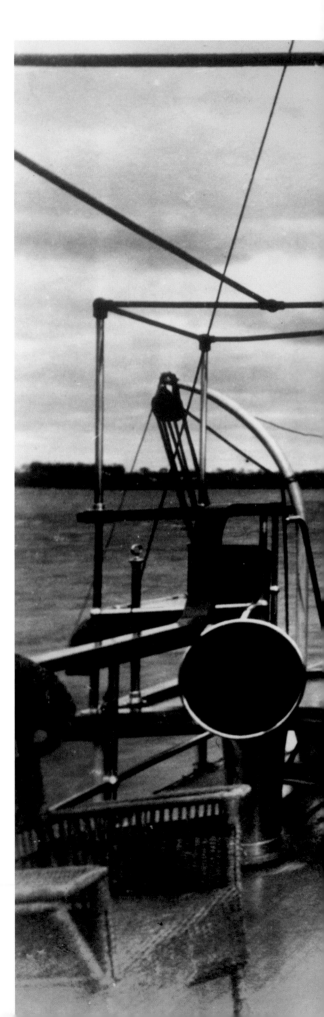

These undated images (above and right) show *Alicia* undergoing repairs. *Alicia*'s open-air bridge deck (right) was typical for the era (its canvas overhead is rolled), offering minimal protection from the elements. Forward, a sundeck atop the deckhouse was "fitted up with lounging chairs and settees" of wicker.

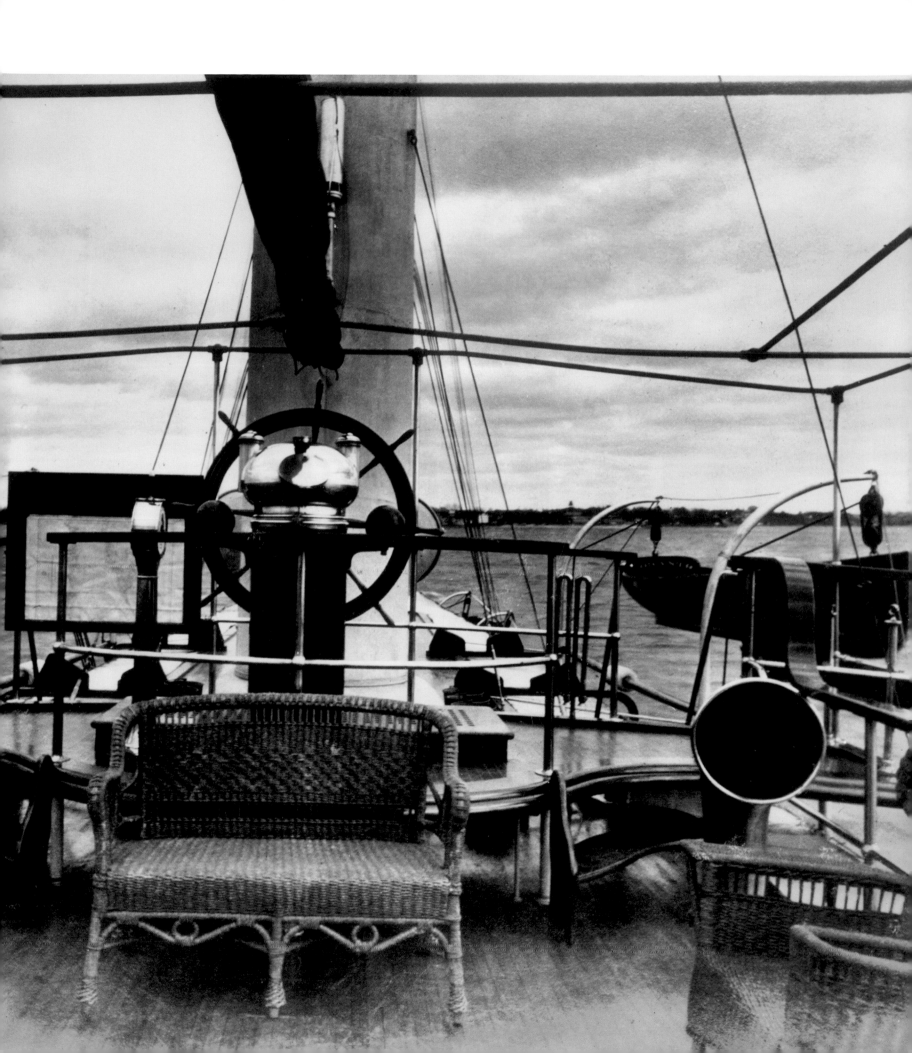

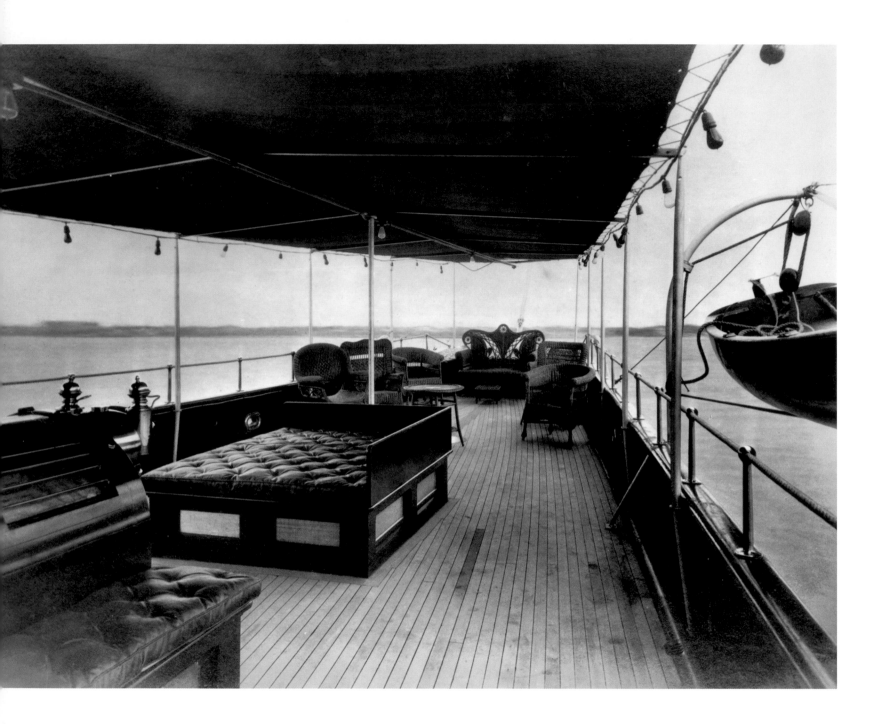

Alicia's aft deck (above) had a highly animated wicker settee at the very stern. Note the string of light bulbs along the edge of the canvas overhead, which must have lent a festive atmosphere at night.

Alicia's polished and immaculate engine room (right) was thirty feet in length and housed a Seabury water tube boiler, a dynamo providing electric power for the lighting system, and a Seabury triple-expansion steam engine. The image here highlights the engine's skeleton frame, "very light [and] amply strong, as proved in many other yachts engined by the [Seabury] company." It must be remembered that such engines were hand built—each being a unique piece of machinist and engineering art—and beautiful.

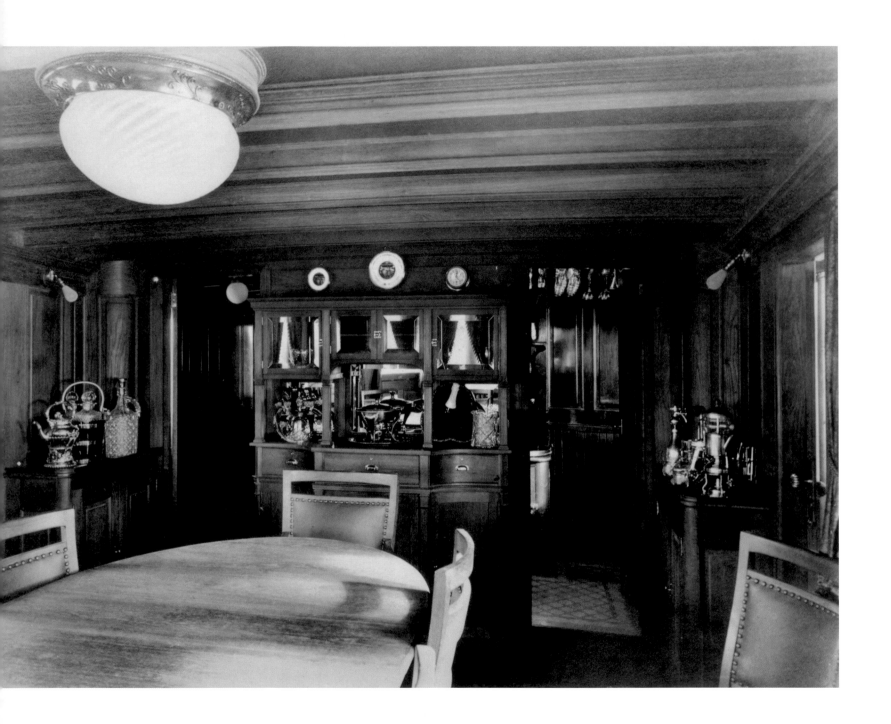

Alicia's deck cabin featured a fifteen-foot-long dining saloon (above and opposite) with joinerwork and furnishings of teak. A butler's pantry, located just aft, is visible through the open door to port. While elegant, this saloon was significantly more subdued than that gracing *Idalia* (see page 37).

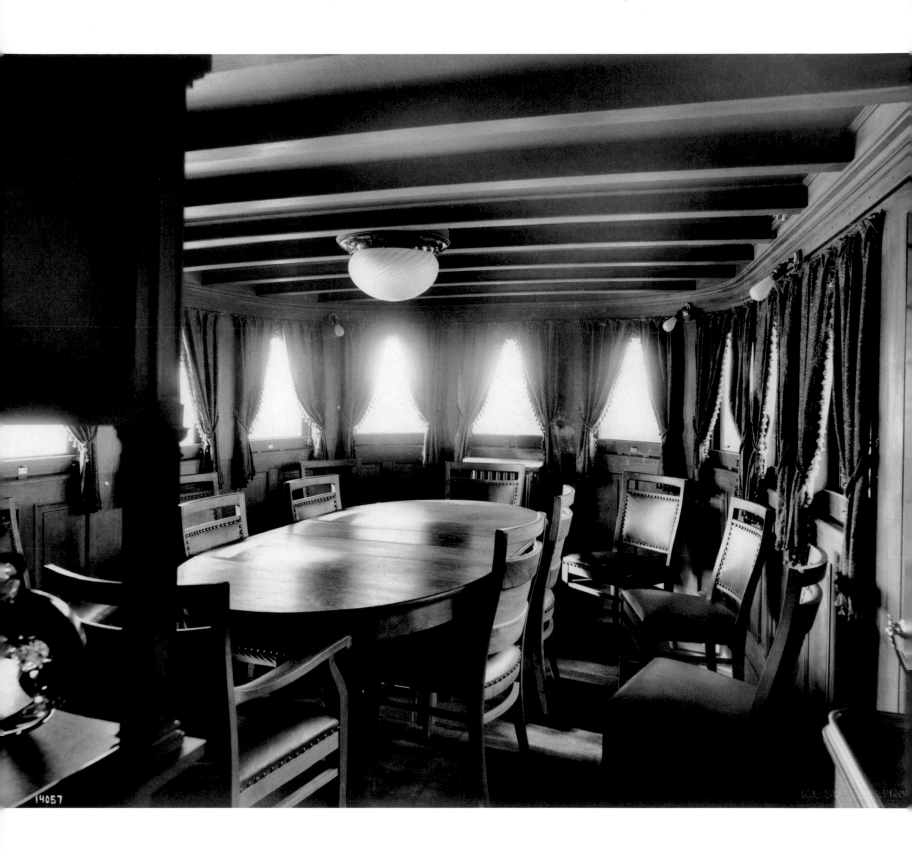

Down below, *Alicia* featured white enameled joiner-work with mahogany accents finished bright, producing the "effect of space, cleanliness and light" and dispelling any suggestion of "dampness or stuffiness." The image at left is looking aft, toward the "Ladies' After Stateroom."

The "Owner's Room" aboard *Alicia* offered a snug, built-in double berth with a set of portières for added privacy, as well as an en-suite head, plus the unexpected pleasure of the aft mast piercing the cabin. There could be no doubt: This *was* a yacht.

The high-end department store B. Altman & Company (located at Thirty-fourth Street and Fifth Avenue in New York City; the imposing building is extant) supplied a 1913 estimate for an interior refit of *Alicia*, including twenty-six pairs of curtains, thirteen green shades, portières, mattresses (at $125 each), and two brass beds (at $34 each)—for a total of $1,122.30. The company submitted a 1914 estimate for the re-covering of various cushions in the "best quality machine buffed leather." It is not clear whether any of this work was completed.

In 1921, du Pont decided to sell *Alicia*. She was "too expensive to operate and drew too much water and was most uncomfortable," du Pont wrote. In a series of letters to Cox & Stevens, yacht brokers and designers, du Pont was cautiously brought to realize that the yacht would bring nowhere near the $75,000 he expected. "We extremely regret that we cannot advise you more favorably," they wrote. *Alicia* sold in the spring of 1922 for $24,000 (including a 7 percent commission of $1,680 to Cox & Stevens)—a remarkable price for a 150-foot yacht in, no doubt, excellent repair (a new, sixty-foot yacht would have cost in the neighborhood of $60,000).

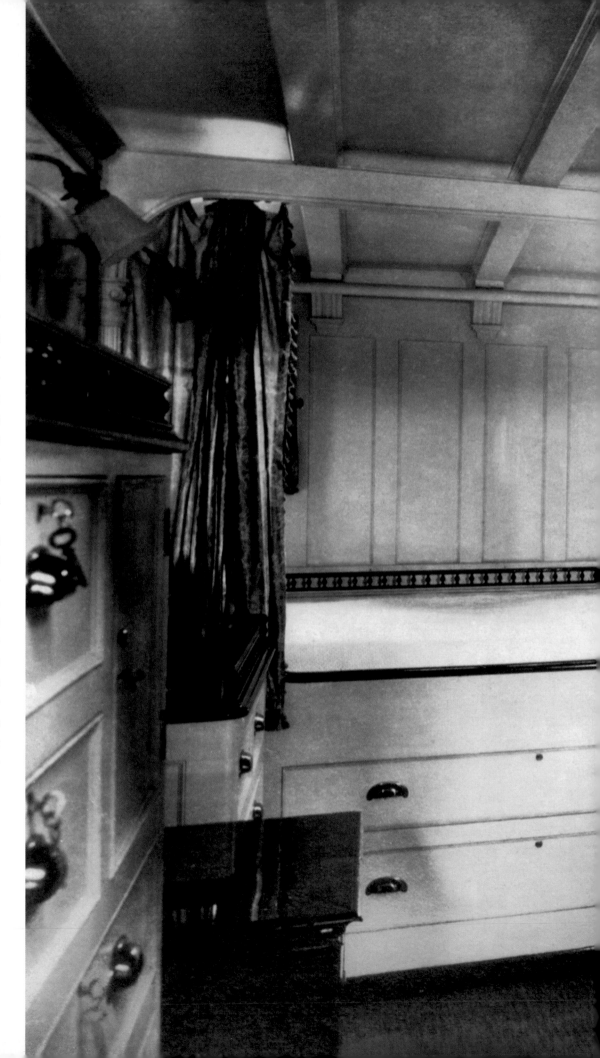

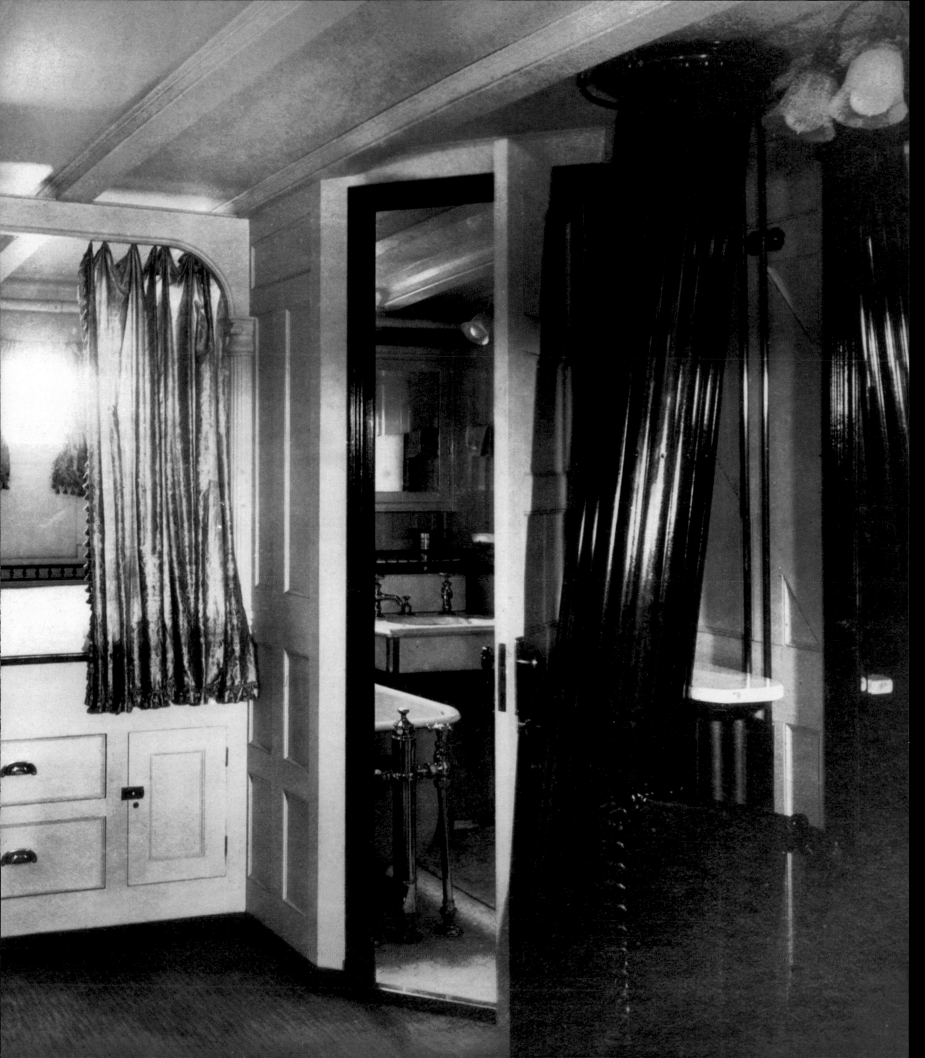

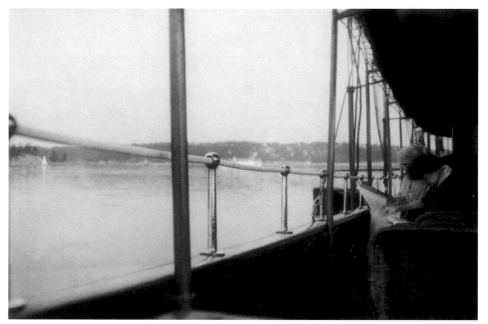

Yachts—then and now—are used for pleasure more often than not, but the overwhelming majority of classic yacht images are static in that they rarely show humans aboard. Thus, the raison d'etre of yachting—havin' fun—is curiously unrepresented by the archival records, which is why the adjacent images are so rare and delightful.

Looking at these frozen-in-time moments allows us to imagine life aboard these majestic creations. One can almost feel the warmth of a summer sun on skin, the passing scent of a gentle salt-tinged breeze, and laughter echoing across expansive teak decks. Imagine a canvas awning fluttering overhead, while friends and family are lulled into an afternoon nap by the gentle roll of these narrow-beamed vessels.

The archival records help us re-imagine classic yachts, but rarely the life aboard.

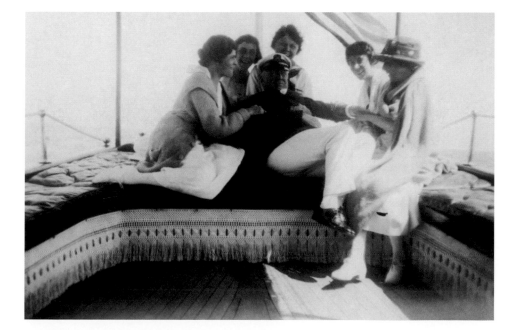

Some casual moments aboard *Alicia,* captured on camera.

Opposite, well-dressed fishing.

Top left, relaxing on *Alicia*'s aft settee.

Center left, the port side of *Alicia;* note the myriad details that collectively create the aesthetic of this classic yacht.

Bottom left, Alfred du Pont and a bevy of unidentified admirers. Note the unusual and elaborate fringe.

NENEMOOSHA

1922

After the death of Alicia du Pont, Alfred du Pont married Jessie Ball; a year later, the couple commissioned *Nenemoosha*, a ninety-seven-foot Edward Carroll design built by American Car & Foundry (known as a.c.f.; see *The Golden Century*, page 241) and launched in 1922 at a cost of $74,835.98. (The engines and other equipment, not included in this price, cost an additional $24,000 or so. Edward Carroll, her designer, received 5 percent of at least the construction costs.)

Alfred du Pont was by no means a distant observer regarding the construction of *Nenemoosha*. "I am practically designing [*Nenemoosha*] myself, which I hope . . . will float right side up," du Pont wrote. The du Pont papers archived at Washington and Lee University contain a wealth of letters among du Pont, Edward Carroll, Captain Peder Songdahl, and a.c.f. regarding even the most arcane details (du Pont wrote: "The [figure]head should be furnished with either a gold band or a band of beads"), interpersonal issues, prices, workmanship (du Pont wrote: "The washstand in owner's stateroom . . . looks . . . twisted and out of shape and generally a discreditable specimen"), schedules, and bizarre prejudices (when the captain suggested using an English-made varnish, Carroll wrote du Pont: "!! Heaven preserve us!!"). And there were other issues. During the construction of the yacht, Carroll wrote du Pont that the a.c.f. yard had "many more men" suddenly on the job, which he attributed to either a "fear of the Lord or Alfred I. du Pont." In April 1922, du Pont wrote Carroll that he could not offer his car in New York (after Carroll presumably requested it), as he did not maintain a chauffeur in the city, and "therefore there [was] no one competent to drive it." Instead, du Pont suggested that in order to show the *Alicia* (now listed for sale), Carroll might do as du Pont would: take the "subway to Flatbush Avenue Station, jump the trolley car and go down to the yacht." One wonders what Carroll thought of such advice for escorting millionaires to view *Alicia*. When Alfred

Designed by Edward Carroll and Alfred du Pont
Built by American Car & Foundry, Wilmington, Delaware
Two 4-cycle, 4-cylinder 9 × 12½ New London Ship & Engine Company diesels

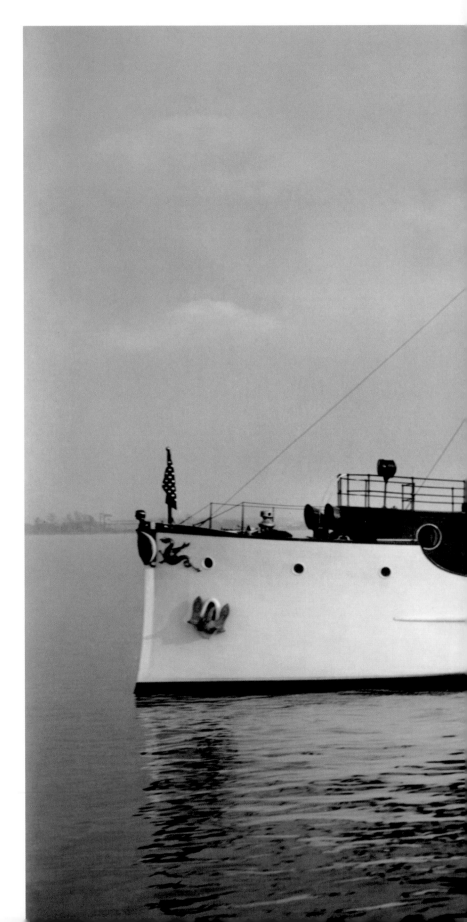

Nenemoosha's type of bow was extremely unusual for a yacht, more typical for a turn-of-the-twentieth-century battleship, such as the *Maine*. Moreover, note the unusual latticed masts, another naval feature, and the elaborate bow decorations. The du Ponts' new yacht presented a unique and formidable appearance.

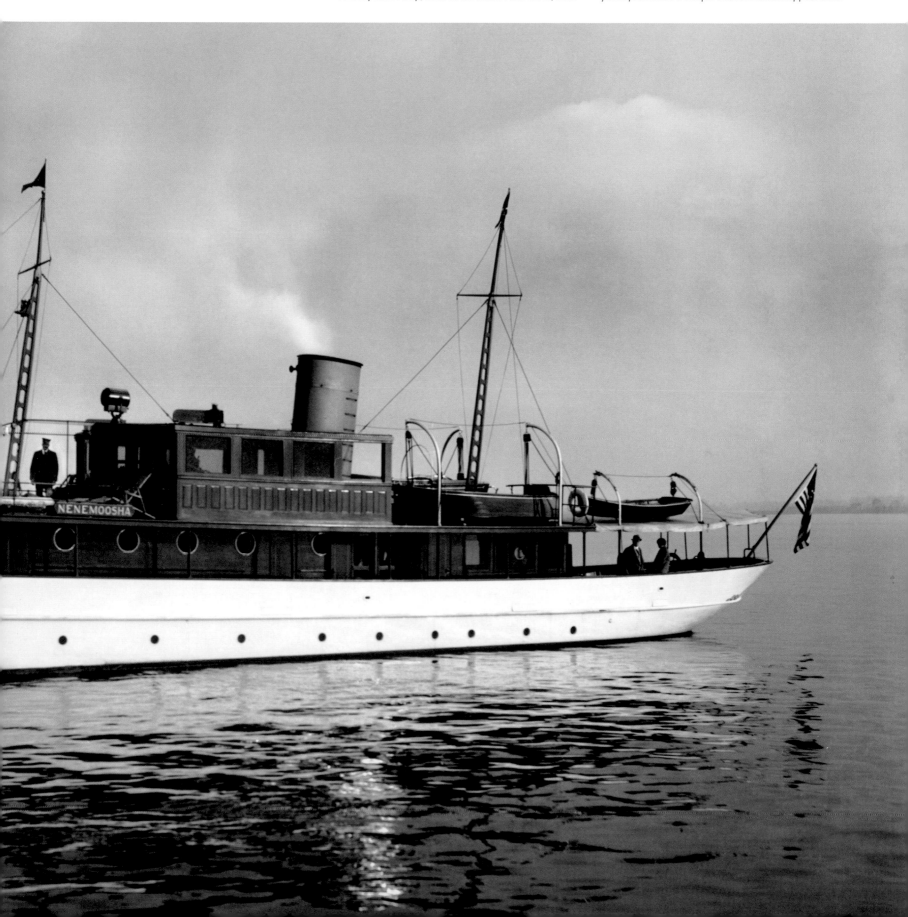

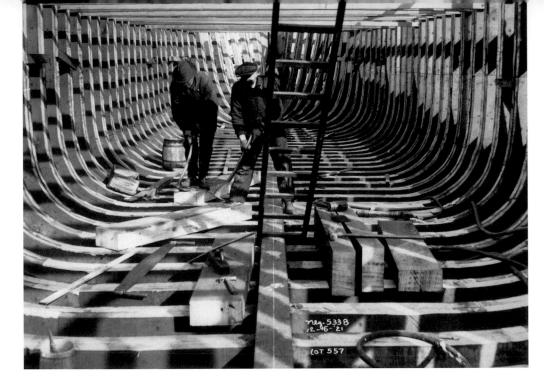

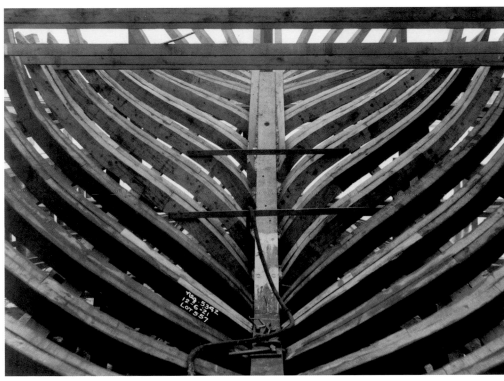

Left (both), *Nenemoosha* under construction.

Opposite, Alfred du Pont.

Below, Jessie Ball du Pont, probably during the 1920s.

asked a prospective chef for the yacht to display his culinary skills at the du Pont estate, Nemours, the chef "became frightened [and] resigned, so to speak." After the launching on April 15, 1922, Carroll wrote du Pont that he "felt like you do when the nurse comes out and tells you that it's a boy, and that mother and son are doing fine."

Why did Alfred and Jessie choose the name *Nenemoosha*? The du Pont papers reveal the answer: "Nenemoosha is Iroquois for sweetheart." Did the du Ponts select the name from a section of *The Song of Hiawatha* by Henry Wadsworth Longfellow?

But Osseo turned not from her,
Walked with slower step beside her,
Took her hand, as brown and withered
As an oak-leaf is in Winter,
Called her sweetheart, Nenemoosha,
Soothed her with soft words of kindness,
Till they reached the lodge of feasting,
Till they sat down in the wigwam,
Sacred to the Star of Evening,
To the tender Star of Woman.

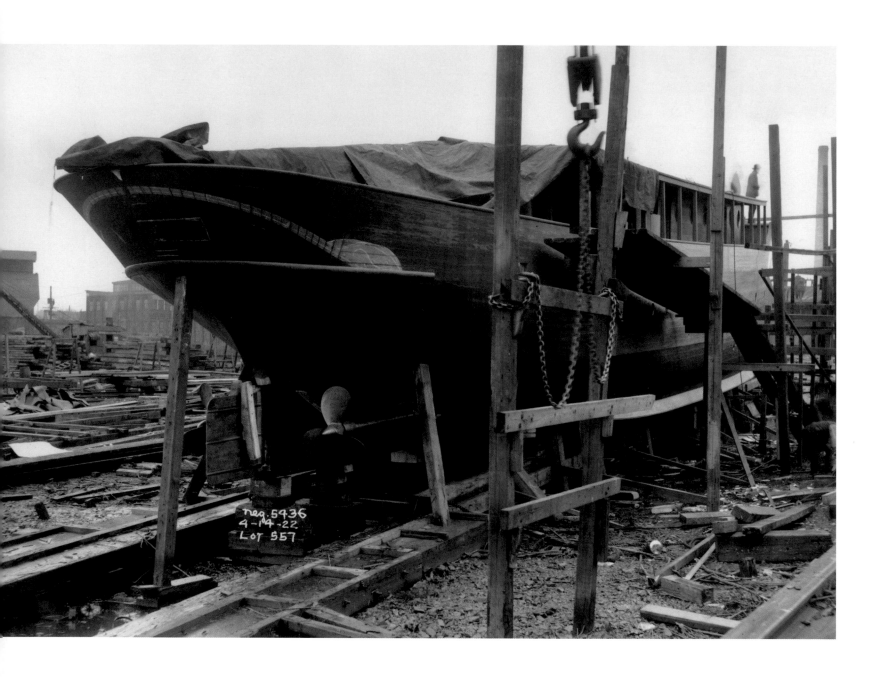

Above, *Nenemoosha*'s original stern design was to have included a carved heart intertwined with the words *Indian Sweetheart,* but du Pont deleted this detail.

Opposite, the vessel almost ready for launching at the a.c.f. yard.

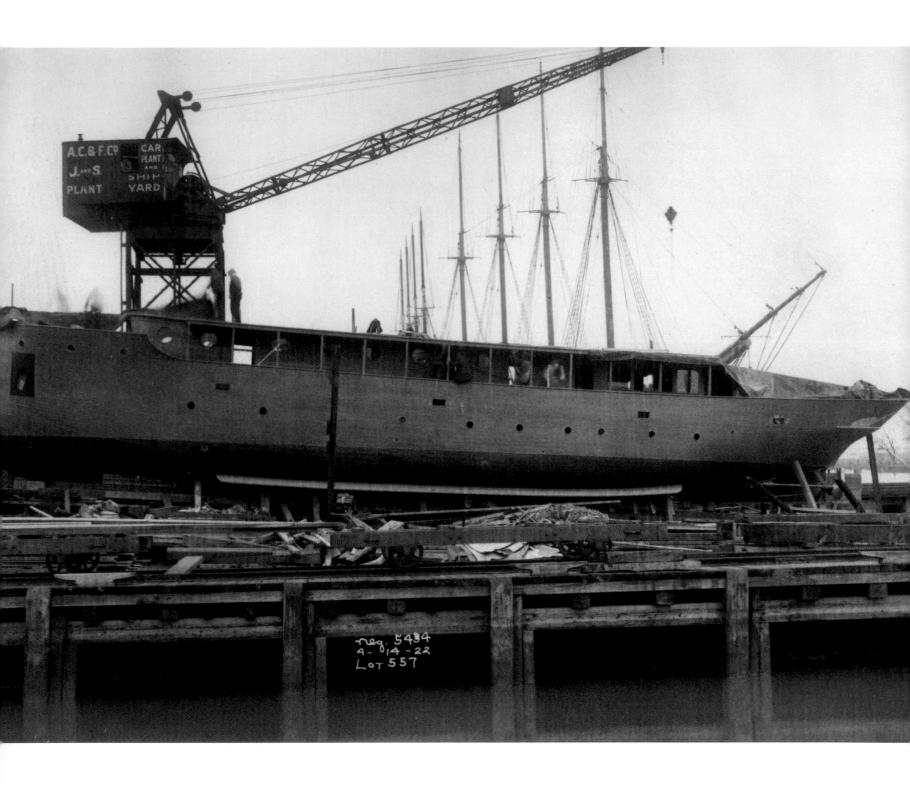

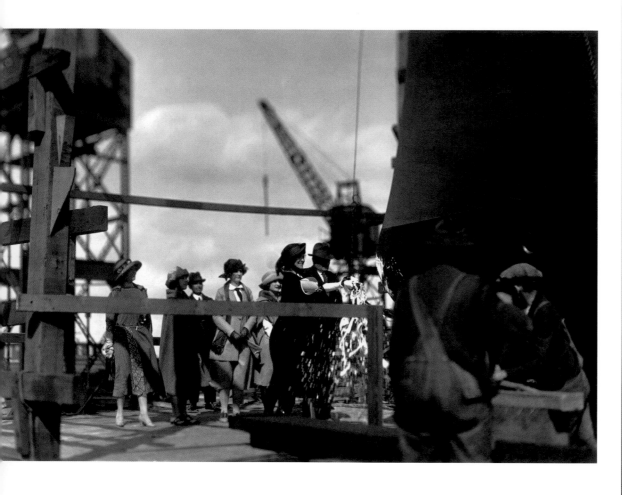

The moment (above), with Jessie du Pont doing the honors.

Right, some of the unidentified officers and crew of *Nenemoosha*. The man second from left is presumed to be Captain Peder Songdahl. To his left would be the chief engineer, while the man second from right would be the assistant engineer. The man third from right would have been, possibly, the steward.

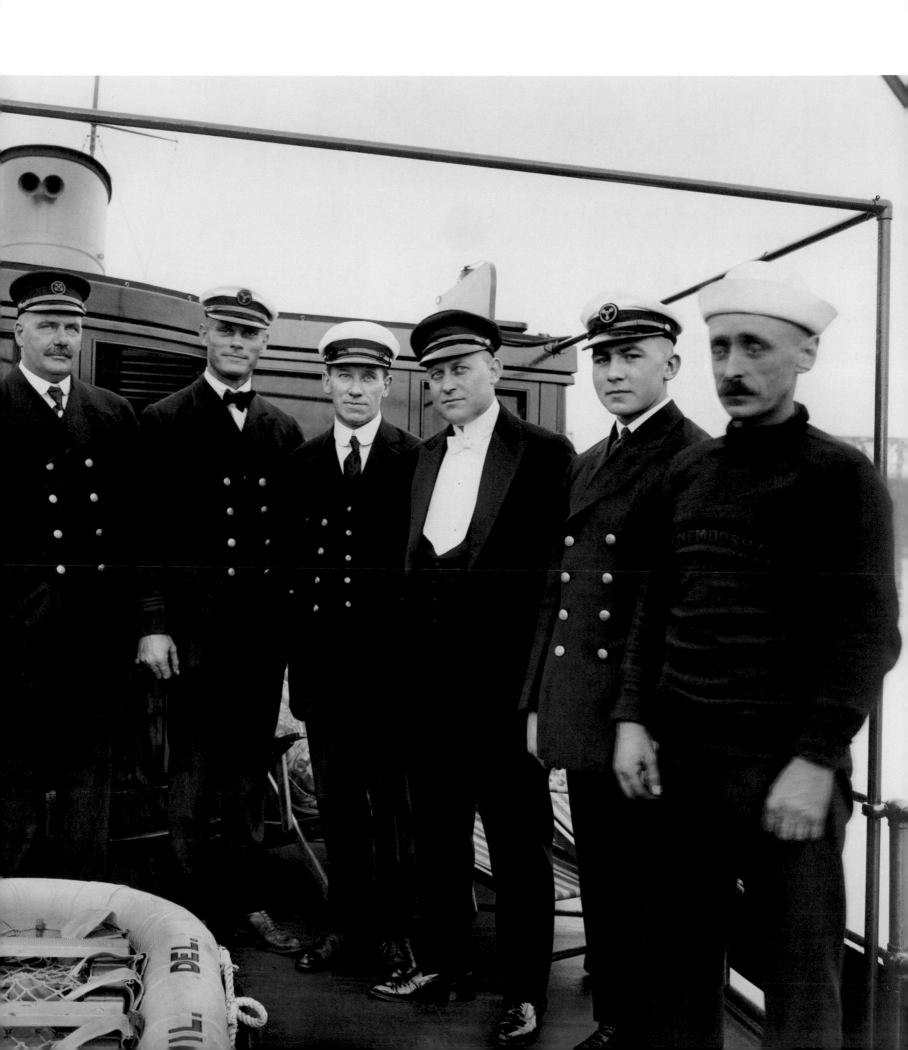

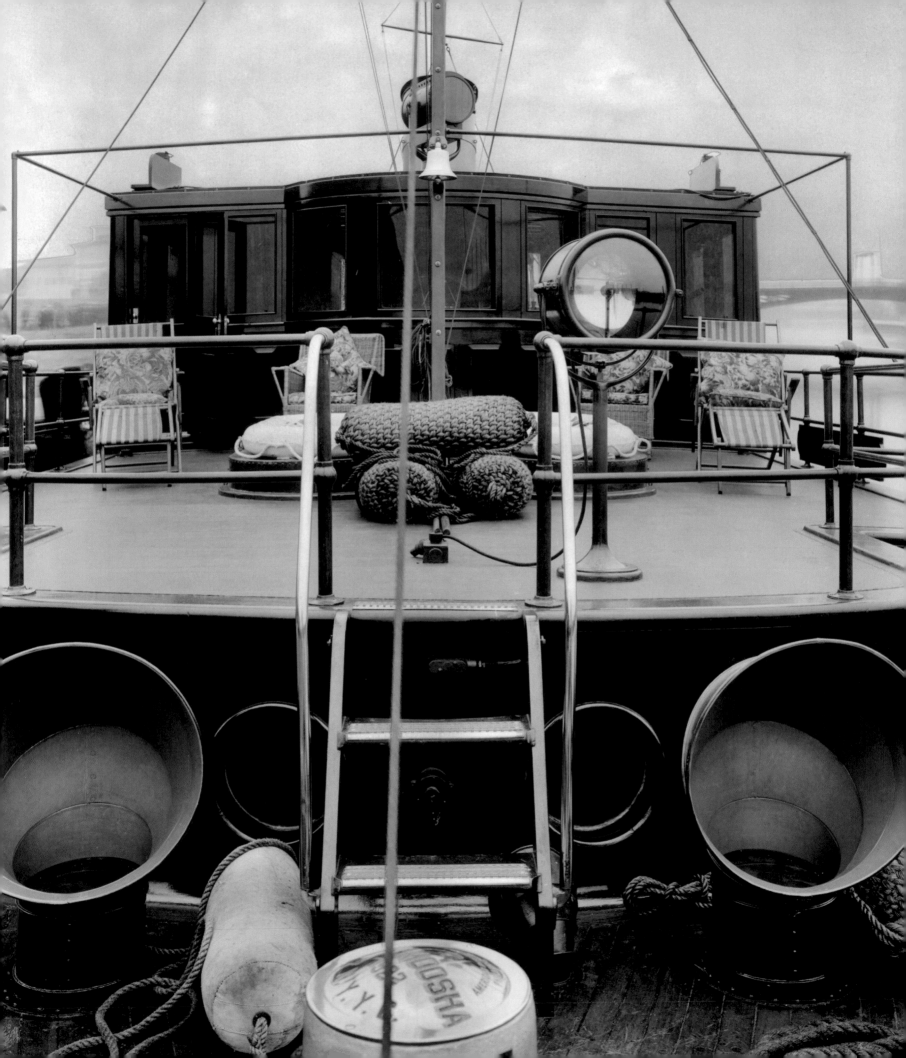

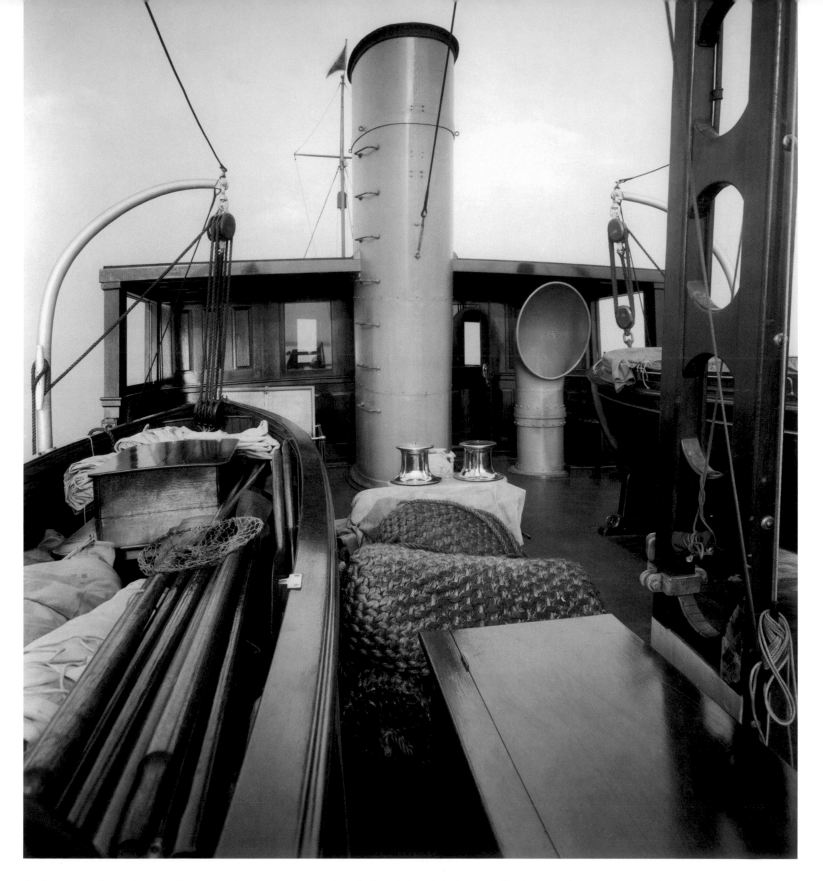

The image opposite was taken on *Nenemoosha*'s fore-deck, looking aft. The portholes fronted the owner's stateroom and must have, on occasion, hindered the privacy of its occupants while the crew used the fore-deck. Edward Carroll, who suggested the location for the owner's cabin (the "choicest"), had tossed off such a concern, stating that the crew had "no business on the forecastle head except when working there." Of course, this statement *confirmed* that there would be a privacy issue.

These extraordinary images of *Nenemoosha,* as well as all those that follow, have never been published.

Above, the upper deck of *Nenemoosha*, looking for-ward, had a wealth of detail, including the pair of boats and the unusual latticed mast.

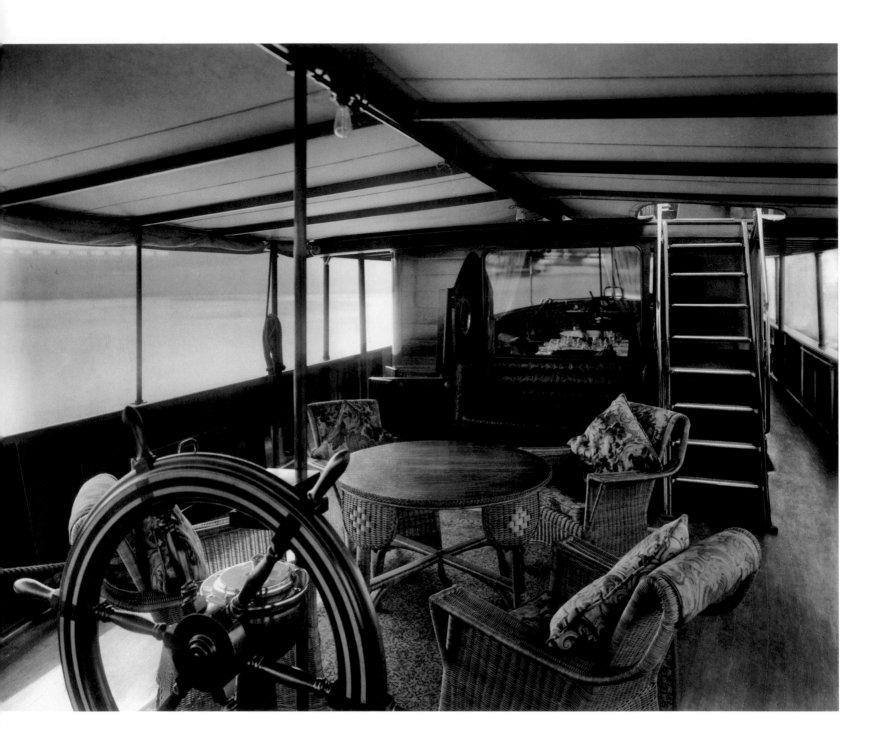

Above, the aft deck of *Nenemoosha,* looking forward. The large window looks into the dining saloon.

Nenemoosha's expansive pilothouse (opposite) would appear to have served also as a saloon. The pair of telegraphs were spaced unusually far from the wheel. The item in the port corner appears to be a B. & H. "naval type" breech-loading bronze cannon.

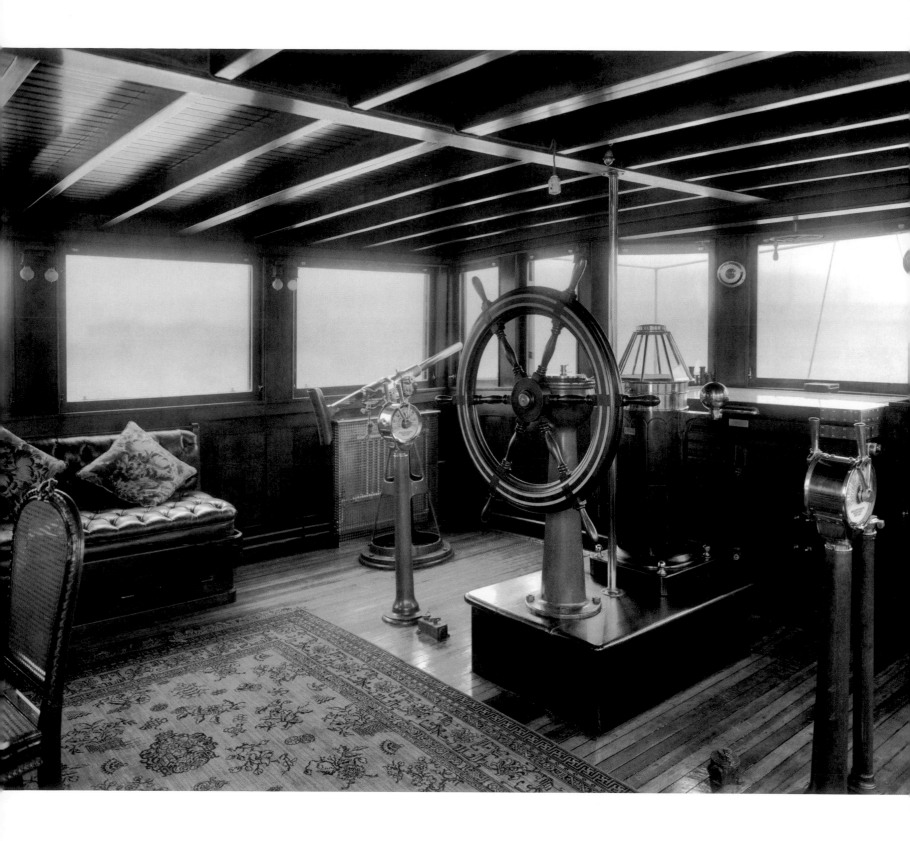

Everything about *Nenemoosha* was unusual. It is not known whether this can be attributed to her designer, Edward Carroll, or the intense involvement of Alfred du Pont, or the more discreet influence of Jessie du Pont. The yacht's dining saloon (top left and right) was located on the main deck, aft (a more typical location would have been the forward section of the deckhouse). Writing desks and settees were also rarely seen in dining saloons.

Alfred was dissatisfied with the designs for this saloon and asked that Thomas Hastings, the co-designer of Nemours and a world-renowned architect, develop plans. In haste, Hastings evidently complied, as du Pont wrote: "You are a perfect brick to hurry along the drawings for the livingroom on the boat!" Letters and drawings scurried back and forth between New York and Wilmington, but, in the end, du Pont decided not to proceed with Hastings's ideas, as they would delay *Nenemoosha*'s launch. When du Pont offered (grudgingly, it appears) to pay Hastings's commission for the last-minute drawings done by his firm, Hastings, perhaps wisely, seems to have read between the lines. R. H. Shreve, from Carrère and Hastings, graciously requested that du Pont reimburse the firm only for out-of-pocket costs—a total of $160.32.

Bottom left, *Nenemoosha*'s main-deck pantry. Note the annunciator in the upper right corner.

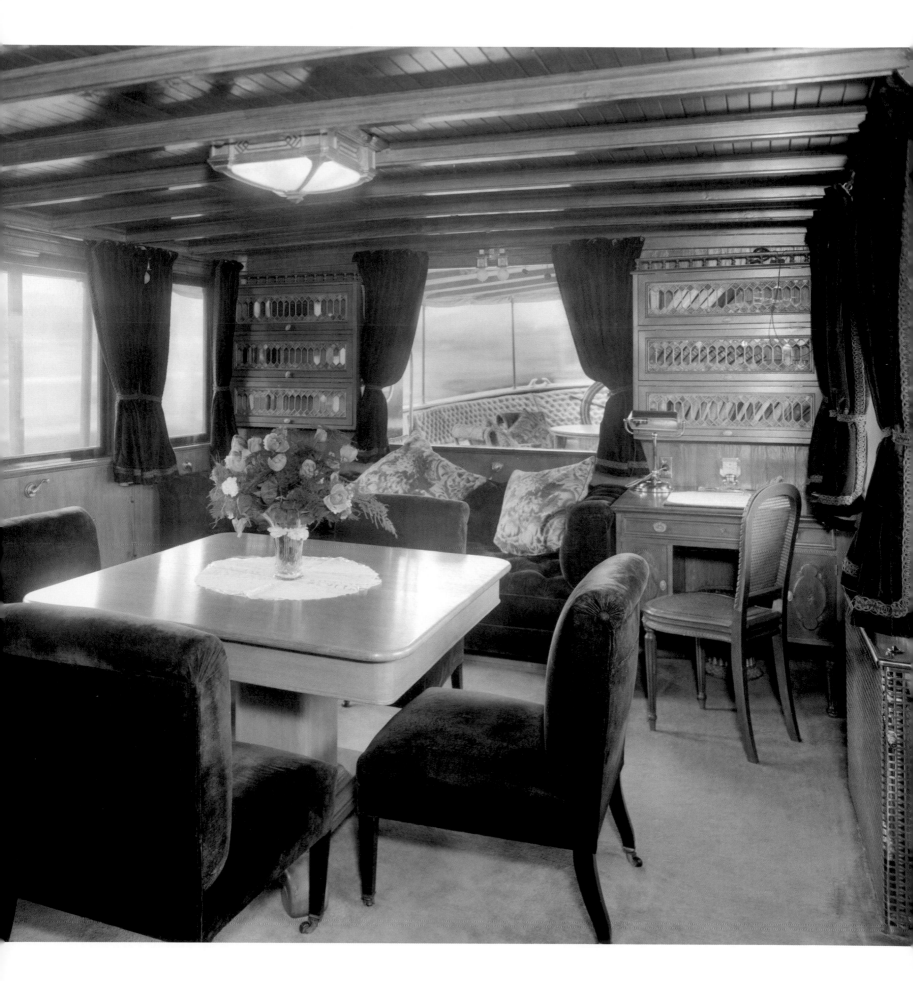

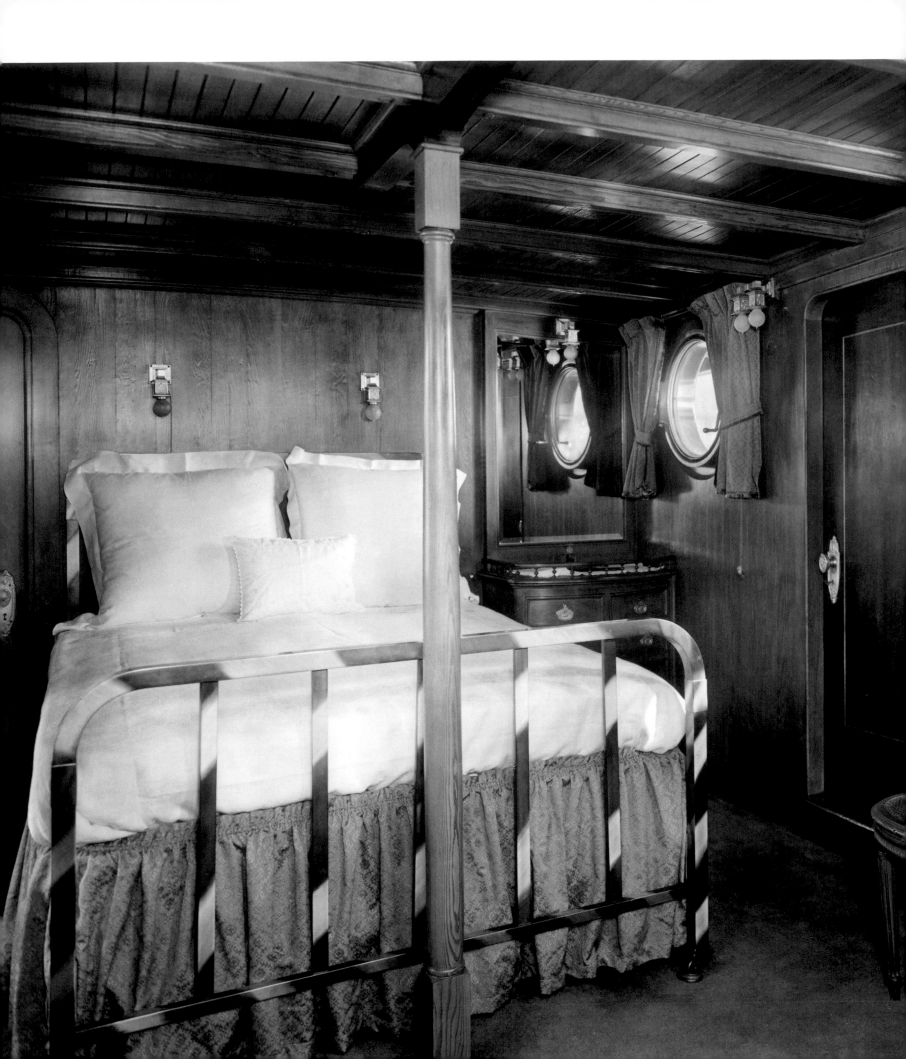

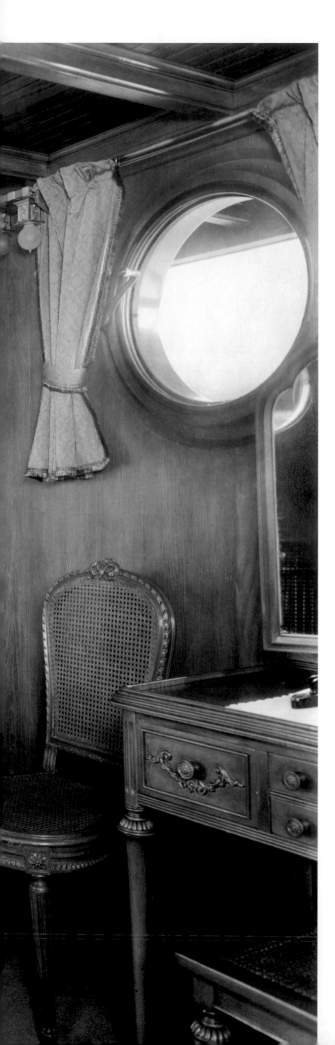

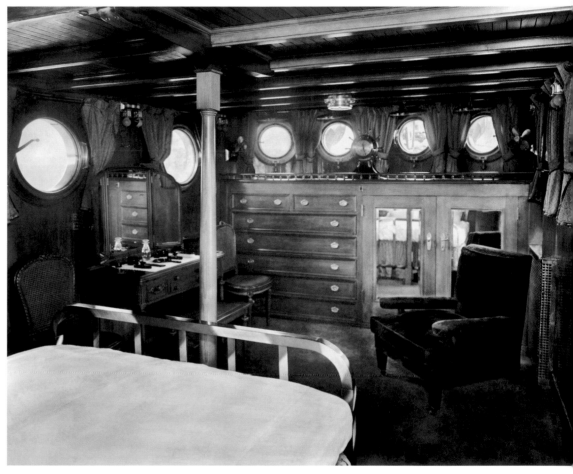

At Edward Carroll's suggestion, all the staterooms aboard *Nenemoosha* were located on the main deck, yet another unusual feature, and one that would explain why the main saloon would appear to have been shared with the pilot station a deck above.

The detailing and appearance of the joinerwork was also unique to *Nenemoosha*. These images are of the owner's cabin, forward, which featured unnautical free-standing furnishings that looked out of place. The large portlights (supplied by Steward Davit and Equipment Corporation, Hudson, New York) were an appealing feature ("Simple as a door knob. Strong as a gun breech block"). Particularly pleased with this selection, Alfred wrote a letter complimenting the company: "I do not know that I could give you any greater praise."

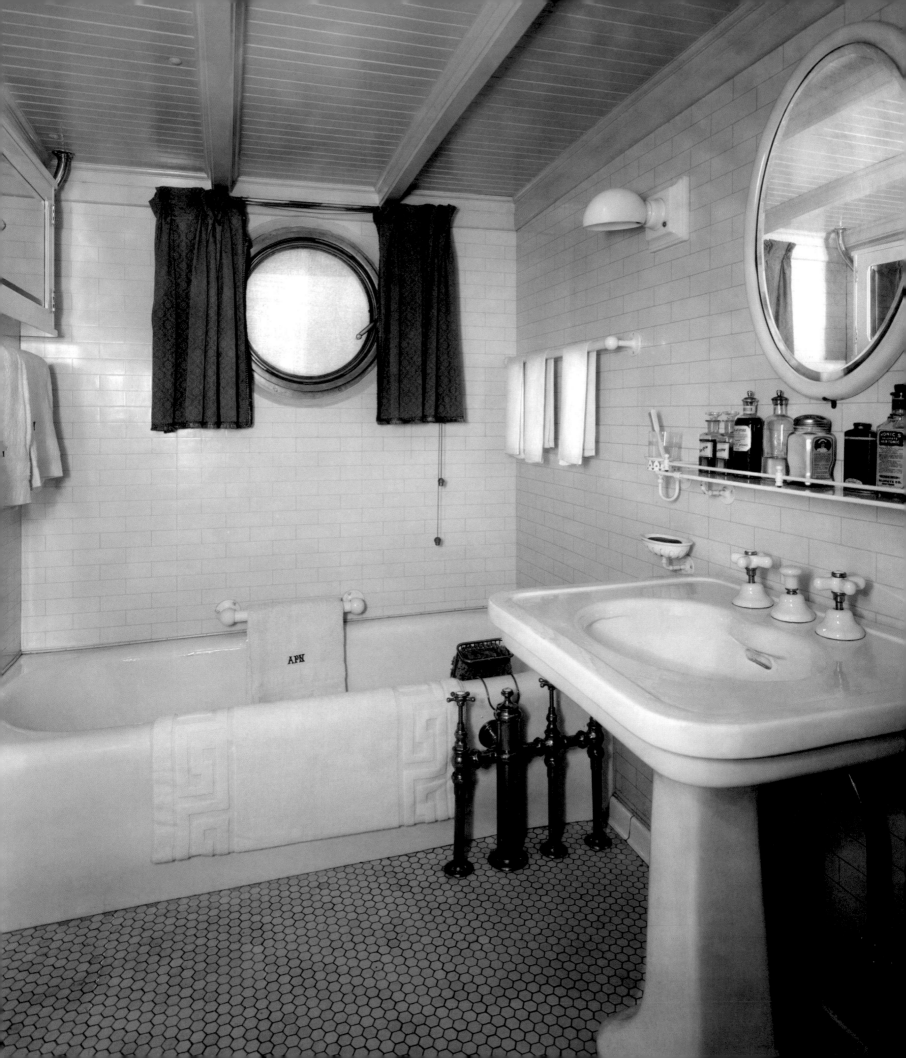

This image opposite is presumed to be the owner's head (looking to port) aboard *Nenemoosha*. Again, unusual features abound. The full-height tile was unique. (Tile is heavy. Having such weight high in a vessel affects stability.) Even the tile floor was rare, linoleum being more typical. The monogram on the towels was also peculiar. What did "APN" stand for? After using *Nenemoosha* for eighteen months, du Pont concluded that there was only "one thing more impractical on a yacht than a bathtub and that is a bowling alley."

The cabin at top right offered the startling feature of a pair of large pocket doors that converted two single staterooms into a double, although the fact that a person sitting on one of the adjacent beds would be unable to see the upper body of the person next to them perhaps made this feature moot. This arrangement, suggested by Edward Carroll, "required considerable thought in laying out the bathrooms." The overall detailing and appearance of the cabins was, as typical for *Nenemoosha*, unusual, but nonetheless inviting and attractive.

Bottom right, the same cabin, presumably looking forward. The round metal item on the bulkhead was a sink; its basin dropped down on a hinge, a clever feature not uncommon on yachts of the era and a piece of hardware that would be quite valuable today. The head in the background would appear to be the same one pictured opposite. Note that there was another tiled area between it and this cabin. Based on comments by Edward Carroll, this area was the guest head. The rounded-off doors were a du Pont preference.

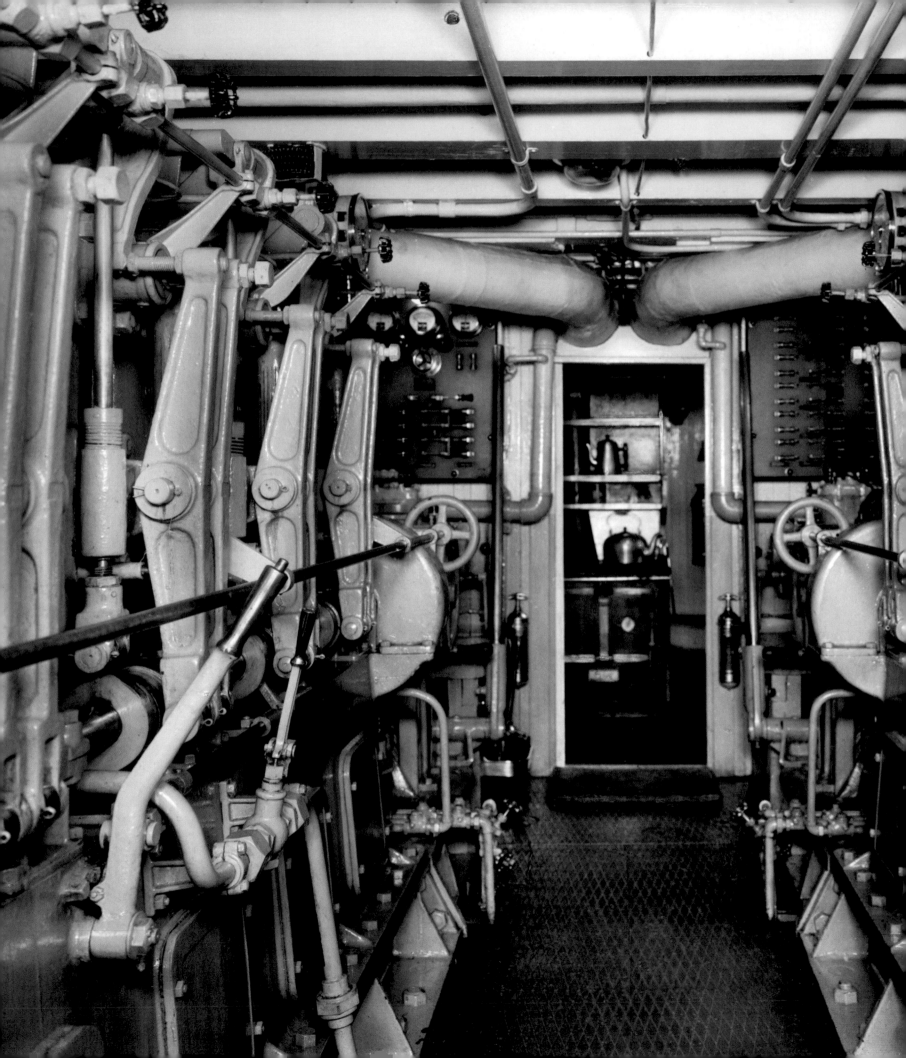

The theme of originality prevalent on *Nenemoosha* continued even into her engine room (left), which housed a massive pair of four-cycle, four-cylinder 9 × 12½ New London Ship & Engine Company (Nelseco) diesels, relatively unusual for a yacht. Edward Carroll later wrote that du Pont had gotten a deal on the "war baby" engines (leftovers from World War I), which were twice the weight allowance that Carroll had calculated and made *Nenemoosha* ride lower than the designed waterline and suffer from attendant maneuverability problems. At the end of their first season of use, the $11,115 engines developed a number of problems that baffled du Pont and his engineer, O. W. Kummerlowe. A series of letters went back and forth between du Pont and Nelseco describing problems with the reversing gears.

During the yacht's construction, Captain Songdahl, in a letter dated December 9, 1921, had strongly urged that Mr. K. Berge be retained as the engineer, as Songdahl had worked previously with him aboard *Alicia* and found him, among other virtues extolled, without "kick or growl." It appears, however, that du Pont had already made up his mind to retain Kummerlowe. In the end, this may not have been the wisest choice. By early 1922, Kummerlowe was the source of simmering tensions. In a letter dated February 12, 1922, the yacht's designer, Edward Carroll, wrote du Pont that he doubted Kummerlowe's "regard for the dignity and sacred sanctity of Naval Architects." (One has to wonder whether Carroll respected the dignity and "sacred sanctity" of

an engineer.) After Kummerlowe met with Nelseco and made extended critiques of Carroll's plans for the engine room, the designer reacted with barely controlled rage. By August, du Pont also seemed to have lost confidence; he wrote: "Kummerlowe seems to think that because there are two engines, there should be two engineers. Of course, this is absurd." Du Pont further stated that Kummerlowe seemed "nervous and dissatisfied." (Such a manner could easily be attributed to a micro-managing owner. Kummerlowe, no doubt, had never experienced someone like du Pont, who was intensely involved in every aspect of his yacht and, it appears, presumed that he knew more than his officers. Perhaps he did.) By September, du Pont stated that he wanted "a better man than Kummerlowe to look after the machinery," and decided to hire "the man Brown," in addition to Kummerlowe. Yet Kummerlowe remained with du Pont until April 1926, when du Pont told him that, "under the circumstances," he should leave. What circumstances?

It is interesting to note subtle class distinctions. Carroll, a paid retainer, always referred in his writings to Kummerlowe, another hired hand, as *Mr.* Kummerlowe, while the boss, du Pont, never did; it was always simply "Kummerlowe"—like "the man Brown."

The preliminary plan (below) from among the du Pont papers details, charmingly, the galley and officers' quarters for, presumably, *Nenemoosha*. Who drew it? Alfred? The captain? The engineer?

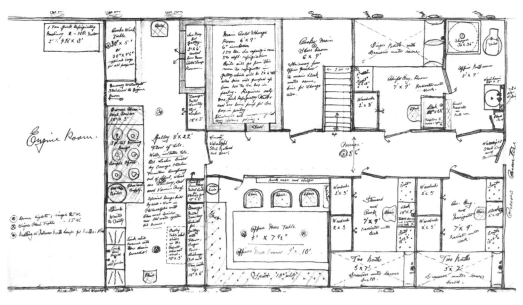

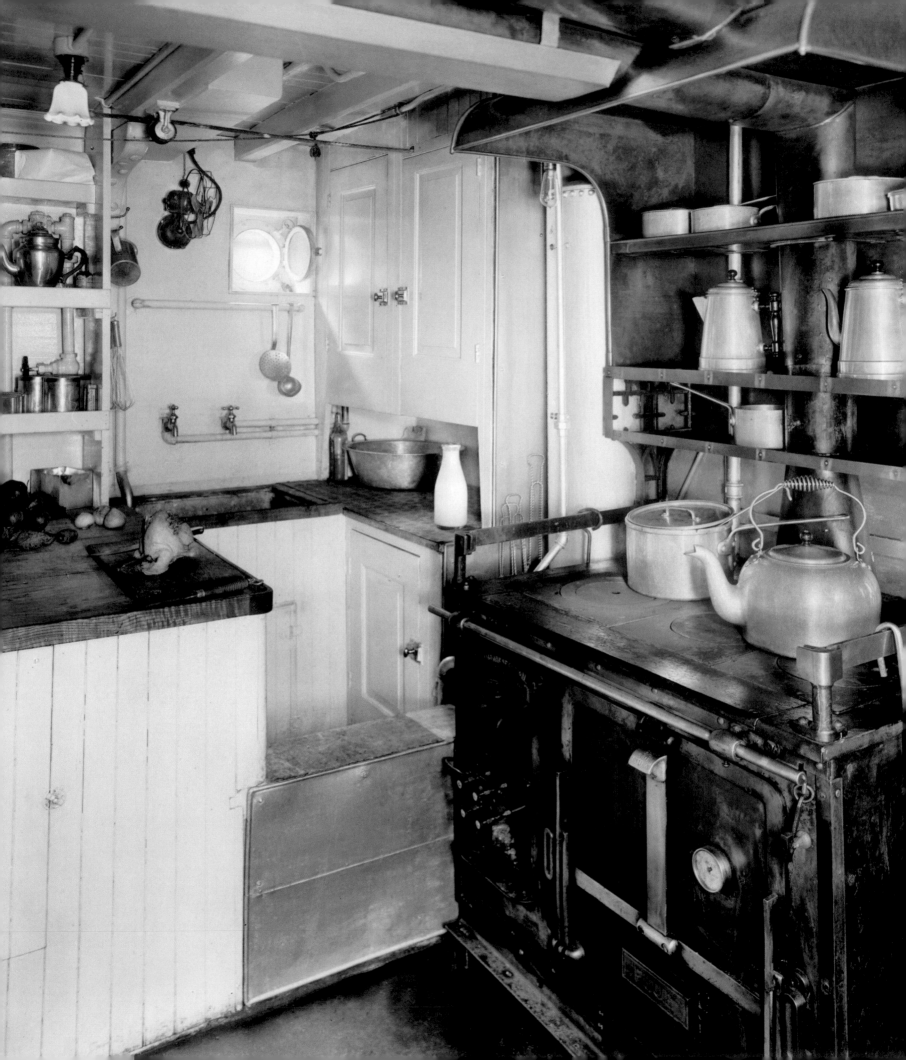

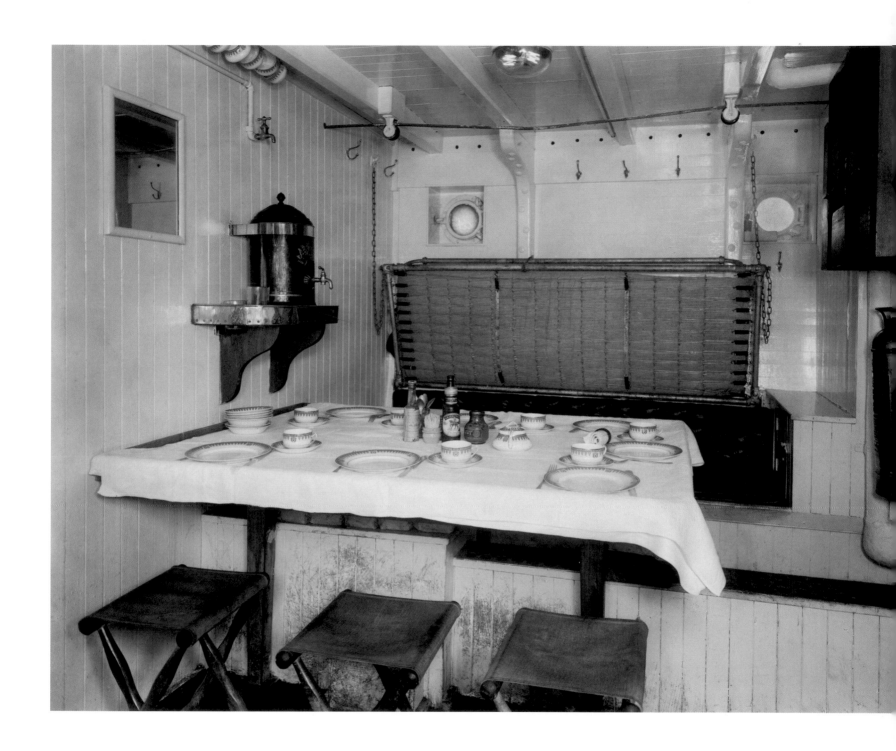

In *Nenemoosha*'s galley (left), one tends to speculate about the purpose of the divider rising from the sole—an extraordinary impediment to preparing meals. (This is likely one of two longitudinal stringers supporting the engine beds.) The small porthole (presumably there were others) appears to have been the only source of natural ventilation; an operable skylight would have been a thoughtful addition.

Crew quarters, such as this mess hall above, were rarely photographed. As such, this and the following images are a delight. Note the scuffing of the joiner-work (below the table) on the new yacht, the overhead cable (likely part of the steering mechanism, controlling the rudder), the faucet above the water tank, and the pipe berth above the settee.

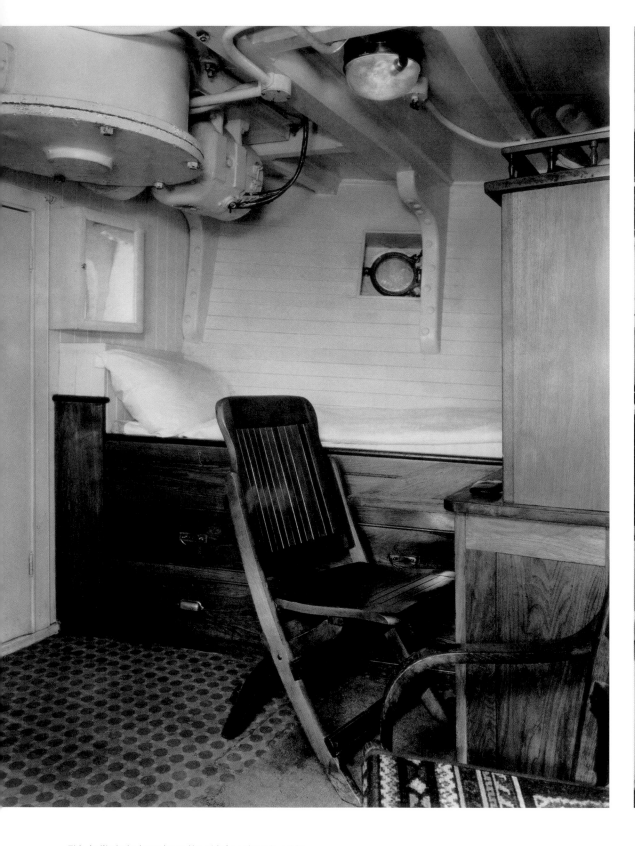

This is likely to have been the chief engineer's cabin.
The overhead machinery probably operated the anchor
windlass on the foredeck.

Additional crew quarters aboard *Nenemoosha*.
Note the drop sink.

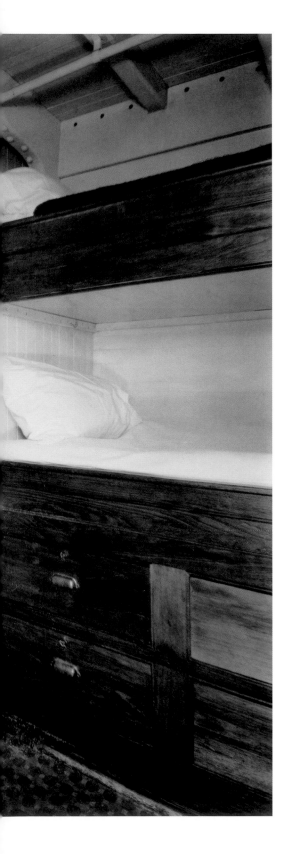

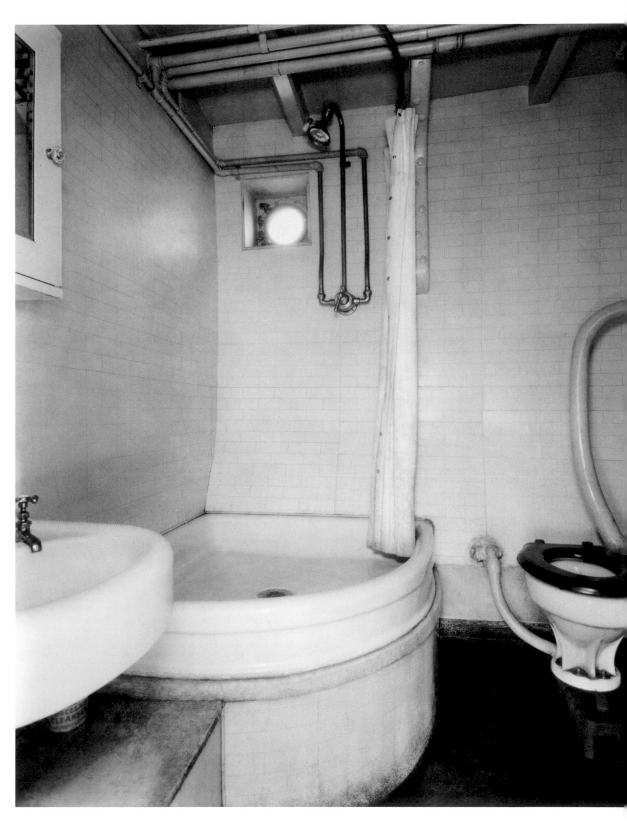

This would appear to be the officer's head aboard *Nenemoosha*. It was a big step up to the shower. Note that the head has no lid; a surreal cost savings by du Pont? This cabin was also dirty, such as at the bottom edge of the head, and the place where the shower meets the sole and the tiled floor/bulkhead. Ironically, engine rooms were maintained to more immaculate standards.

NENEMOOSHA

1925

Alfred du Pont was not satisfied with the 1922 *Nenemoosha* and embarked on a drawn-out process to replace her—and her designer and builder. Another naval architect, A. Loring Swasey, set things in motion for a 130-foot successor with a letter dated July 27, 1923, letting du Pont know about his new partnership of Burgess, Swasey & Paine. Swasey had previously worked with du Pont on the development of a 110-foot subchaser built by the Herreshoff Manufacturing Company in Bristol, Rhode Island (*The Golden Century*, page 98); du Pont then gave the $85,000, twenty-seven-knot vessel to the U.S. Navy. In his unsolicited 1923 letter, Swasey mentioned that if du Pont was interested in "working up a new boat," he would be glad to talk. Alfred replied to the same effect, stating: "I have never yet seen a boat which has come up to my ideas of how a boat should be built." He referred to the 1922 *Nenemoosha* as an experiment, and he acknowledged that her wood construction caused more vibration than a steel-hulled vessel would.

In August that year, du Pont started receiving bids for alterations to the "little boat" (as he always referred to the ninety-seven-foot *Nenemoosha*), to "make her look a little more shipshape and more generally practical." (Architect Thomas Hastings said that the first *Nenemoosha* was the "biggest little boat I ever saw.") The New York Yacht, Launch and Engine Company, Morris Heights, New York, tendered a bid for $11,950 (signifying a major project), but they did not get the job. Alfred wrote that he had "been able to secure much better figures elsewhere." It appears that the Mathis-Trumpy Company was given the project (*The Golden Century*, page 175).

The new *Nenemoosha* retained the battleship-type bow, latticed masts, and graceful counterstern of her predecessor. However, the hull plating extending above the sheer was a highly original feature that would increasingly influence the design of motor yachts in the decades to come.

Designed by A. Loring Swasey of Burgess, Swasey & Paine, and Alfred du Pont
Built by Newport News Shipbuilding
Two 4-cycle, 6-cylinder, 9 × 12½ Nelseco diesels

In November 1923, du Pont sent a letter to Swasey, as well as to Cox & Stevens, William Gardner & Company, and Henry J. Gielow, Inc., and asked each to develop plans for a new yacht. When several of the firms demurred at being paid for their efforts, as du Pont had suggested, he insisted; he did not wish to feel obligated should he not retain a firm, or not go ahead with the project. In a letter to Swasey a few days later, du Pont acknowledged that his "views seem to differ so widely from the average yachtsman's," and that he wished for exemplary crew quarters, as this would be the only way to maintain a crew and receive good service.

By December, du Pont had made up his mind about retaining Swasey. "You caught the spirit of my ideas very cleverly." He had also greatly angered Edward Carroll. A few months earlier, du Pont had been notified by his attorneys (Marvel, Marvel, Layton & Hughes) that Carroll had filed suit, claiming that the design for the new yacht was his. Alfred replied that *he* was its designer, with Burgess, Swasey & Paine developing his ideas; to this, Carroll replied cuttingly and sarcastically. In other letters, Carroll was threatening, accusing du Pont of trying to "hornswoggle"him. Amazingly, by January 1925, the two evidently had made up, as Carroll was anticipating a commission from the sale of the 1922 *Nenemoosha*. Still, things had changed. Whereas Carroll's pre-squabble letters had been gracious and diffident, the post-1925 letters were filled with barely concealed anger; the diffidence was wholly absent. He attacked du Pont for asking $60,000 for *Nenemoosha*, claiming that this was more than twice what *Alicia* had sold for (overlooking the fact that one vessel was two years old and the other twenty), and he delighted in questioning du Pont's competence (although $60,000 was a reasonable price). A week later, it appears that he refused to help broker the yacht, not wanting to see a "fifty thousand dollar check go thru to you." Flipping, he stated that he had recovered "from my severe attack of Dupontitus." Flipping again, he dramatically concluded: "Frankly, I'm ashamed of [*Nenemoosha*]." By May, Carroll was actively blocking interest in *Nenemoosha,* gleefully detailing such exploits to

du Pont and signing one letter, "Your devout enemy." Carroll acknowledged that he might have been shortchanging himself (he would have made $2,000 on the *Nenemoosha* sale, twice what he felt he was owed), but that he received "quite a bit of satisfaction out of it." In July, du Pont's office advised Carroll that *Nenemoosha* had been sold, and for "a sum far in excess of the amount your client offered." Take that. In a remarkable turnaround, it appears that Carroll then asked du Pont for financial assistance. Alfred replied that Carroll should withdraw the suit and request "assistance in a manner as becomes a gentleman." Three days later, the one-sided battle ended when du Pont received a telegram; Carroll finally saw pictures of the new *Nenemoosha* published in *Yachting*. He belatedly acknowledged that his plan had not been stolen, after all, and that the vessel looked "very du Pontesque." He apologized—and then asked du Pont for work!

Alfred, as it developed, also drew the subtle ire of Harold F. Norton, a naval architect with Newport News Shipbuilding, which built the 1925 *Nenemoosha*. In a series of letters to Norton, Alfred boasted that *Nenemoosha* was struck by a series of gales in the summer of 1929, but that such a "sport" met with her approval. "This little craft is the envy of all yachtsmen, who wonder why their boats stay still when mine runs." Alfred also commented that *Nenemoosha* was "now properly manned with decent, self-respecting men," including a new captain, Jesse Smith, Jr. In a response to du Pont's delight, Norton could not help himself: "Of course you know the profit [regarding *Nenemoosha*] was something of a minus quality." Was this a suggestion that Alfred might perhaps forward a bonus for so satisfactory a yacht? Norton further poked, "Your remarks relative to the electric range [presumably as to its operating cost as compared to gas] were read with considerable amusement, but of course when one owns a sufficient block of stock in the General Electric Company, one's interest in the cost of operating an electric range is not particularly acute." Norton did extend one courtesy: relating that du Pont was one of the few men who took such an active interest in the building and maintenance of his yacht.

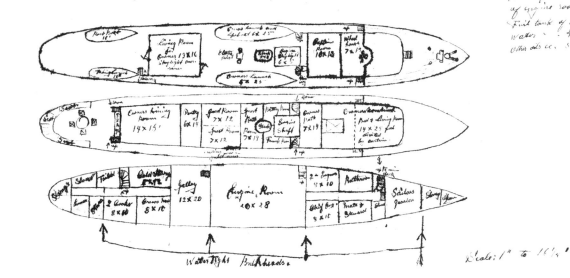

Top right, a preliminary plan of *Nenemoosha* (drawn by Alfred?). This crude plan was transformed into a sophisticated design by A. Loring Swasey of Burgess, Swasey & Paine, but many of du Pont's ideas were not followed. As he was not an easy man to work for, one wonders how Swasey managed this feat. Or did du Pont change his mind?

On the first *Nenemoosha*, the owner's cabin occupied the forward end of the deckhouse, with a nominal dining saloon aft. In the preliminary plans that du Pont presumably drew for the new yacht, an owner's suite—quite vast—was again shown forward. So it is interesting that the du Ponts agreed to use this choice location for a dining saloon (and to end up with an unimposing owner's cabin). Even more interesting is the fact that a dining saloon existed at all. Alfred had complained to Swasey that such saloons were a waste of precious space, and he wished a table incorporated into the main saloon. He considered the forward end of a deckhouse too desirable a location and did not want to waste it with a cabin used only an "hour or two a day."

And though for a man who felt that bathtubs were useless, Alfred received one nonetheless. Did it incorporate a shower?

Much about *Nenemoosha*'s plan was typical for the era, except for the peculiar location of the owner's cabin, and a head in the engine room—a thoughtful du Pont consideration?

Bottom right, the new yacht is prepared for launching at the Newport News shipyard. Note the bilge keel, which helped stabilize rolling.

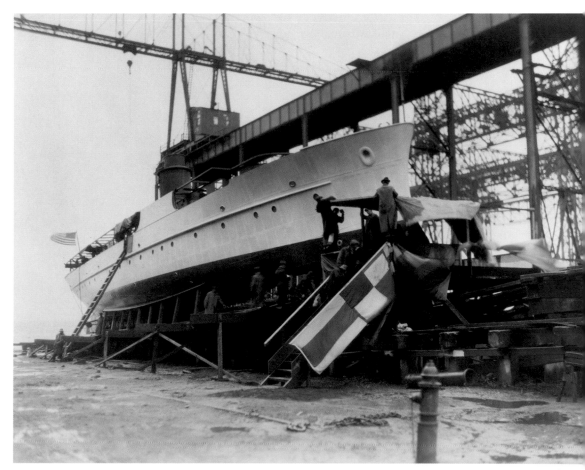

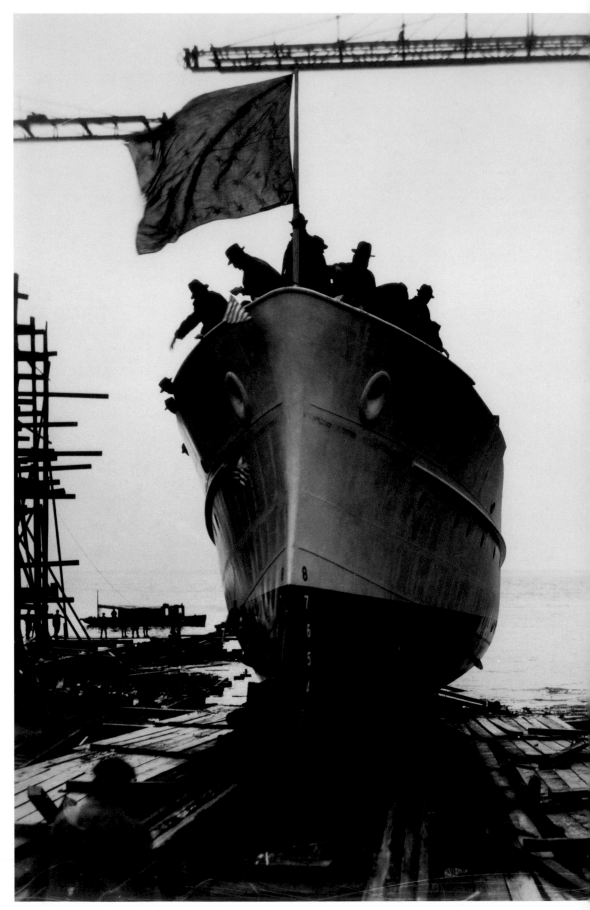

Above, Jessie du Pont prepares, once again, to do the honors.

Right, *Nenemoosha* gliding down the launching ways. At this point, all was not well with du Pont and the yacht's designers. Alfred informed them in December 1924 that he had spent "two days straightening out a hundred and one matters," which he attributed to a lack of proper supervision. He stated that he had left his own people in charge (the captain and the engineer) and would no longer require their services.

Opposite top, this image of *Nenemoosha* dry-docked highlights her unique bow and extraordinary bow carving (added after launching).

Opposite bottom, the dramatic counterstern of *Nenemoosha*. Note the elegant scrollwork.

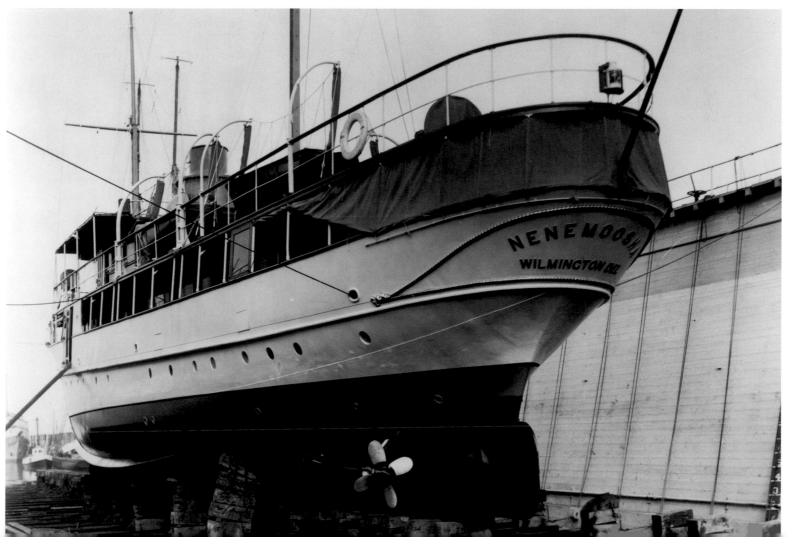

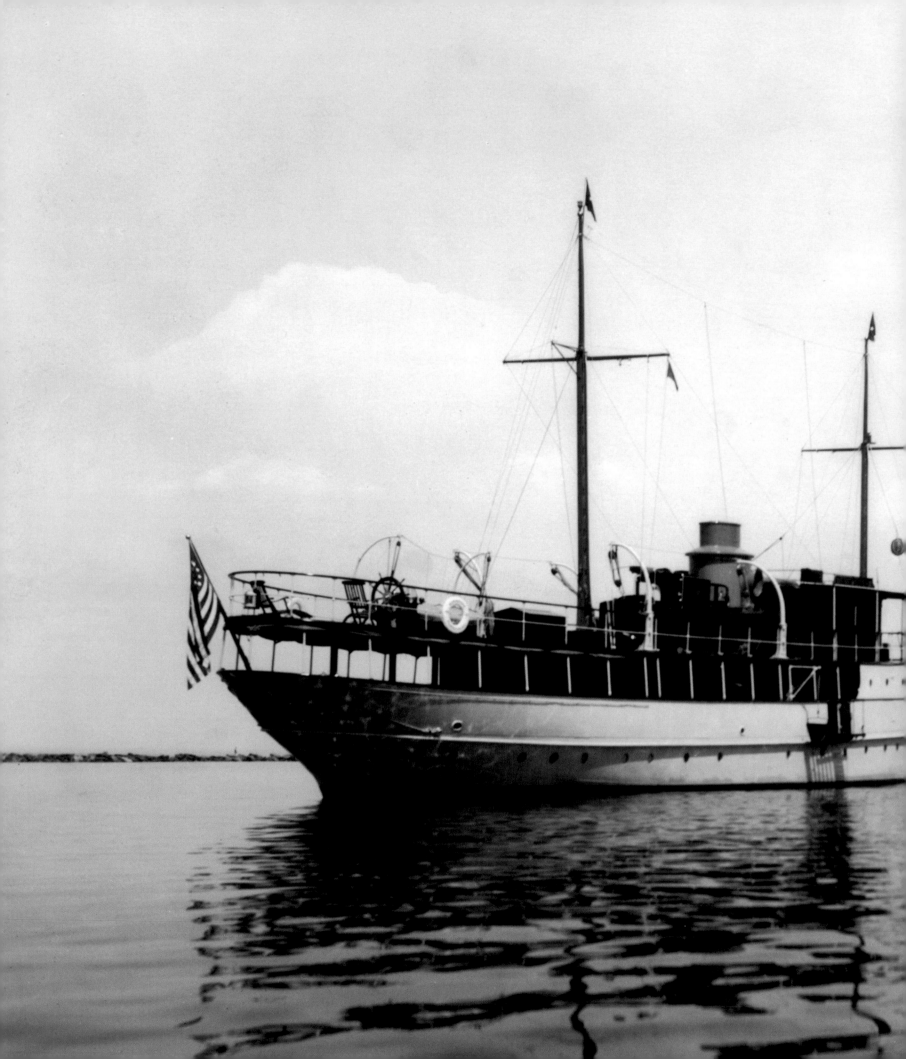

A graceful image of *Nenemoosha*. Note the upper sun-deck, an innovative feature replacing the long canvas overhead then standard, as well as the one-of-a-kind funnel—proof that the unique quality that typified the first *Nenemoosha* was also evident in her successor.

153

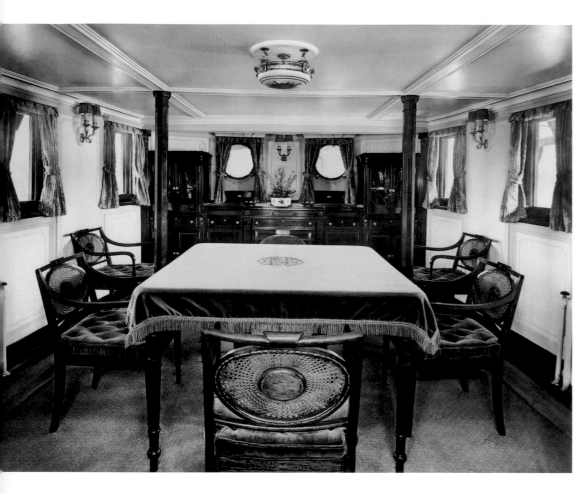

The interior fittings and design of *Nenemoosha* (above) were as remarkable as her outboard profile. A series of octagonal columns finished bright were a highly eccentric feature of the yacht, as the pair in this image indicate (two more were aft, just out of camera range). The reason for their inclusion is unknown. (Du Pont wrote that such "stanchions" were needed to support the weight of the deck above. Yet many yachts had upper decks, and without such elements.)

While *Nenemoosha* was being built, du Pont corresponded with Thomas Hastings, of Carrère and Hastings (the architects of Nemours). Not surprisingly, du Pont had lost all confidence in other types of architects. He wrote: "The so-called naval architects, whom I employed to do some of the drawing and designing of the hull have failed me hopelessly." Alfred claimed that his own engineers were doing "practically all" the draw-

ings. He requested that "some man" from Hastings's office assist with the interior of the yacht in a "simple Colonial" style. Hastings's reaction to this request is unrecorded.

Except for the disappointment of the smooth overhead, this dining saloon offered an attractive and comfortable setting, with the four columns as sentinels.

The first *Nenemoosha* seemed to have lacked a distinct main saloon; this was rectified on her successor with this smoking room (right), a setting that does not appear cozy. The arrangement shown in this image—the port settee bookended by another pair of columns—was a mirror image of the same layout directly to starboard. Opposite the stair (its center position relatively unusual for a motor yacht) was a fireplace. The overhead in this main saloon was more articulated than its complement in the dining saloon.

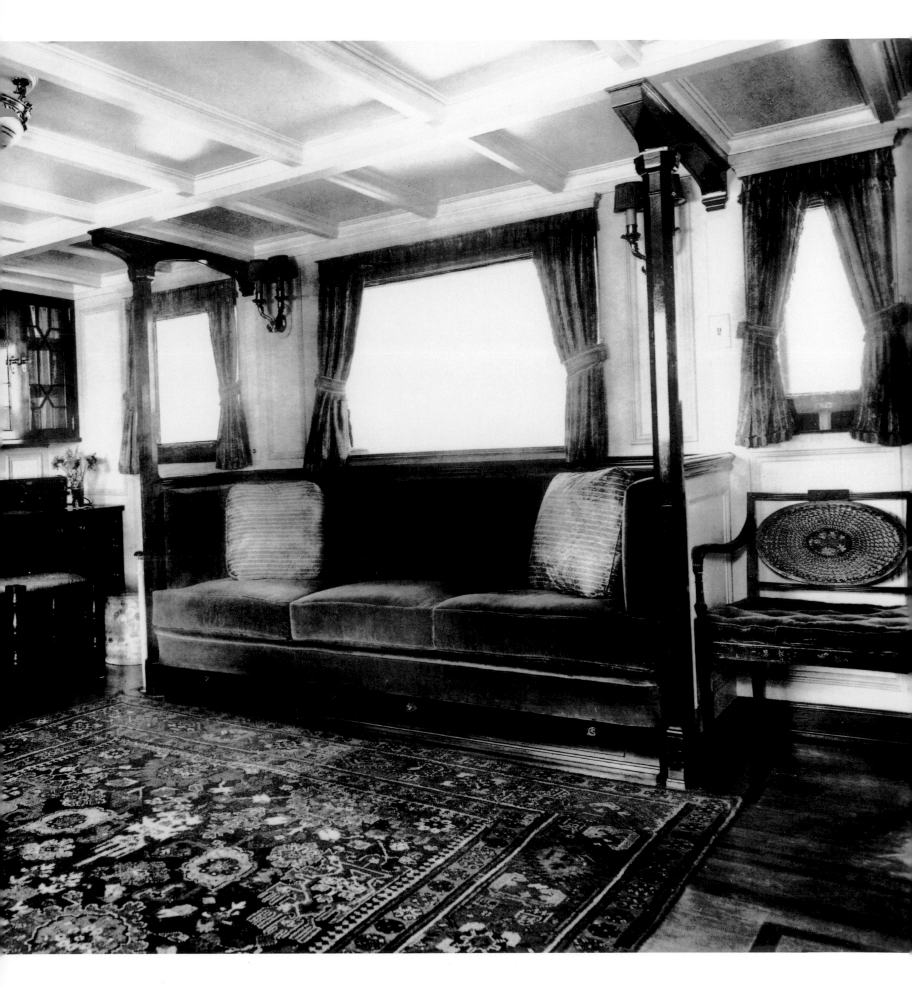

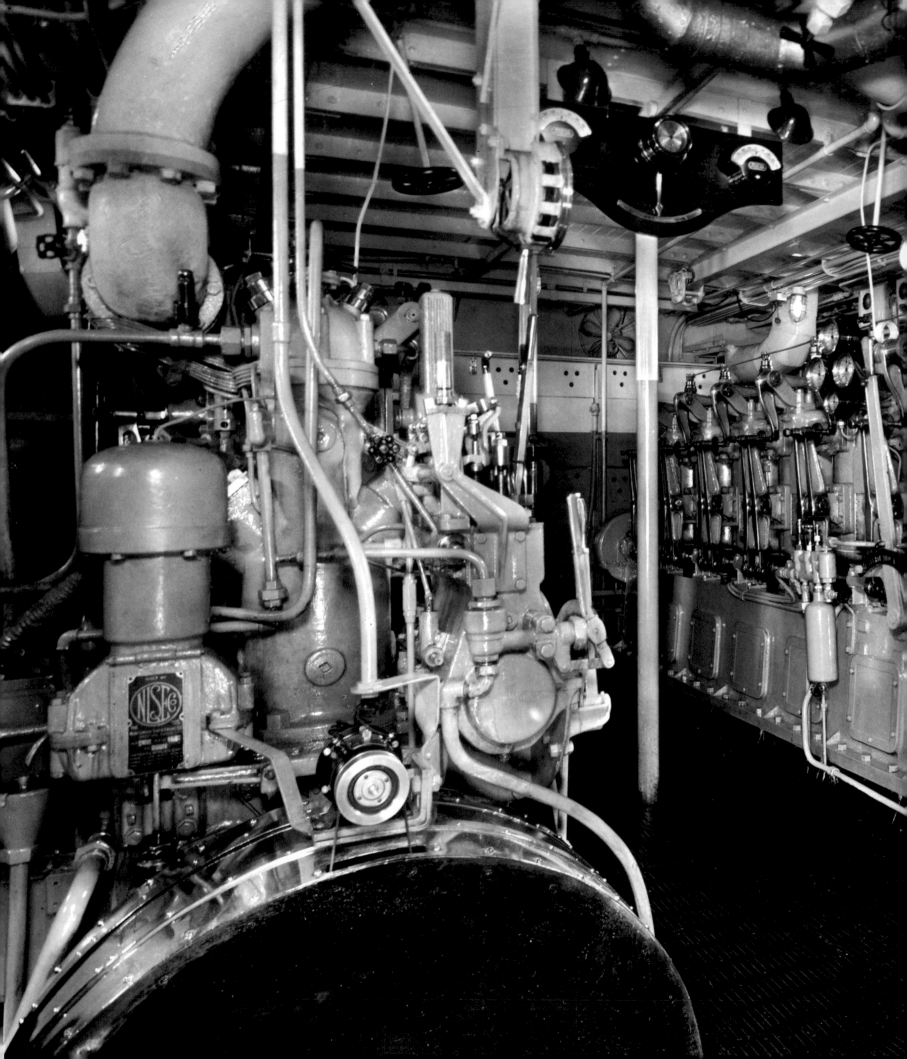

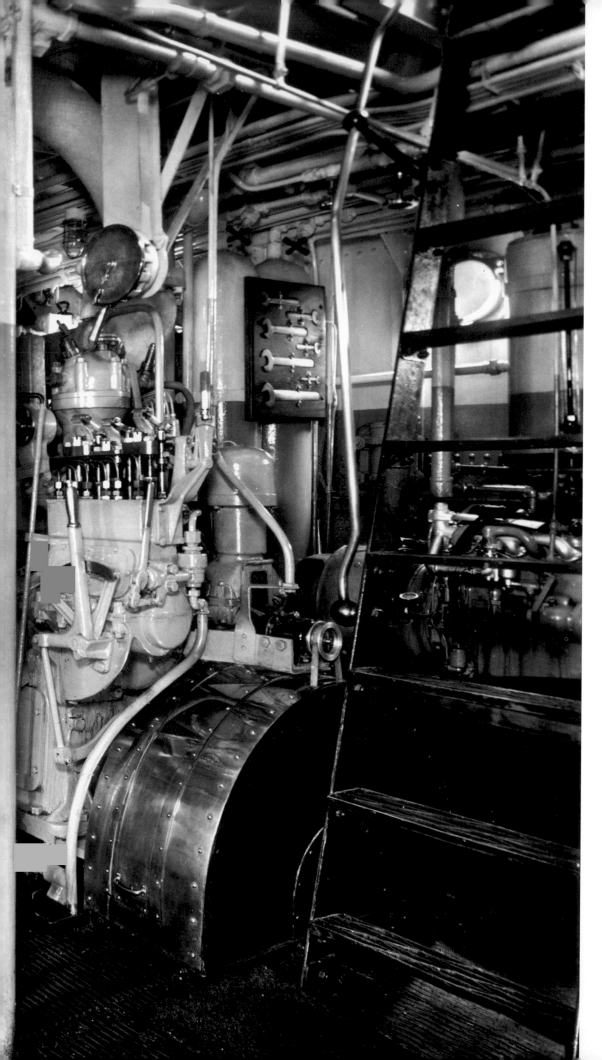

The problems that frustrated du Pont with the Nelseco diesels aboard the first *Nenemoosha* were apparently settled to his satisfaction as he ordered Nelsecos for the 1925 *Nenemoosha*—twin four-cycle, six-cylinder, 9 × 12 ½ diesels. Yet the engines were replaced in 1930 by a pair of four-cycle, eight-cylinder, 9 × 12 Bessemer diesels. This must have pleased Edward Carroll no end; he had criticized du Pont for ordering the problematic "war baby" Nelsecos for the 1922 *Nenemoosha*, and for then ordering the same for her successor.

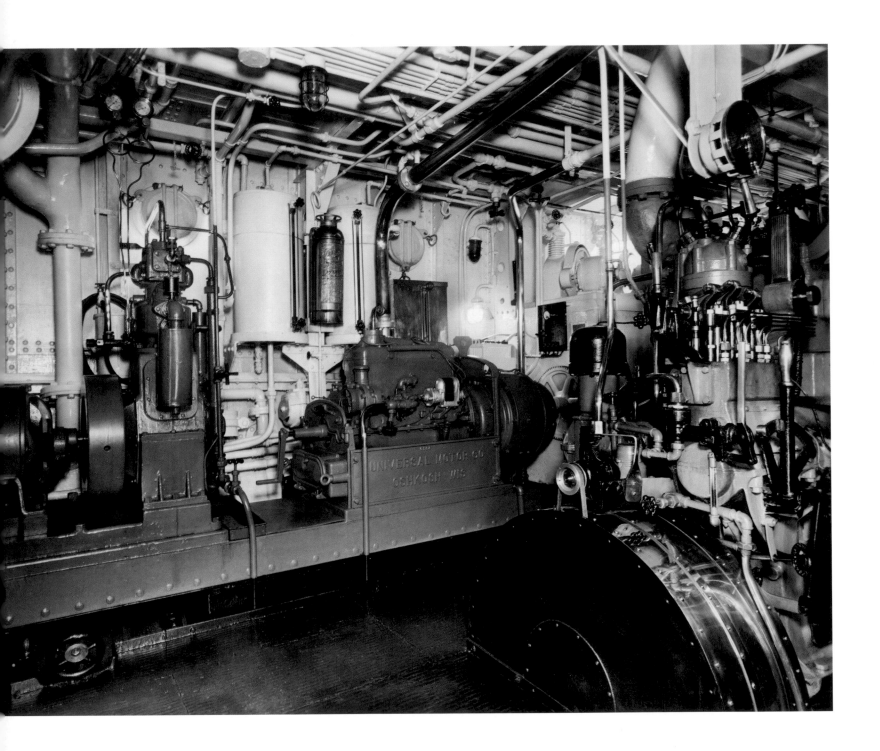

Above, the Universal electric generator, made in
Oshkosh, Wisconsin.

Opposite, *Nenemoosha*'s electric array, by Garrett,
Miller & Company.

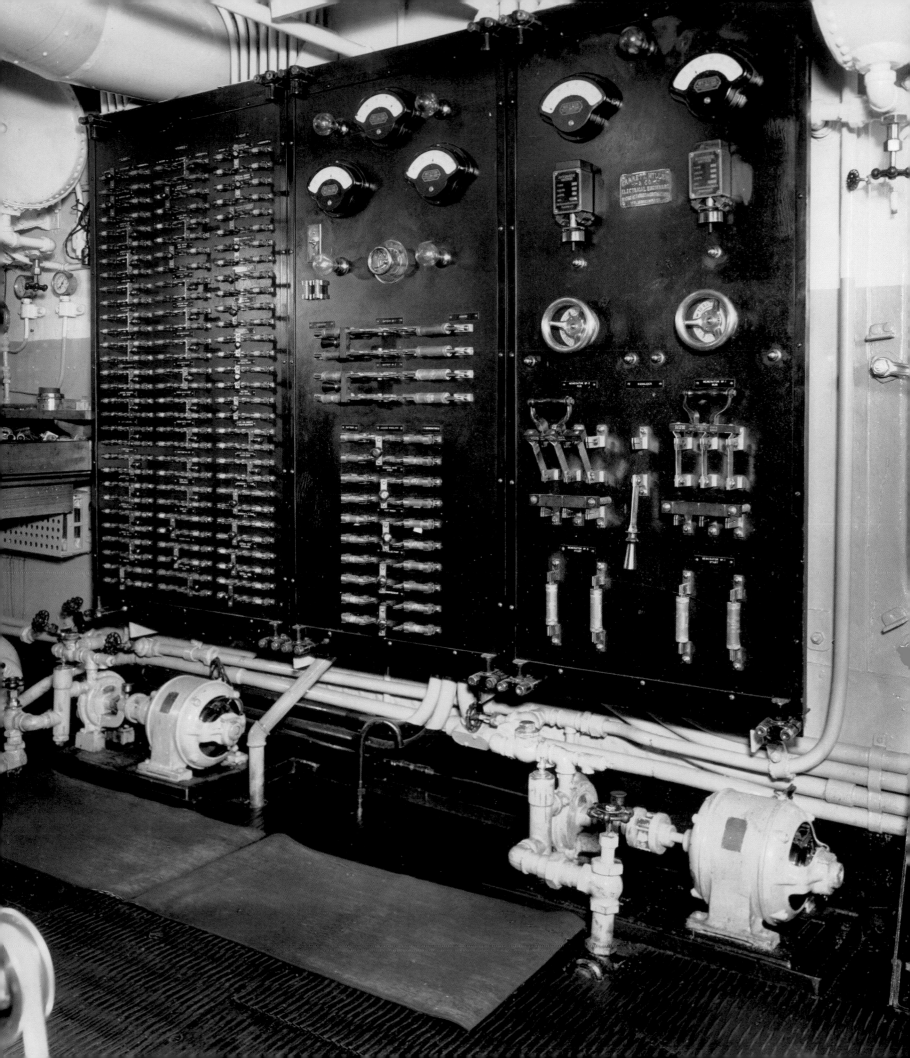

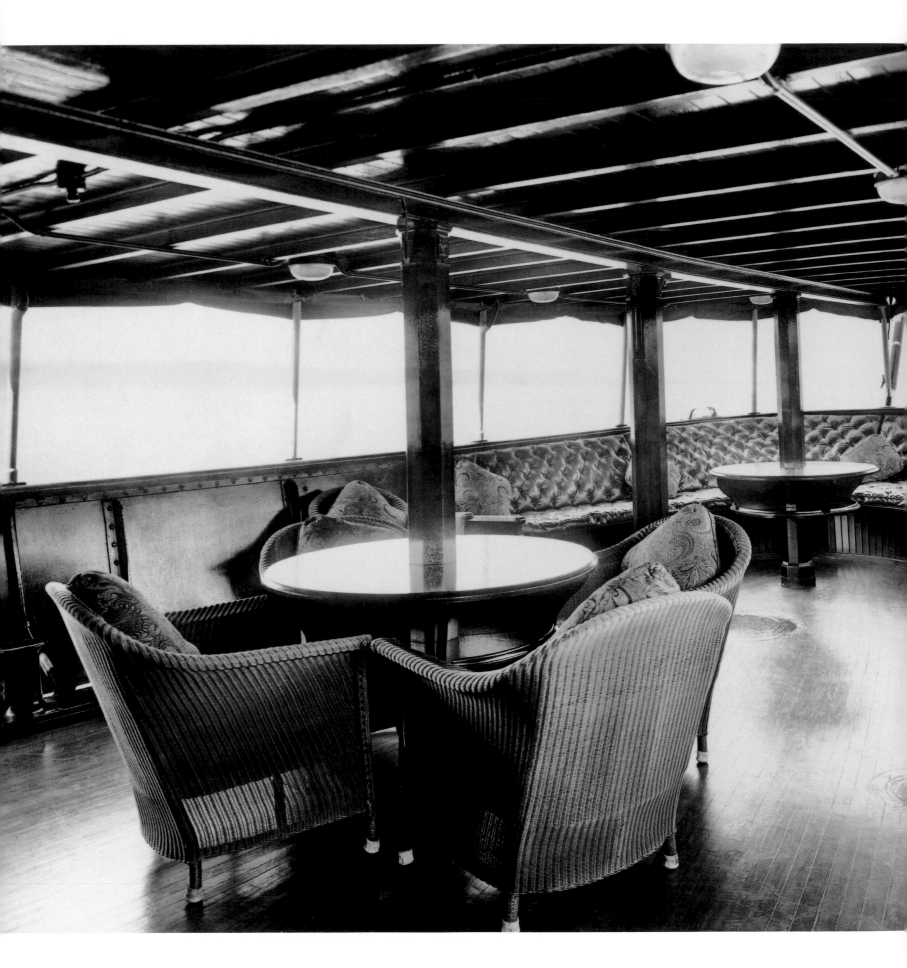

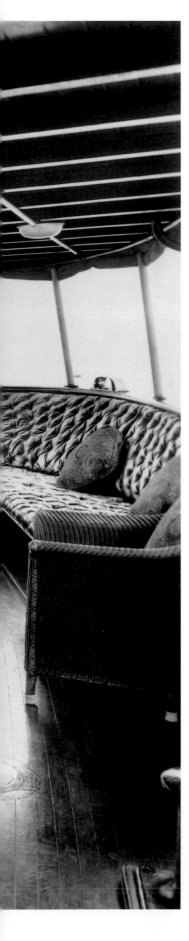

Nenemoosha's aft deck (opposite) provided another re-markable setting. The eccentric columns created a steady rhythm and helped distract from the oppressive solid overhead. The built-in wraparound settee was invit-ingly expansive, while columns pierced the round tables.

Top left, Alfred and Jessie (left), standing on *Nen-emoosha*'s sundeck with Ruth Hurley (her husband, Patrick J. Hurley, was secretary of war).

Bottom left, the searchlight, shined to a mirror-like brilliance, dwarfs an unidentified youngster.

GADFLY

1 9 1 7

In 1934, the du Ponts purchased *Gadfly*, a 107-foot house-yacht built in 1917 for Robert K. Cassatt and previously owned by Jesse Livermore (*The Golden Century*, page 164). The yacht appears to have been berthed primarily in Jacksonville; it is not known why the du Ponts felt the need for a 107-foot yacht concurrent with the 130-foot *Nenemoosha*, although *Gadfly*'s four-foot draft would have allowed her to cruise in shallower waters than *Nenemoosha* could, with her seven-foot draft.

Gadfly was similar in design to Mathis-Trumpy house-yachts of the same era, although lacking the grace of detailing and proportions that defined Johan Trumpy–designed vessels (for more on Mathis-Trumpy, see *The Golden Century*, page 175).

Gadfly was designed by Gielow & Orr, comprising Henry J. Gielow (1855–1925) and Alexander M. Orr (unknown birth and death dates). The partnership was founded in 1910 and dissolved in 1920; Gielow founded Henry J. Gielow, Inc., a prolific yacht design and brokerage firm, which continued after Gielow's death in 1925.

Designed by Gielow & Orr
Built by Kyle & Purdy, Inc., City Island, New York
Two 6-cylinder, 6 1/2 × 9 Winton gas engines

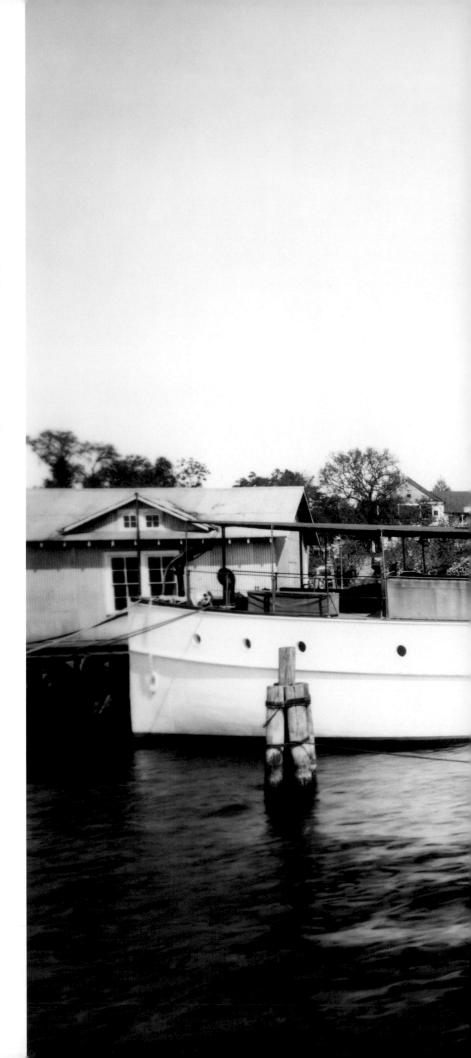

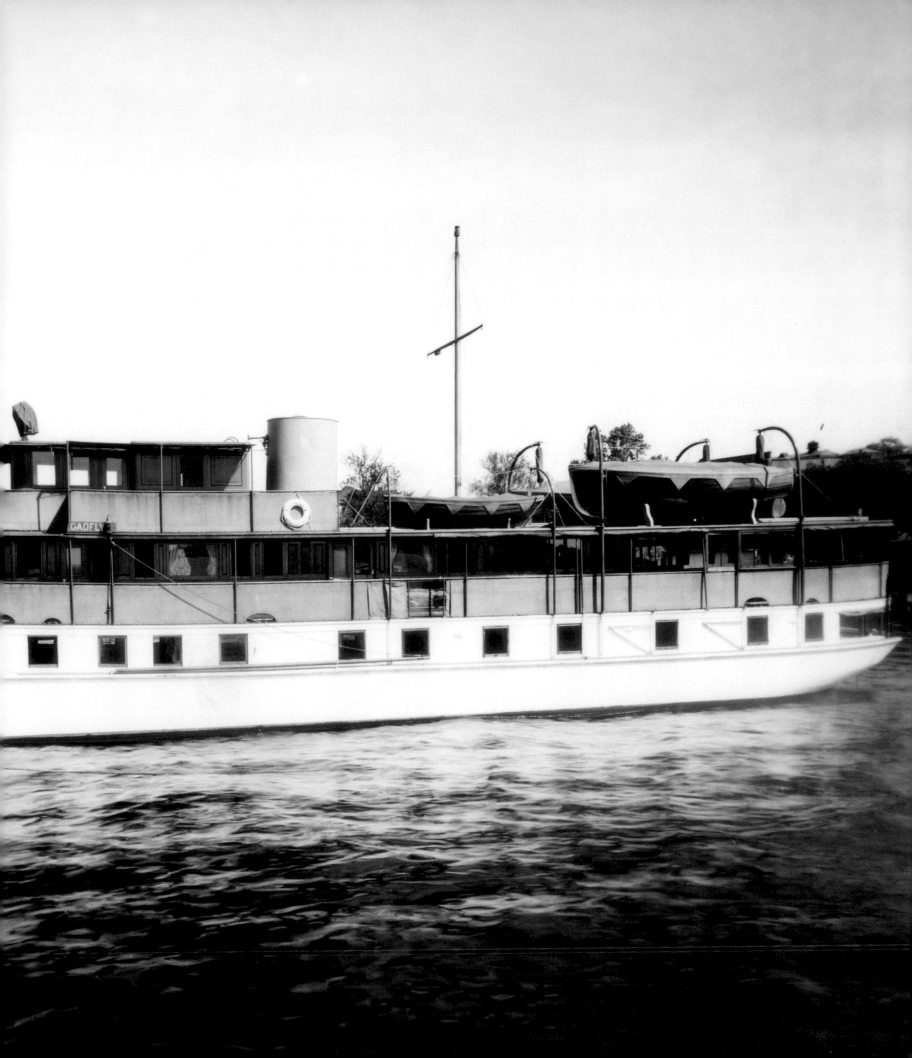

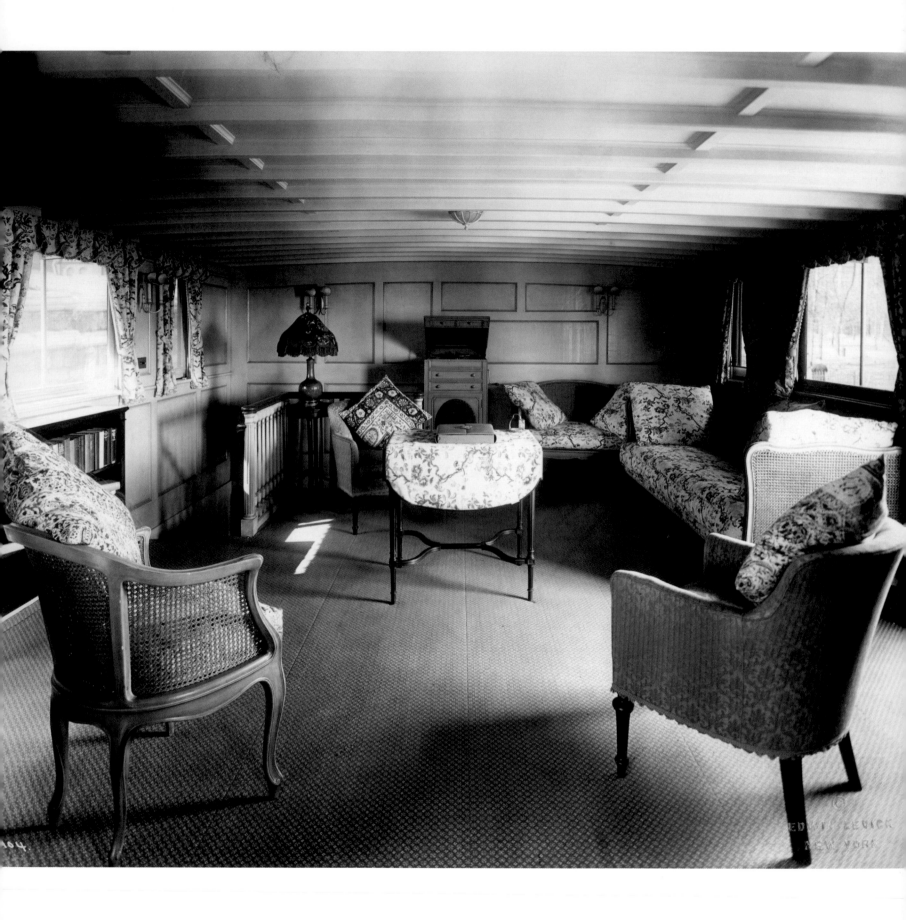

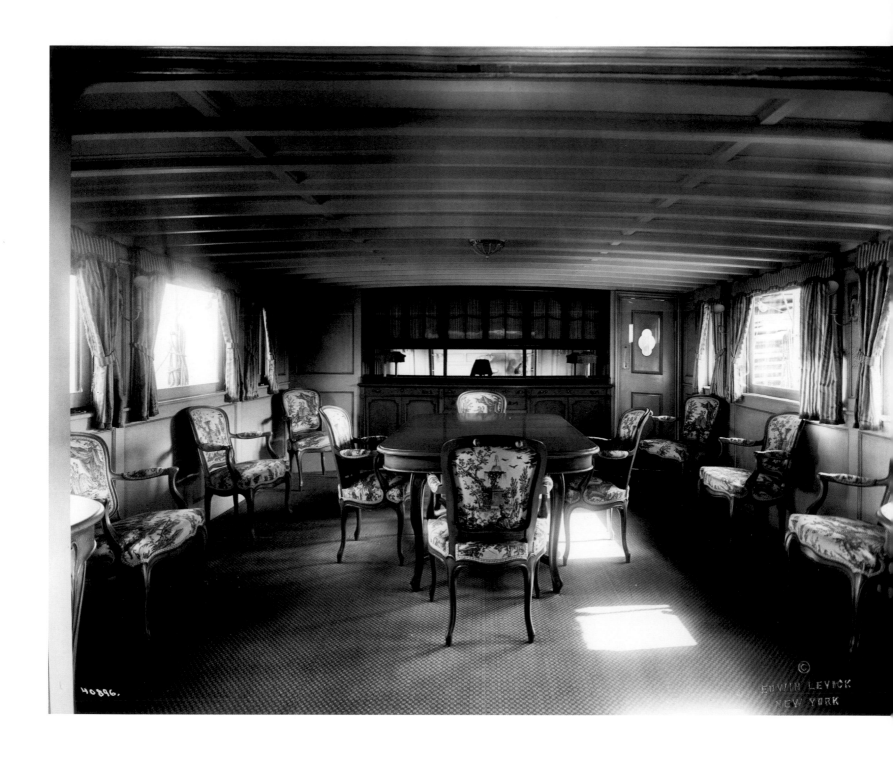

Opposite, the main saloon of *Gadfly* provided expansiveness typical of house-yachts. Compared to the distinctive interiors and detailing of the two *Nenemoosha*s, *Gadfly* seems subdued. One wonders how the du Ponts reacted to this.

Like the main saloon, *Gadfly*'s dining saloon (above) was understated, with incongruous furnishings. It is unlikely that such furnishings were original to the vessel.

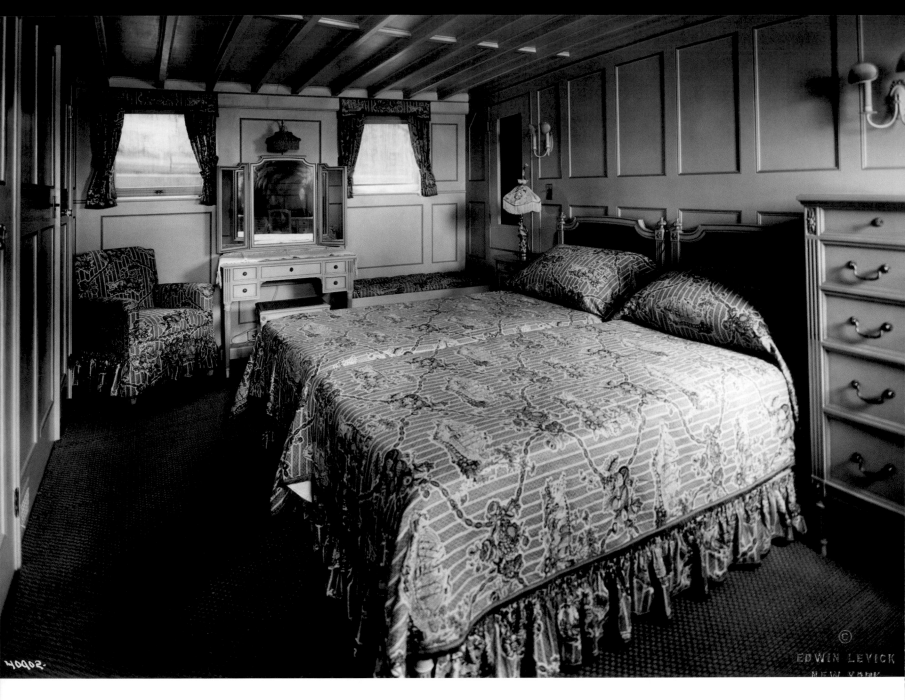

EDWIN LEVICK
NEW YORK

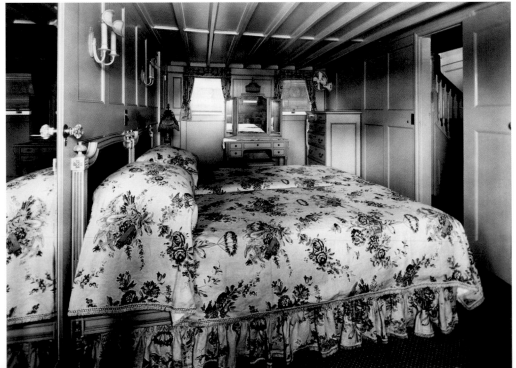

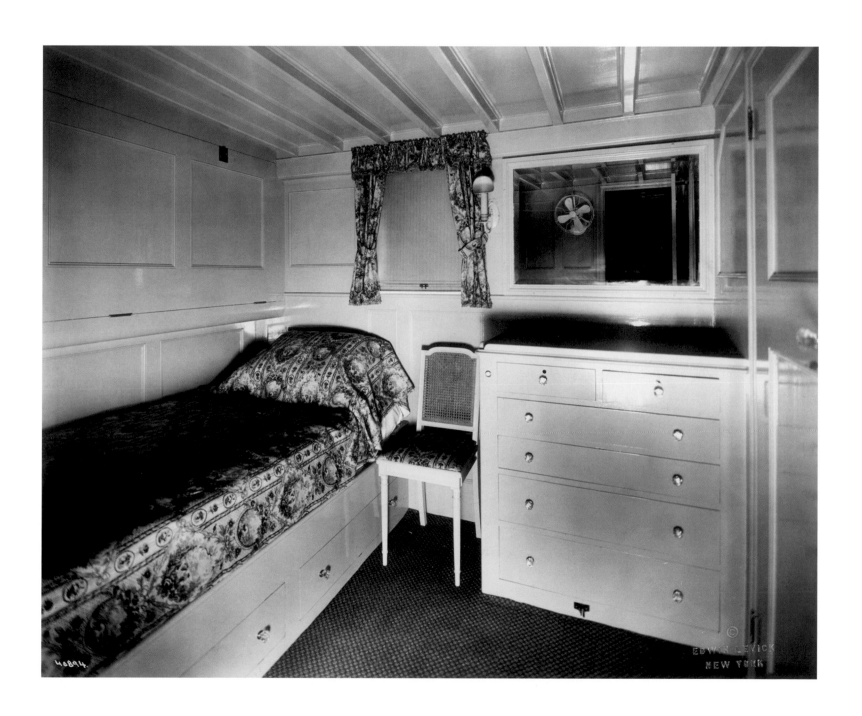

The image, opposite top, would appear to be the owner's cabin aboard *Gadfly*. Again, the freestanding furnishings seem out of place aboard a yacht.

Opposite bottom, a similar stateroom aboard *Gadfly*.

Above, a small, single cabin made appealing be-cause of its scale and built-in furnishings. The large window, typical of house-yachts, would have offered ample light and ventilation. Note the panel above the berth; presumably it dropped down as in a train com-partment to offer an additional berth.

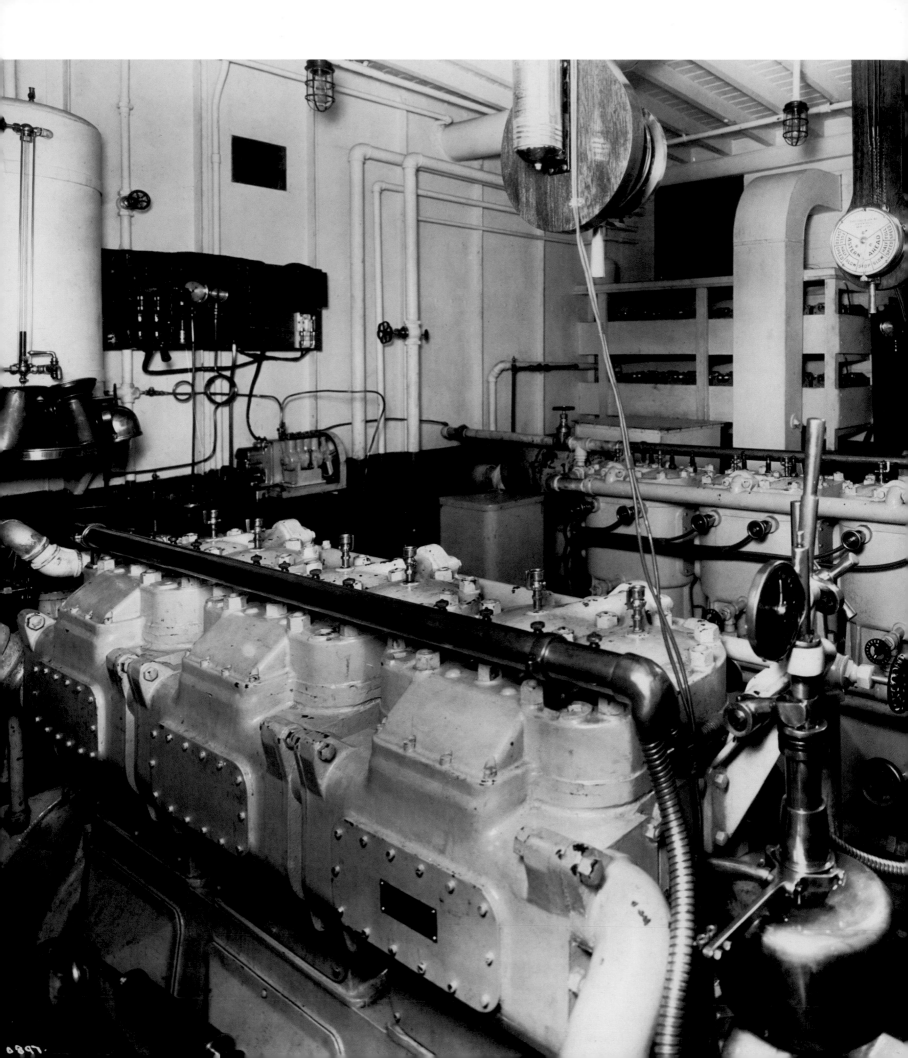

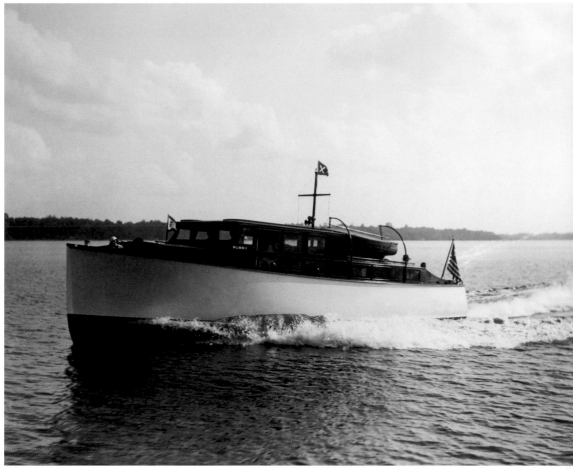

Gadfly's engine room (left); note the builder's plaque on the bulkhead (upper left) and the telegraphs hanging from the overhead. Two six-cylinder, 6½ × 9 Winton gas engines originally powered the yacht. These were replaced in 1921 by a pair of six-cylinder gas 8 × 11 Wintons.

In 1934, the du Ponts also purchased *Mummy* (above), a forty-five-foot Huckins power yacht, and berthed her in Jacksonville. The reasons for this additional purchase are not known, although her small size would have allowed a flexibility unavailable in the two larger yachts.

After Alfred's death in April 1935, Jessie divested herself of *Mummy* by 1937, *Gadfly* by 1941, and *Nenemoosha* by 1942 (donated to the U.S. government). She is not listed in *Lloyd's* after that.

Alfred's dream, the Alfred I. du Pont Institute, opened on the grounds of Nemours in 1940 (today it is known as the Alfred I. du Pont Hospital for Children).

Jessie continued to occupy both Epping Forest and Nemours until ill health in the early 1960s forced her to remain full-time at Nemours. By the 1960s, she was giving away millions annually (reaching a high of almost $3.7 million in 1967). At the time of her death in 1970, she left an estate estimated at $42 million. Her will established the Jessie Ball du Pont Religious, Charitable and Educational Fund, located in Jacksonville. Nemours was opened to the public as Alfred had intended. Epping Forest was transferred to the Alfred I. du Pont Foundation shortly before Jessie's death; the foundation later sold the estate. A real estate corporation purchased it in the 1980s, when a high-end residential community was built on the grounds. The main house, extensively altered, became the Epping Forest Yacht Club. Several main-floor rooms retain their original character, while the riverfront grounds appear essentially as they did in the 1920s.

EMILY ROEBLING CADWALADER

To a researcher, Emily Roebling Cadwalader is an irritatingly elusive figure. Little is known about this woman who is—to a yacht historian—extremely significant: She commissioned the largest private yacht then known (a distinction that rang true until 1999); she also commissioned a vessel that became a renowned presidential yacht. Cadwalader was the granddaughter of the man who built the Brooklyn Bridge and, as such, was familiar with the dramatic statement. Though hardly intended as such, her 407-foot *Savarona* became a symbol of the wild excesses of the 1920s. Remarkably, *Savarona* was but one of five yachts Cadwalader built in just six years. (Emily's husband, Richard M. Cadwalader, Jr., was listed as the owner of the first two vessels, with Emily as the owner of the last three. Was she the driving force behind all five? Anton Fritz, who has extensively researched the Cadwaladers and their three *Savarona*s, believes that Richard was uninterested in things nautical. Conventions of the day thus would explain his initially being listed as the nominal owner, but why did Emily come into her own?)

The couple, who had no children, lived at Fairwold, an 1888 stone house that they purchased shortly after their marriage. Located in Fort Washington, Pennsylvania, the house was extensively altered and enlarged by the couple, and it boasted a ballroom with a loft for a player organ and its twenty ranks of pipes. After Emily died in 1942, Richard (who died in 1960) sold the mansion to George B. Gay, who, unable to maintain it, divided the structure and then donated half to a church, mandating that it be used forever as a house of worship. The Or Hadash, a synagogue, uses it today. The ballroom is a sanctuary.

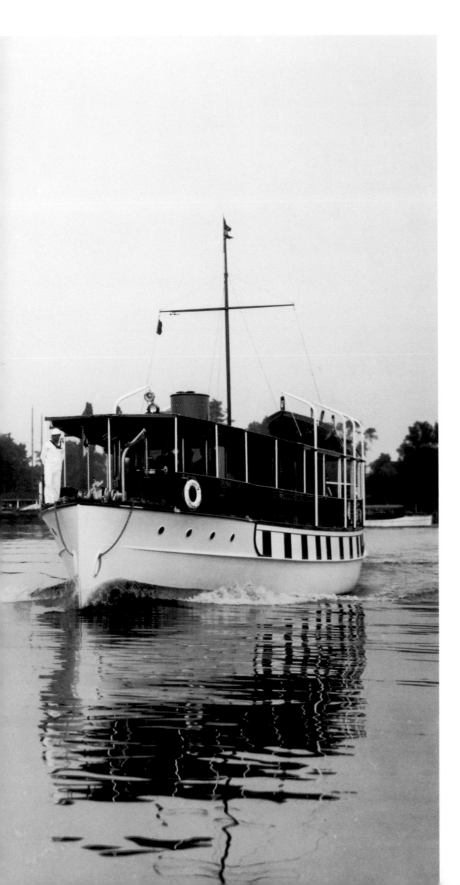

SEQUOIA

1924

Nothing is known about why Emily Cadwalader decided to purchase a yacht, much less why the elegant eighty-five-foot *Sequoia* would lead, in just six short years, to a 407-foot successor. It appears that Cadwalader, in some sort of unexplained yearning, wanted *more*. Within a year, a larger sister ship was accepted; the two yachts were used in tandem until the first *Sequoia* was sold to P. J. Morgan in 1928, who renamed her *Serenia*. Under that name, she was listed in *Lloyd's* until 1962.

Sequoia was designed by Johan Trumpy and built by his Mathis Yacht Building Company (*The Golden Century*, pages 175–91).

Designed by Johan Trumpy
Built by Mathis Yacht Building Company, Camden, New Jersey
One 4-cylinder 5¾ × 7 Speedway gas engine

SEQUOIA II

This 104-foot yacht is today renowned as a U.S. presidential yacht, and her life has been filled with adventure, historic moments, financial pitfalls, sexual escapades, intimate family gatherings, meetings of heads of state, wild parties, disco dancing, wrenching moments (such as when Richard Nixon informed his family about his intended resignation) and, quite likely, guardian angels. *Sequoia II* has been documented to a degree that few, if any, yachts have.

Sequoia II was one of the last Trumpy yachts with a modified transom design; within a year, the company introduced a full counter (see *Freedom*, front endpapers, and *The Golden Century*, page 193) which produced a grace not evident on *Sequoia II*.

As with the first *Sequoia*, little is known about life on board *Sequoia II* during her tenure under the Cadwaladers. When she was replaced with *Savarona* in 1928, the yacht was sold to William F. Dunning of Fort Worth, Texas, who would found an oil company of the same name. The U.S. Department of Commerce purchased the vessel in 1931 for either $48,860 or $200,000 (reports differ); the author suspects the former. Yachts in 1931 were going for fire-sale prices. She was intended to enforce navigation laws and act as a decoy for trapping bootleggers in the Mississippi Delta, but her status was upgraded when Secretary of Commerce Robert P. Lamont brought *Sequoia* to Washington for his personal use. After a fire damaged the presidential yacht *Mayflower*, the *Sequoia*'s status was upgraded significantly further. Herbert Hoover, much maligned by history, would show good character in selecting and loving the yacht; he used her frequently and even showed her off on his 1932 Christmas card.

Franklin Roosevelt—an avid yachtsman—also loved *Sequoia*, and the yacht was altered to fit his special needs. An elevator was installed, allowing the wheelchair-bound president access between decks. FDR enjoyed Potomac and Chesapeake cruises, and an annual voyage to the Harvard-Yale Regatta—always, of course, attracting media attention. Many notables were entertained on board, including Winston Churchill, as well as more discreet guests, such as "constant companion" Margaret Stuckley.

Harry Truman put his personal stamp on the yacht (as he did with the White House, when he ordered the construction of a

Margaret "Daisy" Stuckley, who was FDR's "companion," and often aboard *Sequoia*, was born in 1891 at her family's estate, Wilderstein, in Rhinebeck, New York. The Victorian mansion became celebrated during the latter part of the twentieth century for its genteel decay of "opulent mouldering." The exterior had not been painted in decades, the elements having acted as a thorough, natural paint-stripper. Its elegant interior became a shrine to suspended animation, with an 1888 redecoration startlingly intact, although the silk wall coverings were in melancholy, poetic decay. Before Stuckley died, at the age of ninety-one, she ensured that Wilderstein would be preserved (see Web site: www.wilderstein.org). A battered suitcase found in her cluttered bedroom was filled with correspondence between her and FDR (edited and published in *Closest Companion*, by Geoffrey C. Ward).

Designed by Johan Trumpy
Built by Mathis Yacht Building Company,
Camden, New Jersey
Two 4-cylinder 7½ × 8½ Winton gas engines

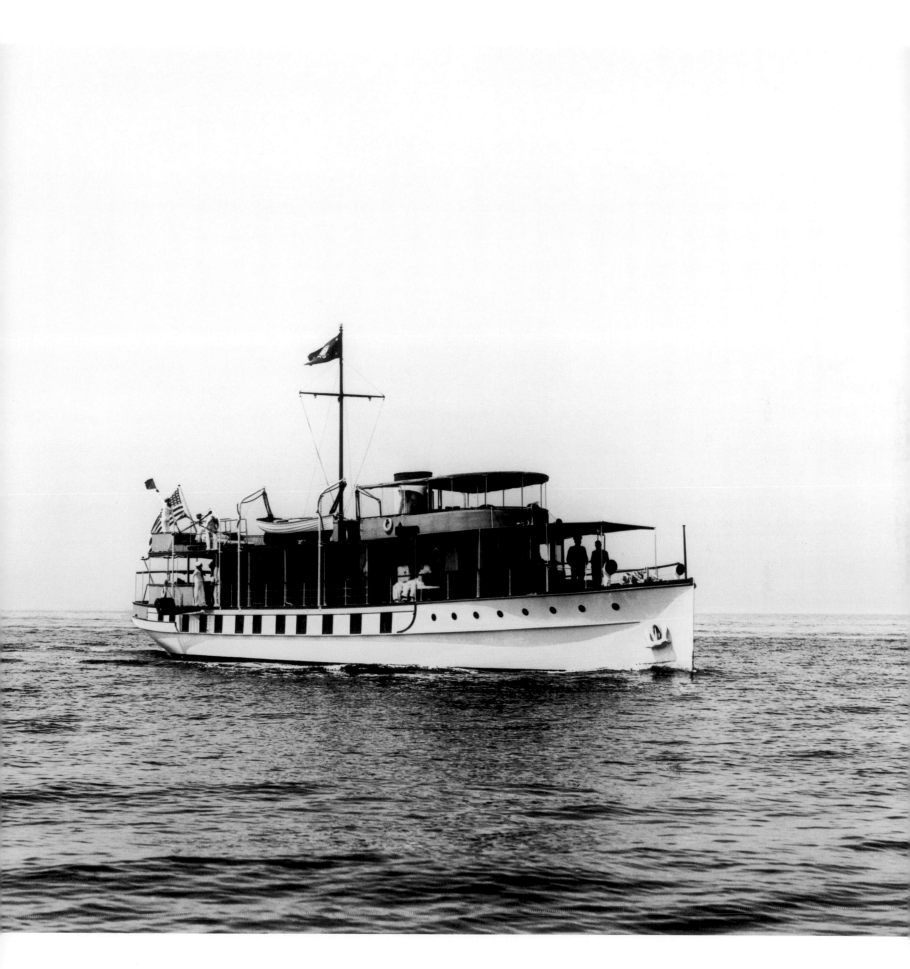

Herbert Hoover aboard *Sequoia*, August 1932. Observe the dark-colored canvas, an important detail not often replicated during a classic yacht restoration, nor found on *Sequoia* today.

balcony nestled behind the columns of the mansion's south portico) by installing a piano and a poker table. The piano, presumably in order to fit, had only sixty-six keys instead of the standard eighty-eight. While Truman enjoyed *Sequoia*, "relishing" a cruise to Key West, he also used the larger USS *Williamsburg* (*The Golden Century*, pages 142–45).

Dwight Eisenhower, a landlubber, rarely used the yacht and never left the Potomac; he preferred golf.

Sequoia returned to her first-rank status upon the election of John F. Kennedy, a lifelong yachtsman. He loved *Sequoia*, and he used the yacht frequently for both official and personal reasons; his last birthday was celebrated on board.

Lyndon Johnson relished the yacht and ordered significant changes. The existing shower would not fit his tall frame; the sole was cut so a lower pan could be inserted. Black walnut joinerwork was installed in the main stateroom, bleached ash in two others; FDR's elevator was converted to a bar; the elegant original, but tiny, Trumpy doorknobs were replaced by inexpensive 1960s versions found in any suburban house; the engines were replaced with twin G.M. 671 diesels; and an array of new navigation equipment was installed.

Richard Nixon used the yacht more than any of his predecessors—eighty-six times. Notable guests included Leonid Brezhnev, Henry Kissinger, and Prince Charles (the bachelor was seated next to then-unmarried Tricia Nixon). Pat Nixon often brought groups of schoolchildren on board. "It was fun having the use of this boat," Nixon observed after his last, sad voyage. His daughter, Julie, thought otherwise, observing that the rest of the family did not enjoy the rather public cruises.

The next president, Gerald Ford, used *Sequoia* little, even though he was a U.S. Navy veteran.

Jimmy Carter, in a move reeking more of public relations than of actually downsizing government expenses, sold the presidential yacht, deeming it "an unjustified and unnecessary frill." (Carter apparently thought otherwise about Air Force One and Camp David.) President Woodrow Wilson claimed that anybody could have done his job—as long as they owned a yacht. "The surest, cheapest way for a president to make friends and soften enemies," Wilson also said. Carter, not paying heed to such sage advice, soon discovered his popularity foundering and his presidency much maligned. What might have happened had he taken advantage of *Sequoia?* Two terms?

In 1977, *Sequoia* was sold for $286,000 to Thomas A. Malloy of Cranston, Rhode Island, who, in turn, resold the yacht four months later for $355,000 to Norman F. Pulliam and twenty-two limited partners. Converted to a South Carolina tourist attraction (at $2.50 a head), the historic yacht was plagued by visitors stealing bits and pieces of her. The partners decided to sell *Sequoia*, but a much-hyped auction produced nothing. The yacht was sold a week later for a reported—and remarkable if true—$750,000 to the Ocean Learning Institute (OLI), of Palm Beach, Florida. OLI president John C. Grant showed a genuine love for the yacht, but it proved harder than he anticipated to raise funds to restore, maintain, and operate her—to say nothing of the $3 million Grant wanted for a marine museum. *Sequoia*, after being ignominiously docked between such vessels as *Hooker* and *Bum-Bum II*, was sold in 1981 for a healthy $1.1 million. The purchaser was the newly formed Presidential Yacht Trust, a group of Republicans, many of whom were affiliated with the American Enterprise Institute. During the ensuing years, the trust was beset with squabbles, resignations, and legal maneuverings. Somehow, though, the trust managed an extensive, fast-track rebuilding during the first six months of 1986, overseen by twenty-four-year-old John Terrill, who commented: "120 volts coursing through 30-year-old wiring did not represent the pinnacle of safety." (Terrill was later made captain, and he graciously gave the author a personal tour.) More than 240 craftsmen, engineers, and electricians worked double, ten-hour shifts every day for six months, replacing 3,000 linear feet of planking and ninety frames. Luckily, the stem and keel were as solid "as the day they had been built in 1925." The yacht's interior—a mishmash of conflicting styles and eras that could only be described as Bureaucratic Modern—was lavishly redecorated by noted New York designer Carlton Varney. While not remotely correct historically (or even nautically), it was nonetheless elegant and inviting—quite likely the best *Sequoia* ever looked, even

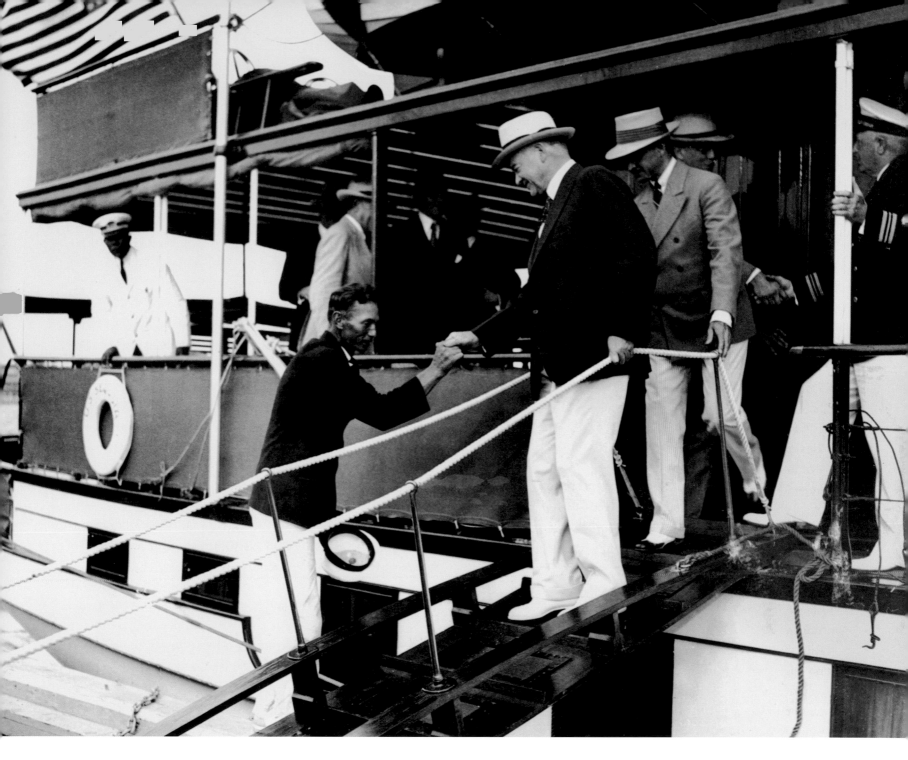

though she was more akin to a floating English country house.

The renewed *Sequoia* left for a 7,000-mile tour of a hundred cities and twenty-two states; she also left behind a lot of unpaid bills. The intention of turning her over to the U.S. government in late 1988 was canceled due to $10 million in debts versus $1.5 million in donations. Finally, in 1991, the yard that did the rebuild, Norfolk Ship and Drydock (Norshipco), seized the yacht for unpaid bills. For the next nine years, Norshipco kept *Sequoia* under cover and in the water. When new owners took over Norshipco in 1998, *Sequoia* was ordered sold. This finally happened in August 2000, when Gary Silversmith purchased the historic

yacht for $1.9 million, intending to create the nonprofit Sequoia Presidential Yacht Foundation and return *Sequoia* to her long-time berth at the Washington Navy Yard, where she may serve as an adjunct to the U.S. Naval Museum and as a cadet training ship.

It is unlikely that *Sequoia* will ever again be used as a presidential yacht. With today's hyper-security consciousness, divers would have to inspect her hull for explosives before any voyage; while underway, several naval vessels would have to escort the yacht, and Secret Service personnel would have to be placed strategically along such routes as the Potomac shoreline. The attendant costs would be prohibitive.

SAVARONA

1 9 2 6

Emily Cadwalader commissioned the eighty-five-foot *Sequoia* in 1924, the 104-foot *Sequoia II* in 1925, and the 185-foot *Savarona* in 1926. The records offer no explanation for this annual—and dramatic—tonnage increase.

Savarona was later renamed *Sequoia* by Cadwalader; this created a myth that she was a presidential yacht, an honor she never served, unlike her 1925 predecessor. After Cadwalader sold the vessel, she was renamed *Allegro* and, in 1929, was purchased by Eugene Francis McDonald (1886–1958). In 1917, McDonald enlisted in the U.S. Navy and served in Washington in the Office of Naval Intelligence. The never-married McDonald had a passion for exploration and archaeology and embarked on numerous expeditions.

But McDonald was also a man with an unusual niche in world history: he was responsible for the television remote control. This device had its beginning in 1918 when a pair of wireless-radio junkies, Karl Hassel and Ralph Mathews, set up a "factory" on a kitchen table making radio equipment for fellow enthusiasts (the Steven Jobs and Gary Wozniak of their day—the founders of Apple Computer). The two men prospered and sold their radios under the name "Z-Nith," after the call letters of their amateur radio station, 9ZN. McDonald, an entrepreneur and former U.S. Navy Lieutenant, backed the fledgling operators; the Zenith

Radio Corporation resulted in 1923 and produced a number of firsts: the portable radio (1924), radios capable of operating on household current (1926), and push-button tuning (1927). Its epoch-making remote control was created in 1950 by Robert Adler and called "Lazy Bones," an apt description. McDonald was thrilled with the invention, as he hated television commercials (believing that television should be run something akin to the way PBS is today), and he realized that viewers could mute commercials with the device.

Decades earlier, McDonald had approached automobile mogul Henry Ford with the idea of selling cars through installment plans; Ford demurred, and McDonald formed a company that purchased cars outright and resold them via such financial arrangements. It proved successful.

After purchasing *Allegro*, McDonald renamed the vessel *Mizpah;* she was acquired by the U.S. Navy in 1942 and served as a convoy escort (*YP-29*). From 1944 to 1945, she served as a navigation school ship before becoming a flagship for Rear Admiral O. M. Read and, later, Rear Admiral Frank E. Beatty. She was decommissioned in 1946 and spent two decades in the South American fruit trade, until a broken crankshaft forced her demise. In 1968, she was deliberately sunk off Palm Beach, Florida, to form an artificial reef.

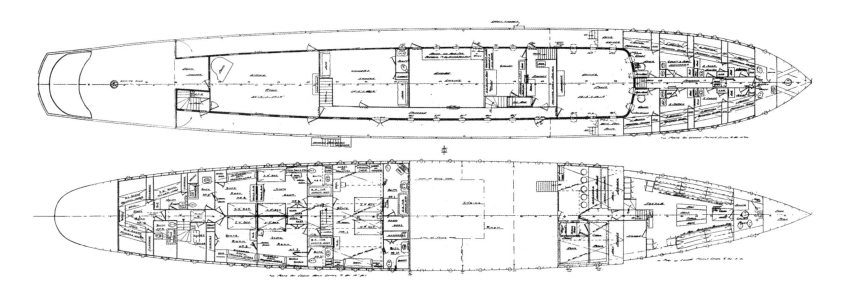

In the early 1930s, designers and brokers Cox & Stevens produced an elegant booklet highlighting various vessels, such as their 1926 *Savarona*, shown here as *Mizpah*.

Cox & Stevens was a dominant force during the 1920s. The principals of the company were brothers Daniel H. Cox (1872–1955) and Irving Cox (d. 1935), and Colonel Edwin Augustus Stevens (1858–1918). Irving Cox had worked at John Roach & Sons, in Chester, Pennsylvania (*The Golden Century*, page 21), while Daniel had been a graduate of the U.S. Naval Academy and attended the Royal Naval College in Greenwich, England. The brothers were partners with William Gardner; Gardner & Cox designed three vessels within this volume: *Oneonta*, *Idalia*, and *Coranto*. A firm called Cox & King (about whom nothing is known) designed *Venetia* (pages 92–97) in 1903. Daniel later developed a partnership with William Gibbs (*The Golden Century*, page 155); Gibbs & Cox designed the 407-foot *Savarona* (pages 192–99).

Philip L. Rhodes (1895–1974) became the chief architect for Cox & Stevens upon the death of Bruno Tornroth (1877–1935), who had been the head designer, as well as a marine engineer and a vice president of the company. Philip L. Rhodes, Inc., succeeded Cox & Stevens in 1946. A large collection of Cox & Stevens material now resides at Mystic Seaport, donated by Philip Rhodes's son, Philip H. Rhodes, in 1975.

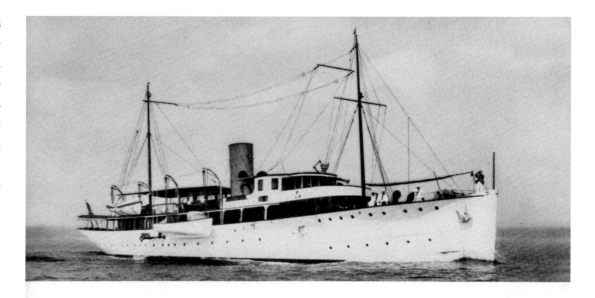

*I*N designing MIZPAH, the Architects were informed that the Yacht would be in commission practically the entire year, being used in Northern waters in the summer, and in Florida and the West Indies during the winter months. These requirements, together with the desire on the part of the Owner for considerable speed, were given careful consideration and resulted in a practical vessel of attractive appearance with unusual accommodations, and having for her type, extreme speed. No attempt has been made to lighten the construction, or in any way sacrifice the seagoing qualities at the expense of speed, but engines of relatively large power have been installed.

The large central deckhouse contains, in addition to the pantry and galley, dining room, library and living room, all of unusually large proportions, attractively laid out and furnished. The quarters for the Owner and his guests are all on the berth deck aft, and as no attempt has been made to crowd in a large number of staterooms, each is large, well ventilated and lighted. The officers and crew are housed forward of the machinery space, there being an upper and lower forecastle.

The appointments of all kinds including furniture, furnishings and decorative features are in accordance with the latest development in yacht design, and no vessel in the fleet has more luxurious living quarters.

The Architects have provided ample space for stores, including cold storage, fuel and water tanks, so that the Yacht may make extended cruises and not be forced to put in for supplies.

Very similar to Arcadia in appearance, MIZPAH has also a record for consistently satisfactory performance.

"MIZPAH"
ex. "Allegro" - ex. "Sequoia"
ex. "Savarona"

L. O. A. 185' 0"—L. W. L. 174' 0"
Beam 27' 0"—Depth 15' 8"
Draft 11' 0"

Machinery—Twin Screw Diesel Engines. Total H. P., 1,800. Speed, 16 knots. Cruising Radius, 9,000 miles. Crew, 28. Staterooms, 7. Baths, 6.

COX & STEVENS, Inc.
331 FIFTH AVENUE
NEW YORK CITY
—
Telephone:
VANderbilt 8011

Page Twenty-seven

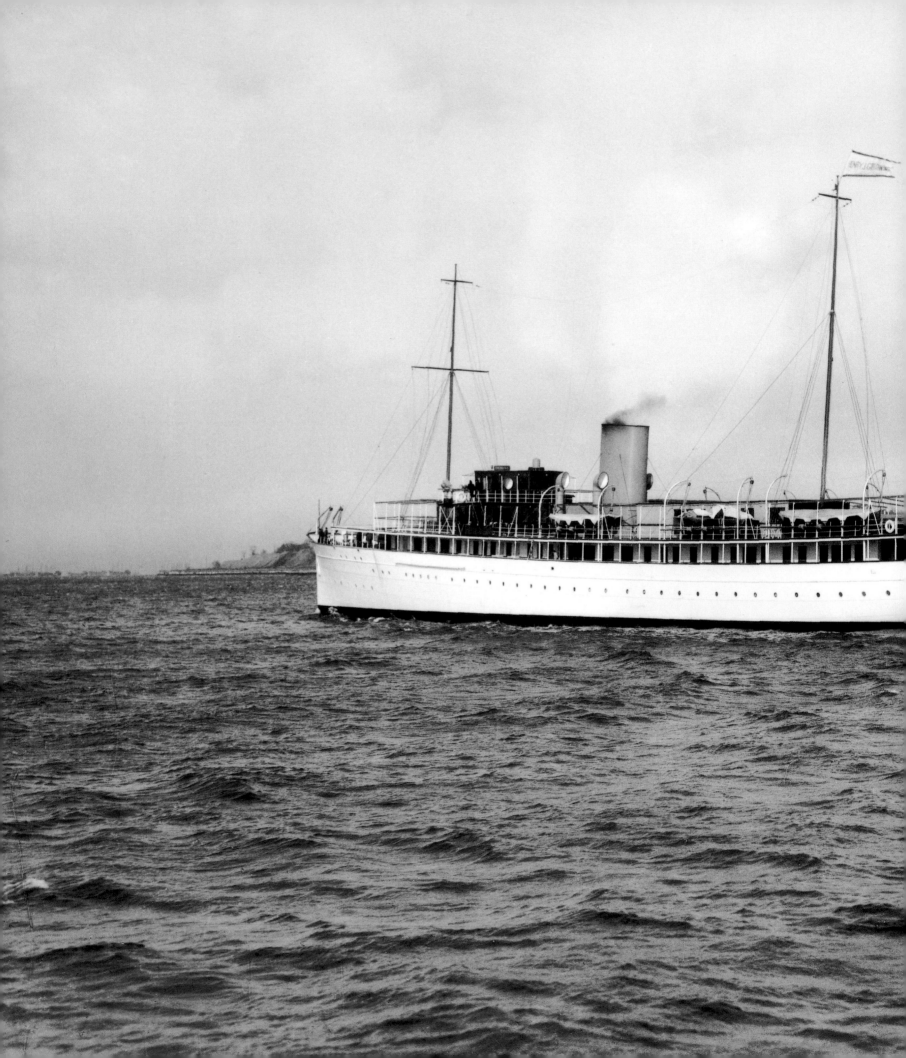

SAVARONA

1928

Emily Cadwalader enjoyed the 185-foot *Savarona* for two years before, yet again, trading up—impressively so. She took possession of a 294-foot, 2,076-ton yacht almost three times the tonnage of her predecessor. The new yacht's first days, however, were inauspicious, almost comically so.

During her maiden voyage from the Pusey & Jones yard in Delaware to New York, *Savarona*'s rudder suddenly proved useless, just as a tramp steamer approached head-on; three whistle blasts warned the steamer away (coming close to the yacht's stern). *Savarona* was "loaded with experts, captains, engineers, yardmen, builders, designers and owner's representatives," none of whom could ascertain the problem. The engines were shut down, the yacht drifted, and the aft deck plates were opened. "McDonald" (presumably Joseph MacDonald, the president of Henry J. Gielow) went below with "spats, cane, silk muffler and derby hat," followed closely by "Sherman Hoyt, the captain, and half the crew." A Bessemer engine employee stayed in the engine room, insisting that "a Bessemer never went wrong." Hoyt found the problem: a keyway had slipped or backed out and the gear shaft revolved idle.

The drama continued. High winds forced *Savarona* to list; shifting the ballast did little good. A gale then encrusted the yacht with a coating of ice. Arriving in New York Harbor at 2 A.M., well before the welcoming committee was awake, *Savarona* dropped anchor. The next morning, it appeared that the anchor was "pretty well on its way to China," as it could not be raised, and it stripped the gears of the anchor winch in the process. After hours of work, the massive chain was cut, dropping "thirty fathoms" into the water.

On the bright side, the gale showed that all the window casings were tight and free from drafts and water leakage, and that the ship was "warm and snug at all times."

Designed by Henry J. Gielow, Inc.

Built by Pusey & Jones, Wilmington, Delaware

Two 1,500-hp 8-cylinder Bessemer diesels that drove her at 14 knots

The snug vessel was not one of Gielow's better design efforts. She lacked the grace more apparent on her successor, and her springy sheer and clipper bow. *Savarona*'s superstructure—decks of stanchions upon stanchions—appeared to be encased in scaffolding, similar to *Lysistrata* from three decades earlier (*The Golden Century*, page 56).

An innovation aboard *Savarona* was her Sperry stabilizer, a "revelation" to those who had never encountered such a device. During heavy seas, the yacht would roll as much as twenty degrees. Once the stabilizer was switched on, the rolling would stop immediately, holding the vessel steady at two degrees.

Emily Cadwalader did not enjoy her steady yacht for long. *Savarona* was sold in 1929, well before her successor appeared, to Colonel William Boyce Thompson, who renamed her *Adler*. Acquired by the U.S. Navy in late 1940, the yacht was converted to a gunboat and renamed *Jamestown* (*PY-55*). During the summer of 1941, *Jamestown* trained U.S. Naval Academy midshipmen, before being converted to a torpedo-boat tender. Berthed in Melville, Rhode Island, she again served as a training ship and a tender for the boats of Squadron 4. In June 1942, *Jamestown* left her comfortable, safe existence and headed to the South Pacific. The marines involved in the offensive against Guadalcanal were suffering critical supply shortages; *Jamestown* was pressed into service escorting resupply vessels, towing barges carrying gasoline and bombs, and, in October, during constant air attack, servicing PT boats. Over the ensuing four months, the vessel worked "feverishly," readying the war-torn PT boats. In January 1943, *Jamestown* entered into a new phase, making "countless" trips from Tulagi to New Hebrides (now Vanuatu) and Rendova to pick up supplies and acting as an escort. After an overhaul, *Jamestown* became a supply ship shuttling material between the Solomon Islands and New Guinea. In early 1945, *Jamestown* was ordered to the Philippines, where she became a floating barracks before resuming convoy duty. She was decommissioned in March 1946 and sold in December to Balfour Gutrie and Company, Ltd. She was sunk near Panama in 1961.

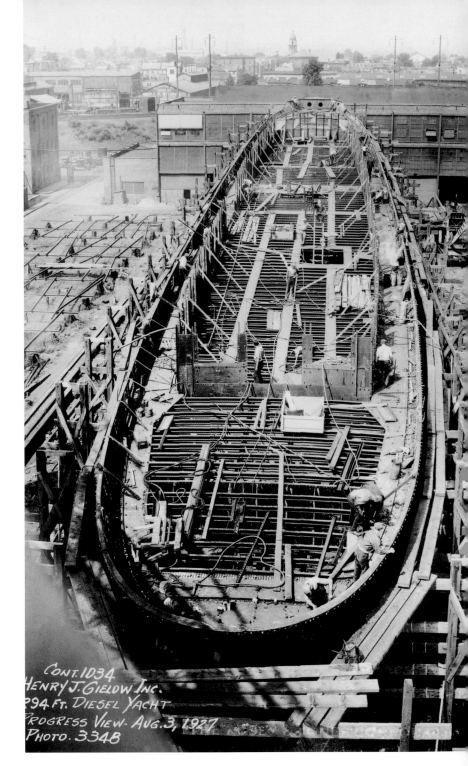

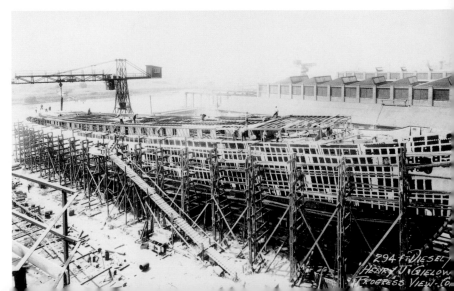

Opposite and below, *Savarona* takes shape at the Pusey
& Jones yard, July 1927.

Bottom, the accommodation plans of the new yacht.

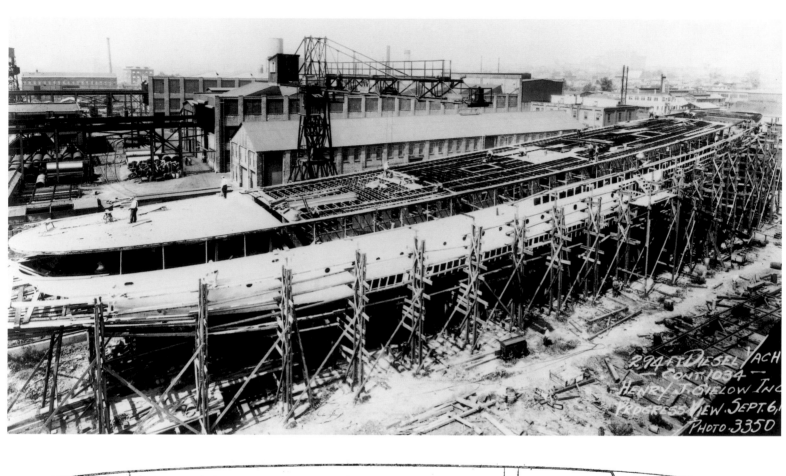

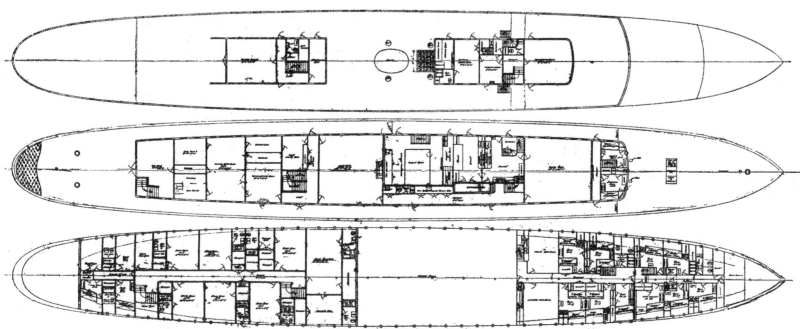

Top left and right, *Savarona* is readied for launching; the massive chains attached to her topsides will drop and arrest the yacht's momentum in the water.

Above left, *Savarona*'s sponsor, Miss Margaret Devereaux, on September 12, 1927.
Above right, the moment.

Opposite, first contact—*Savarona* meets intended element. Observe the chains arresting the yacht's momentum toward the opposite bank.

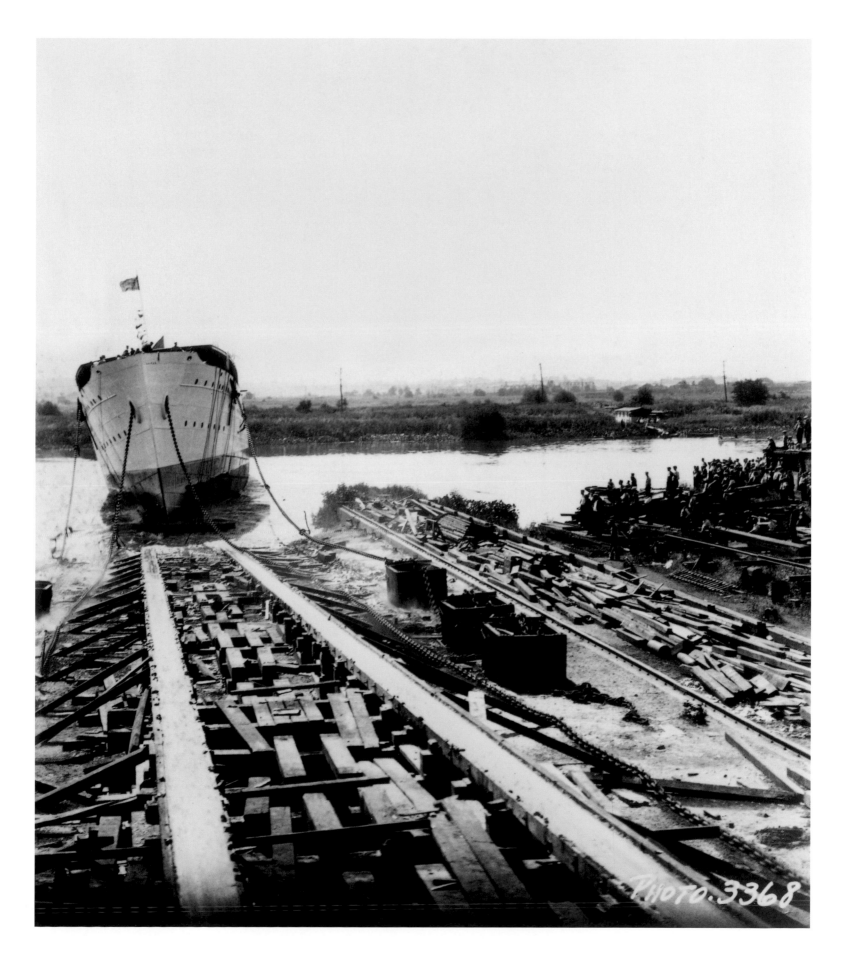

PHOTO.3368

183

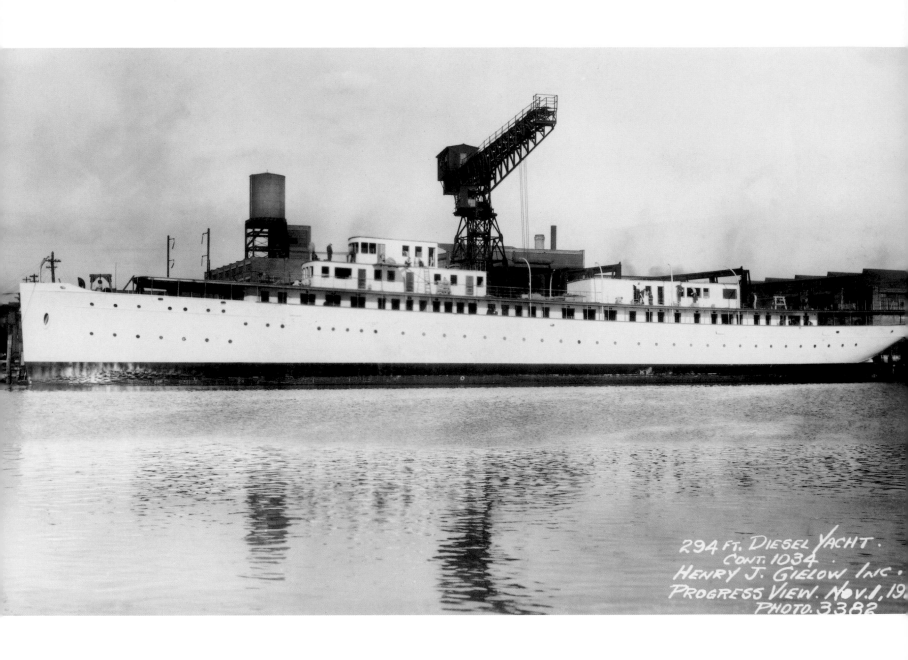

294 FT. DIESEL YACHT.
CONT. 1034.
HENRY J. GIELOW INC.
PROGRESS VIEW. NOV. 1, 19
PHOTO. 3382

Launching a vessel does not mean she is complete.
Equipment, engines, superstructures, joinerwork, and
carpets all still have to be installed. In the two adja-
cent images, *Savarona* slowly takes form, like a giant
Erector set.

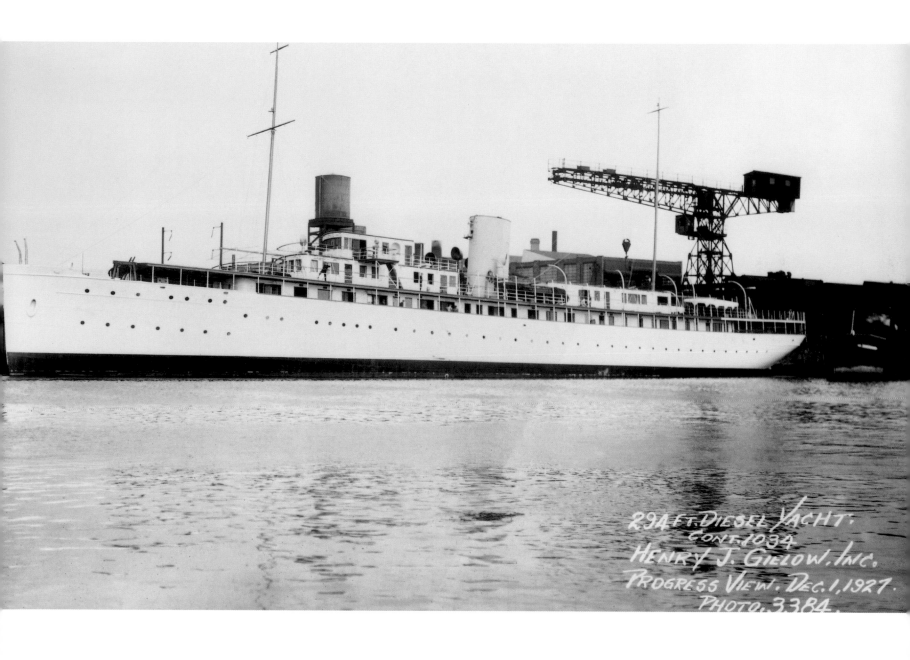

294 Ft. Diesel Yacht.
Cont. 1034
Henry J. Gielow, Inc.
Progress View. Dec. 1, 1927.
Photo. 3384.

Savarona's engine room towered three decks high. The lower level was the base for the main equipment and engines; deck two offered access to the top of the engines and valves, while the upper level was flush with the main deck—the whole having "unlimited" ventilation.

Left, a Sperry stabilizer occupied the forward end of the compartment; just aft lay a pair of six-cylinder Bessemer engines that supplied power to the genera-

tors and a three-cylinder Bessemer auxiliary plant. Next aft were the main propelling engines: twin 1,500-hp Bessemer diesels. The fuel tanks held 102,000 gallons, which allowed a cruising range of 20,000 miles.

The view above was photographed from deck two, likely looking aft.

Below, the main propulsion engines viewed from the lower level of *Savarona*'s engine compartment.

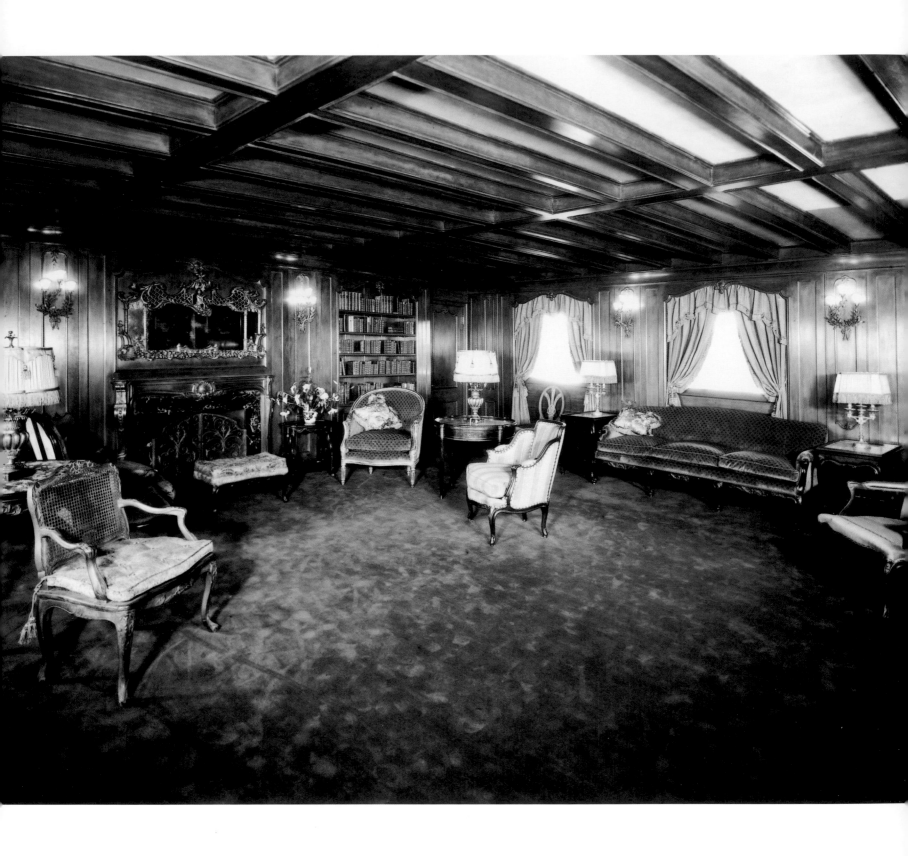

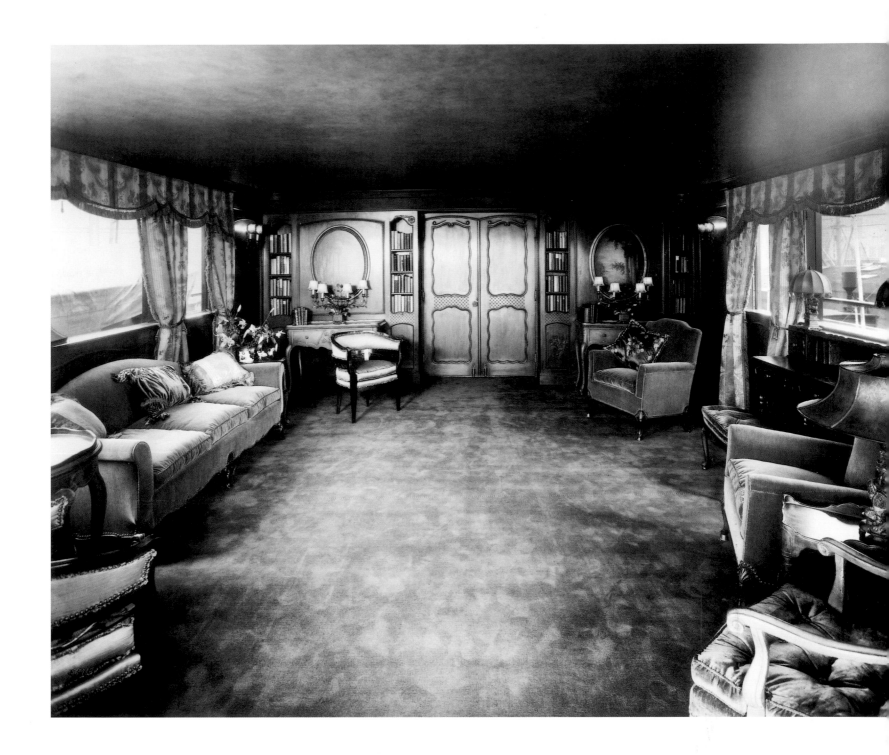

Savarona's deck-level main saloon (opposite) was attractive, with the highest-quality joinerwork, but it lacked the intimate charm of, say, *Idalia* (page 41). This was a setting more imposing than inviting, and it did not convey what one would assume to be an appealing feature: that such a setting floated.

Above, this would appear to be the upper-deck saloon. While contemporary literature applauded the quality of the joinerwork as "beyond an ordinary job" and without any visible seams, the fact that some of it was painted pink would seem an affront to nautically minded sensibilities—understandably so. The smooth overhead also disappoints.

Below, Emily Cadwalader's cabin; only the ports offered evidence that this was a yacht.

Opposite, a more intimate stateroom; again, except for the ports, this setting could easily appear to be in a deluxe, and rather fussy, hotel.

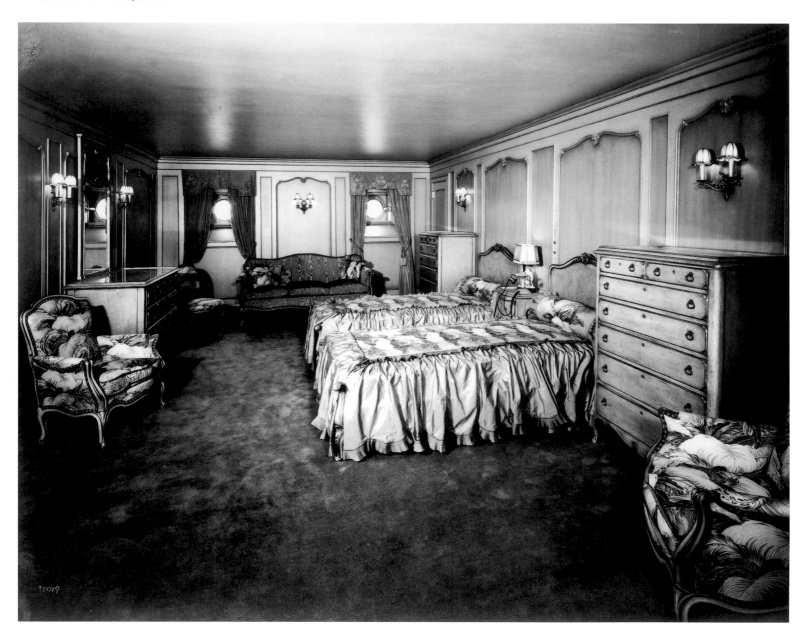

William Boyce Thompson (1869–1930), who purchased the second *Savarona* from Emily Cadwalader, was born in Alder Gulch, a Montana mining town. At eighteen, he was sent to Phillips Exeter Academy, New Hampshire; later he attended Columbia University's School of Mines. Returning to his home state after his freshman year, Thompson worked for his father in family-owned copper and silver mines. He married Gertrude Hickman in 1895, and the couple moved to New York City, where Thompson proved unique among Wall Street traders: a man with a thorough knowledge of the mining business. By 1906, prudent investing had netted Thompson his first million. He later developed American, Canadian, and African mines (the latter for diamonds) that proved impressively successful. To celebrate, Thompson commissioned the noted firm of Carrère and Hastings to design a sprawling estate, Alders (after his birthplace), in Yonkers, New York, for his family (he and Gertrude had a daughter). Thompson became the first director of the Federal Reserve Bank, helped finance a Red Cross expedition to Russia, contributed to the Russian government of Aleksander Kerensky, and later advocated for the support of the Soviet government. In

1924, Thompson, concerned about an expanding global population and the necessity of feeding this growth, founded the Boyce Thompson Institute (BTI) for Plant Research, in Yonkers, with a $10 million endowment. (BTI is extant today, although it has relocated to Cornell University in Ithaca, New York.) Also in 1924, the Boyce Thompson Arboretum was created on the banks of Queen Creek, east of Phoenix,

adjacent to Thompson's western home, Picket Post House. A year later, Thompson suffered a stroke from which he never fully recovered. His purchase of *Savarona* was perhaps a way to effect some healing. After the 1929 stock market crash, Thompson sold heavily. At his death in 1930 (at age sixty-one), he was down to his last "one hundred million."

In a strange bit of history, Thompson had, before

his marriage, dated a young woman named Martha, from Fall River, Massachusetts. The two exchanged many letters ("My very best times have been with you," he wrote), and it is clear that Thompson was thinking of asking the young woman—who become infamous as Lizzie Borden—to marry him.

Boyce previously owned the 1921 *Nourmahal* (see *The Golden Century*, page 91).

SAVARONA

1930

One would think that the 294-foot, 2,076-ton *Savarona* of 1928 would have served any owner well, and with distinction. Apparently, however, this was not the case, as Emily Cadwalader placed an order for a successor more than twice the tonnage: the 407-foot *Savarona* (III), which captured, hands down, the "world's largest" title upon her launching in 1931. It is difficult to realize the scale of the new yacht—4,581 tons—particularly when one considers that the impressive 344-foot *Corsair* (IV), at 2,142 tons, was less than half that gross tonnage (see *The Golden Century*, page 150).

Superlatives aside, Cadwalader's yacht became a white elephant. The import duties would have been so great for the German-built yacht (reportedly equal to her construction costs) that she never entered American waters. She had a crew of eighty-three with a reported annual payroll of $250,000, enough to concern even the heartiest millionaire. Cadwalader used *Savarona* for only two seasons, after which the yacht either remained idle or was chartered, although the $80,000 monthly rental fee discouraged even millionaires during the early 1930s.

In 1938, the Turkish government purchased the $4 million yacht for $1 million (reportedly), to be used by beloved President Mustafa Kemal Atatürk. Terminally ill, Atatürk would spend only six weeks aboard the yacht, holding cabinet meetings and receiving heads of state, such as King Carol of Romania. In November, Atatürk died in Dolmabahce Palace, in Istanbul.

After being laid up for many years, *Savarona* became a school ship for the Turkish Navy, and the ensuing decades passed uneventfully. In 1979, after a fire, the government decided to scrap the vessel, and mounds of debris were removed from the ship and discarded. In a startling turn of events, Kahraman Sadikoglu, a Turkish entrepreneur, leased the yacht for forty-nine years (in partnership with a Japanese property company, Kajima) and embarked on a $20-million, three-year restoration and rebuild. Apparently, Sadikoglu had admired the vessel since he was a child. The Turkish government mandated that the exterior be restored; Sadikoglu gutted much of the remaining interior and scrapped the original steam engines (replacing them with twin 8,200-hp Caterpillar diesels). Only bits and pieces of the original interior survived;

British designer Donald Starkey reportedly discovered parts of the original stair balustrade lying in a pile of debris. He removed all he found, and the items stand today thus resurrected. The stateroom used by Atatürk has been preserved as a shrine (also

Designed by Gibbs & Cox
Built by Blohm & Voss, Hamburg, Germany
Six geared steam turbines
Four Blohm & Voss water tube boilers, 400 lbs. pressure;
water tube donkey boilers, 200 lbs. pressure

mandated by the Turkish government). Donald Starkey's new interior is typical of sleek modern yachts.

One can charter Emily Cadwalader's dream for about $50,000 a day. She is docked in a harbor along the Bosphorus in Istanbul.

(Oddly, *Savarona*'s name has never been changed, a relatively unusual phenomenon for a yacht of such vintage. She was supposed to be called *Gunes Dil* by the Turkish government, but the name never took.)

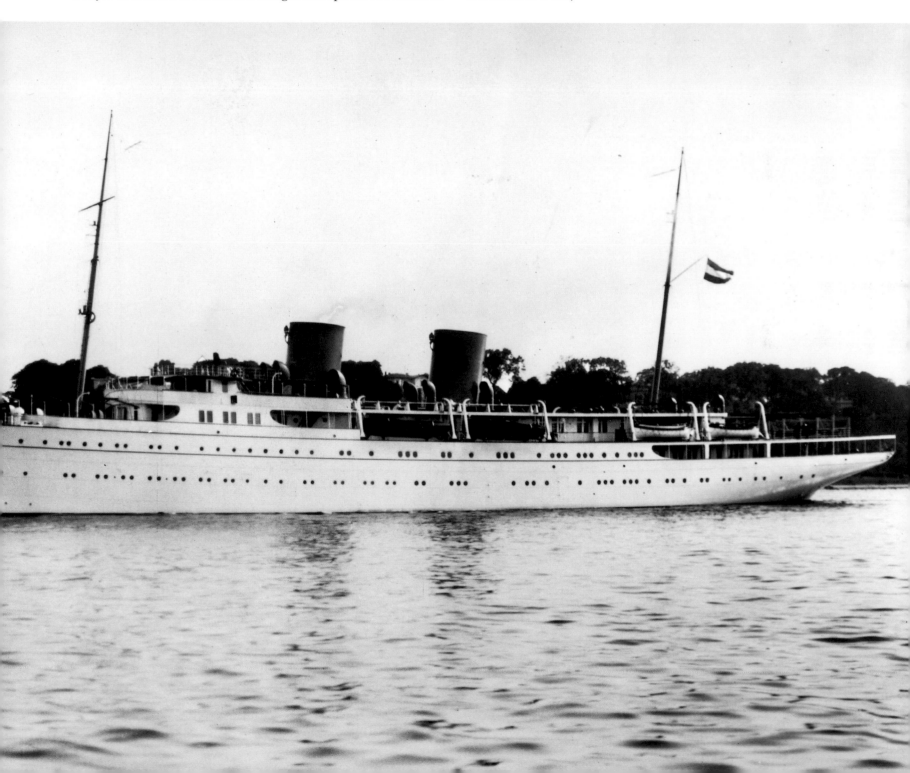

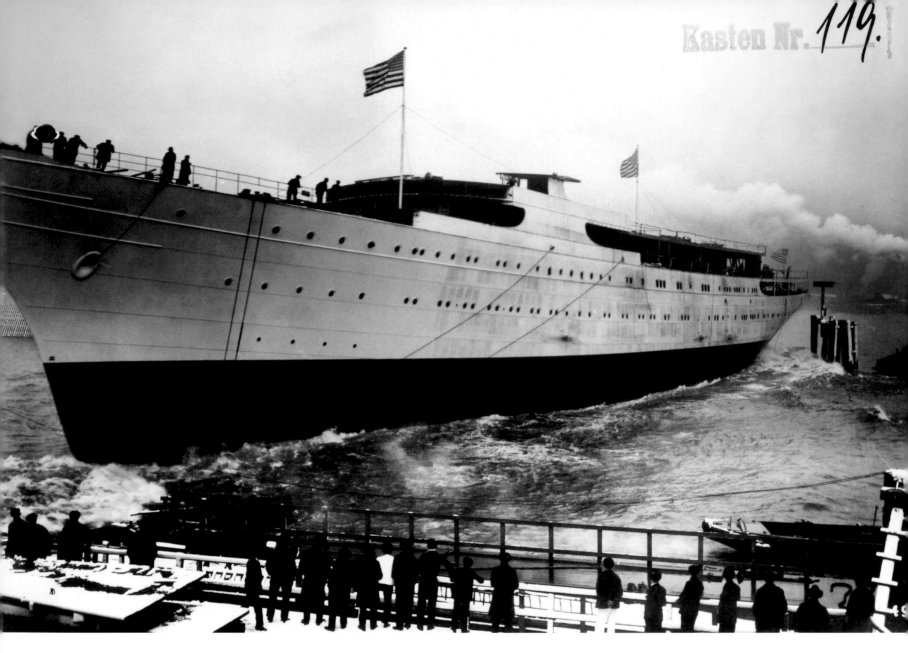

Above, *Savarona* touching water for the first time, at the Blohm & Voss yard. For such a famous yacht, she proved elusive in terms of archival images. Therefore, this image, and the six that follow, are extremely rare and have apparently never been published. (These photographs were marked and fitted into a Blohm & Voss binder; this damage is part of their history.)

Left, the final fitting-out at Blohm & Voss.

Opposite, the engine building and test facility at Blohm & Voss.

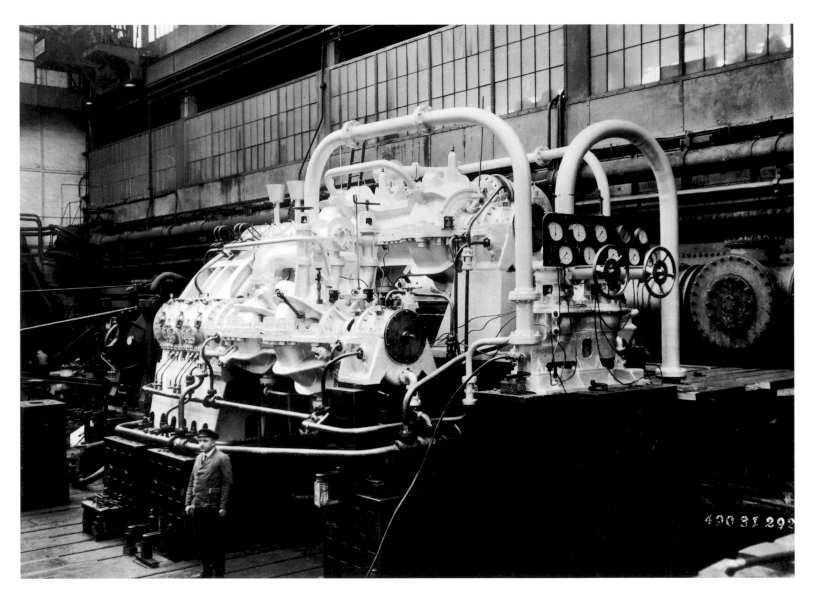

Blohm & Voss, the German company that built *Savarona* in 1930, got its start in 1877 when Hermann Blohm and Ernest Voss founded a general partnership on Kuhwerder, an island that formerly had known only grazing cattle. When anticipated orders were not forthcoming, the men launched an iron barque, *Flora*, on speculation; fortunately, it sold. In 1882, seven ships were launched, and a floating dry dock was completed to help attract repair business. The yard was enlarged between 1887 and 1891 and employed 1,200 persons; by 1894, Blohm & Voss had launched its hundredth vessel and counted as its customers Germany's premier shipping lines and the Imperial Navy. Employment had reached 4,515 by 1902; 7,885 by 1912; and 14,077 by 1918. The company built the famous Atlantic express liner *Vaterland* in 1914 before

converting to war production. (After World War I, *Vaterland* was seized by the United States as a war reparation, renamed *Leviathan*, and rebuilt, in an odd twist of fate, by Gibbs & Cox—*The Golden Century*, page 155—the firm that designed *Savarona*.) In the early 1920s, the company focused its attention on developing the steam turbine engine, becoming a leader in the field. In 1928, the crack Atlantic express liner *Europa* was launched, but the Great Depression drastically cut into orders; by 1932, employment was down to 2,882. Production increased by the late 1930s, helped by Adolf Hitler's policy of rebuilding German naval forces. In 1939, the mighty battleship *Bismarck* was launched. (On her maiden mission, and after sinking the HMS *Hood*—the pride of the English Royal Navy—she was destroyed during an epic bat-

tle with a horrific loss of life. Her remains were discovered by Robert Ballard in 1982 and chronicled in *The Discovery of the Bismarck*.) Employment stepped up to 20,000 during World War II, and 238 U-boats were completed, even as 1,200 high-explosive bombs rained over the yard during the war. After the Allied occupation in 1945, the slipway frame structures were blown up, all facilities were dismantled, and even "the pots and pans in the works canteen" were handed out to fifteen Allied nations. By 1950, employees numbered 127, with a staff of forty-eight. The company slowly rebuilt itself (as Blohm & Voss AG), and by 1957 had 3,450 employees and a staff of 550. Today, the company (split into three corporate components in 1996) builds and repairs a variety of vessels—in its second century of shipbuilding.

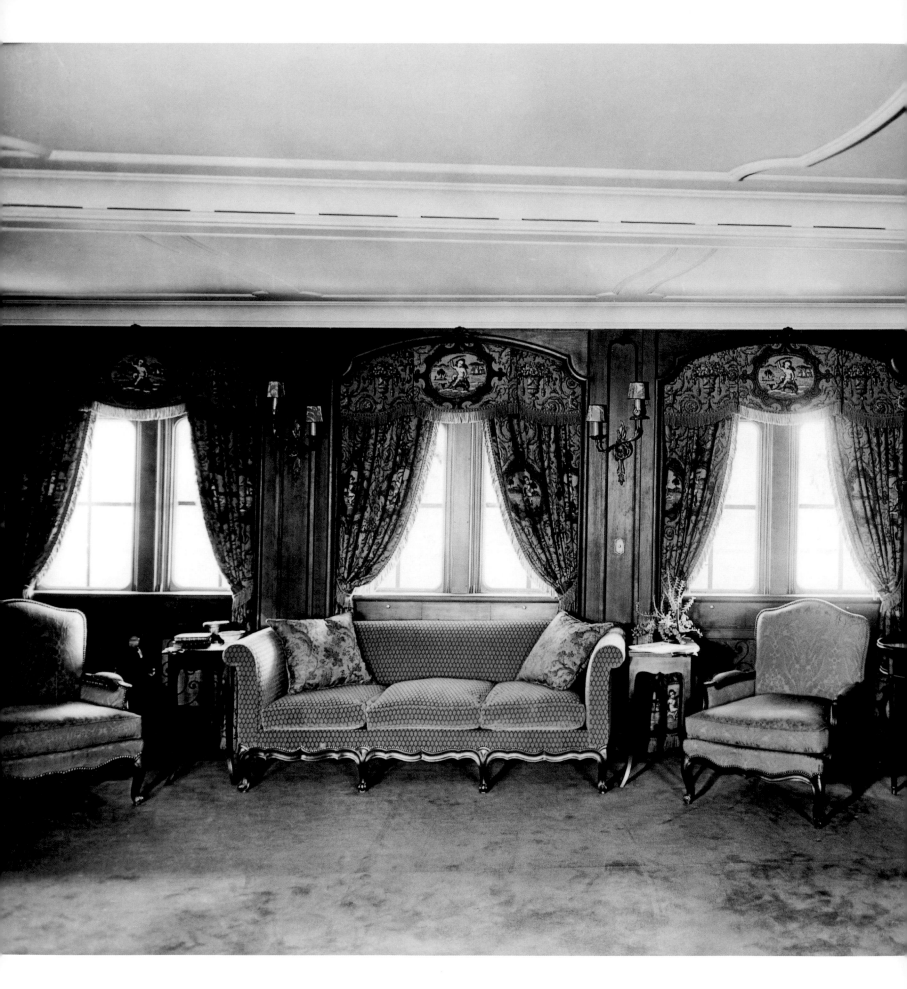

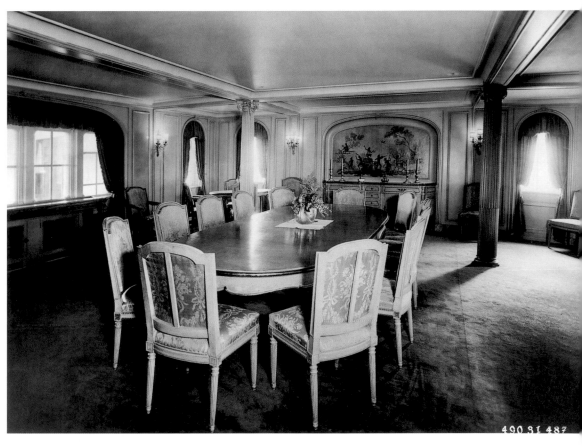

The 1928 *Savarona* had interiors belying their nautical status; so, too, her 1930 successor. The image at left, presumably of the main saloon, offered no indication that one was aboard a yacht; it appeared designed to impress rather than invite. The same holds for the dining saloon, above.

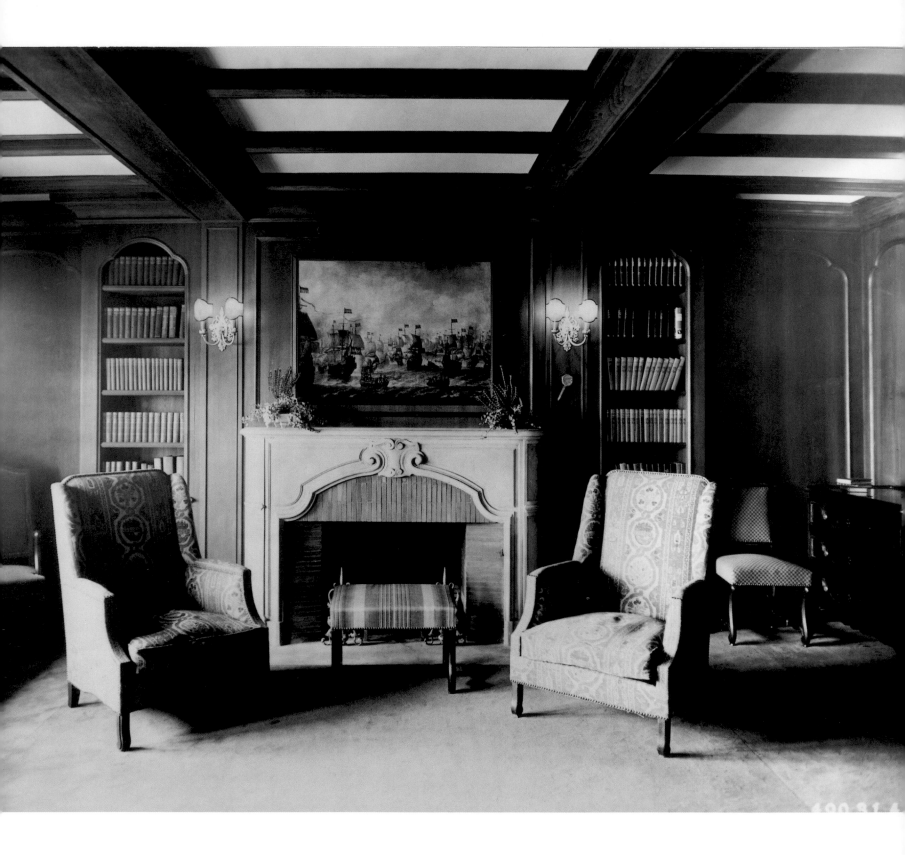

Opposite, the smaller scale of this setting, as well as the beamed overhead, exuded a charm that was otherwise rare aboard the 407-foot *Savarona*.

Above, Emily Cadwalader's stateroom. Compare this with *Idalia* on page 43, proof that bigger is not necessarily better.

WILLIAM C. RANDS

Born in London, William Rands (1872–1952) and his family moved to America in 1884. While he was a teenager, a horse-drawn trolley killed his father when the family was living in Providence, Rhode Island. Forced to provide for his family, Rands quit school and began working, riding a bicycle to and from his job. In time, he became "proficient" at cycling, as recounted by his grandson, William Rands III. After winning several races, a Detroit businessman approached the youth and offered a sizable salary increase if Rands would move to Detroit and race. "It was a very tough decision to leave his mother," recounts his grandson, but Rands moved to Detroit in 1891 and won numerous races. He became a bicycle dealer before shifting his attention toward the nascent automobile industry, and in 1904, he purchased the Wheeler Manufacturing Company, which made such automobile components as tops, windshields, and lamp brackets. Wheeler grew into the Rands Automotive Company, which Rands merged, in 1916, into Motor Products Corporation, a major automotive supplier.

Flush with success, Rands built an elegant limestone home on Detroit's Cass Avenue in 1912–13; he sold the house in 1917 (it is extant and now owned by Wayne State University).

Accessing information on Rands is difficult, as he was "paranoid about being known publicly," as recounts William Rands III, and he "intentionally tried to erase himself from history."

ROSEWILL

1926

When Harry Defoe, of Defoe Boat & Motor Works, heard that fellow Detroiter William Rands was considering ordering a yacht, he hastened to ensure that his company received the commission. A deal was eventually struck for an eighty-three-foot yacht, to be delivered at the knockdown price of $29,500, exclusive of such major items as engines, electric machinery, furnishings, and launches (an eighty-three-foot yacht normally would have cost in the neighborhood of $100,000).

Rands ordered upholstery from the Fisher Body Company (see *The Golden Century*, page 166) and furnishings from another Detroit concern, the Andrew Sisman Company. He enjoyed the elegant, crisp *Rosewill* for only one season before selling to David T. Wende of Buffalo, New York (who renamed her *Restless II*).

Harry Defoe had done his work well, because when William Rands decided to commission a second yacht, he placed the order with Defoe for a 126-footer, *Rosewill II*, a Cox & Stevens design launched in 1931. Rands owned the yacht until 1937, when he sold her to Emma C. Burlington, who renamed the yacht *Burlania*. A year later, she was purchased by Arthur Curtiss James, who owned the 216-foot auxiliary bark *Aloha* (see *The Golden Century*, page 74). After James died in 1941, the renamed *Aloha Lii* was taken over by the U.S. government and disappeared from the record.

Rands later owned *Rosewill III*, an eighty-foot Consolidated built in 1937 and launched as *Nawaja*.

Designed by Hacker & Fermann, Inc.

Built by Defoe Boat & Motor Works, Bay City, Michigan

Two 4-cylinder, 12-cycle Packard gas engines

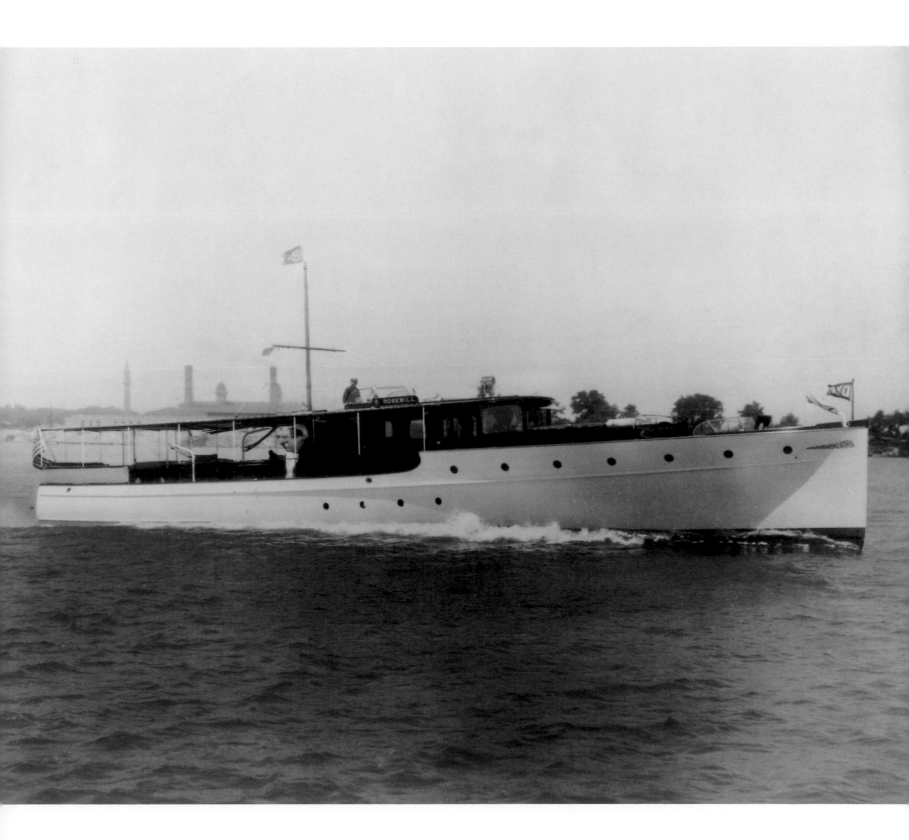

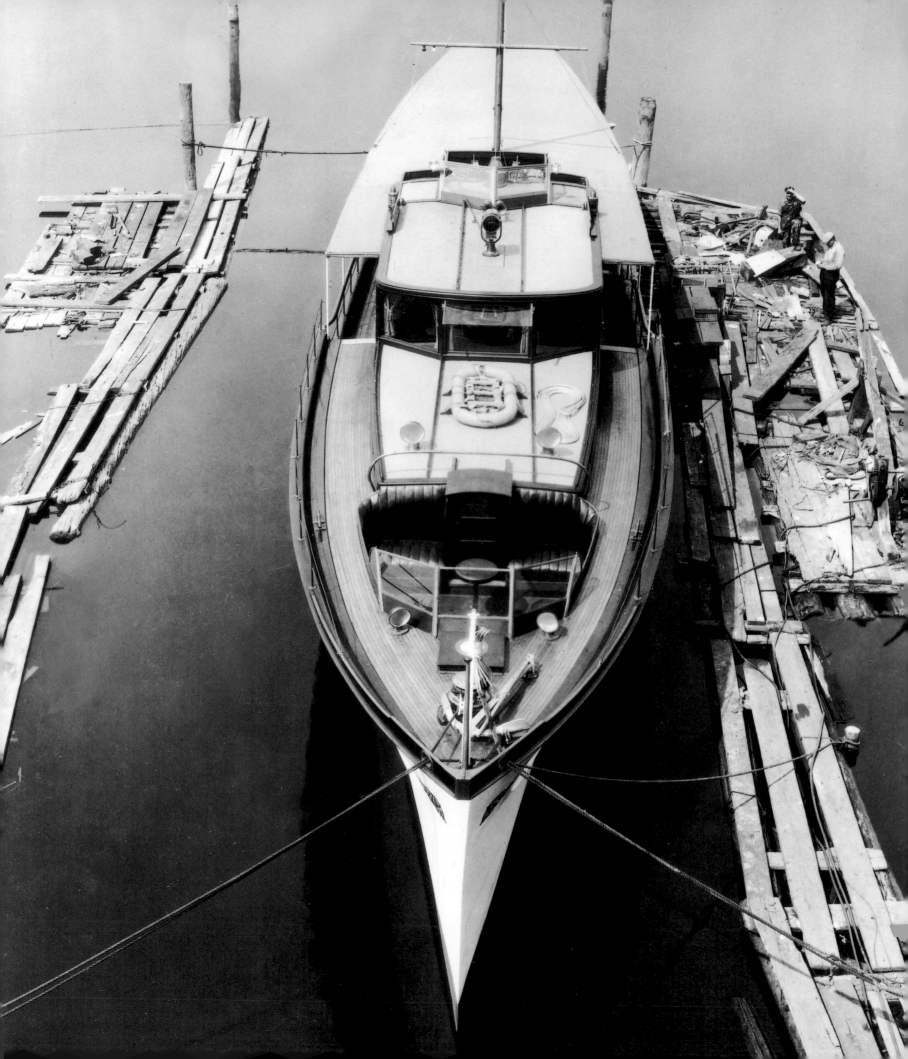

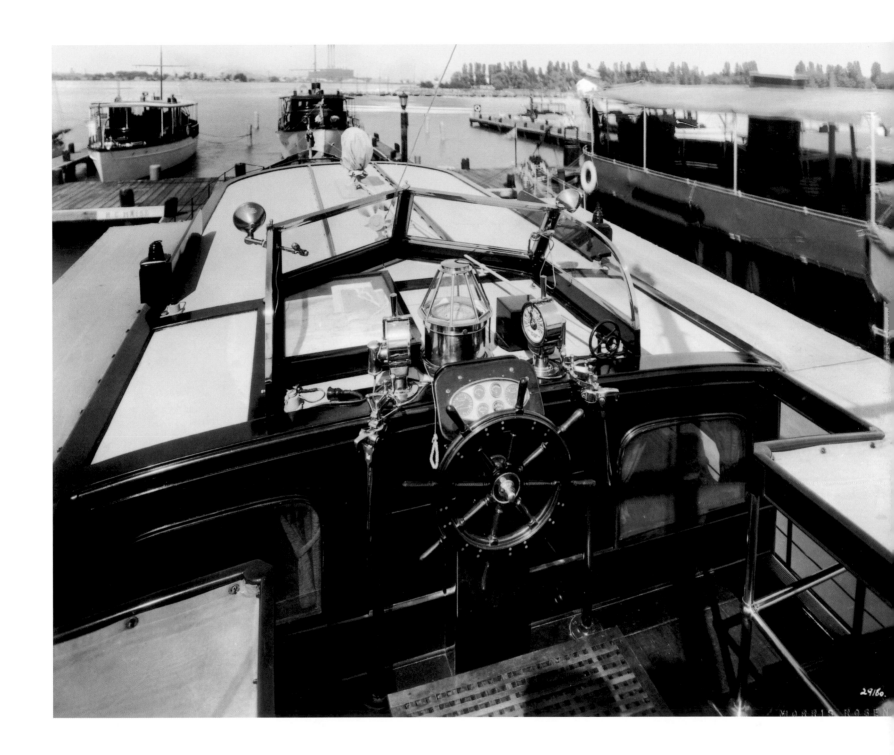

The fine image opposite reveals the art of classic yachts, a vastly different form of expression than its modern counterpart. The lines, materials, and scale of *Rosewill*'s disparate components culminate in a thing of remarkable beauty. It is an image that makes one pause with appreciation.

The close-up of *Rosewill,* above, is no less powerful: her dashing open bridge and brand-new, gleaming controls. Try to imagine the joy of being in such a setting, with the twin Packard engines at full throttle and a crisp wind stinging your face.

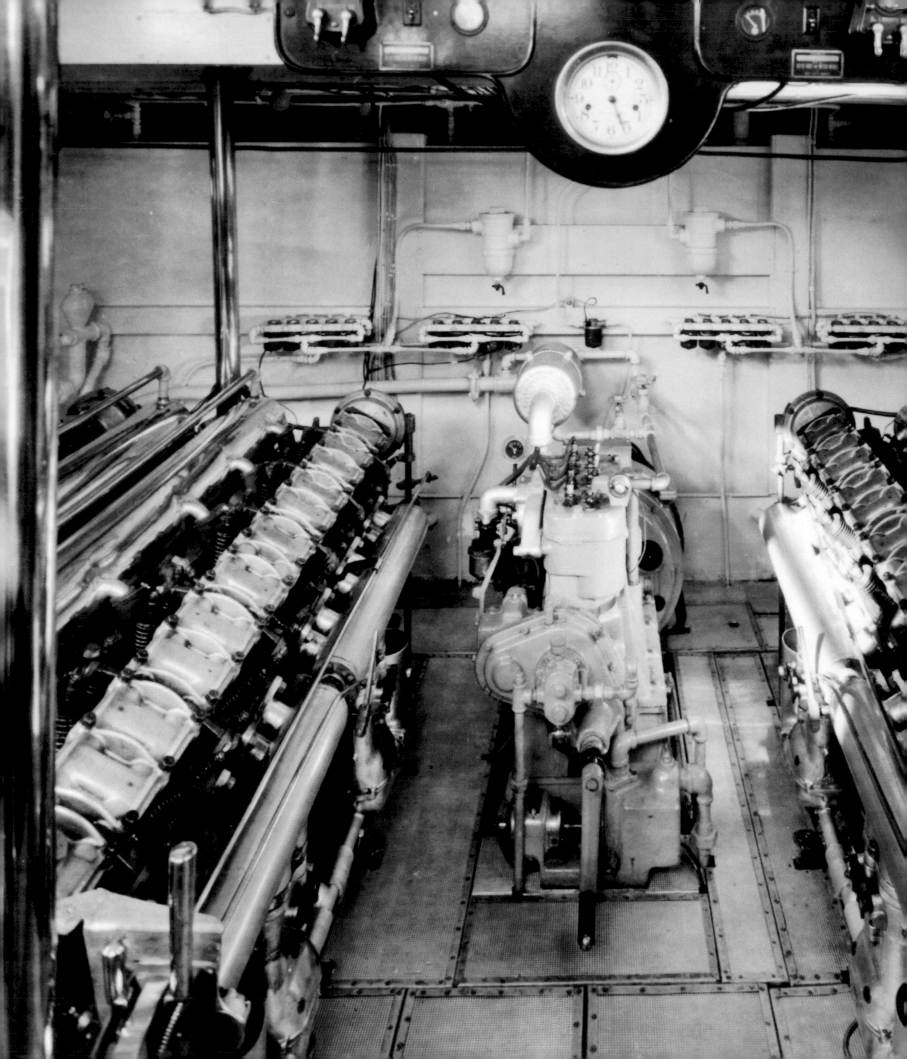

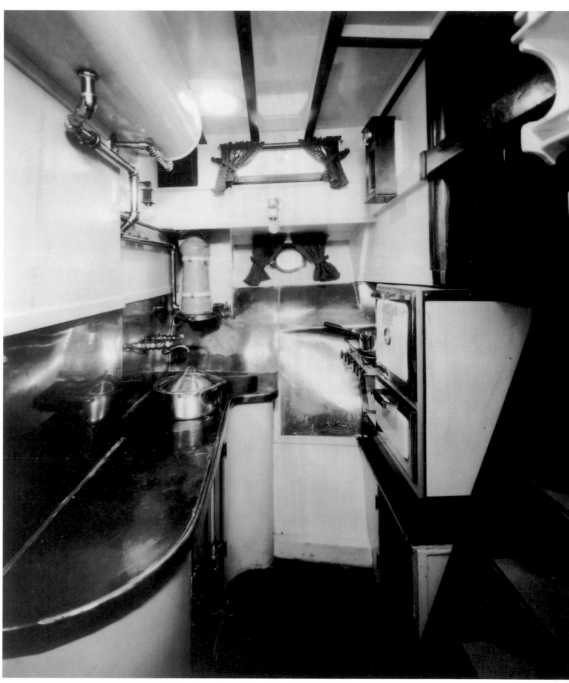

Rosewill's twin Packard engines (left) were located under the main saloon, in a compartment that, while not large or with headroom, was nonetheless efficient—and immaculate.

Rosewill's galley (above) was like her engine compartment—compact, yet eminently serviceable. The counters were, likely, Monel, a material that predated plastic laminate and even stainless steel, and with a high copper content; it required polishing to realize its subtle, glowing beauty.

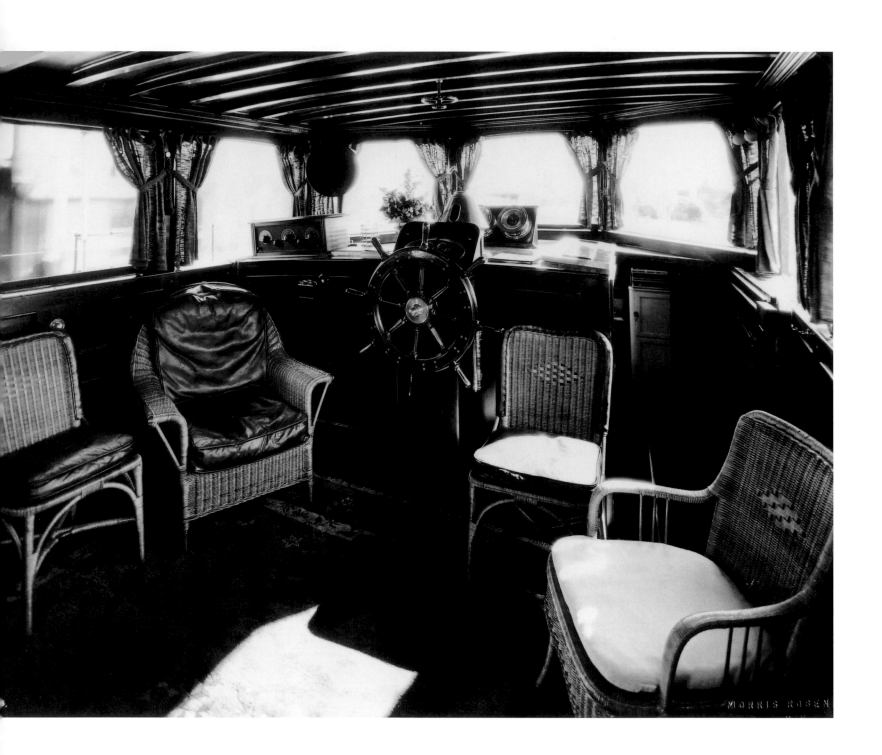

Above, *Rosewill* featured a second pilot station in the main saloon, a sun-filled setting with wicker chairs providing a comfortable resting place.

Opposite, looking aft in *Rosewill*'s main saloon. The built-in settee rested upon the raised, aft trunk cabin.

Note the simplicity of the leaded glass, which was customary for yachts of the era. (Many people restoring a classic yacht opt for even more elaborate leaded-glass patterns.)

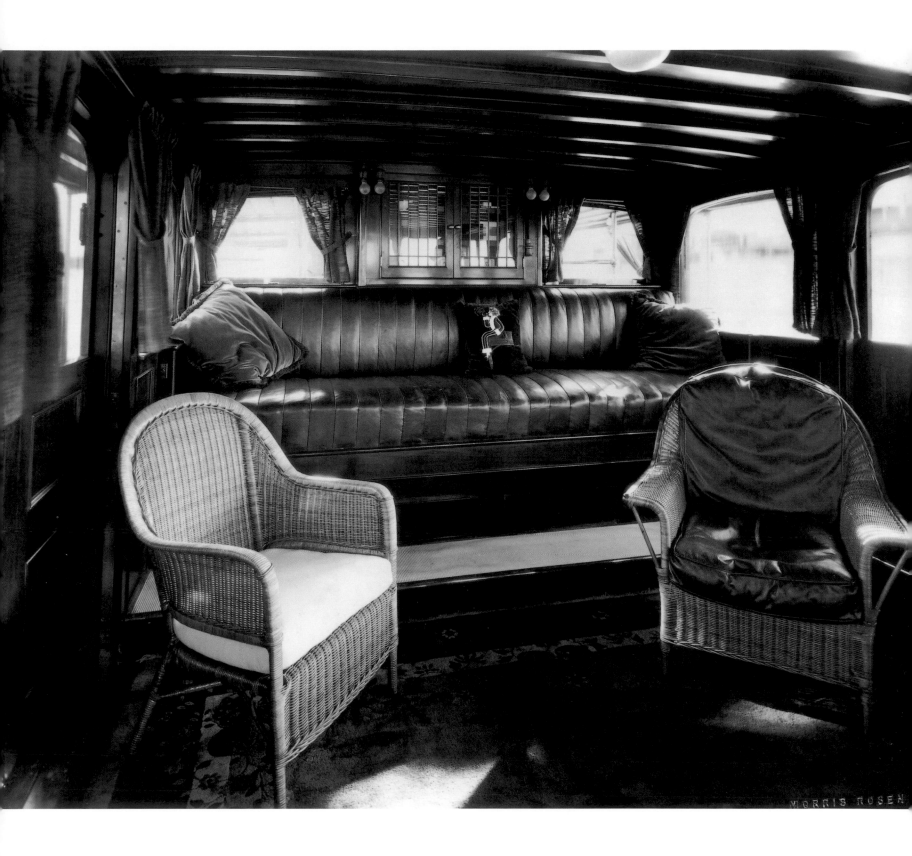

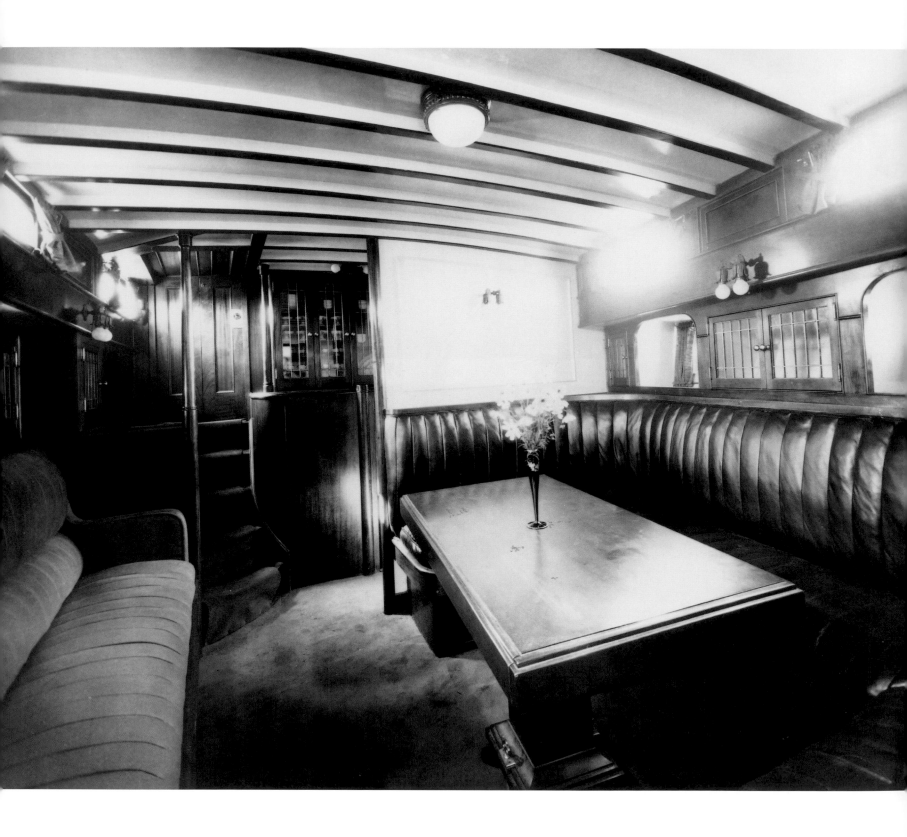

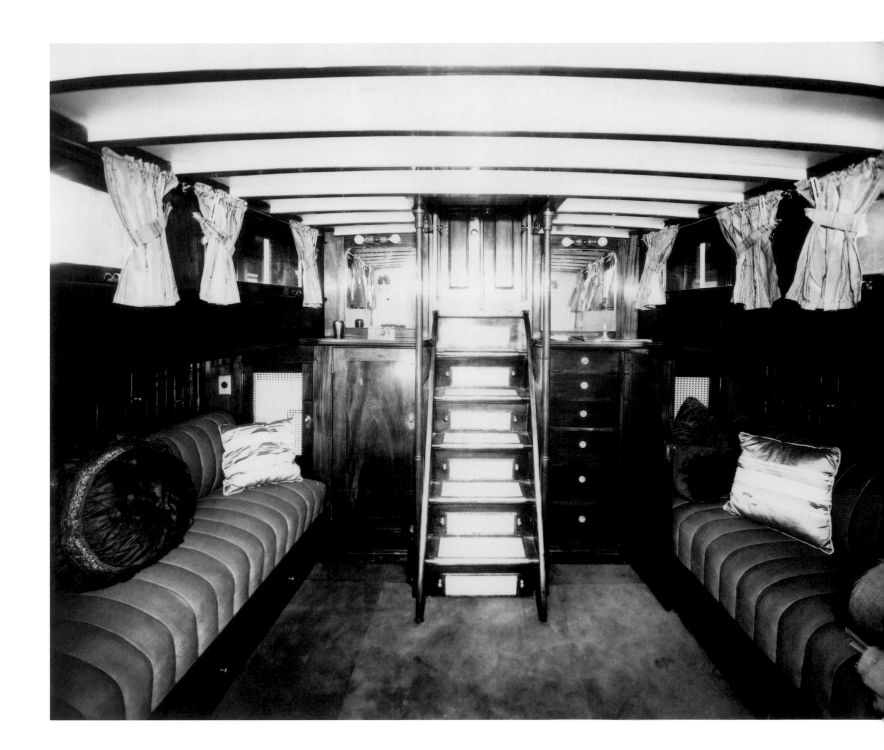

Opposite, from *Rosewill*'s main saloon, one stepped down forward to this cozy dining saloon with a wraparound banquette supplied by Fisher Body.

The cabin above, it is presumed, occupied the aft portion of *Rosewill*'s trunk cabin; the seats probably converted to berths.

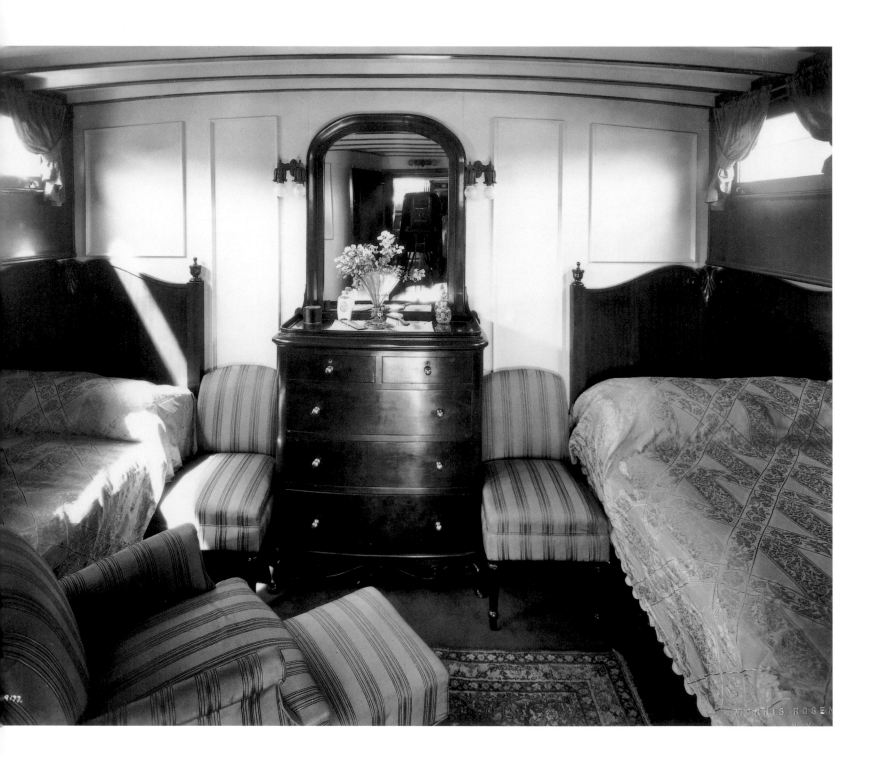

Rosewill's main stateroom, above, had the type of free-standing furnishings that seem inappropriate aboard a yacht, although their simplicity offered some compensation.

Opposite, the narrow beam of *Rosewill,* so typical of classic yachts, provided intimacy—a sensory dynamic to which modern designers pay little attention, with their "bigger is better" philosophy.

The yacht to port is *Comoco*, 140 feet and built in 1927 for Ross Judson.

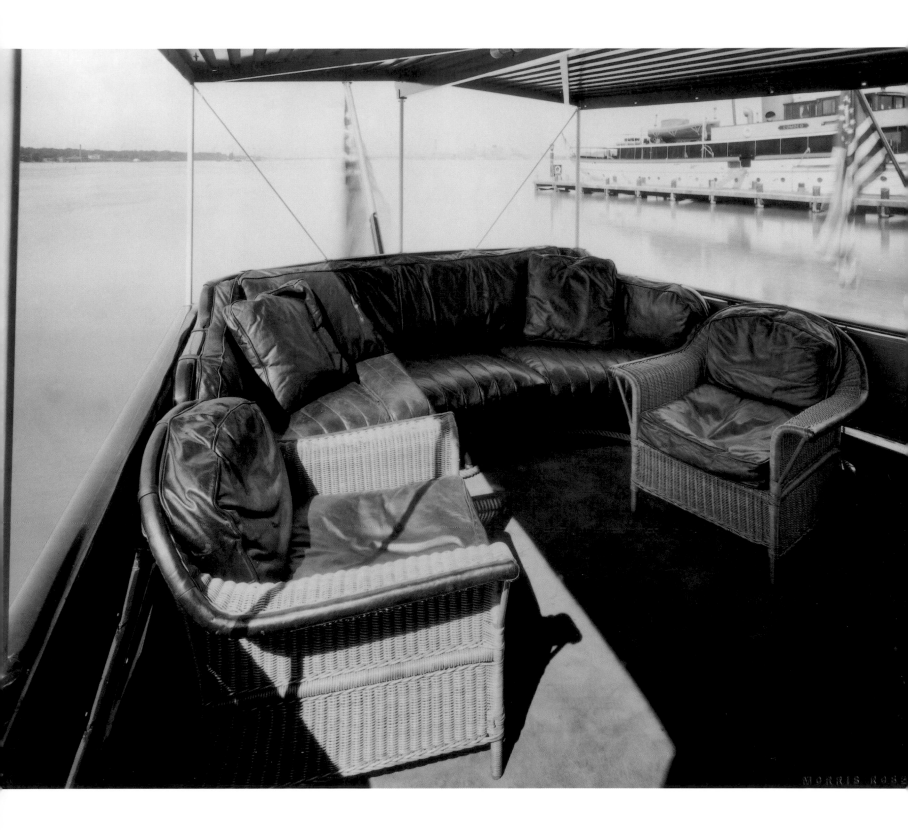

In trying to re-create an opulent era of steam and motor yachting, a historian looks to the chroniclers of the era. Unfortunately, however, there were few. Thomas Fleming Day (1861–1927) is on the short list—a writer (and yachtsman) and one of those rare, great characters that bless civilization occasionally with their presence (like William Sumner Appleton, page 24). Day was born in England, and little is known about his early years or about his parents, Edward Hartsinck Day and Georgina Sarah Day. Charles G. Davis wrote about his initial encounter with a twenty-eight-year-old Day in 1889. On a wharf at the foot of New York's West 152nd Street, Davis saw "a beautiful varnished lap-streaked, double-ended boat, shiny with glittering brass cleats, chocks and rudder," come drifting toward him. Inside the craft was a "young, curly headed chap"—Tom Day.

Day worked for J. J. Bockee & Company (47 Dey Street), which sold the small skiff with the glittering brass cleats that so impressed Davis. The two men started talking, retired to the adjacent wharf pub, and Davis commented, "Tom was a good salesman. He was quiet, yet attractive, and brimful of information on boats." At the time, Davis was an apprentice to naval architect William Gardner (page 38), and he soon fell in with the earnest "chap" he had met, joining the monthly meetings Day held for a small, select coterie of yachting enthusiasts at his home at 147 East 127th Street (no longer extant), where the group would "congregate around the dining table to smoke, have coffee, and talk over yachting as only the sincere devotees of the sport can."

A historian longs for a time-travel machine.

This band of devotees, lamenting the dearth of written stories about their passion, decided to join forces and rectify what they considered untenable. *The Rudder* magazine was the result, and Day became its editor—a position he would hold for twenty-six years. The magazine debuted in May 1890, with "not much in it but what was there was news—real news."

This gang of earnest yachtsmen also organized a Corinthian Navy, which held its first race in 1890 at Echo Bay, New Rochelle. Day was vice commodore. In 1902, he organized a 330-mile race between Brooklyn, New York, and Marblehead, Massachusetts, for small yachts (thirty feet and under, waterline length). This race inspired what is today known as the Bermuda Race, begun in 1906. Day was an ardent champion of ocean racing, and he endlessly needled his *Rudder* readers about never straying from sight of land. To him, *real* sailing was associated with the open water, not protected inlets, sounds, and rivers.

Day was unusual in that his passion for sailing was nearly

Opposite, this evocative image of Thomas Fleming Day, the longtime editor of *The Rudder* magazine, was taken in 1898 by his friend Charles G. Davis, who wrote a touching account of his extraordinary friend in the May 1930 issue of *The Rudder*.

matched by one for motor yachting; people then, as today, tended to be in one camp or the other—fiercely so. Eager to promote powerboats, he donated a sterling silver cup to the New York Athletic Club for a motorboat race. After the sinking of the *Titanic*, people's faith in ocean traveling was deeply shaken. In 1914, to help restore confidence, William E. Scripps (of Scripps Motor Company, and the son of the *Detroit News* founder) decided to sponsor an extraordinary 6,000-mile voyage from Detroit, Michigan, to St. Petersburg, Russia, aboard a gas-powered (16-hp Scripps), thirty-five-foot custom craft with a 240-square-foot sail. Scripps selected Day—by now known as "The Old Man" and "Tuffernhell"—as captain of the *Detroit*. The previous year, Day had crossed the Atlantic in a twenty-five-foot yawl, the *Sea Bird*, which he chronicled in a "chatty, nothing-to-it" book.

Day had hoped to persuade the public that traveling vast oceans aboard a small motor craft was safe—even safer, he claimed, than by traveling aboard a great liner "with their proneness to meet with disaster."

Also on board were "green hands" and Harvard graduate Charles C. Earle (age twenty-one), chief engineer Walter Moreton (twenty-nine), and second engineer William Newstedt. Compared to his crew, the Old Man, at fifty-three, must have seemed just that. In time, Day would praise Earle and Moreton, but he felt otherwise toward the hapless, seasick Newstedt: "I coaxed and cursed him, but to no avail."

Newstedt's discomfort can be imagined. The crew was subject to piercing cold (Day wore five shirts under a vest, a coat, and foul-weather gear—and still felt numb), empty stomachs, dry throats (they carried no bottled water), soaked legs (the low deck was constantly awash), stinging skin (the salt encrusting their faces worked into the pores and stung like pepper), and long stretches at the wheel, often thirty-six hours straight. Yet one of Day's few complaints was about not shaving: "The spirit of the hobo liveth not within me."

The Scripps engine did not help. It proved so loud that the small crew had to wear earplugs and shout to be heard. An efficient muffler "would have added greatly to our comfort," Day dryly commented after the fact.

Enjoying good speed (an average of 144 daily sea miles), the little *Detroit* at one point encountered the massive liner *Amerika;* its thousands of passengers and crew frantically shouted and took pictures of the diminutive craft when it pulled alongside. The captain of the *Amerika* was miffed at the "Yankee impudence" of the tiny *Detroit* stopping his mighty ship. His passengers, no doubt, felt otherwise.

After twenty-one days of constant rain and wind, the intrepid vessel reached Queenstown, Ireland. The town had not anticipated this extraordinary guest, but soon dozens of reporters converged upon the four haggard, exhausted men. But the weather forced a departure earlier than the *Detroit* crew would have liked, and they headed west, landing in Russia on September 13. Unlike their arrival in Ireland, they received a tumultuous and immediate welcome. As the *Detroit* made its way up the Neva River in St. Petersburg, the quays and bridges were teeming with well-wishers waving hats and scarves, while the numerous private and imperial yachts dipped their colors.

Day later wrote about this epic journey in *The Voyage of the Detroit*. Other Day books include *Songs of Sea and Sail* (1898); *On Yachts and Yacht Handling* (1899); *Hints to Young Yacht Skippers* (1902); *On Yacht Sailing* (1904); *The Four and the Fire, or Five Nights in a Great Yacht Club* (1907); *The Adventures of Two Yachtsmen* (1907); *Across the Atlantic in Sea Bird* (1911); and *Bristol Jack and Other Poems* (1922).

After leaving *The Rudder*, his longtime port, Day focused his attention on various marine-related businesses in New York. The historical records offer us little more.

In 1927, *The Rudder* wrote that Day "set sail on his last cruise, a voyage to the Islands of the Blessed." To translate, Day died on August 19, at sixty-six. His ashes were spread at sea by Fred Thurber, his crewmate aboard the *Sea Bird*. Day left a wife, the former Anne Pirine Dunham (whom he married in 1889) and three children. Day had been a member of fifty-four yacht clubs. Today, the Thomas Fleming Day Memorial Trophy is one of the few reminders of a unique, irascible, prolific, dashing, driven man.

The "Old Man" and his crew aboard *Detroit*.

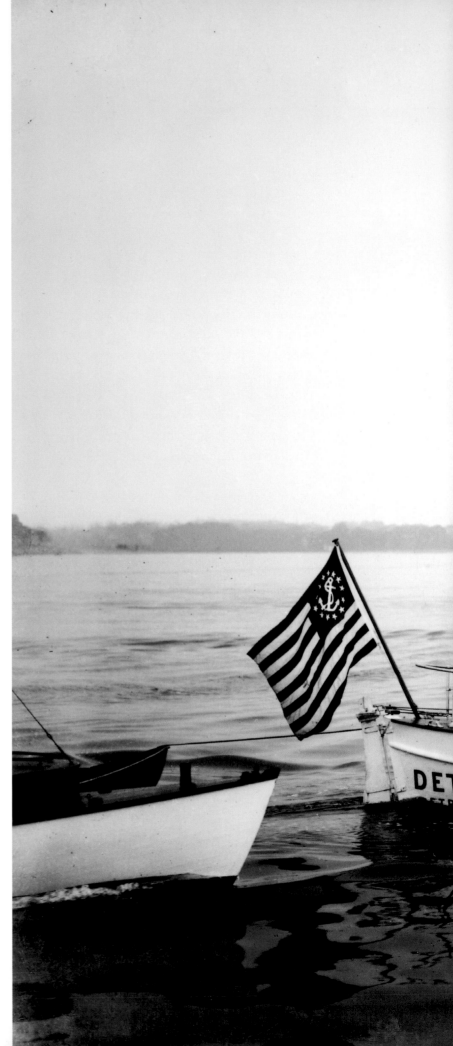

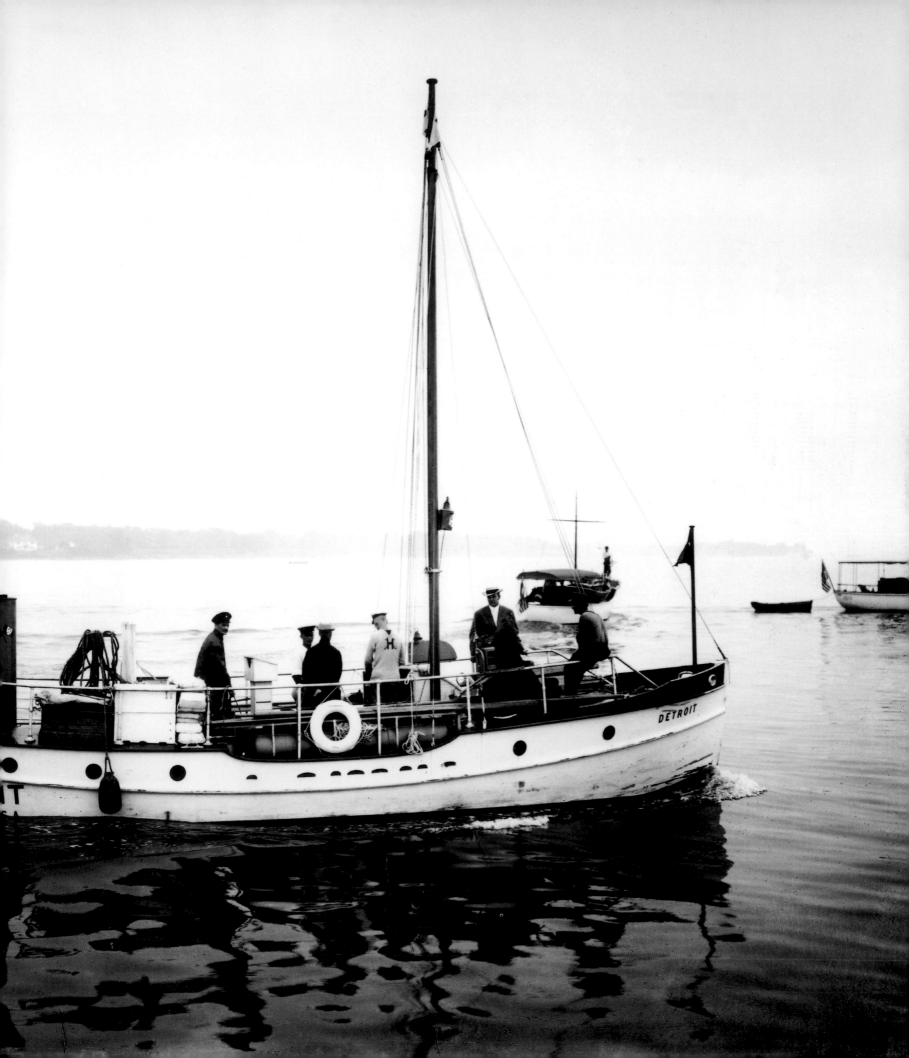

NATHANIEL L. STEBBINS

The maritime photographers of this opulent era were also few, most notably Morris Rosenfeld and Edwin Levick (detailed in *The Golden Century*; their collections now are at Mystic Seaport Museum and the Mariners' Museum, respectively). Another major talent of the era was Nathaniel L. Stebbins (1847–1922), whose work is substantially represented in this volume. Stebbins was, like Thomas Fleming Day, a rare chronicler of the era, but he worked with images, not words. The son of Reverend Rufus P. Stebbins and Eliza (Livermore) Stebbins, Nathaniel was born in Meadville, Pennsylvania. Early on, he evidenced a love for all things nautical, and as a young man he voyaged to South America; the experience cemented a passion for the ocean. In the early 1880s, he shifted his attention toward photography and improvised a darkroom in his home. In the decades that followed, this nascent hobby developed into a career, although it is not known whether Stebbins ever earned a living from his photography; indeed, little is known of his life in general. It appears that he may have been married twice and had at least one child, Katherine. He published several books of images, including *American and English Yachts* (1887), with a text by the leading naval architect of the day, Edward Burgess (who would die four years later from overwork; he was forty-three); *Yacht Portraits of the Leading American Yachts* (1889); *Illustrated Coast Pilot* (1891); *The Yachtsman's Album* (1896); and *The New Navy of the United States* (1912). After the turn of the twentieth century, *The Rudder* magazine began featuring many Stebbins images.

Besides photographing yachts, Stebbins enjoyed sailing them, owning a forty-foot sloop for many years and, later, a yawl; he also chartered a steam yacht for a season, and was a member of several yacht clubs. In photographing races, he would hire a tugboat in order to be able to maneuver quickly. His daughter, Katherine (Stevens), reported many years later that, while trying to get his shot, her father (who was of slight stature) would be balancing over the bow rail with the heavy box camera standard for the day, as the vessel heaved up and down upon the waves and his family watched apprehensively. Stebbins could not "swim a stroke."

After Stebbins died in 1922, his collection of 20,000 glass-plate negatives (records indicate that he had taken 25,000 images during his career) were purchased by another photographer, Edward U. Gleason, who had been involved in Stebbins's business for several years. Upon Gleason's death six years later, about two hundred images were purchased by two separate individuals (these images are now at the Peabody Museum and the Mariners' Museum). The remaining collection was considered next to worthless, and much of it was disposed of. One individual thought otherwise about its relative value: the enterprising William Sumner Appleton (page 24) acquired all that remained—2,500 glass plates and a similar amount of

prints in bound albums. These images now reside at the Society for the Preservation of New England Antiquities (SPNEA; see page 24).

Occasionally, Stebbins images surface. Author W. H. Bunting writes in *Steamers, Schooners, Cutters & Sloops* about his experience while "visiting a delightful eighty-six-year-old former railroad man, who lived in a cottage stuck off in the woods of western Massachusetts. Housekeeping was not the old gandy dancer's forte, and the overstuffed chairs were slick with grime and upholstered in dog hair. The atmosphere was rich with the combined aromas of kerosene fumes, five elderly and overfed dogs, a one-legged crow, and twenty years of cigar smoke, all a-simmer from the heat of two stoves running wide open, with throttles 'in the corner.' While the old man swayed around the room like a drunken belly dancer, demonstrating how he balanced on shaking bridge trusses while heavy freight trains rolled beneath him, my eyes were fixed by a wonderful 'lost' Stebbins framed on the wall. It was taken in 1886, and showed the grounded remains of the tug *John Markee*, a victim of a boiler explosion. A man and a boy sat on the rail cap, while two boys in a dory hung on to the rudder."

As Bunting observed, Stebbins, who had contributed so much to chronicle a remarkable era of yachting, died without comment in the Boston newspapers or even *The Rudder* and *Yachting*. But William Appleton remembered.

BIBLIOGRAPHY

Adams, H. Austin. *The Man John D. Spreckels.* San Diego, California: Frye & Smith, 1924.

Bowbrow, Jill, and Dana Jinkins. *The World's Most Extraordinary Yachts.* Maine: Concepts Publishing, 1986.

Bunting, W. H. *Portrait of a Port: Boston, 1852–1924.* Cambridge, Massachusetts: Belknap Press of Harvard University, 1971.

———. *Steamers, Schooners, Cutters and Sloops;* the maritime photographs of N. L. Stebbins taken from 1884 to 1907, Boston: Houghton Mifflin Co., 1974.

Couling, David. *Steam Yachts.* Maryland: Naval Institute Press, 1980.

Crabtree, Reginald. *The Luxury Yacht from Steam to Diesel.* New York: Drake Publishers, 1974.

Dear, Ian. *The Great Days of Yachting.* London: B. T. Batsford, Limited, 1988.

Drummond, Maldwin. *Salt-Water Palaces.* New York: The Viking Press (in association with Debrett's Peerage Limited), 1979.

Feversham, Lord. *Great Yachts.* New York: G. P. Putnam's Son's, 1970.

Hewlett, Richard Greening. *Jessie Ball du Pont.* Gainesville, Florida: University Press of Florida, 1992.

Hofman, Erik. *The Steam Yachts, An Era of Elegance.* Lymington, Hampshire, England: Nautical Publishing Company, 1970.

Lloyd's Register of American Yachts. Lloyd's Register of Shipping, various years.

McCall, Dorothy Lawson. *The Copper King's Daughter.* Portland, Oregon: Binfords & Mort, 1972.

McCutchan, Philip. *Great Yachts.* New York: Crown Publishers, 1979.

Meisel, Tony. *Yachting, a Turn of the Century Treasury.* New Jersey: Castle, 1987.

Phillips-Birt, Douglas. *The History of Yachting.* New York: Stein and Day, 1974.

Robinson, Bill. *The Great American Yacht Designers.* New York: Alfred A. Knopf, 1974.

———. *Legendary Yachts.* New York: The MacMillan Company, 1971.

———. *The World of Yachting.* New York: Random House, 1966.

Rosenfeld, Stanley, and William H. Taylor. *The Story of American Yachting, Told in Pictures.* New York: Bramhall House, 1958.

Rousmaniere, John (and the editors of Time-Life Books). *The Luxury Yachts.* Alexandria, Virginia: Time-Life Books, 1981.

Thompson, Winfield M., and Thomas W. Lawson. *The Lawson History of the America's Cup: A Record of Fifty Years.* Boston: Thomas Lawson, 1902.

Tolf, Robert, and Robert Picardat. *Trumpy.* Maryland: Tiller Publishing, 1996.

Tompkins, Eugene. *The History of the Boston Theater, 1854–1901.* Boston: Houghton Mifflin, 1908.

Walker, Fred. *Song of the Clyde, A History of Clyde Shipbuilding.* New York and London: W. W. Norton & Company, 1984.

Wall, Joseph Frazier. *Alfred I. Du Pont: The Man and His Family.* American Philological Association, 2001.

ILLUSTRATION CREDITS

Cover: Thomas W. Lawson, courtesy of the Boston Public Library, Print Department

Front Endpaper: *Freedom*, © Mystic Seaport, Rosenfeld Collection, Mystic, CT

Page 1: Hotel del Coronado, Library of Congress, Prints & Photographs Division

Title page: *Venetia*, San Diego Maritime Museum

Copyright page: *Dreamer*, Peabody Essex Museum

Contents page: *Coronto*, Society for the Preservation of New England Antiquities

Pages 20–21: *Venetia*, courtesy of Richard Wheeler

Pages 22–25: Nathaniel L. Stebbins image, Society for the Preservation of New England Antiquities

Pages 26–27: Author's collection

Pages 28–29: Library of Congress, Prints & Photographs Division

Pages 30–31: Nathaniel L. Stebbins image, Society for the Preservation of New England Antiquities

Page 32: top, Maine Maritime Museum; bottom, U. S. Naval Historical Center

Pages 33–45: Nathaniel L. Stebbins image, Society for the Preservation of New England Antiquities

Page 46: *The Rudder*

Pages 47–51: Nathaniel L. Stebbins image, Society for the Preservation of New England Antiquities

Pages 52–55: Courtesy of the Boston Public Library, Print Department

Pages 56–57: Nathaniel L. Stebbins image, Society for the Preservation of New England Antiquities

Pages 58–59: Courtesy of the Boston Public Library, Print Department

Page 60: top, Courtesy of the Boston Public Library, Print Department; bottom, Scituate Historical Society

Pages 61–64: Courtesy of the Boston Public Library, Print Department

Pages 65–66: Scituate Historical Society

Page 67: Courtesy of the Boston Public Library, Print Department

Pages 68–69: Scituate Historical Society

Page 70: top, Courtesy of the Boston Public Library, Print Department; bottom, Scituate Historical Society

Page 71: Peabody Essex Museum

Pages 72–75: Nathaniel L. Stebbins image, Society for the Preservation of New England Antiquities

Pages 76–79: *The Rudder*

Pages 81–83: Courtesy of the Hotel del Coronado

Page 84: top and bottom left, Author's collection

Pages 84–85: California State University, Henry Madden Library

Page 86: Courtesy of the James S. Copley Library

Page 87: Author's collection

Pages 88–91: Courtesy of the James S. Copley Library

Pages 92–99: James Burton image, © Mystic Seaport, Rosenfeld Collection, Mystic, CT

Pages 101–53: Special Collections, Leyburn Library, Washington and Lee University

Pages 154–55: Courtesy of the Hagley Museum and Library

Pages 156–59: Special Collections, Leyburn Library, Washington and Lee University

Page 160: Courtesy of the Hagley Museum and Library

Pages 161–63: Special Collections, Leyburn Library, Washington and Lee University

Pages 164–68: Edwin Levick image, Special Collections, Leyburn Library, Washington and Lee University

Page 169: Special Collections, Leyburn Library, Washington and Lee University

Pages 170–71: Courtesy of the Annapolis Maritime Museum

Page 173: The Mariners' Museum, Newport News, VA

Page 175: Herbert Hoover Presidential Library

Page 176: *The Rudder*

Page 177: Author's collection

Pages 178–79: © Mystic Seaport, Rosenfeld Collection, Mystic, CT

Page 180: Courtesy of the Hagley Museum and Library

Page 181: top, Courtesy of the Hagley Museum and Library; bottom, *The Rudder*

Pages 182–85: Courtesy of the Hagley Museum and Library

Pages 186–91: © Mystic Seaport, Rosenfeld Collection, Mystic, CT

Pages 192–99: Courtesy Anton Fritz

Pages 201–2: Historical Collections of the Great Lakes, Bowling Green State University

Pages 203–11: Morris Rosenfeld images, Historical Collections of the Great Lakes, Bowling Green State University

Page 212: *The Rudder*

Pages 214–15: © Mystic Seaport, Rosenfeld Collection, Mystic, CT

Page 217: Society for the Preservation of New England Antiquities

Back Endpaper: *Going Home*, Library of Congress, Prints & Photographs Division

Back Cover: Nemours, Leyburn Library, Washington and Lee University; *My Gypsy*, Nathaniel L. Stebbins image, Society for the Preservation of New England Antiquities

INDEX

Page numbers in italics indicate illustrations.

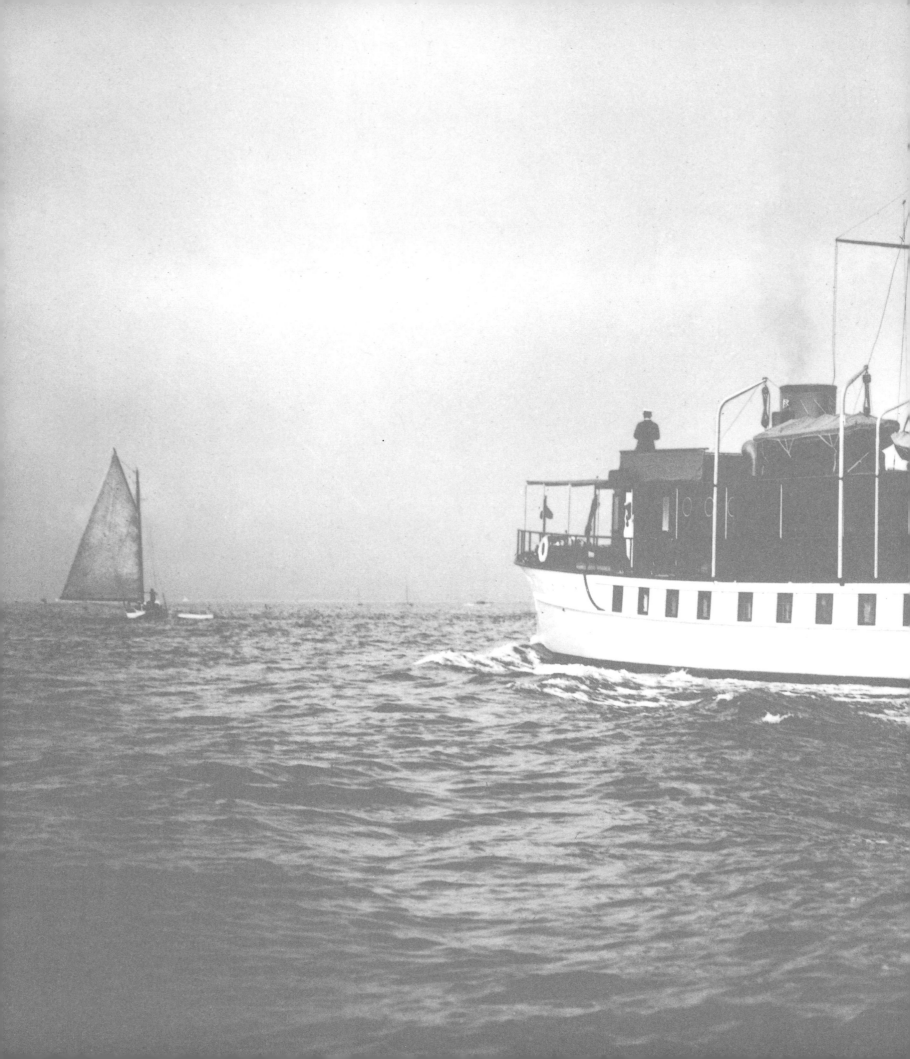